Byzantine Art

Oxford History of Art

Robin Cormack is Professor in the History of Art in the University of London and Deputy Director at the Courtauld Institute of Art. He is author of *Writing in Gold. Byzantine Society and its Icons* (1985), *The Byzantine Eye. Collected Studies in Art and Patronage* (1989), and *Painting the Soul. Icons, Death Masks, Shrouds* (1997).

He co-operated in the production of the film *A Window to Heaven* (Getty Foundation and Metropolitan Museum Program for Art on Film, 1990), and was the Royal Academy consultant for the exhibitions *From Byzantium to El Greco* (1987) and *The Art of Holy Russia. Icons from Moscow 1400–1660* (1998).

Oxford History of Art

Titles in the Oxford History of Art series are up-to-date, fully-illustrated introductions to a wide variety of subjects written by leading experts in their field. They will appear regularly, building into an interlocking and comprehensive series. Published titles are in bold.

Oxford History of Art

Byzantine Art

Robin Cormack

OXFORD
UNIVERSITY PRESS

OXFORD
UNIVERSITY PRESS

Great Clarendon Street, Oxford OX2 6DP

Oxford New York

Athens Auckland Bangkok Bombay
Calcutta Cape Town Dar es Salaam Delhi
Florence Hong Kong Istanbul Karachi
Kuala Lumpur Madras Madrid Melbourne
Mexico City Nairobi Paris Singapore
Taipei Tokyo Toronto
and associated companies in Berlin Ibadan

Oxford is a trade mark of Oxford University Press

British Library Cataloguing in Publication Data
Data available

Library of Congress Cataloging in Publication Data
Data available

0-19-284211-0

10 9 8 7 6 5 4 3 2 1

Typeset by Paul Manning
Printed in Hong Kong
on acid-free paper by C&C Offset Printing Co., Ltd

Contents

Preface

This part of the *Oxford History of Art* must expect to engage with a variety of viewpoints which may be mutually incompatible. Byzantine art for some will be seen as a direct continuation of Greco-Roman art. In this case, it is the next stage in a story in which the art and aesthetic ideas of antiquity move on and are developed in the different circumstances of a society that described itself as Roman, at least until it had doubts in the thirteenth century, but that thought and wrote predominantly in Greek rather than Latin. From such a perspective, Byzantine art emerges as western art and will be seen at its most effective in its continuation and adaptations of classicism. Byzantine intellectuals encouraged this viewpoint when they praised their own art for its 'lifelike' appearance, and when they even invoked the famous artists of anti-quity in comparison. The ninth-century intellectual Photios, who became patriarch and head of the Byzantine church, actually described one church pavement in Constantinople, decorated with inlaid representations of various animals, as a work of art that surpassed that of Phidias, Parrhasios, Praxiteles, and Zeuxis. No one now will take his claim at face value, and most will regard it as eccentric, probably demonstrating book learning rather than an appreciation of ancient art. Yet it is the shock of Byzantine remarks like this that injects a tension into a viewing of Byzantine art as a continuation of antiquity. How true and how false is our perception of Byzantine art and the Byzantines' perception of their own art?

The opposite standpoint is to put the greatest emphasis on discontinuity with antiquity. The question is then how radically Christian art rejected classical learning and culture because they were unacceptably tinged with paganism, and how far the innovation of Byzantine art lay in the exploration of non-naturalistic imagery. Was there a deliberate and positive move against and away from classical 'illusionism' and towards an art that might better convey and symbolize the eternal values of the Christian religion and the superiority of another world beyond the earthly world? This view has sometimes stimulated the idea of Byzantine art as an abstract form of art more in line with the orient than with the west, and has encouraged the viewing of Byzantine art as a non-western art.

These two views of Byzantine art are perhaps the extremes and exist with many variations in between. This book aims to deconstruct the extremes by arguing that Byzantium and Byzantine art are products of the Roman world, and that any stark east–west polarity in culture had already

been broken down by the internationalism of the Roman empire when Christian art developed.

The method of this book is to accept that these general questions have always dominated the literature on the subject, and that they can only be broken down and tested through analysis of all the specific images and materials that make up the totality of Byzantine art. At the same time, there is no such thing as an innocent eye, and everyone will come to Byzantine art with the baggage of these and other equally broad assumptions as they face the objects. It follows that the quality of any particular Byzantine work will for some lie in its classical echoes, and for others in its bold decorative features, and this may lead to profound disagreement over the nature of the period itself and the materials that hold the best clues to its understanding. Any resolution of these questions must in the end involve treating particular moments of time in depth and with a full awareness of how the Byzantines themselves structured their thought processes. A full art history of Byzantium is also a cultural history of Byzantium. This probably means that studying Byzantium chronologically can demonstrate the extent and nature of change over the centuries, yet it may involve too restricted a selection of materials; whereas studying it synchronically through chosen themes may allow greater consistency of choice of materials, but distort the period by underestimating the amount of change. The solution here has been to work chronologically, and to impose 'periods' on the full range of Byzantine art history, while admitting that the boundaries are artificial and may overlap. Over a long period of time it emerges that Byzantium sometimes looked to the east for ideas, sometimes to the west, sometimes both ways at once.

The problem of writing about Byzantine art is to indicate both the immensity of the field and the manifold contribution of art-historical literature to its understanding. At the same time, it always seems like a subject in its infancy: there is much to do and no agreement even about the questions or the methods appropriate to this field. My main acknowledgement in this book is perhaps less to the many people who have helped me in all sorts of ways and more to a recognition of all the previous (and current) writers in this field, with their remarkable diversity of interests and methods. In keeping with a book on Byzantium, they will remain anonymous here, although they all know that it is real individuals that make a way of thinking and looking. There has been too little space to do any more than indicate lines of thinking and to expose the material that needs explaining. Until recently, Byzantine art history put a premium on describing and dating its materials. This for a long time privileged the study of illuminated manuscripts above other art forms, since the miniatures and all the codicological aspects of books made the medium the most amenable one in which to establish precise dates and contexts. But for most people the definitive encounter with Byzantine art will not be the handling of an illuminated book (even if this happens in a remote Orthodox monastery), but to enter into the charismatic space of a decorated church where it is art that controls and orders both mood and thought. It is paradoxical, therefore, to enter Byzantine art through a book, except that it can remind us that Byzantines, too, wanted to write down and record for us precisely that they felt these same emotions on entering the supreme achievement of the whole period, the church of St Sophia at Constantinople.

R.C.

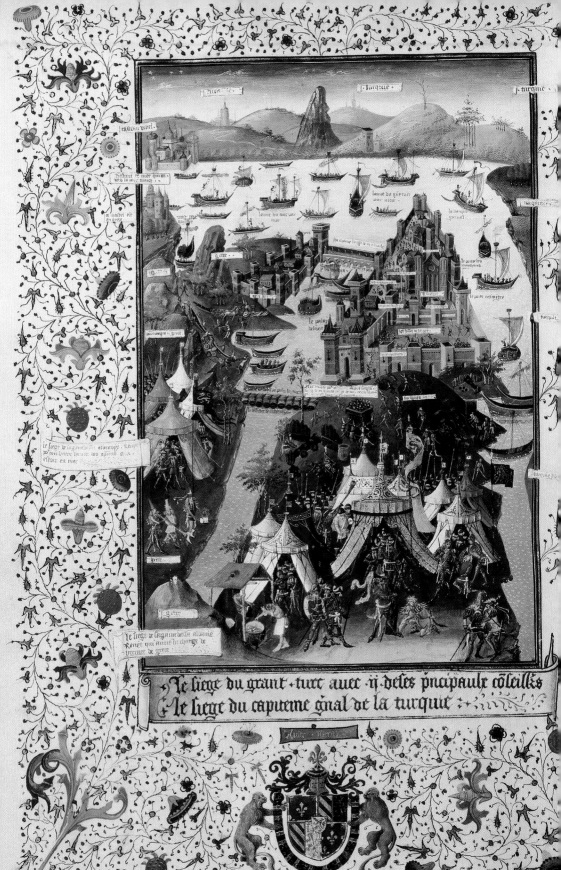

Le siege du grant turc auec ij deses principaulx conseilles
Le siege du capiteine general de la turquie

Rome with a Christian Face?

Early Byzantine Art 330–527

1

To modern eyes, the life of Jesus Christ marks *the* turning-point in world art history. He was born at Bethlehem before 4 BCE and baptized in the river Jordan in 28 or 29. He died at Jerusalem in 30 or 33. His short period of intensive public activity (one year at the least, five at the most) in the Roman province of Palestina was charismatic enough to launch a new religion, distinctive for being monotheistic but without too remote a godhead. While the growth of Christianity may not be the single cause of the fall of the Roman empire in the west, its spread challenged existing social codes and attitudes and offers one clue to the radical transformations of Greco-Roman art. The political centre where the conversion of the ancient world crystallized was Constantinople [1]. Its citizens saw themselves as Romans, reborn after baptism into a Christian cosmos on earth. The rest of the Mediterranean world soon imagined Constantinople as a kind of fantastic Eldorado. Its history and art are the keys to understanding the processes of the 'rebirth' of ancient art, if that is how to describe the changes. Yet this period and this culture are widely regarded as the most intractable—the most 'Byzantine'—in the history of art. This cannot be true: the survival of much of the art of this society, as well as its literature, offers exceptional opportunities for understanding the period and its aims and attitudes. Many Byzantine churches with their original decoration survive, and in St Sophia we can even stand in the great interior created in the sixth century, and see the same mosaics that the Byzantines, too, watched glittering in sunlight and candlelight. A monastery church like Hosios Lukas still today has its daily services in an eleventh-century interior and monks who keep up the same patterns of perpetual worship that the Byzantines knew in their daily experience [81]. In a sense, therefore, Byzantine art remains a living art, although it began 2,000 years ago. This heterogeneous display, where one church may offer a single experience through art produced at different times and in different circumstances, is a problem for western art history as it undercuts the standard method-

1

Manuscript illustration of Constantinople on 22 April 1453. *Voyage d'Outremer* by Bertraus de la Brocquière. Fifteenth century.

The vista of Constantinople is from the west, showing the city under the final siege of the Ottoman Turks. The western perception was of a fortress city protected by sea and massive land walls. The Golden Horn is on the left. The buildings are here represented in western styles—even St Sophia has been transformed into a Gothic cathedral.

ologies which emphasize chronology and progress. One perpetual issue is to recognize where there are continuities and where there are differences from the ancient world, and how to explain them. Equally, from a modern perspective, some features of Byzantine art have survived in western art, others seem different and remote. This perception, too, needs assessment. It appears to dissolve the highly negative interpretation of Byzantine art first set out in 1550 by the painter Giorgio Vasari (1511–74) in his *Lives of the Most Excellent Italian Architects, Painters and Sculptors* which has since been the dominant view in much scholarship: that the arts of antiquity 'died' in the Dark Ages, only to be revived by Giotto in the thirteenth century.

What is Byzantine Art?

The most frequent answer to this question is probably 'religious icons', and the Byzantines might have said the same (but in Greek), 'holy icons'. They meant by the word *eikon* any kind of image in churches; and since care, devotion, and vast resources were lavished on the production of these objects, it makes sense to call these working images 'art'. So the art of the Byzantine period can be conceived as above all a religious art. It is distinctive enough to have spawned our everyday use of the word 'icon' as something above and beyond a mere portrait. Byzantine art spans more than 1,000 years, and was centred on a Christian society based in Constantinople, which was dedicated in 330, and was the capital of a Christian empire until 1453 when its religious landscape and art became Islamic [2].

Icons were at the centre of Byzantine art and life. They were seen and venerated by all those who identified themselves as belonging to the culture. They were made to last for eternity, outliving humans, yet serving the beliefs and attitudes of their producers and audience in all sorts of ways. For a significant time in Byzantine history, the icons were at the centre of a burning dispute over what kind of imagery was admissible under God's law, and their production and veneration was banned by the iconoclast emperors. The end of this dispute, which declared that hostility to Christian figurative icons was heresy, meant that ever since, all Orthodox Christians show their faith by kissing icons.

Byzantine art was (more accurately *is*) one of the most solemn and elevated modes of religious expression ever developed. Icons can manipulate viewers and create an atmosphere more potent than most other art forms. Byzantine icons had a functional as well as an aesthetic aim: they were made as props in the face of joy and sorrow, happiness and pain. They received the prayers and veneration that passed through them to the 'other' world that they symbolized, and they were expected to reflect the powers of God. Each icon had to maintain its power for century after century. An icon in a church was available in what was for Byzantines a second home, the meeting-place of an ex-

tended family. In these circumstances, artists developed a mode of expression intended to endure beyond the topical and the individual moment. The consequent 'timelessness' of Byzantine art is one of its distinctive features, and by definition is found in all its periods of production. While there is an obvious interpretation—that artistic conformity offered spiritual comfort through familiarity and at the same time confirmed the unchanging truths of Christianity—yet the constancy of Byzantine art through repetition and copying, rather than novelty and surprise, will need a fuller explanation in terms of the ways in which Byzantine society functioned. What is clear is that the symbolic language of icons had to be as durable and familiar as the regular celebration of the Christian liturgy in church. Yet under the stereotypes a chronological treatment of Byzantine art reveals changing forms of expression and the emergence of new subjects.

If Byzantine art represents a major and influential 'period' of world art, our study will gradually expose its 'character', and clarify its features, including those appropriated by other cultures, such as Renaissance Italy. The study of Byzantine art over the last 100 years has produced many approaches and definitions. Sometimes these reveal a formal approach and definition ('Byzantine art is a style or mode of expression'), sometimes a cultural approach ('Byzantine art is an evolved type of classicism'), sometimes a political approach ('Byzantine art is the art of Constantinople, the capital of the eastern Roman empire'), and sometimes an approach concerned with the history of spirituality ('Byzantine art is the art of the Orthodox church'). Some scholars avoid as essentialist the question, 'What is Byzantine art?' and question whether the 'props' for religious devotions and Christian worship merit the name 'art' at all, and indeed whether their producers are artists in the same sense as an artist today. This pluralism is salutary, and is a caution that the way to survey the period is to start with a minimal functional definition of our subject.

The simple definition of Byzantine art is that it was the art of a community based in Constantinople between 330 and 1453. The small town of Byzantium was renamed by the reigning Roman emperor Constantine the Great in 330 and this date marks the beginning of its history as an imperial residence, dominated by the Great Palace. Byzantine art has frequently been defined as the art of Constantinople, making it an imperial art, the continuation of Rome, but situated in the east and separate from the medieval art of the west. The Byzantines themselves colluded with this, calling themselves Romans and keeping the trappings and institutions of empire. The official titles of the emperors were inscribed in Greek: *Autokrator*, and later *Basileus*; sometimes *Basileus Romaion*, 'Emperor of the Romans', and sometimes *Pistos en Christo Basileus*, 'Faithful in Christ Emperor'. The usual art-historical periods derive from imperial dynasties—Constantinian,

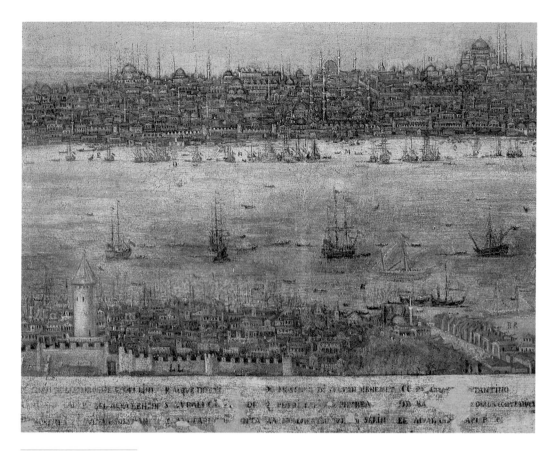

2
Drawing of the cityscape of Ottoman Constantinople over the Golden Horn. Sixteenth century.

Macedonian, Komnenian, and Palaiologan. Other divisions of the period are found, too, but the dividing moments are also political: Early Byzantine (330 to iconoclasm), Middle Byzantine (ninth century to 1204) and Late Byzantine (1261 to 1453).

Geographically, the concept of the art of Constantinople as that of an imperial capital has encouraged reference to metropolitan art and to the art of the 'provinces' or 'regions' as if there were a clear dichotomy in the culture. Is some Byzantine art 'provincial', and what would that mean? Another related issue is whether Byzantine art includes or excludes regions or countries such as Syria and Egypt, which were early to pass out of the political control of this empire but not out of its cultural influence. The usual solution is exclusion, and the use of different categories, such as Coptic art for Egypt. This is supported on the grounds that regions that diverged from the doctrines of the Orthodox church, and were politically lost to Byzantium, are outside the culture. The anomaly is that very often their art remained closely tied to Byzantine art; and in the case of the countries to the east of Byzantium, while it may be tactically easy to exclude Armenian art as the product of a heretical church, yet its neighbour in the Caucasus, Georgia, shares many features with Armenian art and architecture as well as

with Byzantium, and it was always part of the Orthodox community. Inherent in this problem of distinguishing between the art of Byzantium and its neighbours is the question of whether in the art of Constantinople Byzantine art is regarded as existing in a 'pure' form.

The cut-off date of 1453 is artificial also. Orthodox church art did not stop with the Turkish conquest, and the Greek patriarch remained in Constantinople. Orthodox Christians still used a mixture of old and new icons in their churches and homes. Russia, Crete, and other places maintained the production of icons after 1453. In all, the dating of Byzantine art to the period 330 to 1453, and its location in Constantinople and its orbit, are in many ways arbitrary, but more manageable than any alternatives.

Byzantine art should not be regarded as merely religious art. Constantinople and other cities were full of buildings and objects that we would describe as 'secular'. Again, however, this is not a clear-cut dichotomy in the context of this society. The Great Palace of the Byzantine emperors between St Sophia and the Bosphoros was a centre of administration; but it was seen in Byzantine eyes as a 'sacred' palace. Its ceremonial was often led by the church, and its precincts had as many churches and relics as private rooms and treasures. The emperors had a special position and privileges in a Christian state, and the associated responsibilities. They built and maintained the defences of the city, and monumentalized the streets and fora; but the most spectacular buildings were those churches and monasteries of the city that they founded. The landscape of Constantinople was inescapably

The Orthodox church

Orthodox faith depends on the definitions of the seven Oecumenical Councils, the last being at Nicaea in 787, although later 'local' councils, such as the councils of Constantinople of 1341 and 1351, are regarded as important for their clarifications of doctrine. Other eastern churches split off from the Orthodox church after particular councils, including the Coptic church (which sent missionaries to found the Ethiopian church), the Jacobite church, the Nestorian church, and the Armenian church. The Georgian church was always, however, part of the Orthodox community.

The Orthodox church split from the Latin church in 1054, and was never effectively reunited. The veneration of icons has become one of the distinctive features of the Orthodox church. The bread and wine in the eucharist are considered to become at the consecration the true and real Body and Blood of Christ. Monasteries became highly influential. From the sixth century, bishops were chosen from the celibate priesthood but, provided a priest married before ordination, a married ministry was allowed. The patriarch of the Orthodox church has continued to reside in Constantinople.

The arts of the non-Orthodox churches of the east were in part dependent on Byzantine art, in part had their own traditions. Georgian art is very closely related to Byzantine art, but its church architecture is recognizably distinct. The liturgical arrangements of the other churches differ from those of Byzantium.

Christian, and in the sponsorship of art, Christian art always took pride of place. Although the profile of the modern city is dominated by the minaret and the mosque, its Christian topography has remained clear through what has survived, despite major losses such as the church of St George of the Mangana which the emperor Constantine IX Monomachos (1042–55) commissioned, 'fired by an ambition to rival all the other buildings that had ever been erected, and to surpass them altogether'.[1]

The link between all Byzantines was their deep knowledge of the Bible.[2] Byzantine art expressed and relied on this common culture. The icon gains its emotional and spiritual dimension from its references to Scripture; it also acted as an enhancement of the Christian message which rendered the church a place of beauty as well as of truth. Icons had to touch the heart and the mind. In this world, secular art, even the portrait of the emperor, took a minor place.

The Importance of Constantine and Constantinople

The city of Constantinople will dominate this book, just as it dominated the horizons of all the people who lived in the period of Byzantine art. Constantinople was the centre of their world, both physically and symbolically. It was so radically enlarged and redeveloped in the fourth century that it is to all intents a new city, with new walls, roads, and public buildings. It was meant to display Constantine's military triumph and liquidation of rival emperors in the Roman world. Our image of Constantine has become that of a statesman who changed the world through his conversion to Christianity, and who was baptized and forgiven his sins on his deathbed in 337.[3] These two events—the dedication of the city as a triumphal declaration and the conversion of Constantine—have triggered the notion that Constantinople was founded as a new Christian capital of the Roman empire from the beginning, as 'New Rome' and the 'Queen of Cities'. The truth is more banal: its rise to superiority was slow.

Constantine's decision changed the course of history. Whereas the emperor Augustus (63 BCE–14 CE) firmly established Rome as the capital of a world empire under a ruling dynasty, the disruptions of the third century led Diocletian (c.240–c.312) to reorganize the state in 293 as a decentralized 'tetrarchy', with four emperors providing leadership in different areas, which in practice meant east and west. The size of the Roman army doubled and a new larger administrative bureaucracy was developed. Constantine was initially one of the tetrarchs, but gradually eliminated the others, and became the ruling emperor of a reunited empire, residing in the east and rejecting paganism. Nevertheless there continued to be emperors in the west until 476, and Justinian in the sixth century tried to unite the empire again. By the seventh century, Constantinople was the recognized capital of a

Roman empire, but it was a far smaller dominion, lacking both the west and the Middle East. Warring emperors in the tenth and eleventh centuries expanded the frontiers to east and west, but by this time the 'Holy Roman empire' had been established under Charlemagne (768–814), declared by his coronation in St Peter's in Rome as *imperator Romanorum* on Christmas Day 800, and to both the north and east of Constantinople there were rival Christian and Islamic dominions. Byzantine emperors adapted the institutions of the state to these changing circumstances, but in name at least the autocratic system of the Roman empire continued. The capture and looting of Constantinople by Crusaders in 1204 and the establishment of a Latin empire there was the most serious blow to the pretensions of the Byzantines. Although the Latins were expelled in 1261 and the Byzantine system restored, the extent of the empire was greatly reduced to western Asia Minor and parts of the Balkans and Greece, and the advance of the Turks, who finally captured Constantinople in 1453, effectively strangled Byzantine institutions. Although we might try to give a justification for describing Constantinople as the capital of the Roman empire from 330 to 1453, Byzantium in the course of this period went through many transformations and adaptations. What began as the eastern Roman empire continually changed in its size and structures, but it did retain a system in which an emperor in Constantinople remained the accepted leader. After 1261 the so-called empire was more clearly a Greek state which had separated from the Latin west.

Constantine defeated his co-emperor Licinius on 18 September 324 at Chrysopolis on the eastern side of the Bosphoros, and in a few days declared the foundation of a new city on the site of Byzantium on the other side of the Bosphoros. It was then little more than a small port and fishing town on the promontory formed by the conjunction of the Sea of Marmara with the Golden Horn and the Bosphoros, although the emperor Septimius Severus (193–211) had undertaken some development. Constantine's initiative so changed the appearance of the city that thereafter it was perceived as nothing less than a *natural* imperial capital on the Bosphoros, between Europe and Asia, between west and east.[4] He clearly visualized a metropolis on a grand scale, and understood the drawbacks of the site that had to be remedied—its vulnerability to attack on the land side and its lack of a fresh water supply. He built land walls in an arc about 4 kilometres inland from the old city and quadrupled the previous size of Byzantium, guided, reputedly, by an angel. By 413, when the status of the city as a capital was accepted, a further and stronger circuit of walls was constructed another 1.5 kilometres to the west by Theodosios II (408–50). These Theodosian land walls still dominate the modern city. A water supply was brought in by aqueducts, which fed enormous cisterns to conserve supplies.[5]

Constantine's supporter, the historian and bishop Eusebios, inter-

3

Church of the Holy
Sepulchre, Jerusalem. Begun
325/6, consecrated 336,
repaired after Persian
damage of 614; remodelled
by Crusaders after 1099 and
dedicated 1149.

Up to the Crusader rebuilding,
the pilgrim entered the church
from the main street of
Jerusalem and walked
westwards through a courtyard
and into a five-aisled galleried
basilica, then on past the hill of
Golgotha in an open,
colonnaded area, and finally
came to the Rock Tomb itself,
within a domed circular church
(the *Anastasis* Rotunda).

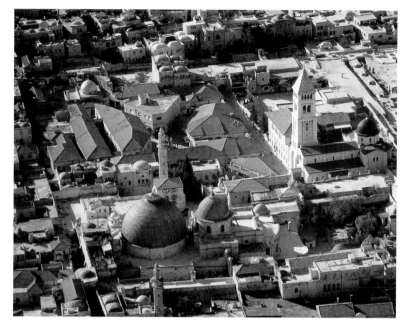

preted the defeat of Licinius as the supreme victory that God gave
Constantine, and significantly one of the first major churches to be
completed in Constantinople was that of St Eirene, 'Holy Peace', to be
the first cathedral. Meanwhile, Constantine's church building in other
cities was equally, if not more, enthusiastic: Jerusalem (unlike
Constantinople) had witnessed the life of Christ, and Rome was the
place of the martyrdom of St Peter. In both of them, the sites of
Christian witness were designated for conspicuous commemoration—
notably the Holy Sepulchre [**3**] and the church of St Peter's. It was only
in later centuries that Constantinople rivalled these cities as a pilgrim-
age centre, and it achieved this by amassing the most famous relics
connected with Christ, Mary, other saints, and biblical events (from
relics of the True Cross to timbers from Noah's Ark). The monumental
settings made for the display of these holy relics were as spectacular as
the early buildings of Rome and Jerusalem.

The vast building site was dedicated on 11 May 330. At its centre was
the imperial palace, and grants of land and the free issue of bread were
encouragements to new settlers. Like all late antique cities in the east-
ern Mediterranean, Constantinople was spacious. A colonnaded main
street (the *mese*) ran from the centre (the arch of the *Milion* near the
Hippodrome) to the Golden Gate in the land walls; throughout the
city were open squares and fora. The most famous was the *phoros*, the
circular forum with the central porphyry column of Constantine, now
called the 'Burnt Column', referring to fire damage in 416 after which
its seven drums of stone were reinforced with metal hoops. Originally,
it had supported a statue of Constantine 'with rays of the sun radiating

from his head', though this may have been a recycled bronze statue of the sun god Apollo brought from Phrygia. This statue was blown off in a disastrous gale in 1106, crushing people below it, and it was replaced with a cross.[6] Constantine's city was in fact notorious for its appropriation of pagan statuary from all over the empire—the smart comment was that of St Jerome: 'Constantinople was proclaimed through the nudity of nearly all other cities.'[7] Imperial officials—very likely pagans—chose their statuary well and, after further appropriations in the course of the next century, the list of masterpieces brought to Constantinople was truly astounding, amongst them tripods from Delphi, the Serpent Column of the Plataean tripod from Delphi, which was set up on the *spina* of the Hippodrome, a Zeus from Dodona, an Athena from Lindos, the four gilded bronze horses from Chios (now in S. Marco in Venice), 80 bronze antique statues in the baths of Zeuxippos (all lost in a fire in 532), the chryselephantine statue of Zeus by Phidias from Olympia, the Aphrodite of Cnidos by Praxiteles, and other masterpieces in the palace of Lausos, a private mansion in the centre of the city, which was burnt down in 475.[8] This artistic repertory has given rise to the description of Constantinople as a 'collage city', a place where an 'art' heritage created an artificial and theatrical backcloth rather than constituting an organic element of life.[9] The frequent fires over the centuries and the plundering of the city by the Crusaders in 1204 meant the gradual destruction and disappearance of nearly all these masterpieces of ancient sculpture. Despite their presence in the city, and further examples outside Constantinople in Asia Minor and Greece, the works quite simply never acted as the models from which any Byzantine artist recreated the aesthetics of a Greco-Roman past. In this sense, Byzantium did 'reject' classical antiquity, and has correspondingly been assessed negatively when compared with the Italian Renaissance. The study of Byzantine art is, however, a much more complicated story than this, involving a positive transformation of figurative art. Medieval Constantinople has been seen as the birthplace of ignorance and superstition; but the fear found in early Christian apologetics that pagan statues housed demons maintains the idea of the power of art already widespread in the ancient world. In addition to classical statues of the gods, the streets and squares of Constantinople contained other objects, such as a huge stone scarab from Egypt and a large bronze goose, both of which are now in the British Museum.

Much of the information about the foundation and development of Constantinople comes from chronicles and other popular writings.[10] The problem for art history is the muddled and contradictory nature of their statements. The fifth-century chronicler Zosimus implies that Constantinople was not founded as a Christian city; Malalas (sixth century) speaks of the dedication ceremonial as including a 'bloodless

sacrifice to God' and a dedication to Fortune (*Tyche*), which almost implies that it was, since the pagan idea of Fortune as protector of the city gradually became a Christianized symbol. The *Chronicon Paschale* (seventh century) speaks ambiguously of a 'bloodless sacrifice'.[11] The accounts are inconsistent; perhaps they only show that politically it was unwise to be too open in 330. Soon enough the anecdotes and legends began to circulate, such as the story that Constantine had buried beneath his column both the Palladium of Rome and a number of Christian relics, including the actual twelve baskets that Christ filled in the Miracle of the Multiplication of the Loaves and Fishes. These, no doubt, were to establish the city as a Christian foundation.

Two features of the new city are clear: it was a grand Roman city with those public amenities that emperors could supply, such as a prominent hippodrome for regular chariot races and other entertainments. But its Christian character is less openly stated—churches were gradually built and co-existed with older pagan temples. There were no instant grand churches of the scale of Old St Peter's in Rome; nothing as charismatic as the Holy Sepulchre in Jerusalem or the other sites in the Holy Land. By the end of the fourth century the pilgrimage visit to Palestine was a spectacular spiritual event, spawning a proxy literature for others less fortunate.[12] The character of early Christian architecture was being developed outside Constantinople: all around the Mediterranean, large wooden-roofed basilicas were established as the prime form of church for the regular Sunday eucharist, and more architecturally adventurous churches, often with a central plan, were designed to decorate holy places, to act as a memorial or *martyrium* for early Christian saints, or the sites connected with the events of the Bible.[13] The sites of the Holy Sepulchre and Golgotha were developed in 325/6 after a visit by Constantine's mother Helena, and the myth that she had found the True Cross there soon emerged. The complex included a basilica for communal services and the liturgy, while around the Rock of the Tomb (the *aedicula*), the *Anastasis* Rotunda was built to give a focus for the Easter ceremonial and for pilgrimage prayer [3]. The vast basilica of St Peter's at Rome, which was built by 329, combined in one transept church both the *martyrium* for the tomb of the saint and a congregational church. Kalat Siman in Syria (built *c.*480–90) is a great pilgrimage *martyrium* around the column, 16 metres in height, on which the extreme spiritual athlete St Symeon Stylites spent most of his life (*c.*389–459) [4].

Constantinople became the largest and grandest city of the Middle Ages, with its collection of many of the holiest relics and images brought from Jerusalem and elsewhere and displayed in its famous churches and monasteries, and in the chapels of the Great Palace, which established it as a place of pilgrimage in its own right. The mosaic above the south-west entrance door into St Sophia expresses the

4

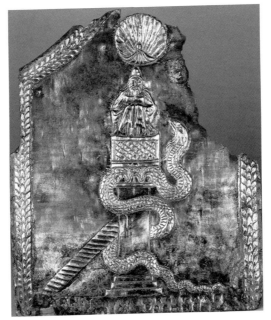

Silver-gilt plaque, made probably in Syria around 500 as a revetment for a box or other object.

Inscribed 'I offer this in thanksgiving to God and St Symeon'. The anonymous donor has lavished considerable expense to show devotion to the holy man. In monastic robes, Symeon the Stylite stands behind a balustrade at the top of the column on which he spent most of his life. The conch shell denotes his sanctity. His disciples and pilgrims who visited him could mount the ladder. The snake represents Symeon's supremacy over evil. After his death in 459, Symeon's relics, column, and image instantly became objects of popular veneration.

later Byzantine view of the history of Byzantium [**5**]. The legend behind the emperor to the right reads: 'CONSTANTINE THE GREAT EMPEROR AMONGST THE SAINTS'; in his hands Constantine holds the city of Constantinople. To the left a second emperor is identified as 'JUSTINIAN EMPEROR OF ILLUSTRIOUS MEMORY', and he holds the church of St Sophia, which he rebuilt between 532 and 537. Church and city are offered to the Virgin Mary and Child, 'MOTHER OF GOD'. The mosaic symbolizes the key moments in Byzantine history—the foundation of Constantinople and the construction of the Great Church, as St Sophia was generally called, at the centre of the Christian empire. Mary and Jesus visually confirm their protection of city and church. The heavenly and earthly empires converge in Constantinople.

When Constantinople was founded, the character of a Roman city did not have to be invented; convention dictated most of its ingredients—walls, a road system and colonnades along the streets, public spaces and amenities, a water supply, a hippodrome, a palace, a harbour, cemeteries. Since it grew out of the Greco-Roman world, Constantinople had a Greco-Roman past. But its geographical location in the east led to special circumstances. The physical resources of the region differed from those of Italy: the cities of Asia Minor and Syria with their access to marble quarries had encouraged the architecture of column and lintel in contrast to the concrete and tufa of Italy.[14] So, in Constantinople the proximity of the Proconnesian quarries on the islands in the Sea of Marmara, and the corresponding relative ease and economy of the transport of this dazzling white marble, guaran-

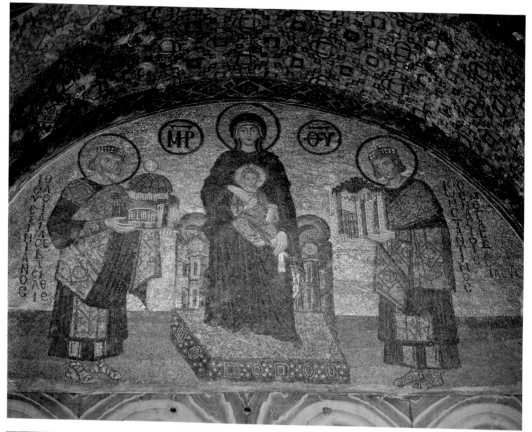

5

Mosaic lunette over the doorway into the inner narthex of St Sophia at Constantinople from the south-west vestibule. Late ninth or tenth century.

The vestibule was enhanced with grand bronze double doors by the iconoclast emperor Theophilos in 838/9, and became the main entrance into St Sophia. The mosaic above the inner doorway from the vestibule into the inner narthex was an additional improvement by an unknown sponsor of the decoration after iconoclasm. It retrospectively celebrates Constantine's foundation of the city and Justinian's construction of St Sophia, and conveys the medieval ideal that Constantinople was under the special protection of the Virgin.

teed a marble city, even if the marble was often merely the facing of brick architecture. The only real surviving legacy of the concrete-vaulted architecture of Rome in Constantinople is the sixth-century dome of St Sophia, the concrete architecture of the Pantheon translated into brick [**16**]. The environment of the city instantly reflected its position between east and west. However, the success and continued redevelopment of Constantinople means that little survives from the early centuries—the key churches that we can still see are St John Studios (*c.*450) and St Sophia (the first church was built in 360, and rebuilt in 532–7). An early description, in the *Notitia urbis Constantinopolitanae* of *c.*424–30, lists the most notable buildings of the 14 regions of the city (with 14 churches and 4,388 houses).[15] While Constantinople grew as the first Christian capital, many of its features directly continued Greco-Roman patterns and traditions.

The Beginnings of Byzantine Art

Christian art did not originate in Constantinople, or in Jerusalem, and no recognizable Christian imagery has survived from before 200, most probably because there was none.[16] Early churchmen were more concerned to find reasons to condemn pagan images and their worship,

6

6

Wall paintings of the Christian
baptistery at Dura Europos,
Syria. 240s. Excavated
1932.

One house, built around 232 in
the Roman settlement of Dura
Europos on the Euphrates near
the Persian frontier, was
converted into a church in the
240s, but destroyed with the
rest of the city when it fell to
the Sasanians in 256. The
baptistery (6.8 m x 3.1 m) was
the only room decorated;
remaining paintings include,
above the font, Adam and Eve
and the Good Shepherd, and
Old and New Testament
scenes on the walls.

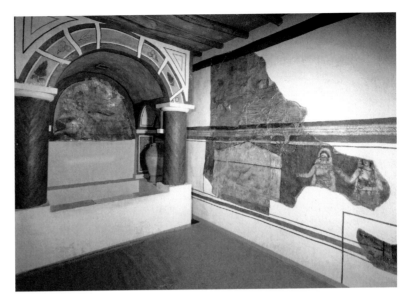

and to contrast the demons of paganism who demanded sacrifices with
the invisible God of the Christians.[17] Despite this theoretical reason-
ing in the literature of Christian apologists, by the middle of the third
century Christian art was flourishing across the Roman empire. Was
this a change of heart, or is it simply that we cannot generalize across
early Christian communities? The issue of hostility to images was not
finally resolved at this time, and it re-emerged most violently in the
century of Byzantine iconoclasm. What has survived from the early
period is the art connected with death and salvation both in churches
and funerary monuments. With this art, Christianity became socially
visible, and added art to its missionary armoury.[18]

The best testimony of the beginning of Christian art is in a modest
mud-brick house at Dura Europos decorated with wall paintings,
which was discovered by excavation between 1931 and 1933, detached
and transported to the Yale Art Gallery, in New Haven, and is now se-
verely faded.[19] Dura [**6**], in Syria, was a substantial frontier city be-
tween Rome and Persia until it was destroyed after falling to the
Sasanians in 256. All the decorated monuments found in the city—
pagan temples, Jewish synagogue, and Christian church—belong be-
fore this final date. The house-church was a private dwelling near the
walls which was converted for Christian ritual use around 240. Only
one of the rooms was decorated with wall paintings; this was the bap-
tistery hall, which had scenes from the Old and New Testaments on
the walls. The images above the font included the Good Shepherd and
Adam and Eve. There is nothing distinctive about the style of these
paintings; they have the same heavy schematic figures that local artists
painted in the other buildings of Dura. Their subjects, though, are
clearly Christian and derive from the Bible. They gave newly con-

verted Christians at the charged moment of baptism a glimpse of the new world of biblical stories and figures which was to replace the old mythologies.

The Dura Europos Christian wall paintings are not unique in the third century. Better known are the early Christian paintings of the catacombs outside the city walls of Rome, a sequence that begins in the third century and continues into the fourth and fifth centuries, with a few later additions. Christians in the east and west of the Roman empire therefore began in the third century to use and adapt the art forms of the Greco-Roman world to declare their faith and the promise of life after death.[20] The evidence of the catacombs has inherent limitations: these were not public churches but underground tombs, private memorials to poor members of a proscribed and illegal group in Rome. But they demonstrate that Christianity, like other religions in the period, including Judaism, used art as a means of communication. So when Christianity became legal under Constantine in 311/12, it was no longer a religion of the book alone but, like polytheism, had accepted images. In Rome, Christians had produced carved sarcophagi as well as the catacombs, with very similar schemes showing salvation scenes from the Old and New Testaments. But the most spectacular evidence again comes from the eastern empire: a set of small marble sculptures made in Asia Minor in the second half of the third century [7].[21] Of the eleven, three consist of pairs of male and female portrait busts; one is a Good Shepherd, and the other four represent the Story of Jonah from the Old Testament (swallowed by the whale; cast up from the whale; under the gourd tree; and praying). Jonah images were popular in the catacombs, too, no doubt because Christ himself made the analogy between Jonah's three days and nights inside the whale and his own resurrection from the sepulchre. The early church was dedicated to interpreting the events and persons of the Old Testament as 'types' which foreshadowed the Christian dispensation of the New Testament; throughout Byzantine art there are many cases of pictorial imagery which illustrate and confirm such typology.[22] The artistic interest of Jonah was also that his image spoke clearly to the initiated Christian believer, but was invisible to the pagan viewer, who would recognize here a familiar mythological figure, like Endymion, sleeping in perpetual youth under a tree and visited by his lover, the moon goddess. Similarly ambivalent was the representation of Christ as the Good Shepherd, to be seen as the classical figure of Hermes carrying a sheep on his shoulders, except by the new Christian initiated.

The Jonah figures resemble polished white marble statuary in the classical tradition. Jonah's face might be taken for that of a Hellenistic figure or even a god. Of course, the subject matter excludes this, but the sculptural taste reveals no new Christian aesthetic, but a continuation of past well-tried traditions. A close look shows that the images are un-

Jonah cast up out of the whale. Second half of the third century. Marble, probably carved in Asia Minor.

The small sculpture is part of a group carved from the same marble (male and female portrait busts, the Good Shepherd and Jonah swallowed, cast up, under the gourd tree, and praying). Probably made to decorate an aristocratic Christian tomb.

finished—the supporting struts were never removed—and would have been intended to be even more refined. Most likely, they were intended for a family mausoleum, but for some reason they were buried, perhaps never used, and are correspondingly well preserved.

Early Byzantine Art

The Christian art of Constantinople continued within established traditions, but it was legal and encouraged. Within the city were displayed all manner of famous works of antiquity in various media. Yet the history of early Byzantium is also the gradual history of the abandonment of the public production of bronze and marble statuary. In the early centuries, there were great ambitions to revive the imperial grandeur of old Rome—Constantinople even had two cochleate columns to match those of Trajan and Hadrian, one of the triumph of the emperor Theodosios I (379–95), the other of Arcadios (345–408). There were marble and limestone sarcophagi intended to match the Roman production of the fourth century, the outstanding piece being a child's marble sarcophagus found at Sarigüzel. The Roman state relief, which had publicly proclaimed imperial power and triumph, was a

Marble base of Obelisk of Theodosios I, Hippodrome, Istanbul. *c*.390.

The base, one of a series of monuments on the *spina* of the Hippodrome, supported the obelisk of Pharaoh Thutmosis III (*c*.1504–1490 BCE), and was decorated in relief on all four sides, celebrating imperial power. It shows Theodosios with his family receiving gifts from barbarians and giving a wreath to the winner in the Hippodrome. The reliefs also graphically record the transport of the obelisk to Constantinople and its erection in the Hippodrome in 390.

medium continued in Constantinople, as in the Hippodrome where the base of the Egyptian obelisk had reliefs of Theodosios I and his court [**8**]. Here there were also portrait statues to celebrate both emperors and popular charioteers.[23] One imperial statue, a bronze colossus, perhaps of Marcian (450–7), was transported to Barletta in southern Italy in the Middle Ages.[24] Other cities of Asia Minor, such as Aphrodisias and Ephesus, also had a production of portrait statues of notable local figures which lasted to the sixth century. But sculpture was a medium in decline everywhere, and it is not surprising that the famous Proconnesian quarries appear to have fallen into disuse in the sixth century. Thereafter, marble in the city is often recycled, either transported from other cities in the region, or salvaged by taking the columns and capitals of the arcaded streets and using them in the construction of later churches. Even the celebrated and conspicuous

equestrian statue of Justinian on a column in the Augusteon in front of St Sophia was not of Justinian at all, but a reused statue of Theodosios II (408–50). Nevertheless, there was always a number of trained carvers in the Byzantine period, more often putting their expertise to the decoration of architectural ornament, or the sculptural enhancement of the sanctuary screen, but even on occasion producing figurative reliefs or images.

The Geography of Byzantine Art

The world of Byzantine art extended beyond Constantinople. It was at its greatest extent in the sixth century, and significantly it is from the reign of Justinian (527–65) that the most extravagant claims of a Byzantine emperor's personal patronage appeared in the court historian Procopius's *On the Buildings (De Aedificiis)*, which includes the territories of Asia Minor, Syria and Palestina, across Egypt and North Africa and Italy, and over much of the Balkans and Greece.[25] Clearly, then, it was believed that Byzantine architecture and art might be found in all sorts of terrain, ranging from desert to highly fertile lands, and from mountain uplands to coast. Correspondingly, Byzantine buildings might be of stone, marble, brick or wood (or a combination of all of these), and Byzantine art also involved contact with all kinds of different local traditions. But through the eyes of Procopius as he listed all these monuments it is clear that Constantinople was perceived as the place with a centralizing role, and as the nucleus of power, and therefore of influence. If the patrons of Constantinople wanted to see mosaics, or ivory or gold, then these materials had to be acquired and developed. For those who lived in Constantinople, the rest of the empire immediately outside the walls was regarded as 'exile'; even the popular twelfth-century archbishop of Athens, Michael Choniates (1138–1222), reveals in his letters that he felt excluded. Our view of Byzantine art needs to recognize it as an international art in geographical terms, but a centralized art in terms of visual taste.

The Bird's Eye View of Byzantine Art

The geographical extent of Byzantine art in the early centuries of its development is significantly broad; and even in the final period before 1453, when the survival of an east Roman empire was more façade than reality, Byzantine art was in use and production in Asia Minor as well as eastern Europe. This geographical spread has meant that its relation to western art has always been under question: Byzantium has a 'non-western' flavour. The debate is encapsulated in the title of an exhibition in Athens in 1964, *Byzantine Art. An European Art*. Again we are confronted with the question of the role of Byzantine art in the development of the Italian Renaissance, the so-called 'Byzantine Question'.[26] The issues to bear in mind in this debate are whether Byzantine art

represents a self-contained and identifiable 'style' that was consistently 'different' from that of the west. How far was Christian art in the eastern Mediterranean a separate development from that in the west? How far, on the contrary, was Byzantine art an integral part of western art? Since we have already seen that in the first phase of Christian art both Rome and Dura Europos have much in common, we need to be alert to the question as to whether later on Byzantine art developed independently from the west.

Since 'Byzantine' is simply a convenient modern term which leaves open the nature of the cultural affinities of the empire, it has in turn provoked debates on the nature of that culture, calling into question its Roman or Greek or oriental affinities. Most of the written literature we call Byzantine was in Greek; but several other languages were spoken in the capital and around its regions. The word 'Byzantine' avoids specifying how far a Greek-speaking society is Greek or Hellenic. The question does not arise for the early years of Constantinople, for the Roman empire was well aware that Greek traditions were one ingredient among several of the formative elements of an international culture. In the period of Constantine, the Roman emperor was still a roving commander, and the moment Constantinople might have been perceived as the capital of an 'east Roman empire' is debatable. The pre-eminence of Constantinople only definitely emerged as patterns of regional administration changed with the fall of the western Roman emperor, Romulus Augustulus, in 476, and the rise of Islam in the seventh century which led to the permanent contraction of the Roman sphere of influence.

To use the term 'Byzantine art' is to participate in a well-known controversy: when did 'antiquity' end? When did Christian art supersede pagan art? The dilemma is that antiquity had not ended when Byzantine art began. From the point of view of Constantinople, the only turning-point was the fall of the city in 1453. Yet there are definite stages in the early history of Byzantium that are marked in the production of art: the development of Constantinople under Constantine (324–37); the expansion of the empire and patronage of Justinian (527–65); and the declaration by the iconoclast emperor Leo III (717–41) in the early eighth century that figural art was to be henceforth banned from the Christian church. These moments might all be claimed as markers of the end of antiquity.

Byzantine art has often been studied unencumbered by much history of the society which it served, putting emphasis on description and admiration for its (undoubted) technical expertise. Indeed the quality of its art might seem a better justification for studying Byzantium than its history ('a monotonous story of the intrigues of priests, eunuchs and women, of poisoning, of conspiracies, of uniform ingratitude, of perpetual fratricides', as one nineteenth-century historian put it).[27] Attention has often focused on pinpointing the date and

provenance of objects and monuments, sometimes in the face of extreme disagreement or under the sceptical eyes of those who declare all Byzantine art to look the same. This work has been done in many languages and requires reading many (from the Greek and Latin of the Middle Ages to Russian and other Slavonic languages, Arabic, Syriac, Armenian, Georgian, and the languages of western Europe). Not only is Byzantine culture many-faceted; so also is the literature that discusses it. A common refrain concerns the loss of material and analytical distortions this might cause. Of course, the problem is undeniable: this period is remote in time, and its art subject to damage and deterioration. Less will survive from the early centuries, and later periods will be correspondingly better represented; in times of prosperity or change, buildings were often reconstructed and redecorated and the earlier art was covered or discarded. Modernization may demote old works, even in a culture where tradition and continuity were respected. Other reasons for the disappearance of Byzantine art are not hard to find. There was the long period of iconoclasm from around 726 to 843 when new images were banned and old images were destroyed. Even more basic is damage from fires, which so frequently happened in Constantinople and other cities filled with wooden buildings, from natural disasters such as, in this part of the world, earthquakes, and the losses connected with war, invasion, and occupation, although the looting by the Crusaders after the Sack of Constantinople in 1204 is probably a mixed blessing as the gold objects now to be seen in S. Marco in Venice might not otherwise have survived [**66**]. An art history reliant on chance survivals clearly risks distortion and misrepresentation, but there are antidotes, such as questioning the loss of some objects and the survival of others. The recent discovery of significant numbers of painted icons in the monastery of St Catherine on Mount Sinai does not simply change our empirical knowledge of the nature and importance of the icon from the sixth century, but also informs us about the importance of monasteries and the production of art in them, about the nature of pilgrimage, and about the quality of art that can be found (and made) in a place that could hardly be more remote from Constantinople [**24**].

Loss of material is only one side of the equation. Far more intimidating is the sheer quantity of material we still have, and the prodigious span of times and places it covers. In the Byzantine period, as in any other, our viewing of art is always selective, and dependent on subjective judgements about inclusions and exclusions. Even those who lament the amount of loss are unlikely to be very familiar with everything we have. Any survey of Byzantine art will be individual, and so involves more constructive principles than the simple deduction of patterns from a line-up of survivals. Surveys of the whole culture have been carried out on a chronological basis; the more difficult issue is whether to treat all the different media and materials that Byzantine art employs together or

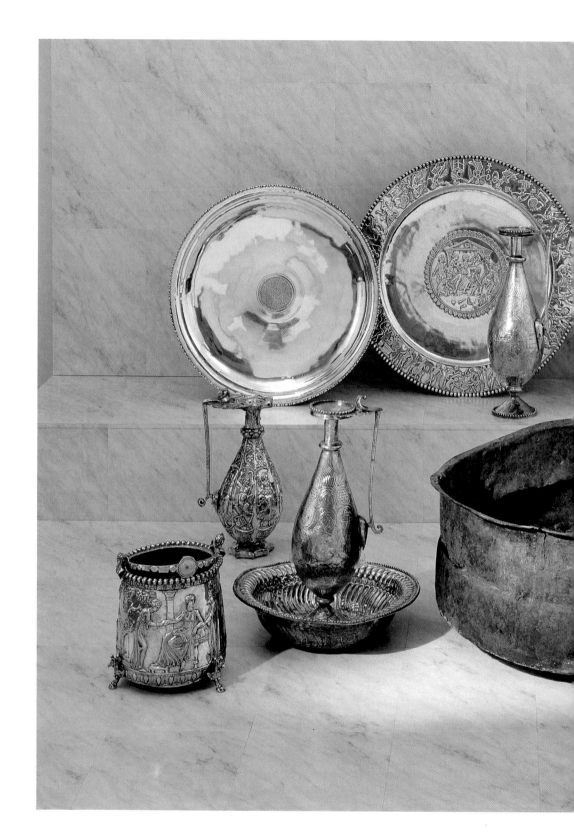

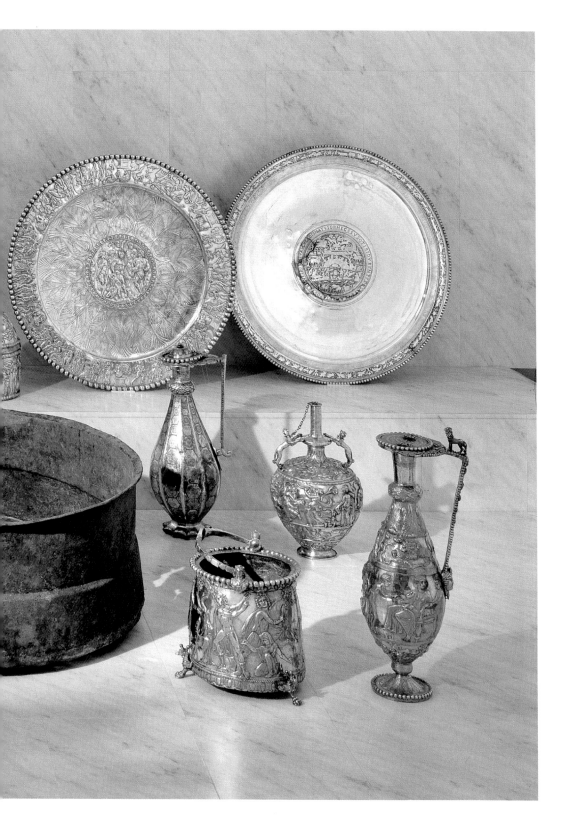

The Sevso Treasure of silver,
silver-gilt, and bronze
tableware and toiletry pieces.
Fourth century.

The number (14 in all), sizes of
the pieces, and their weight,
totalling nearly 69 kg or 209
Roman pounds (the hunting
dish alone is over 70 cm in
diameter and weighs nearly 9
kg) make it one of the most
lavish dining-room sets yet
found. The hunting dish has a
Latin inscription naming Sevso
and the christogram shows
that he is a Christian. His
choice of art is seen to maintain
the past values of the styles
and subjects of pagan
antiquity.

separately—can monumental mosaics and manuscript miniatures be easily compared? It is clear that some artists specialized, and a treatment of one medium as a whole can be very fruitful: steatites and ivories have been well handled in this way.[28] Similarly, enamel-working demanded a special training to gain familiarity with the properties of gold and glass.[29] Sculptors in marble, ivory, and other materials needed a long training, not just in how to cut the materials, but how to obtain them and prepare them.[30] Scribes and manuscript painters needed specialist skills and knowledge, both in the handling of materials, and in finding and copying texts and pictorial models. Every manuscript is a combination of the old and the new—existing texts and pictures are copied, altered, and adapted until a new book emerges. But the history of these various media does not depend entirely on the special demands of the material; artists did not work in isolation from each other, or the rest of the society that consumed art. Some artists worked in several media, combining, for example, expertise in manuscript illumination and icon painting, and maybe other media, too. This means that the chronological development of all the branches of Byzantine art was a highly complicated process, and the strands of artistic production and viewing interwoven. If art history is constructed through the eyes of the artists or the patrons, the most challenging or most expensive medium may seem the dominant factor in shaping the culture. But from the viewer's perspective, it is the combined effect of many experiences that evokes a visual response. Gazes of viewers in a Byzantine church may have focused on all sorts of details and individual objects, but they most likely saw the interior as a unity, like Procopius in the church of St Sophia:

The vision constantly shifts suddenly, for the beholder is utterly unable to select which particular detail he should admire more than all the others. But even so, though they turn their attention to every side and look with contracted brows upon every detail, observers are still unable to understand the skilful craftsmanship, but they always depart from there overwhelmed by the bewildering sight.[31] [15]

A text like this offers insights into the original experience of Byzantine viewers, and points to both differences and similarities in our own viewing of the same art. Procopius neatly evokes the complexity of the interior decoration of St Sophia—mosaics, sculpture, and other objects—without dwelling on any detail; he suggests that the experience of entering the church was to see it as a whole. It seems likely that this was how Byzantines experienced other churches, too, as the sum of their parts, however heterogeneous the forms and dates of the decoration. This is a characteristic of Byzantium—that its art does change considerably over the period, but any church may display the old and the new together. A newly produced icon might actually replicate an old and hallowed model, perhaps older than the existing icons in the

church. This makes such concepts as continuity, conservatism, tradition, and innovation particularly delicate to analyse. The survival of classicism becomes especially difficult to pinpoint, for there is a perpetual dialogue between past and present [**9**]. Byzantium never shook off its classical past, because neither writers nor artists wished to jettison pagan knowledge, even if it was in theory superseded by Christian truth. The continued appearance and reappearance of classical features in Byzantine art has led art historians to speak of periods of 'Renaissance'. Others have seen these phases as shifts between western and non-western interests, sometimes defined as the contrast between 'perceptual' and 'conceptual' art. The history of Byzantine art certainly vacillates between a greater or lesser use of classical means of expression, and we shall often return to this issue. But it seems unlikely that the issue of 'east and west' can be quantified by defining classicism as western and deviation from it (towards schematism and frontality, for example) as eastern. What seems to lie behind the dichotomy is the feeling that Constantinople, treated from a European viewpoint, looks east, as it did when it was the capital of the Ottoman empire, but that it looked west when Constantine incorporated it as a Roman city. It is part of the broad question of how far Byzantine art is a direct successor of Greco-Roman art and how far in reaction against it. What, in other words, is *different* about Byzantine art? Was it revolution against or evolution from its past? This is essentially a formalist question, but it does involve a consideration of the functions of that art, and of how both style and function change over the long period of its production.

Time and Style

Since a distinctive feature of Byzantine art is its long time-span of production and use, and its balance of continuity and change in style, at least one comparison of an early and late work is needed to clarify the point [**10, 13**]. The early example is a vast monumental mosaic, the late a small portable icon. The first impression is that they represent a similar subject, Christian saints, painted after their deaths, when they were, according to Christian belief, in heaven. Neither of these images is dated, and nothing is stated about their artists or even their patrons. Their own internal visual clues are the only guides to reading them. Similarly, both the subject and the meanings of the images depend on our analysis—there are no Byzantine texts in this case describing the viewing experience. Where we start depends in part on the questions we want to answer. If we are primarily concerned with their relation to antiquity, then a formal analysis and a dating will be paramount, and emphasis will be on their technical finish—both represent the highest quality in Byzantine workmanship, and are key works of their periods. But if we want to know how the imagery operated, then identifying the figures and the composition will be the first stage. The existence of in-

10

Dome mosaics of the Rotunda (church of St George), Thessaloniki. Fifth or sixth century.

The circular building was erected by the emperor Galerius (305–11) as part of his new palace in the city, and later converted into a church. The mosaic decoration consisted of registers around a central medallion with Christ. The lowest had 8 panels (6 m × 8 m) containing 20 saints standing in the sanctuaries of magnificent churches. Heaven would seem to be palatial architecture in golden light.

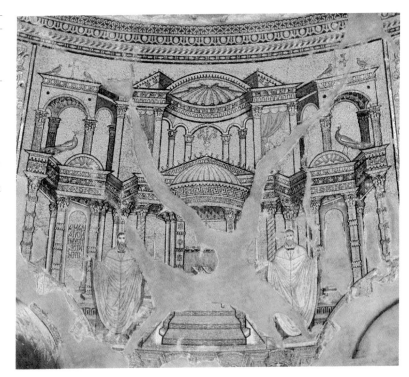

11

The Rotunda (church of St George), Thessaloniki. Built 305–11, converted into a church in the fifth or sixth century.

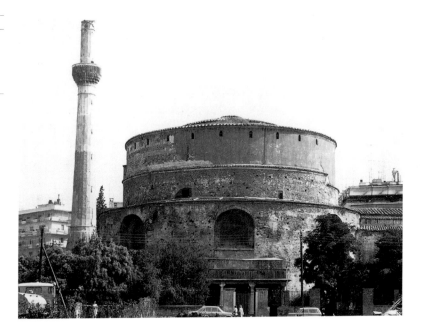

scriptions that identify the figures in both works obviously gives a firm point of contact. It takes us immediately beyond a general imagery of the so-called 'community of saints' to a more precise symbolism.

Dome mosaics of the Rotunda (church of St George), Thessaloniki. Fifth or sixth century.

The mosaic showed a standing Christ in a medallion supported by flying angels, but the tesserae have now mostly fallen out of the plaster. The original artist's underdrawing on the masonry indicates the plan for the imagery.

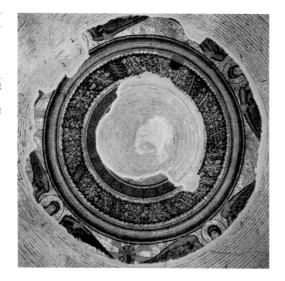

Although the figures of the saints themselves must convey fundamental and unchanging Christian beliefs, particular saints may indicate more topical concerns.

The monumental mosaic is in a church in Thessaloniki in north Greece; the icon is now in the British Museum in London. Both use gold leaf lavishly: in the mosaic, it is sandwiched into the glass tesserae which are used among the coloured glass and stone cubes that make up the surface over the wall; in the icon, it is spread over the painted gesso layer which was laid over the wood panel. The gold is one of the first things one notices, and it was intended thus, since gold declares the preciousness of the works and therefore the commitment of the patrons, it conveys heavenly light, and it elevates the human figures from the real into the heavenly world beyond. Whatever the date and place of production, these must have been part of any viewer's response.

Although neither work gives any record of its circumstances of production, Byzantine art history in general has shown considerable consensus about some of their features. Neither work of art is actually in Constantinople, yet both are treated as Constantinopolitan art, primarily because of their quality of execution, seen as in best practice. The mosaic involved the massive operation of a team of workers, high up on a scaffolding in a church, a team who had been trained in the techniques of setting the thousands of tesserae into wet plaster, and who produced one of the most remarkable mosaics of the whole Byzantine period. The icon is a small painted wooden panel, no doubt the work of one artist, experienced in the technical expertise of making long-lasting icons in the durable medium of egg tempera. The mosaic is today severely damaged, mostly the result of earthquakes; most of the upper parts of the original decoration have come away. The whole area has been estimated as covering a surface of 1,850 square metres.[32] Less harm was done when

the building was converted into an Islamic mosque and the images were painted over. The icon has suffered some damage, too, in this case from its church display and the consequent abrasion caused by handling and kissing; some of the names of the figures have been rubbed off and so not all the figures can be definitely identified. It also had a title at the top, of which only a couple of letters are left.

The mosaics are in the dome of the vast circular church at Thessaloniki known today as the Rotunda or church of St George [11]. The building was used as a Turkish mosque from soon after 1430, and its Byzantine dedication fell into obscurity. If its architecture is reminiscent of the Pantheon in Rome or of an imperial mausoleum, this correctly points to its architectural origins, not as a church, but as one part of a vast development of around 300 of the emperor Galerius, which included a triumphal arch, palace, and hippodrome. The Rotunda may have been intended as a pantheon or as his mausoleum; but when Galerius died in 311, he was not buried here. A whole mythology about the pagan Galerius is found in the local writings of Thessaloniki, particularly in the stories of St Demetrios and his martyrdom; Galerius was also said to have had a daughter, a Christian convert, who was patron of the church of Hosios David [53].[33] But none of the archaeological studies of the city or embroidered local legends enlightens us about the date of the conversion of the Rotunda into a church with mosaics. All depends on an attribution derived from the style and content of the mosaics, and perhaps that of a carved marble ambo, also in the church, which might have been made at the same time.[34]

Dating the Rotunda is a typical Byzantine enigma. Apart from the mosaics in the dome, others are to be found in the barrel-vaults of the window niches. The eastern sanctuary vault is a later rebuilding, and has ninth-century wall paintings in the eastern apse. The window mosaics may also be later—this is part of an unresolved architectural question concerning alterations to the church. The vertical walls of the church would originally have been covered with shining marble revetments; only the bare brick of the structure now shows. The substantial vista of surviving mosaic, originally eight panels around 6 by 8 metres, each a two-storeyed architectural façade with standing figures in the foreground, sweeps concentrically around the dome, the panels being only the lowest register of the ceiling decoration[10]. Every panel is crammed with detail—lamps, candles, ciboria, crosses, Gospel books, ornamental friezes, curtains, peacocks, doves, and more. In front of the glittering façades stand motionless saints, two or three in each of the seven panels (the eighth on the east is lost). They wear vestments and hold up their arms in prayer. The visual evocation is of the celebration of the liturgy in heaven, its audience the living faithful who have come to the church for the commemoration of Christ on earth, and who see the promise fulfilled of the believer, after death, entering into the

sacred presence of God. The inscription beside each saint records his month of death and commemoration. Art is used here as a way of transforming a mere list of special saints into a visual statement of the fundamental Christian belief of life after death; this truth is established by showing to those who entered the church in cosmic time an image of the infinite time of the other world.

Since the saints are individually chosen and named, the composition is not merely a generalized one, but the spectator is to derive some significance from the particular saints. These were as follows, beginning with the panel to the right of the apse:

1. Saint [inscription lost], Leo (soldier; June), Philemon (flute-player; March)
2. Onesiphoros (soldier; August), Porphyrios ([occupation unknown]; August)
3. Kosmas, Damian (doctor; September)
4. Saint [inscription lost], Romanos (priest), Eukarpios (soldier; December)
5. Saint [inscription lost, perhaps Arkadios], Ananias (priest, January)
6. Basiliskos (soldier; April), Priskos (soldier; October)
7. Philippos (bishop; October), Therinos (soldier; July), Kyrillos (bishop; July)
8. Lost panel.

Seventeen male figures are shown: if we assume that the lost east panel was symmetrical with its pendant over the west door and also contained 3 figures, the original contingent was 20 figures (for whom we have 14 names). Despite this set of names, the choice or the logic followed in grouping the figures has not been satisfactorily explained; nor do all their festival dates recorded here correlate with church calendars, Greek or Latin. There are anomalies: no record at all of a soldier Leo martyred in June is found in Byzantine writings, and we know next to nothing about some of the others, such as Basiliskos and Therinos, for example. The carefully varied facial types might suggest they are 'real' portraits, a faithful attempt at a likeness; but that they were portraits rather than types seems unlikely, and the style is naturalistic rather than realistic.

The treatment of these saints has been taken to indicate an early date, close to classical antiquity, which might explain the use of naturalism and the knowledge of complex façades, remarkably like the 'baroque' façades of Petra or Pompeii, as well as the unsystematic list of saints. It may be that these martyr saints were depicted because their relics had been acquired and kept in the two large crypts below the ambulatory of the church. No other Byzantine monument has this combination of saints, nor even this compositional scheme. While finding a parochial reason for the choice of saints would help in making the references more precise, there is another question yet. How does this register fit into the whole decoration, and does that have a single subject?

Icon of the Triumph of
Orthodoxy. Constantinople
[?]. Second half of the
fourteenth century.

The icon declares the
importance of icons in the
Orthodox church by
representing their veneration
by those who fought for
Orthodoxy during the period of
iconoclasm between *c.*730
and 842. Empress Theodora
and her son Michael III on the
left and Patriarch Methodios
on the right officially
established the triumph of
Orthodoxy over iconoclasm in
843. The *Hodigitria* icon
painted by St Luke is the main
image shown; two icons of
Christ are held by iconophiles
in the register below.

Above the saints the dome is now almost completely denuded of
mosaics and contains only a few fragments; but it can definitely be said
that a standing figure of Christ was set in the medallion at the apex—
his halo survives in mosaic, and the rest is known from the chance
preservation of an underdrawing directly on the brick surface [12].
This medallion, encircled by a ring of 24 stars and a garlanded wreath,
was held up by 4 flying angels. It contained the standing figure of a
young Christ against a silver ground, a cross in his left hand, and his
right hand raised upwards. Between the flying angels were a phoenix
and a luminous cross. The mosaic fragments of the register below are
just about sufficient to indicate that there were figures here, and proba-
bly a background of palm trees. It has been calculated that there were
somewhere between 24 and 36 figures, perhaps of angels.

If this dome is seen as one complete but monumental ensemble, we
want to identify the subject, even though it has no title and there is no
known similar composition. One proposal, the Ascension of Christ,
can be ruled out because there are no apostles as witnesses. This, any-
way, is the scene of the later painting in the apse, and Byzantine
churches do not repeat major scenes. More convincing is the sugges-
tion that this is the *Appearance of the Risen Christ in Glory at the Second
Coming* (known in Greek as the *Parousia*). This fits more of the ele-
ments, and has the added attraction that in the early Byzantine period,
the Second Coming was believed to be imminent, so imminent that it
may explain the initial lack of interest in investing in art in primitive
Christian communities. Christ's return at the Last Day to judge the
living and the dead marks the end of the present order and the entry of
redeemed and resurrected humanity into a new life in heaven. This
image could be envisaged as a part-literal, part-symbolic representa-
tion of this Christian doctrine, an interpretation that would seem ap-
propriate as the Rotunda mosaics were created in a period when the
Christian world was still new, and both insiders and outsiders needed
convincing of its truths: the mosaics themselves are triumphal and op-
timistic. By the ninth century, however, images of the Last Judgement
worked by terrifying their audiences: Methodios, a Byzantine artist
working for King Boris of Bulgaria in 864, was commissioned to paint
a subject that would induce fear in its audience; he did not hesitate to
choose the Second Coming of Christ, showing the righteous being re-
warded, and the sinners eternally punished for their misdeeds. Boris
was instantly converted and baptized.[35] The details may be all or part
fiction, but the truth is immaterial so long as the story demonstrates
the Byzantine understanding of the power of the image.

Can we date the Rotunda mosaics? To extend the previous imperial
structure into a great church was obviously a massive engineering job,
and the mosaics, too, must have taken months, if not years, to put in
place from a scaffolding. This is yet another reason to think of support

and workers from Constantinople, perhaps being sent by the emperor. Thessaloniki was an old Hellenistic city with greatly improved potential since Constantine's development of its harbour in the fourth century. Its real importance only began in the mid-fifth century when it was redeveloped as a provincial capital and as the base of the principal military general of the west, the *praefectus praetorio* of Illyricum. This was a significant upturn in its history, and must account for the construction of a set of grand and beautiful churches, of which the Rotunda is only one and not perhaps the most important. Thessaloniki in the fifth and sixth centuries appeared to have a bright future, but conditions in the Balkans conspired to diminish its strategic and commercial importance. The occupation of the region by Slav tribes from the late sixth century pushed the city into a defensive position, but it did survive and had further periods of minor prosperity from the ninth century, and particularly in the fourteenth century.

The history of Thessaloniki from the mid-fifth century gives us a context in which to date the enterprise, but no clear clues. The style and possible imperial connections have led some scholars to date it earlier than this—to the late fourth century and the patronage of Theodosios I (379–95), relying on a comparison with the classicizing figures on the sculptured base of the obelisk of Theodosios in the Hippodrome of Constantinople [8]. Theodosios was indeed in Thessaloniki in 390, but his recorded activity was to put down a riot with a massacre of thousands of citizens, an outrage for which Ambrose, bishop of Milan, forced him to do penance. This stylistic and historical correlation is poor circumstantial evidence, yet the dating was so forcefully made in 1953 that it became the consensus for a generation or more, and is still upheld by some.[36] If the stylistic comparisons are seen as too vague, then to connect the historical face-lift of the city from the mid-fifth century with the renovation of the Rotunda and the development of other churches offers a different solution, although one that sets problems of deciding the relative order of the monuments and their mosaics. Can they be put in sequence, and are there any fixed points in the series? Priority in date has been given to the Rotunda and the basilica of the Virgin (the *Acheiropoietos* church), followed by St Demetrios [44] and Hosios David [53]. But it is still not certain where all these churches in Thessaloniki fit in the decades after the mid-fifth century. If all the elements of the Rotunda—dome mosaics, window mosaics, and marble ambo—are homogeneous, then probably all except the basilica of the Virgin belong to the first half of the sixth century.

This hesitancy and lack of precision point to the weaknesses of the stylistic arguments. Some scholars have seen the mosaics from close to on a scaffolding, some only from the ground, some from photographs. Does this matter? Different devices of laying the mosaic cubes in each of the faces can be seen from close to, sometimes soft gradations, some-

times chequerboard effects; from a distance, the impression was indeed sculptural. But to compare this impressionist style with the impressive portrait sculpture of the late fourth century found both in Constantinople and in the cities of Asia Minor, such as Ephesus and Aphrodisias, is to maintain little more than that this kind of early Byzantine art is in the classical tradition. The later dating refers to more precise correlations with other mosaics in Thessaloniki and Ravenna, and compares like media with like. But to date the Rotunda mosaics at some time in the second half of the fifth century or early sixth is to be less precise than might be expected, even if it has the advantage of seeming to accord better than other hypotheses with the indications offered by style, the choice of saints, and historical circumstances.

Although the artists are unknown, their 'sources' are clear enough. Christ in Glory and Paradise were designed in the naturalistic style of antiquity and the perspectival architectural setting is as dramatic as the stage scenery and funerary monuments of Greco-Roman imagination. Early Byzantine art has in this case adapted the visual vocabulary of pagan art for maximum effect on the Christian viewer. In a sense, this use of the past expresses the total triumph of the early church over antiquity. The mosaics of the Rotunda are an index of Christianity's success; their quality is equally an indication of the major importance of Thessaloniki in the new order of the Roman empire.

The icon, the second object, is a work of art of a different form, period, and function [13]. The comparison has its value, but in the end suggests that a systematic treatment of Byzantine art in time and context offers more than the broad synoptic treatment. The icon is small in scale (39 × 31 cm), appropriate for individual, even private, viewing, painted on wood, and easily moved and transported.[37] Its subject has broad connections with the Rotunda, since it includes a group of saints, shown by definition after death and in paradise since they are surrounded by divine light, symbolized by the gold ground of the background, who are arranged in registers around an image of Christ, this time portrayed not in his appearance at the Second Coming but as a child with his mother Mary, and so symbolizing the Incarnation. The saints, like the martyrs of the Rotunda, represent ideal models of the Christian life. The icon, like the Rotunda mosaics, conveys the triumph of the church, charismatic models, and Christian doctrine. But despite the similarities, its references are subtly different.

The icon has no date, signature or provenance recorded on it. The consensus has been to attribute it to an artist from Constantinople, on grounds of style and quality, but Crete has also been suggested. As for a date, its production in the last quarter of the fourteenth century likewise depends on stylistic parallels, from which one can either build up a general impression of the nature of art in Constantinople or Crete around 1400, or look for the closest stylistic comparisons and link its

date with them, choosing for example a group of icons connected with a known patron of the period just before 1384, now in the monastery of the Grand Meteoron in northern Greece.[38]

Although Byzantine artists did not give icons titles in the modern sense, their convention was to identify (or to authenticate?) pictorial scenes and figures in writing. In the case of the icon, although only two letters of the title survive, as red paint easily rubs off gold leaf, they are enough to identify the scene as being that of the Sunday of Orthodoxy. This subject is also known as the Triumph of Orthodoxy, or the Restoration of the Holy Icons: on the first Sunday of Lent, the Orthodox church commemorates the restoration of icons after iconoclasm, which was first celebrated on 11 March 843. The service included a recitation of the text called the *Synodikon of Orthodoxy*, which listed the true doctrines of the church.[39] The icon was presumably made to be displayed annually at this festival, and it declared orthodoxy and the triumph over heresy firstly with the representation of an icon. This famous image was kept in Constantinople at the Hodigitria monastery and was believed (at least from the eighth century) to have been painted from the life by the evangelist St Luke. Secondly are represented the iconophile champions (some with icons) who battled for the Orthodox church from 726 to 843: the upper register includes the reigning emperor, Michael III (aged 3 at the time) and the regent Theodora, his mother, and on the other side of the icon, with its winged guardians, the patriarch Methodios. The other figures are monks or bishops, except for one nun, the legendary martyr St Theodosia of Constantinople, who holds the icon of Christ, which we are told decorated the bronze Chalke Gate at the entrance to the imperial Great Palace before iconoclasm, and which she had tried to protect from destruction. Everything in the icon is designed to symbolize true belief, and the fact that the veneration of icons—including, of course, this one—was the sign of the Orthodox church. And that this was as true in the fourteenth century as in previous centuries, and must remain so.

These cross-period comparisons help to point to continuity and change, but not perhaps with any great precision. Clearly both works continue the traditions of classical antiquity, but in such different ways and in such different contexts that each needs separate analysis and interpretation. Each uses representations of saints to symbolize Christian belief and church doctrine, and both are remarkable for their high technical expertise; but these elements can be found in religious art from many other times and places. The precise meanings of each work are locked in their periods, and the particular reasons in their selection of saints. The many meanings of the icon of the Sunday of Orthodoxy will only emerge if we treat it in its historical context, exploring the choice of saints and the purpose in declaring orthodoxy at a time of doctrinal dispute and definition within the church, and of outside threat from Islam.

Similarly, the context of early Byzantine Thessaloniki is necessary for the understanding of the evocations of the Rotunda mosaics. Both works include martyrs, but those in the Rotunda who are victims of the persecution of Christians under pagan Roman emperors are very different from Orthodox martyrs fighting against Christian imperial heresy.

Working chronologically, and taking into account the changing ideologies and outlooks of Byzantine society which are embedded in its art, a complication arises which is underlined by this comparison. Byzantium is a cumulative culture, both in its collection and display of classical art and in its piecemeal enhancement of church interiors. The images of the Rotunda may date to around 500 but they have since that date remained in place in the church, probably because they were too high for the iconoclasts to attempt to destroy. By the fourteenth century, the Rotunda would have contained many icons, some of the date, no doubt, of the Sunday of Orthodoxy. In Constantinople, St Sophia underwent progressive renovation with new decorations, more relics, and treasures in nearly every Byzantine century. If Byzantine viewers were so comfortable in the presence of such disparities, our understanding of their notions of change and continuity must adapt to this situation.

Between Constantine and Justinian (527–65), Byzantine art was established, in a period that has been seen as one of evolution and experiment in a Darwinian model of survival. A case in point would be the

14

Mosaics of the triumphal arch of S. Maria Maggiore, Rome. 432–40 (under Pope Sixtus III).

The fifth-century basilica church was altered in 1288–92 when the original apse and its mosaics were replaced, and of the original 42 panels of the nave with scenes from the Old Testament, 27 have survived. The mosaics from the arch around the apse represented the Infancy of Christ, and acted in part as visual exegesis on the role and status of Mary, to whom the church was dedicated.

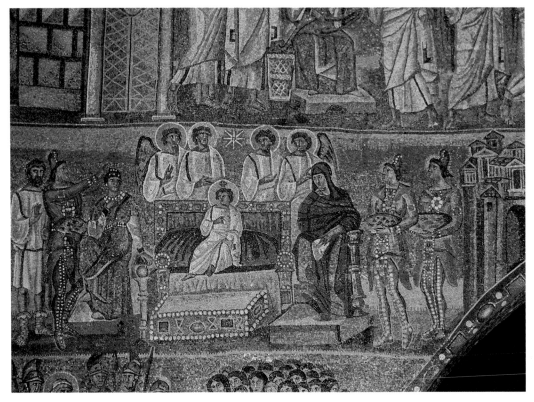

unique representation of the Adoration of the Magi in the cycle of mosaics representing the Infancy of Christ placed on the triumphal arch of S. Maria Maggiore in Rome between 432 and 440 [**14**].[40] In this scene, the newly born Christ sits upright and unaided on a central throne—in later representations the child is always held on his mother's lap. Regarding this pose as an anomaly in the sequence of representations of Christ and a scheme which failed to survive is not helpful, and may hinder an understanding of the reasons why this imagery was chosen in this decoration. Similarly, in this set of mosaics, we have to ask not only the meaning of its chosen iconography, but what is deliberately omitted. Why is there no scene of the Nativity? Neither the unique scene of the infant on the throne nor the omission of the Nativity is a deviation from a norm, but the consequence of special planning. The planners were avoiding too explicit references to the nature of Christ as God or man at the moment of the Incarnation because of current theological controversy about the status of Mary: they used art to express their own contributions to the debate. When decisions about the role of Mary in early church councils solved the dilemma and church dogma changed, so did the imagery. It took several more centuries of debate before the status of Mary as Mother of God was explicitly defined, and Marian art could directly express the theology.

Emperors and bishops were at the forefront of the wholesale conversion of the Mediterranean into a Christian landscape, commissioning the building of phenomenal numbers of churches and the sponsoring of their interior decoration and sanctuary fittings, such as crosses, chalices, patens, candles, altar cloths, Bibles, and all other necessary objects for the glorification of God at services. Each church desired to place a relic of a dead saint beneath its altar; when Simeon Stylites died there was a scramble for his bones and, all over the empire, relics were transferred into churches with great ceremonial [**4**]. Both relics and images of saints were already prized as being the channels between human prayers and God. In addition to the official community leaders, the countryside and cities also saw the growing popularity of hermits and monks, who acted outside church institutions in part as the conscience of society, genuinely living in imitation of Christ, but who were also practical sources of help and advice, visited by rich and poor alike. This public acceptance of Christian humility and human sinfulness led to the domination of Christian art in public, although in domestic items traditional classical forms, and even pagan themes, with only lip service to Christianity, prevailed, as we see in the Sevso Treasure, a magnificent family set of dishes and utensils [**9**].[41]

The mosaics of the Rotunda mark the increasing dominance of the church and its institutions in life and art from the fifth century. The calendar mosaics reflect the church year, and the organization of daily life by the liturgies and festivals of the ecclesiastical hierarchy.

Constantinople was the city where the frameworks of classical anti-quity and pagan culture were maintained, but gradually subverted by the changes of priority in building and in the functions of art. The past was not rejected, but selectively maintained. The building of churches not only changed the whole map of every city; with the entry of relics and the dead into the city, and the abandonment of the classical necropolis, a whole new city environment was created by Christian builders and artists. Patronage changed as each city became less the arena of individual sponsorship by the local aristocracy, and more the site of largesse at the will of a distant ruler. Over these early centuries, Constantinople gradually, and partly by default, emerged as the capital with the permanent presence and patronage of the emperor.

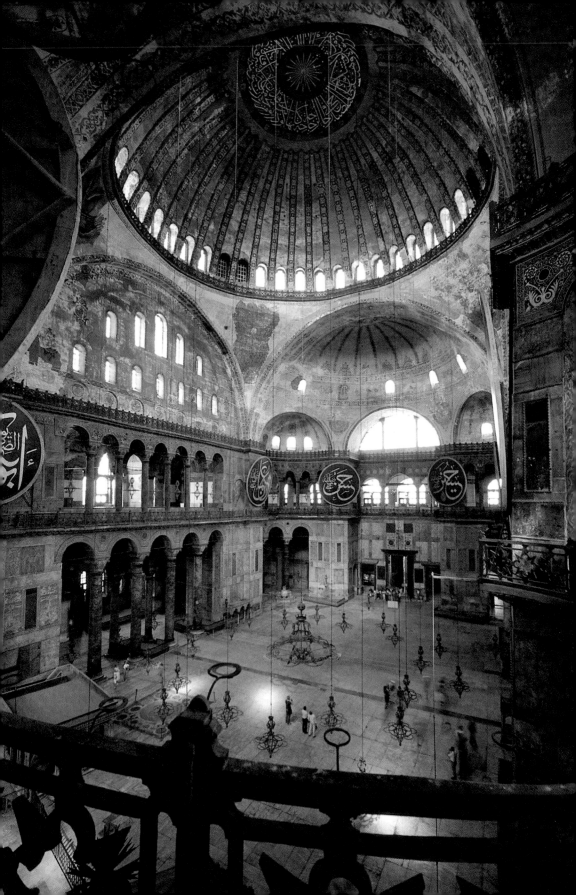

In the Shadow of St Sophia

Byzantine Art in the Sixth Century and its Aftermath 527–680

2

However gradual the development of Byzantine art may appear to us today, there were moments of decisive change. One is Christmas Day of the year 537, which utterly changed the Byzantine imagination. It was the dedication day of Justinian's new church of St Sophia, which replaced the church dedicated in 360 and burnt down in the Nika riots of January 532. The speed of the rebuilding was phenomenal since it was consecrated only six years after work started. St Sophia remains one of the great achievements of world architecture [**15, 16**]. In it, every Byzantine saw the perfect church. Germanos, patriarch of Constantinople from 715 to 730, wrote from the perspective of St Sophia an interpretation of the symbolism of the Byzantine church:

The church is the temple of God, a holy place, a house of prayer, the assembly of the people, the body of Christ. It is called the bride of Christ. It is cleansed by the water of his baptism, sprinkled by his blood, clothed in bridal garments, and sealed with the ointment of the Holy Spirit, according to the prophetic saying: 'Your name is oil poured out' and 'We run after the fragrance of your myrrh', which is 'Like the precious oil, running down upon the beard, the beard of Aaron'.

The church is an earthly heaven in which the super-celestial God dwells and walks about. It represents the Crucifixion, Burial, and Resurrection of Christ: it is glorified more than the tabernacle of the witness of Moses, in which are the mercy-seat and the Holy of Holies. It is prefigured in the patriarchs, foretold by the prophets, founded in the apostles, adorned by the clergy, and fulfilled in the martyrs.[1]

This manner of writing, *mystagogy* (interpretation of church liturgies), was simultaneously clear and cryptic. Germanos's *Ecclesiastical History and Mystical Contemplation* was, in Byzantine readership terms, a 'best-seller', and available in dozens of manuscript copies, including Latin and Russian translations. It set out a framework of church symbolism which interwove the timeless themes of art and liturgy with the special and topical variations that might apply to any particular church

15

Interior of St Sophia, Constantinople. View towards the west.

The fittings in the sanctuary and Muslim placards owe to the Islamic conversion into a mosque. In the Byzantine period, there was an altar and *ciborion*, and a screen and an *ambo* in front of it. Justinian donated liturgical vessels of gold and silver and works in precious stones, and embellished the sanctuary with 40,000 pounds' weight of silver. After the earthquake of 557, Justinian replaced these equally lavishly, including a silk altar cloth depicting Justinian and Theodora with Mary and Christ.

St Sophia, Constantinople, from the south. 532–7.

The minarets belong to the Ottoman conversion of the church into a mosque. In Byzantine times, the square of the *Augustaion* lay to the south, the *Milion* and the Hippodrome to the south-west, and the Great Palace with its entrance from the Chalke Gate to the south-east. This spacious area was the symbolic centre of Constantinople.

or occasion. When the later patriarch, Photios, publicly inaugurated the image of the Virgin and Child in the apse of St Sophia on Easter Saturday 19 March 867 [**67**], his audience would have recognized echoes from Germanos in his homily. The occasion was a celebration of Orthodoxy after iconoclasm; the theme, the beauty of images and the heresy of the vanquished iconoclasts, whose attacks on the icons of Christ render them comparable to Jews at the crucifixion. As the congregation was invited to look up into the apse, Photios spoke in the tradition of Germanos:

Do you see of what beauty the face of the Church was deprived? Of what splendour it was robbed? Over what graces did gloomy dejection prevail? That was the reckless act of a criminal hand, on the side of the Jews, not lacking in impudence. This is a most conspicuous token of a heart seized by God and of the Lord's love, whereby the initiated band of the apostles were led to perfection, through which the martyrs' winged course sped to the crowns of victory, and the prophets, God's tongues, with knowledge of future things and truthful foretelling, came unto men bringing undoubted belief. For truly are these things the prizes and gifts of a most sincere and divine love, from which depends likewise the veneration of holy images, just as their destruction comes from an uncontrollable and most foul hatred. Those men, after stripping the Church, Christ's bride, of her own ornaments, and wantonly inflicting bitter wounds on her, through which her face was scarred, sought in their insolence to submerge her in deep oblivion, naked, as it were, and unsightly, and afflicted with those many wounds—and so emulating Jewish folly ...[2]

17

**Inner narthex of St Sophia
with the mosaic decoration of
crosses from the Justinianic
foundation. 532–7.**

The vaults of the church were
all decorated with crosses and
non-figurative imagery. During
the use of St Sophia as a
mosque, the crosses were
concealed, and restoration
since 1932 has only uncovered
a fraction of the original
decoration. The lunette over
the central door from the inner
narthex into the nave was
redecorated with figurative
mosaics after iconoclasm.

Centuries later again, George Sphrantzes, writing in the last days be-
fore Constantinople fell to the Ottomans in 1453, takes us back to the
themes of Germanos:

That most huge and all-holy church of the Wisdom of God, that Heaven
upon earth, throne of the glory of God, the second firmament and chariot of
cherubs, the handiwork of God, a marvellous and worthy work, the delight of
the entire earth, beautiful and more lovely than the beautiful.[3]

St Sophia defined the symbolic centre of the city. To be overawed, any
visitor must go inside. Germanos's many-layered interpretations con-
vey how it was to be viewed. This was less as a place of private contem-
plation than as the arena for the public and state adoration of God. Few
viewers would understand anything about its engineering achievement
and how the dome was actually supported by piers and buttresses.
What mattered was the conviction that God was inside the church. If
all its parts symbolized the events of the New Testament, then it be-
came both a way of memorizing that history and believing that it was
mystically re-enacted in the course of the church year. In the later
Byzantine church this idea of the decoration as memory and re-enact-
ment is smoothly conveyed through figurative cycles. The surprise that
has been felt in Justinian's church of St Sophia is its total lack of figura-
tive mosaics. Instead, St Sophia evokes the presence of God by end-
lessly repeated images of the cross in the gold mosaics of the vaults
[17]. The solution is simple and unifying, not unlike the later Islamic

mosque with non-figurative ornament and the divine words of the Koran. Other churches of Justinian's reign, such as S. Vitale at Ravenna and the church in the monastery of St Catherine at Sinai, are in contrast striking for their figurative mosaics [**32, 25**]. The decision at St Sophia might have been purely practical, to speed the execution or because the architectural surfaces were felt to be unsuitably high for imagery. Or the reason may have been more theoretically based, reflecting thinking about appropriate ways of decorating sacred spaces. Either way, the visual effect achieved, as Procopius discovered, was distinctive. Viewers in the nave found their gazes sweeping around the interior instead of stopping to focus on any particular section, as a figurative set of images would have encouraged; and indeed has done since the redecorations introduced after iconoclasm.

The impact of St Sophia relied in great part on its enormous height and width. The structural challenge was to work on this scale and to cap a building of stone, brick, and mortar with a great dome. Significantly, the names of the architects were recorded, Anthemios and Isidoros. When the first dome fell in an earthquake in 558, again the restoration architect is known: it was Isidoros the Younger, nephew of the first Isidoros. A redesign was thought necessary—the present dome is 20 Byzantine feet higher than the first. This meant that when the church was reconsecrated on 24 December 562, the dome rose to about 56 metres above floor level. It had a diameter between 30 and 31 metres; the Pantheon at Rome had a span of 43.5 metres and the Rotunda at Thessaloniki had a diameter of 27.5 metres but these were on a circular base. St Sophia has the axis of a basilica (79 metres in length and 72 metres in width), but is virtually a central plan. The main nave from west to east is more than twice its width of about 30 metres. In comparison, the typical Gothic cathedral nave of the later Middle Ages is much narrower. The shapes of the interior surfaces covered by a carpet of mosaics were formed by the supporting system of the dome: pendentives rising from four piers, arches, semi-domes, and the infill of the arches by the north and south tympana. The current building dates in the main from the sixth century, but with extra buttresses and supports and all the additions from the Ottoman conversion into a mosque. Work done by the Swiss architects Gaspare and Giuseppe Fossati between 1847 and 1849 helped to preserve the structure, and while they saw at that time more Byzantine mosaics than have survived today, they were required to cover these and the rest of the church with plaster and neutral designs.

The sixth-century interior without the distraction of figurative mosaics was lighter and fresher than it is today. The eight porphyry columns were reused, but all the other columns and marbles were quarried for the building, including Thessalian green marble, and considerable amounts of white Proconnesian marble. The walls were covered

with veined marble revetments—a Byzantine conceit was to interpret the shapes of these veins as figures and forms within the stone. The capitals have deeply etched and undercut acanthus designs and include the personal monograms of the emperor Justinian and empress Theodora. The carving was meant to give the impression that the forms spread out over the colonnades and cornices, like living plants. The panels and balustrades and other relief sculptures were inventive and varied in their designs. Many of the cornices, doors, door frames, and sanctuary barriers were sheathed with polished bronze and silver-gilt sheets. Attention was given to detail, but time was short and not everything is fully finished; this cannot be used as a measure of a decline in sculpture, but rather as an indication of the complexity of the organization of the whole operation.

The sculptural carving of St Sophia is highly distinctive, and out of sympathy with any rules of the classical orders. Two churches in Constantinople had already experimented along the same lines: the first was the centrally planned monastery church of Sts Sergios and Bacchos, a slightly earlier (between 527 and 536) commission of Justinian. Today its cornices and capitals have been whitewashed, the consequence of its use as a mosque. It was also one of the sources of the architecture of S. Vitale in Ravenna, which was fully completed around 548 [32]. The second, the church of St Polyeuktos, started in 524, was a grand foundation of Anicia Juliana, the daughter of the western emperor, Anicias Olybrias (472).[4] As a commission of the traditional aristocracy, but not the emperor, this is a special category of monument, and it has been argued that it was built as an open challenge to the new ruling family from the Balkans. Anicia's patronage represents the state of the arts in Constantinople before the reign of Justinian. Her claim to her imperial pedigree appears in a long verse inscription carved around the church [18]. As a patron, she had already built a church near Constantinople which was recorded in a roundabout way by a luxurious, illustrated copy of the medical manual, *De materia medica*, of Dioskorides of the mid-first century.[5] This massive book (37 by 30 cm) had 498 miniatures, mostly a repertory of medically efficacious useful plants, arranged in alphabetical order in this edition, which also includes pictures of snakes, spiders, scorpions and other insects, animals, and birds from other texts. One miniature [20] shows Anicia Juliana as a princess enthroned between personifications of Magnanimity (*Megalopsychia*) and Prudence (*Sophrosyne*), and with Gratitude of the Arts at her feet; she appears to be putting gold on an open copy of the book held up by a cupid. An acrostic note written in the ornament gives the essential information: the book was a gift from the town of Honoratai, near Constantinople, where Anicia Juliana had built a church in 512. It has been assumed that she paid for the book as well, whose later history shows how much it was a treasured posses-

18

Architectural sculpture from the church of St Polyeuktos, Constantinople (region of Saraçhane). Built 524–7 by Anicia Juliana next to her palace, it collapsed after the tenth century, perhaps in the twelfth or thirteenth century (several reused marbles now in Venice). Discovered 1960 and excavated.

The excavation of the foundations suggested a grand, probably domed, church built in Constantinople before Justinian's great churches. A 76-line verse inscription (recorded in the tenth-century *Palatine Anthology*) sets out the aristocratic pedigree of the founder and her qualities. Like the carving of St Sophia a few years later, the delicate cutting and repertory of forms show innovation and a transformation of the conventional antique models.

19

Marble relief of Christ from the church of St Polyeuktos, Constantinople. Probably 524–7.

This is one of the ten figurative panels, possibly from a sanctuary screen. The severe damage to Christ's face and to the other figures has been interpreted as evidence of an eighth-century iconoclast attack.

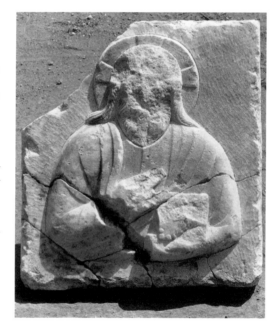

sion. It was sometimes used as a model for further copies; later owners wrote notes in it. It was in Latin hands after the Fourth Crusade (1204); in the rich library of the monastery of St John the Baptist at Petra, in Constantinople in the fourteenth and fifteenth centuries where it was rebound and edited in 1406; after 1520, it belonged to the Jewish physician of the Ottoman sultan Süleyman the Magnificent; and it was finally purchased by Charles V, and passed into the Austrian National Library. It offers a clear case of how Christian patronage in Byzantium preserved and transmitted pagan knowledge.

Polyeuktos, the patron saint of Anicia Juliana's church, was a military saint (martyred in Cappadocia around 251) of whom as little is known as of some of the saints in the Rotunda at Thessaloniki. His skull was among the church's collection of relics. As architecture, the

church of St Polyeuktos was on a large scale and experimental in its forms. Lavishly decorated with mosaics, multicoloured marbles, opulent fittings, and sculpture, it also contained a figured sanctuary screen [**19**]. We now know it only as an archaeological site (found during roadworks at Saraçhane), and it did not survive through the Middle Ages but lay in ruins by the early thirteenth century when its sculpture was avidly looted for other buildings (such as the Pantokrator monastery in Constantinople), and by the Venetians who shipped capitals and blocks to display in the Piazzetta di S. Marco. Its plan and structure were challenges to the designers of St Sophia; both churches are 'domed basilicas'. Before St Polyeuktos was excavated in the 1960s, the plan of St Sophia appeared almost totally original and unprecedented, especially when compared with the earlier church of St John Studios (around 454), a wooden-roofed basilica with fine but traditional 'classical' architectural sculpture. It now seems that although no

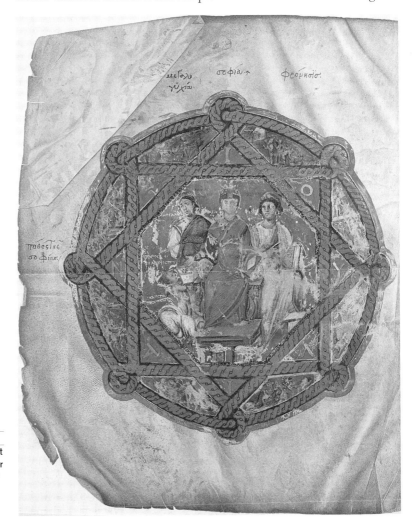

20
Manuscript page with portrait of Anicia Juliana, showing her with her copy of Dioskorides' *De materia medica* with its 498 miniatures, mostly of useful plants. *c.*512.

21

21

Alahan Manastiri, Cilicia. Interior of east church. 474–91 (sponsored by Emperor Zeno).

This hillside complex includes two churches and several other buildings, as well as tombs. The development has been interpreted as a special place of pilgrimage as a *martyrium*. The east church is one of several in this region to experiment with cupola structure.

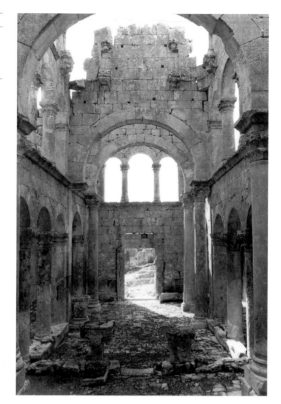

other churches matched the engineering daring and elegance of St Sophia, there were earlier experiments with the placing of a dome over an oblong nave, especially in southern Asia Minor, as in the monastery of Alahan kilise in the fifth century [**21**].[6] The solution in St Sophia determined the ideal form of the Byzantine church thereafter, but never again was a building of such enormous daring attempted in Constantinople, until the imperial mosques of the Ottoman period.

The imperial attention—and funding—given to St Sophia can be interpreted as a direct indication of the ways in which art helps to promote a political image. Justinian's armies reconquered North Africa and Italy and extended the eastern frontiers, as part of the attempt to restore the traditional boundaries of the Roman empire. Hence the defensive nature of so many of the buildings paraded by Procopius as achievements of the age. The policy was of renewal of a strong Roman empire under one administrative system and code of law, and unified by a single Christian creed. Adulatory texts and the visual arts are all part of the effort to improve Byzantine morale. One such case is the five-part Barberini ivory [**22**] showing a triumphant Christian emperor. He resembles Constantine, but the ivory is to be dated by style to the reign of Justinian. No doubt, therefore, the emperor was to be seen as Justinian himself, celebrating Christian victory over Persian captives. The question remains as to whether Justinian himself commis-

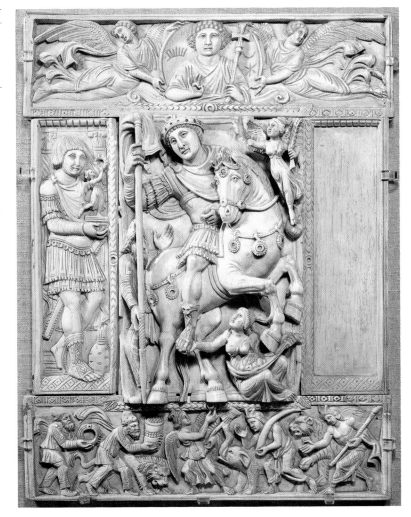

22

Five-part ivory panel of an emperor in triumph (the 'Barberini ivory'). Constantinople. First half of the sixth century.

A young Christ in a medallion supported by angels surveys the scene below: a heroic emperor in armour and on horseback is crowned victor. Below the horse is a personification of the earth; other figures (the one behind the horse perhaps a Persian) offer homage (and ivory) to the Christian emperor. The identification of this emperor as Justinian is inferred from the stylistic dating of the ivory; if so, it might record peace with Persia.

sioned it, or whether this was part of the court's promotion of its emperor.[7]

The completion of St Sophia managed at a stroke to confirm Constantinople as the capital of a renewed Christian Roman empire. If the rites at the dedication of the city were ambiguous, nothing done by Justinian lacked clarity in his aim of world empire. This makes it all the more unexpected that he so seldom travelled out of the city. One of his few recorded journeys was a pilgrimage in 563, at the age of 80, to fulfil a vow to visit the celebrated church of the Archangel Michael at Germia in Asia Minor, a journey, no doubt, of great personal religious significance. His interest in Michael is again indicated by an ivory of an archangel, probably Michael, which has been suggested as one of Justinian's commissions from the early years of his reign. This impressive object is the largest single piece of carved Byzantine ivory [23].[8] It has the stylistic feature that the figure and the surrounding architectural

23

Ivory panel of an archangel. Constantinople. Second quarter of the sixth century.

This is the largest surviving Byzantine ivory piece, usually seen as the right part of a diptych (with the emperor Justinian proposed as the image for the left panel), and identified as St Michael. The archangel holds a sceptre and orb, and is portrayed ambiguously in the space (in front of the columns, but on the steps behind them).

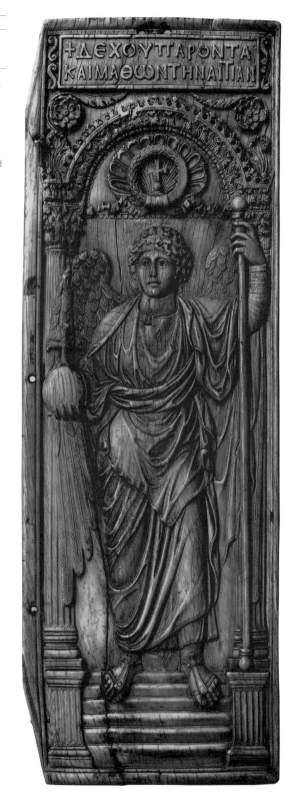

niche are naturalistically represented, yet the logic of the space is contradictory, with the sceptre and orb in front of the columns, and the archangel holding them balanced on the top step behind them. The ivory carries a prayer, 'Receive this suppliant, despite his sinfulness', possibly to be understood as an expression of humility on the part of the emperor. In a sense, this ivory and the Barberini ivory are entirely random survivals with no basis for attribution to the person of Justinian. Attributions depend on their exceptional style and size, which would seem to point to an imperial commission, a hypothesis that should not be lightly dismissed as these pieces were also regarded as exceptional in the Middle Ages. The Barberini ivory was important enough to be recorded in the south of France in the seventh century, and the St Michael ivory, more simply, has survived, despite its fragility (it has a

How to date a dated inscription or colophon

In Byzantium the system of dating before and after the birth of Christ was not used. Instead, the perspective was to compute each year from the creation of the world. A second system was in operation at the same time. This was to refer to each year according to its place in the tax cycle. Starting in 312, each tax year was numbered from 1 to 15 and then the cycle started again. A tax year was called an indiction. It took some centuries before this double system was regularized and harmonized into the developed Byzantine system which, after iconoclasm, seems to have been accepted in all the regions. A few rules may help the art historian to understand the figures (the numerals are the letters of the classical Greek alphabet, and not Arabic) which may appear in a Byzantine text which was meant to date the time of production or some other event in the history of the object. They should also explain why a date may be given in the form 1066/7, resulting from the conversion of a Byzantine year beginning on 1 September to a modern year beginning on 1 January.

1. In the developed Byzantine system, years are counted from the (supposed) creation of the world on 25 March 5508 before the birth of Christ. The Byzantine year ran from 1 September to 31 August. Thus
(a) to convert the Byzantine year during the months September to December, subtract 5509, e.g. 1 September 6574 = 1 September 1065.
(b) to convert the Byzantine year during the months January to August, subtract 5508, e.g. 1 January 6574 = 1 January 1066.

2. Byzantine inscriptions usually record the number of the indiction (tax year). The indictions ran in cycles of 1 to 15. The first indiction year was 312.
 To discover an indiction nmber, divide the Byzantine year by 15. If the number divides exactly, this year is the fifteenth indiction. Otherwise, the remainder represents the indiction number.

e.g. $\frac{6574}{15}$ = 438 remainder 4

Therefore the year 1065/6 was Indiction 4.

3. *Byzantine numerals*
Usually indicated by a stroke above the letter (e.g. $\bar{\alpha}$)

α	1	ϙ	90
β	2	ρ	100
γ	3	σ	200
δ	4	τ	300
ε	5	υ	400
ϛ	6	φ	500
ζ	7	χ	600
η	8	ψ	700
ϑ	9	ω	800
ι	10	ϡ	900
κ	20	,α	1000
λ	30	,β	2000
δ	40	,γ	3000
ν	50	,δ	4000
ξ	60	,ε	5000
ο	70	,ϛ	6000
π	80		

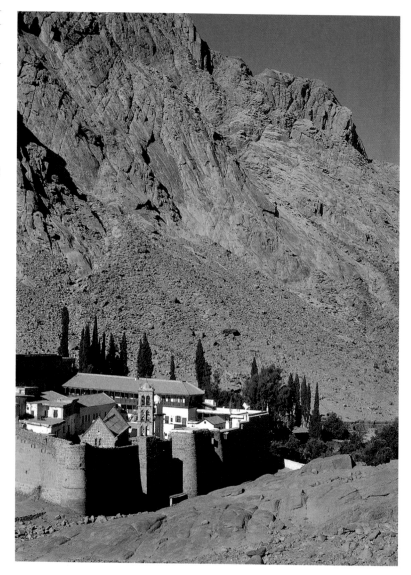

The monastery of St Catherine, Sinai, Egypt. 548–65.

The pilgrimage site and monastery were developed by Justinian after the death of Theodora. The church, dedicated to the Virgin Mary, according to Procopius, commemorated the site of the Burning Bush, and another chapel was built on the summit of Gebel Muza, where Moses received the Tablets of the Law. It was a fortified monastery in the granite wilderness of the Sinai peninsula, made mostly out of local materials, but the sanctuary was embellished with imported Proconnesian marble.

long crack on the left side), because of its size. A factor of the survival rates of medieval objects is the importance with which they were often regarded and the consequent care that was bestowed upon them.

It has been suggested that pilgrimage to the holy loci, such as the cult site of St George and places in the Holy Land where the footsteps of Jesus could be followed, was in effect discouraged by the building of St Sophia.[9] As architecture it surpassed the domed church of the Holy Sepulchre in Jerusalem, and it displayed a growing collection of relics concerned with the life of Christ, such as pieces of the True Cross or the well-head where Christ met the Samaritan woman, and others like pieces of wood from Noah's Ark.[10] The Holy Land at this time was still a thriving centre of monasticism and pilgrimage, and of continued im-

25

Apse mosaic of the monastery of St Catherine, Sinai, Egypt. 565/6 or possibly later.

Two scenes on each side of the upper east window show Moses and the Burning Bush and Moses receiving the Tablets of the Law. The triumphal arch has the Lamb of God between archangels, and two medallions, probably of St John the Baptist and the Virgin Mary. The conch of the apse had the scene of the Transfiguration of Christ, framed by twelve apostles, prophets, and two of the monks from the community at the time of the dedication, John the Deacon and Longinos the Abbot.

26

Detail of apse mosaic of the monastery of St Catherine, Sinai, Egypt. 565/6 or later.

Details of the mosaic's production were inscribed above the prophets on the right (their medallions reduced slightly in diameter to allow for the writing): 'In the name of the Father, the Son, and the Holy Spirit, this entire work was done for the salvation of the donors in the lifetime of the most reverend Longinos, priest and abbot, with the help of Theodore, priest and second-in-command. Indiction 14.' Justinian died in 565. The mosaic is possibly from the later sixth century, perhaps sponsored by John the Deacon.

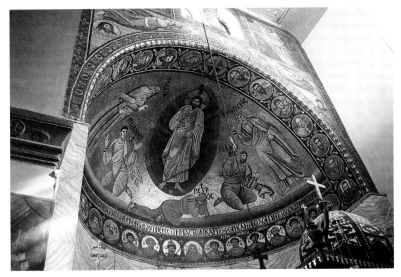

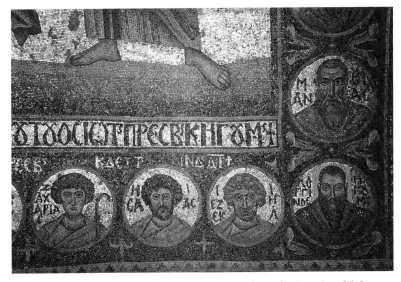

perial patronage, such as Justinian's Nea (New) church of Mary at Jerusalem, which recent excavation confirms was of vast proportions. One of the most impressive foundations of the reign was the building on Mount Sinai of a fortified monastery with a new church dedicated to the Virgin Mary, which marked the pilgrimage site of the Burning Bush, below the peak where Moses received the Law from the hand of God [**24**].[11] The inscription on the wooden roof beams of the church records that Justinian's sponsorship came after the death of his wife in 548 'for the memory and repose of our late empress Theodora'; and most likely the date given (indiction 14) in the mosaic inscription refers to 550/1 or 565/6 (for Byzantine chronology see box) [**25, 26**].

Mount Sinai was already a favoured destination of pilgrimage in the fourth century. The Spanish nun Egeria was there in the winter of

383–4, and she records for her community back home that she was able to hear a reading from the Book of Moses in the garden of the Burning Bush, to pray in a church there and to attend the eucharist.[12] Procopius brings the story up to date in the sixth century:

On this Mount Sinai live monks whose life is a kind of careful rehearsal of death, and they enjoy without fear the solitude which is very precious to them. Since these monks have nothing to desire, for they are superior to all human wishes and they have no interest in owning anything or in caring for their bodies, nor do they seek pleasure in any other thing whatever, therefore the emperor Justinian built them a church which he dedicated to the Mother of God, so that they might be enabled to pass their lives in it, praying and holding services.[13]

These graphic descriptions disclose the nature of life in the sheltered valley on the mountain. The monks followed a strict nightly and daily schedule of services for the worship of God, joined by pilgrims who wished to visualize events of the Bible on the actual site of their happening, and to pray and worship there. In our terms, the Sinai church was a memorial, a *martyrium*, on the site of the Burning Bush, but its form was that of a wooden-roofed basilica, and it was not centrally planned with a cupola. It was built by a local architect, Stephanos of Aila (Eilat), and the 'relic' it celebrated, the Burning Bush, was to be found at the east of the apse. The monastery was fortified with high walls into which were carved many crosses to act as the symbolic defence of the holy place. Justinian also based a frontier garrison there.

Over the centuries, the impact of the interior decoration of the church has been diminished by the addition of icons, an eighteenth-century iconostasis and crucifix, candelabra, and suspended ostrich eggs (symbolizing virgin birth). In the sixth century, the view down the nave must have been overpowering, the east end full of colour and light. Above the sanctuary, mosaics and a marble revetment covered the eastern wall and apse. The two uppermost mosaics around the window evoked the biblical events of the site, Moses at the Burning Bush and Moses receiving the Tablets of the Law. The arch below contained two angels and medallions of St John the Baptist and Mary with the Lamb of God at the apex; this scheme is one of the first examples of a *Deisis* (prayer) composition, which became extremely common in later periods, and represents an intercession image where John and Mary are treated as the highest representatives of humanity to mediate with Christ. The conch of the apse contains a stark image of the Transfiguration of Christ, the moment when his divinity was revealed to the apostles in the presence of Moses and Elijah. This scene is framed by portrait medallions of the 12 apostles, 2 monks, and 17 major and minor prophets. Since David, placed at the centre of the prophets, was seen allegorically in Byzantine eulogies as the biblical counterpart

of the emperor, it has been proposed that his image was intended to be read as that of Justinian. Such a reading of David as the contemporary emperor, which has been suggested for a number of other church mosaics as well, such as in the *Anastasis* at Nea Moni on the island of Chios in the eleventh century [**97**], prompts the question of how far Byzantine art introduced topicality in its religious images in this way.

At the east end of the church, the emphasis on colour and gold was designed for maximum impact on both visitors and monks: the spectator was to be almost literally blinded by the shining light of God in the sanctuary. Equally powerful was the direct style in the depiction of the Transfiguration. Its huge heavy figures are far from the elegance and naturalism of those in the Rotunda mosaics; in comparison, they might be called anti-classical. More human, but still mask-like in appearance, are the faces of the Baptist and Mary, and the witnesses of Christ, the prophets and apostles, and even the abbot of the monastery, Longinos, and John the Deacon. Their square haloes, a convention found here, in Rome and elsewhere, signify the figures as living persons. The conspicuous dedication inscription around the base of the Transfiguration is very topical in content, recording the dedication and not the timeless theological meanings of the imagery. It is clear that the mosaic was executed from the top down, as space was made for an addition to the dedication inscription by reducing the size of the prophets' medallions on the right side. This section gave the date and another monk's name: 'In the name of the Father, Son and Holy Spirit, this entire work was made for the salvation of those who have endowed it, in the lifetime of Longinos the most holy priest and abbot ... with the help of Theodore the priest and second in command, in indiction 14'.

The inscription records the production of the image, and the participation of leading monks within the community, with only an oblique reference to the sponsorship from outside. Attention is drawn to the hopes of the patrons in gaining salvation for their souls in the afterlife. As for the meanings of the particular scenes represented, and the stylistic choices made to express these, the art is left to speak for itself. Its exegesis depends on every viewer's knowledge of the Bible, and its commentary and interpretation, and how much of that knowledge is brought into play in the act of responding to the images.[14] For one individual, the three scenes, each showing a vision of God, may suggest the stages of a symbolic progress towards the ultimate revelation of the incarnate Christ, conveyed in the person of Moses who is both viewer and viewed in the mosaics. For another, the reaction might be closer to the allegorical thinking which is expressed fully in Germanos's writing. Each visitor to the sites on Mount Sinai can meditate on the ways of viewing God. We need, as much as the Byzantine in the sixth century, to understand how this art functions. In mystical terms, the church

Icon with the *Heavenly Ladder* of John Climakos. Sinai or Constantinople. Late twelfth century. Monastery of St Catherine, Sinai, Egypt.

The diagonal ladder with 30 rungs (symbolizing the 30 years of Christ's 'hidden life') leads from earth to heaven. The text on which the icon is based taught the virtues necessary for spiritual perfection, and the vices to avoid. Monks on the right pray before climbing the ladder; other have begun, but some are pulled off, to fall into the mouth of Hades. At the top of the ladder, John Climakos is received into heaven. Behind him is, most likely, Archbishop Antonios, abbot of Sinai, for whom the icon was made in the monastery.

28

Mosaic apse of the church of the Panagia Angeloktistos, Kiti, Cyprus. Sixth or seventh century.

The apse, now incorporated into a domed church of the eleventh century, with Crusader additions, represents within a decorative border the archangels Michael and Gabriel (with orbs and staffs) on each side of the standing Virgin and Child. The inscription describes the Virgin as St Mary instead of Theotokos (Mother of God) which was increasingly the norm after the fifth century. The reason for the emphasis on this epithet here is unknown.

offers a straight vision of the divine light; in intellectual terms, it is a complex meditation on the subject.

The evidence of Sinai demonstrates that Byzantine art in the sixth century represents more variety than the art of Constantinople, and that the art of Constantinople alone cannot sufficiently document the period. Distance from the capital does not imply distance from the intellectual currents of the period. The monks of Sinai were not merely isolated hermits, and one of the most influential spiritual handbooks of the period was written by an abbot of Sinai—*The Heavenly Ladder* of St John Climakos (before 579–*c*.650) [**27**].[15] The architect was from the Sinai region, and must have experienced considerable difficulties in transporting materials and builders to the site. The marble revetments, however, came from the Proconnesian quarries, and the mosaicists who came to complete the church with its final decoration may even have travelled from Constantinople. A mosaic panel there of the Presentation of the Christ Child in the Temple in the church near the aqueduct of Valens, known today as the Kalenderhane mosque, shows a related style of expression. The panel belongs to one phase in the complicated history of rebuildings of this monastic complex, and has been dated to the period of Justin II (565–78). But even a correlation of style between these mosaics would not be an adequate basis to decide the place of training of the mosaicists of the Sinai apse. This was a period of considerable production of wall mosaics around the empire—in Asia Minor, Constantinople, Cyprus [**28**], Thessaloniki and in Italy—and even greater expanses of floor mosaics, including a large and spectacular section in the Great Palace at Constantinople showing hunting scenes and other secular subjects in a very classical style.[16] In the case of pavements, individual artists or workshops can be traced in several works, and similarly in Thessaloniki, the same artists no doubt worked on several of the monuments decorated in the period of the Rotunda.

But in the case of Sinai, even if there is no precise answer as to whether the artists came from Jerusalem or Constantinople, the more significant issue is how monks and pilgrims from many backgrounds responded to its decoration. Is this what is meant by calling the art of the period of Justinian 'international'?

Justinian's ambition to recapture the west is equally marked by artistic patronage, most conspicuously at Ravenna in northern Italy.[17] This low-lying city in the marshes was developed only in late antiquity when the western emperor Honorius moved his court from Milan in 402, hoping for a more secure and inaccessible place as his capital. Its nearby port, Classe, gave access to the Adriatic. Extensive building works in a difficult terrain soon gave it palaces, churches, a cathedral, the Basilica Ursiana, with an (Orthodox) baptistery, and the small, highly decorated, cruciform oratory built by Galla Placidia, the daughter of the emperor Theodosios I, who had a high-profile career in the west, which included acting as regent to her son Valentinian III, emperor in the west from 425 to 455. The oratory is known, incorrectly, as her mausoleum. The building phase ended when Ravenna became the capital of an Ostrogothic empire (493–540), but under Theodoric (king of the Ostrogoths from 471, and ruler of Italy from 493 to 526) further churches were built—and Theodoric's own mausoleum—only with the complication that since he was an Arian Christian, differing from the Orthodox by denying the full divinity of Christ, the city found itself with churches designated to serve each community. It now had an Arian baptistery, and an Arian cathedral originally dedicated to Christ, then rededicated by the Orthodox to St Martin, the 'hammer of heretics', and then again, to S. Apollinare Nuovo when the saint's relics were transferred from S. Apollinare in Classe in the later Middle Ages. The mosaics of S. Apollinare Nuovo [29], like those of S. Maria Maggiore in Rome, encircled the viewer in the nave, and were not limited to the sanctuary alone, although the apse mosaics were largely lost in an earthquake in the eighth century. In a church founded for the Arian community, the original mosaics, we must assume, were planned with specifically Arian resonances. This is implied by the fact that on its later sixth-century conversion into an Orthodox church, much of the first phase was torn down and replaced with new mosaic images. Yet precise identification of what constitutes Arian imagery is impossible, a situation that does not bode well for the success of clear art-historical analysis of other Byzantine decorations which might equally be expected to communicate specific doctrines through pictorial means. This is particularly so since at this early period, differences of opinion—i.e. heresies—were clearly articulated and debated in the Oecumenical Councils of the church, where the presence of bishops from the whole Christian world guaranteed the decisions as binding. After the Seventh Oecumenical Council in 787, held at Nicaea, the

29

Mosaics of the church of S.
Apollinare Nuovo, Ravenna.
South wall, looking east.
Sixth century.

The Christ cycle belonging to
the original Arian church of
around 500 was set up high on
the wall, above the windows;
the Orthodox procession of
martyrs (male on the south
wall) is much more prominent.
The palace of Theodoric was
stripped of its figures between
the columns by the Orthodox
restoration; the figures were
replaced with curtains, but
their hands are still visible over
the columns.

Orthodox church accepted no other councils as being oecumenical; but some later 'local' councils were decisive with regard to the expression of Orthodox doctrine, outstandingly the councils of Constantinople of 1341 and 1351 which endorsed the views of the late Byzantine Hesychast movement on the nature of divine light [113]. But after iconoclasm had been rebutted at Nicaea, the expression of divergent views was more muted.

In the Arian period of mosaics to which belong, for example, the 26 scenes of the life of Christ in the upper registers of the nave walls, there are clues to particular choices and arrangements. In the Miracle scenes, Christ is beardless, and bearded in the Passion scenes. This contrasts with the Rossano Gospels, a luxurious manuscript (one of a small group with their parchment pages expensively dyed purple) with miniature paintings of the sixth century. Produced in the Greek east, it is now in the possession of Rossano Cathedral in southern Italy. In its cycle of Miracle and Passion images Christ is depicted bearded throughout [30]. Equally symptomatic of careful decision-making was the exclusion of the Crucifixion, matching the strategy at S. Maria Maggiore at Rome where the absence of the Nativity signalled controversy about the nature of Christ. In this case the decoration begs the

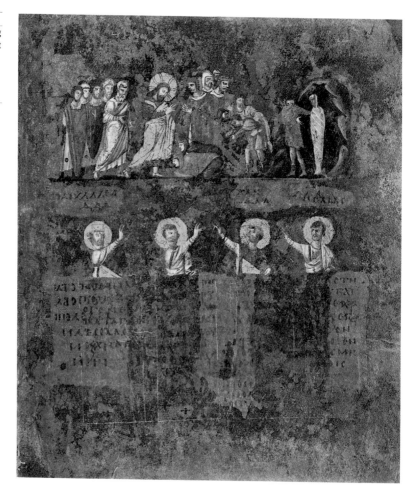

question whether Christ died on the cross. The sectarian situation in
Ravenna does, therefore, emerge pictorially, hard though it may be to
pin down all the pointers conclusively, partly because as religious art, it
inevitably explores ambiguity. Attempts to link the choices in the
Christ cycle to particular liturgical practices have not been successful,
partly because service-books of the Byzantine rite are not available for
this early period.

The victorious entry into Ravenna of Justinian's army led by
Belisarios in 540 totally changed the politics of the city. Maximian
(546–56), an energetic Orthodox bishop, was soon in office and in-
volved in several enterprises, including the import from
Constantinople of a panelled ivory chair with his monogram carved on
it, although this may have been to hold a Gospel book rather than
Maximian himself [**31**]. Under him the see was elevated to an arch-
bishopric, increasing its ecclesiastical prestige through the sponsorship
of new churches not only in Ravenna but on the eastern shore of the
Adriatic at Poreč, where the Basilica Eufrasiana still survives, and Pola.

**Ivory-panelled chair of
Archbishop Maximian.
Constantinople [?]. 540s.**

The panels contain the
monogram of Maximianus
Episcopus, St John the Baptist
holding the Lamb of God, and
the four evangelists, and
scenes from the story of
Joseph in the Book of Genesis
(sides of chair) and the
Gospels (both faces of the
back). There are also ornate
decorative border panels. The
imagery is as complex as in a
manuscript of the period, and
so sets the question of how
texts might relate to such a
cycle.

From 568 the administration was changed and Ravenna was governed
by an exarch, who combined civil and military power; the exarchate of
Ravenna, nominally under the control of Constantinople, lasted until
the Lombard occupation of 751. The re-establishment of Byzantine
control was instantly a *leitmotif* in the art of Ravenna. Maximian dedi-
cated the new church of S. Apollinare in Classe at the tomb of
Ravenna's first bishop. The basilica church has a Proconnesian marble
revetment and a mosaic of the Transfiguration in the apse, the final de-
sign of which differs from its underdrawing and was probably due to an
intervention by Maximian himself. The mosaics of S. Apollinare
Nuovo were altered around 550 with the insertion of a new set of
Orthodox saints on the side walls above in the nave and the crude re-
moval of the figures of Theodoric and his court, some of whose hands
were left visible on the columns of the palace. The 22 virgins and 26
martyrs depicted in procession were mostly chosen from the saints of
the western part of the Roman empire, but with a few eastern saints in-
cluded.

The church was octagonal in
plan, and both plan and
architectural sculpture derive
from the Justinianic buildings
of Constantinople of the 530s
when it seems to have been
founded. It was dedicated by
Maximian in 548.

The most elaborate interlinking of the strands of politics, church, and art in Ravenna, however, emerges in the church of S. Vitale. One of its most enduring images is that of the Byzantine emperor and empress, symbolizing their powers in the recovered city, replacing the departed images of Ostrogothic rulers of S. Apollinare Nuovo.

S. Vitale [32] was a centrally planned octagonal church with many detectable Byzantine echoes. Its plan shows some knowledge of Constantinopolitan architecture from the beginning of Justinian's reign, such as the church of Sts Sergios and Bacchos, and it has marble capitals that can be deciphered as virtual copies of several others in Constantinople. The marble came from the Proconnesian quarries and the capitals were therefore probably blocked out there by Byzantine sculptors and transported by sea. S. Vitale was a *martyrium*, housing the relics of the local martyr Vitalis, and it had such an effect on Agnellus, the ninth-century priest who wrote an ecclesiastical history of Ravenna, which records several now-lost inscriptions and decorations, that he elevated it to be the most impressive church in Italy. According to Agnellus, its sponsor was a local rich worthy called Julius Argentarius, whose name implies he was a banker, who spent 26,000 gold *solidi* on it (Agnellus obviously regarded the sum as a fortune), and it was begun under Bishop Ecclesius (522–32) after an embassy to Constantinople. Ecclesius is certainly commemorated as the founder in the apse mosaics where he is shown giving a model of the church to Christ and the name of Julius Argentarius appears in Latin inscriptions and monograms in the church. Since other monograms have the name of Bishop Victor (538–45), and the church was dedicated by Maximian in 548 (shortly before news of the death of Empress Theodora on 28 June 548 would have reached the city), it is clear that its building and decoration were carried out over a long period, partly under the Ostrogoths and Arians, partly under the Byzantines. The mosaics, limited to the sanctuary and eastern apse, and all the more effective for this focus of attention, belong to the moment in Ravenna soon after the Byzantine reconquest and the imposition of Orthodoxy. The precise dating of the sanctuary mosaics is difficult and complicated by both medieval and modern restorations. Although the decoration can be read as a unified scheme, it has been suggested for technical reasons (a horizontal break in the surface and the use of slightly different materials for the tesserae) that the vault, apse, and imperial panels were designed under Victor in 544–5, and the rest completed by Maximian, who may have substituted Victor's head on the Justinian panel with his own, adding the prominent inscription to ensure that the viewer remembered him.[18]

The mosaics of S. Vitale are the best measure of the stage of complexity reached by Byzantine art under Justinian. There is one overarching theme—the salvation of mankind by Christ and the

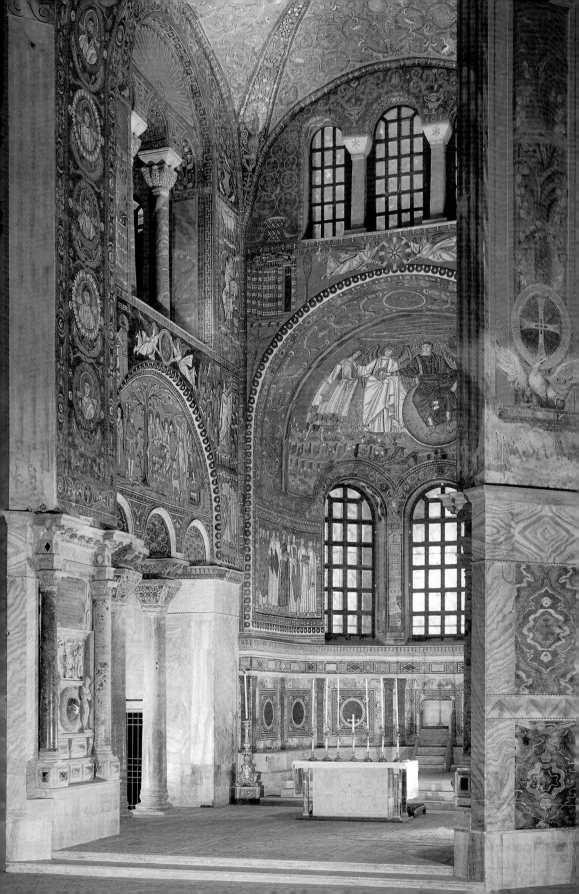

sacramental re-enactment of this event in the eucharistic sacrifice which regularly takes place in the holy space that the mosaics help to create. The various parts fit symbolically into this theme; but they stimulate additional readings as well. A case in point is the medallion at the centre of the vault in which the Lamb of God is held up by four angels. The Lamb, instead of a figure of Christ as in the central medallion in the Rotunda at Thessaloniki, is chosen here to emphasize the liturgy and is a direct reference to Christ as a sacrificial victim. But there are other references. The visual progression across the sanctuary of three images—God the Father at the apex of the arch, the Lamb in the vault, and a young Christ in the apse—will be read as a reference to the Orthodox doctrine of the Trinity. Similarly, the theme of sacrifice is found in the semicircular tympana mosaics (Abraham and the Three Angels and the Offering of Isaac for sacrifice by Abraham on the left, and Abel offering a Lamb and Melchizedek with Bread and Wine on the right). But again the viewer will register the exegetical interest of the choices, with their reference to the typology of the Old Testament and the New. This typology is reiterated in the mosaics by the inclusion of both Old Testament prophets and the four New Testament evangelists, with their particular symbols; the evangelists are higher in the hierarchy of witnesses by their position on the wall, and larger in scale, since the mosaicists here, unlike those working on the mosaics at S. Maria Maggiore, understood how to make the imagery more legible to the viewer on the floor. Typology was an interest as strong as ever in the sixth century, both in church decoration and in manuscripts such as the Rossano Gospels.

The two imperial panels immediately evoke for us the imperial presence of the rulers who, we also know, never actually went to Ravenna [**33, 34**]. But their primary visual references in the context of the decoration were to sacrifice and the liturgy. Theodora is carrying a chalice for the wine and Justinian a paten for the bread. The celebrant bishop carries a cross, and the tonsured priest the Gospel book, both of which will be carried ceremonially into the sanctuary, accompanied by the heavy scent of incense from the hand of the third priest. This moment marks, according to Germanos, the First Coming of Christ. Even the scene-setting is carefully delineated: the plain gold behind Justinian evokes the nave of the church, while the fountain and doorway beside Theodora convey the moment of her entrance into the church. The ceremonial is called the Little Entrance, the beginning of the early Byzantine liturgy when the congregation met in the courtyard, or atrium, at the west end of every church, and processed together into the nave to start the service. We may interpret the garments of the participants in terms of 'power dressing', and the communication of their status as court, clergy, and army. But in the embroidered garment of Theodora we can see that the Three Magi have been portrayed, and

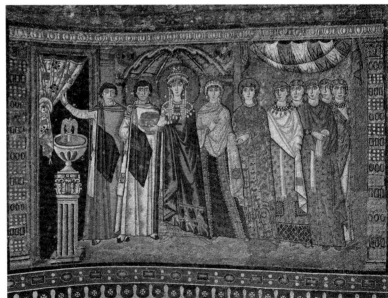

this may have references that are more exegetical than political. The Magi's appearance was taken as a symbol of eucharistic sacrifice, and this is a possible meaning. But they were also interpreted eschatologically as the images of Christians who will greet Christ on his Second Coming as the Magi did on his First. There may be a reference to another level of meaning in the mosaics: Christ in the apse is enthroned on a globe with the four rivers of paradise beneath his feet, offering a martyr's wreath to St Vitalis. In his hand he holds a book, probably the

Book of Life, which he will have at the time of the Second Coming and Last Judgement. This scene in the apse is the Second Coming, in a version quite different from that at the Rotunda; the procession in the sanctuary below evokes the First Coming on earth.

There is another aspect of the imperial panels that must strike the modern viewer. Does the panel claim pictorially a certain equality between the figures of emperor and empress? Does the prominent crown attempt to elide Theodora with the Virgin Mary as Queen of Heaven, as she is shown in S. Maria Maggiore and elsewhere in Italy, though not in Constantinople? Does the symbolic presence of the empress in the sanctuary subvert the conventions? Back in Constantinople, the emperor was the only lay person able to enter into the sanctuary of St Sophia with clergy during the liturgy; this was not a place for women. Procopius alerts us to these questions with his own ambivalent account of the empress, sometimes beauty, sometimes demon.

Ravenna is full of imagery, and we cannot doubt that, under Justinian, Constantinople was too. A court poet Corippus wrote a Latin verse panegyric on Justinian's successor, Justin II (565–78), which starts with an account of Justinian's lying-in-state for which the empress Sophia had commissioned a rich vestment, a textile embroidered like Theodora's, which was decorated with scenes of imperial triumph, including Justinian's trampling underfoot a vanquished barbarian king, while conquered kings and people bow down to him.[19] With our knowledge of the Barberini ivory [**22**] and other triumphal monuments in Constantinople such as the columns of Theodosios and Arcadios, and a mosaic of Justinian's victories over Goths and Vandals on the Chalke Gate of the palace, this text is to be read not as poetic licence, but as a clear record of the art of the sixth-century palace.

Justinian's 'new world order' did not survive. The period from Justinian to the eighth century was one of continual disasters—devastating episodes of plague, invasion from the Persians in the east, and incursions from Slavs from the north. The career of Muhammad (*c*.570–632) brought the rise of militant Islam and the instant loss to Byzantium of their eastern regions and major cities, including Jerusalem (lost in 638) and Alexandria (lost in 642), and then military threats to Constantinople itself, which was blockaded first in 674–8, and under siege in 717–18. The period after Justinian was far from a time of consolidation of his enterprises: it was a 'dark age' of desperate adaptation and re-creation in the face of rival warring societies. A sign of the times was the fate of the city of Justiniana Prima, which had been built in a spirit of optimism in the 530s as a new town to mark Justinian's birthplace in the Balkans. Designated an archbishopric, its planned role was to replace Thessaloniki as the seat of the praetorian prefect of Illyricum and ecclesiastical capital of western Illyricum. Its actual small site with several churches has been excavated at Caričin

Grad (45 kilometres south of Niš).[20] But the grandiose plan was abandoned by 545, and the place was a ruin and in enemy country by the early seventh century. The city is an extreme example of over-ambition, but the situation was that all other Byzantine cities in the empire, in both Asia Minor and Greece, also went through a period of sharp decline in the seventh century.

Can the character of Byzantine art in this period be used as evidence of broader historical change? The problem is that decline is a notoriously complicated notion at any period, and no less so in the century or more after Justinian's death. The Byzantine objects we know are frequently the production of the rich and the powerful, and decline at this level means something different from the decline of a city. The production of silverware over this period is a case in point. Silver was the most precious metal in Byzantium after gold, and much prized, both in aristocratic homes for dining, and in churches for crosses and for liturgical vessels like the patens and chalices needed for every eucharist. Artistically it was a conservative medium, and pagan mythological subjects continued to be repeated on Christian commissions, as we have seen in the Sevso Treasure [9]. Silverware is notable for its continuation of classical styles and motifs into the seventh century. The history of the medium can be traced precisely, thanks to the practice of applying multiple control stamps (up to five) to a proportion of silverware between the fourth and eighth centuries, which often give dating evidence; these stamps might be expected to give a guarantee of metallic purity but, oddly, modern scientific analysis has not found much difference between stamped and unstamped objects. Comparison of datable plates shows how high standards of production and similar styles were maintained over the early Byzantine period. The *Missorium* of Theodosios I of 388 [**35**] shows the enthroned emperor giving a codex to a man kneeling in front of him; he is accompanied by his sons and guards, and in the zone below is a personification of the earth. A set of nine plates with the Life of David, stamped between 613 and 630, and therefore made under Heraclios (610–41), is designed and engraved in very much the same style [**36**]. This set, which was found buried in Cyprus, was probably a domestic service, and it has been suggested that the choice of David scenes might have been a subtle means for a noble family to flatter the successful emperor. If this referred to military success, the set should date from Heraclios's Persian victory of 628 and his assumption in 629 of the title *Basileus*, intended to echo the achievement of Alexander.[21]

The sequence of stamped silver—and presumably the extensive production of silverware—ends abruptly, if not totally, in the reign of Heraclios; this happened to coincide with the State confiscation of precious metals to help the treasury during his Persian war, during which Heraclios successfully recaptured the True Cross looted by the

35

Silver-gilt *Missorium* of Theodosios I. Constantinople [?]. 388.

The inscription records that the *Missorium* was made to celebrate the tenth anniversary of Theodosios's reign. Its weight of 50 Roman pounds is recorded on the back. The emperor, his heirs on each side, hands a codex to an official. Earth is personified below. The symmetry and delicate style suggest the good order of the Christian Byzantine state.

Persians from Jerusalem. His reign caused a lacuna in silverwork, and many owners hid their treasures underground or in caves for (over-optimistic) safe-keeping. But this situation is less to be described as one of decline than of change. The large so-called Stuma Treasure of at least 56 objects found in Syria (at Stuma) in 1908 must represent the holdings of the village church of St Sergios at Kaper Koraon between 540 and 640, which was hidden at the time of the Arab advance; the Sion Treasure from Lycia consists of 71 items (30 are pieces stamped between 550 and 565, and were presented by Bishop Eutychianos to the church of Holy Sion), and these were probably concealed at the time of Arab raids along the coast of Asia Minor.[22] The burying of the Stuma Treasure probably heralded the decline of the Christian community in this Syrian village; but the church of Sion continued in existence.

36

The David plates: David and Goliath plate. Constantinople. Date-stamped 613–29/30.

Largest of the nine display plates with the life of David, found in Cyprus in 1902 (now divided between Nicosia and New York). David and Goliath meet; Goliath is slain; David beheads him. Possibly one set of several to celebrate Heraclios's victory over the Persians in 628. They are as traditionally classical as Theodosios's *Missorium*.

The evidence of art is incomplete without the broader context that monasticism, for example, can illuminate. Monks had the same aim as the rest of Christian society, and this was to fulfil Christ's exhortation, 'You, therefore, must be perfect, as your heavenly Father is perfect' (Matthew, 5: 48). In this aim monks renounced their earthly ties and devoted themselves to God, like the apostles. They made vows of poverty, chastity, and obedience, but they did not regard what they had renounced as sinful; property, marriage, and independence were allowable to other Christians. The outcome was that monasteries were donated endowments and property through legacies and gifts from all levels of donors hoping for the salvation of their souls, while the monks fought on their behalf with prayer. Church and monasteries emerged secure from the crisis of the seventh century with substantial property.

37

Icon of Christ. Constantinople
[?]. Sixth century (with later
Byzantine repaint).
Encaustic. Monastery of St
Catherine's, Sinai, Egypt.

All the emphasis is on evoking
the portraiture and presence
of Christ directly before the
viewer. The naturalistic style
acts in support of this aim.

Whatever treasures might have been lost could be replaced with new materials and forms of art.

The period between Justinian and iconoclasm was a time of material dislocation and cultural and political change.[23] This happens to be matched quite specifically in art with new subjects and changes in emphasis in different media—the painted icon emerges as a popular medium of expression [**37, 38**]. Some of these developments may reflect direct responses to crisis, but this is not an explanation for them all: no period is that simple. In Byzantium the agenda of the church in this period remained focused on the proper definition of the nature of Christ, and every emperor had a view on christology. Justinian was fully involved with the definitions of the Fifth Oecumenical Council of Constantinople in 553, which was precipitated by an imperial decree in 543–4 against *The Three Chapters*, books that supported the idea of the two separate natures in Christ, instead of the belief that in the Incarnate Christ was a single person, at once God and man. The next stage, which was partly to resolve imperial interventions from Heraclios and Constans II, was the Sixth Council at Constantinople in 680–81. This was against monothelitism, which proposed that there was one will in Christ, and countered the Orthodox formulation of two wills in Christ, human and divine. These two councils were followed up by the Trullan Synod of 692—otherwise known as the Quinisext or Fifth–Sixth Council to show it was a culmination of both councils—which took place in the domed room (*Trullos*) of the palace of Justinian II at Constantinople. This synod is celebrated for the number of disciplinary canons it passed, including prescriptions concerning art and the representation of Christ; according to canon 82, Christ was in future to be represented in his human form and not as a lamb. The concern with christology among both church and emperors, whatever the state of political crisis, must be the clue to the key innovations in artistic representations of the theme of Christ's death—the death of Christ on the cross, his entombment, and his resurrection from hell. Until the seventh century, Christ was shown living on the cross, with his eyes open, as in a manuscript dated to 586 from Syria [**39**]; the innovation was to show him dead, and so not to fudge the theological issues. The *Anastasis* was a new subject, showing Christ releasing Adam and Eve and the other righteous from hell and taking them to heaven on the third day [**40**]. It represents the events of Easter Sunday, and in the Byzantine church it became the conventional way to represent the resurrection of Christ, unlike in the west where the more literal ascent to heaven was favoured. This means that it was a picture to be displayed and venerated in the church on Easter Sunday during the services. It was one of a set of festival or liturgical icons, and the idea of a 'set' of major festivals was to be developed after iconoclasm.[24]

The period from the reign of Justinian to iconoclasm saw the trans-

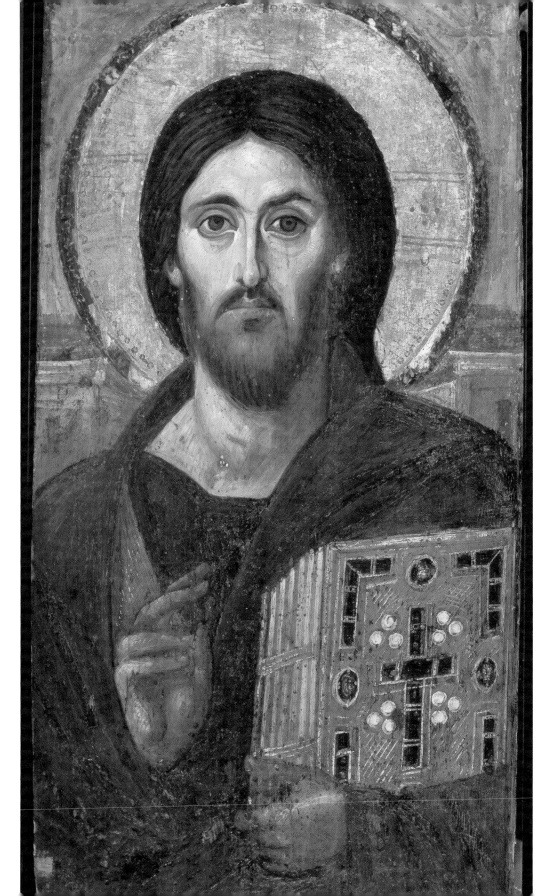

38

Icon of Christ the Saviour and Apa Mena (Abbot Menas). Bawit, Egypt. Sixth or seventh century. Tempera.

The cult of St Menas spread widely in the Byzantine world, but originated in Egypt (from his shrine at Abu Mina). This icon shows Christ with his protective arm around a holy monk in Egypt, who presumably adopted the name of the saint when he entered a monastery and is now promised paradise.

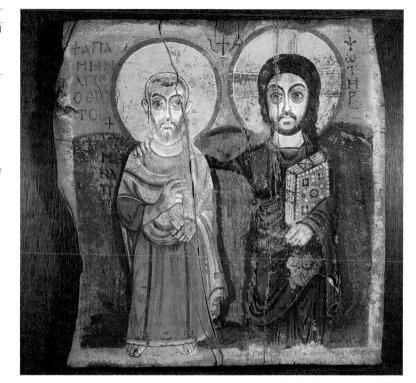

39

Manuscript illustration of the Crucifixion. Rabbula Gospels. Produced at the monastery of Beth Mar John of Beth Zagba, north of Apamea, Syria. Dated 586.

The manuscript was written for use in a Syriac-speaking community, but the artist may have had access to Byzantine manuscripts with New Testament illustrations.

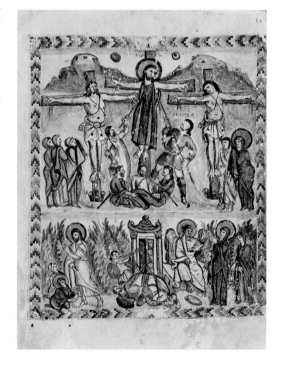

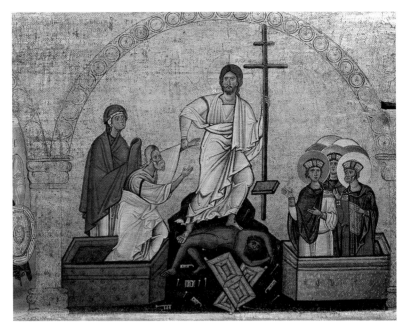

Templon beam with the **Anastasis** and other festival scenes. Sinai [?]. Tempera. Twelfth or thirteenth century. Monastery of St Catherine, Sinai, Egypt.

The iconography of the *Anastasis* (Resurrection of Christ) is first found around the eighth century, and after iconoclasm became one of the standard scenes of the festival cycle. This beam from St Catherine's indicates that it was one of the scenes chosen for the decoration of the sanctuary screen in the Middle Byzantine period.

formation of the eastern Roman empire into a smaller remodelled society, a transformation that art both reflected and supported. The population of the empire was diminished both through loss of territories and through the virulence of the sixth-century bubonic plague, of which Justinian himself was a survivor. But such events do not necessarily diminish artistic patronage; as in the time of the Black Death in the fourteenth century, legacies may increase church and monastic resources. In Byzantium, increasing numbers of icons might suggest a different kind of spirituality and need, opening up increased channels to mediate with God; or the medium might have developed for a number of other reasons, such as their value and equivalence to writing in expressing and demonstrating the superiority of Christian truth over pagan beliefs, and so making accessible to the whole Christian community the knowledge necessary for a good life. Icons may have acted as the stimulus to a personal emotional worship, or iconoclasm may have been a reaction to their excessive prevalence. The simple explanation for their expansion in the period after Justinian as a straight response to crisis is unsustainable.[25] Most of the icons known from this period are at St Catherine's Monastery on Mount Sinai, some brought from afar, some perhaps painted there, as by the twelfth and thirteenth centuries, icons were certainly made on site.[26] They indicate the range of subject and types from this period: the technique used in these early icons for binding the pigments was either encaustic (wax) or tempera (a mixture of egg yolk and water), the same media used in Egypt in the Roman period for mummy portrait paintings, but icons in comparison with these naturalistic images differ in the attempt to convey the 'other-worldly' aspect of holy

Icon of the Crucifixion. Sinai
[?]. Eighth century. Tempera.
Monastery of St Catherine,
Sinai, Egypt.

The Virgin (labelled St Mary)
and St John the Evangelist
stand in front of the two
thieves, and the Roman
soldiers cast dice at the foot of
the cross. Christ wears the
long *colobion* (not a loincloth).
The most striking features of
this icon (compared with the
Rabbula Gospels, for example)
are the closed eyes of Christ
and his wearing of the crown of
thorns. His death and suffering
are clearly indicated by these.

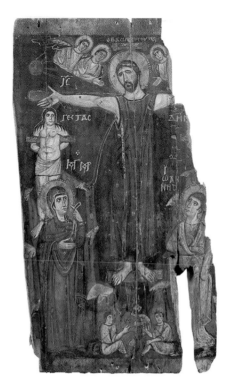

images. The icons at Sinai consist of small portable images, larger devotional panels, diptychs, and triptychs. The subjects are Christ, the Virgin Mary, St Peter, St John the Baptist, other saints, and a number of festival scenes, including an eighth-century panel of a Crucifixion with Christ shown dead [**41**]. The dating depends on a comparison of a wall painting of the Crucifixion in the church of S. Maria Antiqua in Rome dated to the period of Pope Zacharias I (741–52) [**42**]. This church in the Roman Forum housed a Greek monastic community from the sixth century, and attracted patronage from several popes, a number of whom in this period came from the east.[27] All these paintings and icons are important for their evidence of parallel interests in christology and devotional art in east and west, and in their stylistic treatments. In this period, the artistic connections between east and west are greater than their differences.

Thessaloniki remained in acute crisis from the late sixth to the late eighth century but, like Constantinople, it survived. After its magnificent period of expansion in the fifth and early sixth centuries, the city at the end of the sixth century suddenly became the target of Slav attacks and sieges for the next two centuries.[28] Building activities were largely confined to defensive measures, and the lines of communication to Constantinople were frequently precarious. The eparch (praetorian prefect) was appointed from Constantinople as a governor, but tenures were short, and the community showed more faith in the leadership of their

42

Wall painting of the
Crucifixion. 741–52.
Theodotus chapel of the
church of S. Maria Antiqua,
Rome.

The wall painting in Rome has
stylistic connections with the
Sinai icon, but shows the
conventional imagery, with
Christ's eyes open, as in the
Rabbula Gospels.

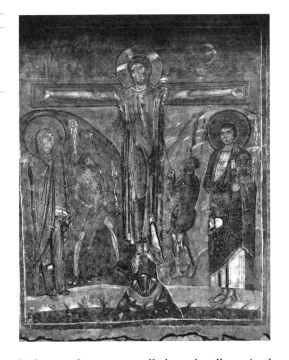

bishops, who were usually born locally, or in the supernatural defender of the city, St Demetrios, whose cult, perhaps not surprisingly, was encouraged and further promoted by the bishops. While Constantinople in this period claimed the protection of Christ, whose icon was carried around the walls in 626, and credited with saving the city, as well as the Virgin Mary—in a later text, it was the icon of Mary that saved the city in 626—, the citizens of Thessaloniki knew of dozens of stories of the powers of St Demetrios, regaled in a series of sermons written in the early seventh century and recorded in the *Miracles of St Demetrios*, and further supplemented in the late seventh century. When the church of St Demetrios was seriously burnt around 620, funds were found to rebuild it without delay and to redecorate it with additional mosaics, including a set of panels on piers at the opening to the sanctuary. One panel shows St Demetrios with his arms around the bishop and eparch, the latter named Leo elsewhere in the church, who claimed responsibility for the restoration in a conspicuous inscription written at its base, addressed to the viewer [**43**]. It does not refer to the fire (this was mentioned in another mosaic in the north inner aisle which portrays the bishop and his deacon), but to one of the several unsuccessful attempts by the Slavs to storm Thessaloniki by sea: 'You are looking at the builders of this famous house from where the martyr Demetrios is the one who turns back the barbarian wave of barbarian ships and redeems the city.'

To our eyes, the bishop (with his square halo, which merges into the crenellations of the city walls) is reminiscent of the mosaic of the abbot of Sinai and the eparch is reminiscent of one of Justinian's companions

Mosaic panel of St Demetrios with the bishop and prefect. Church of St Demetrios, Thessaloniki (on pier to right of the sanctuary). *c.*620.

St Demetrios protects both church leader and governor of the city with his embrace. The city wall behind acts as equivalent to a square halo, indicating, as in the case of the abbot and deacon at Sinai, that these were living personages at the time of the mosaic's production. They are far less idealized and more naturalistic than the saints in the Rotunda mosaics, but as images of state and church power they are instantly recognizable.

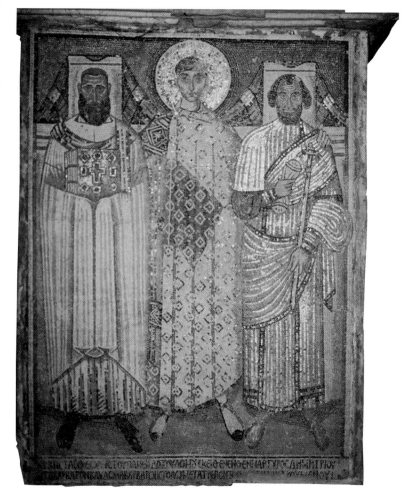

at S. Vitale. But the comparison only serves to emphasize the differences. The Ravenna mosaics communicate the triumphant church and emperor; the Sinai mosaics are the ultimate vision of divine light for the pilgrim or monk. The panel of St Demetrios lacks the element of 'timelessness' and works in a very different way. The precise historical moment when the mosaic was set up in war-torn Thessaloniki is deliberately emphasized. Though the mosaic represents a mixture of living humans offering thanks to a saint and the young saint himself who is promised paradise for his faith, it is not a mosaic about fundamental Christian truths or doctrines. It is much more specific. The original Byzantine viewers would be inside the renovated church, in front of the sanctuary, seeing a visible sign of Demetrios's protection of the city. They would have come to thank the saint and to pray for continued favour. The image is a promise that St Demetrios lives in his house in the city, a literal pledge, for in the nave behind the viewer was a high

Mosaic panel of the
enthroned Virgin and Child
with St Demetrios, saints,
and donors. Church of St
Demetrios, Thessaloniki.
North inner aisle. Sixth
century. Watercolour copy by
W.S. George.

The mosaic was discovered
during restoration work in 1907
when the church was still a
mosque. It was destroyed by
fire in 1917. Scale copies were
made very soon after its
discovery. The Virgin is on a
lyre-shaped throne and is
attended by archangels. St
Demetrios intercedes for the
donor on the left, and St
Theodore is on the right. Other
saints are in medallions, and a
second donor, a woman, is on
the right. The scheme is
similar to apse compositions
and icons of the period.

silver octagonal ciborion in which the saint was said to reside. This had
been burned down in an earlier fire in the 580s but had been fully re-
stored as a result of a new donation of silver from a local citizen.
Qualifying as a new type of icon, the mosaic both records the fears and
thanksgivings of the authorities and offers a permanent image for ven-
eration and prayer. Bishop and eparch act as mediators for the city to
the saint, and so enter into sacred space themselves. A sixth-century
mosaic in the church (lost in the fire of 1917) is more conventional [44].
It shows how the same schemes were used in small devotional icons,
such as the Virgin and Saints icon at Sinai [45], and in large public mo-
saics. The intercessory saints in Thessaloniki are Sts Theodore and
Demetrios, who support the donor in his prayer to Mary enthroned. A
visual formula for the prayer and veneration was now so developed that
it could be adapted to a variety of situations.

It is clear that all levels of Byzantine society around the empire were
accustomed to using icons. The cult of St Demetrios clarifies one fur-
ther point. It might be suspected that in this period the power of icons
was deemed no less strong than that of relics. The special fact about
Demetrios revealed by the writer of his *Miracles* was that while his
church contained a ciborion and icons, it had no relics. None the less
he could be seen fighting, easily recognizable, among the defending
soldiers and citizens on the walls. In Thessaloniki and elsewhere, art
was an indispensable part of life.

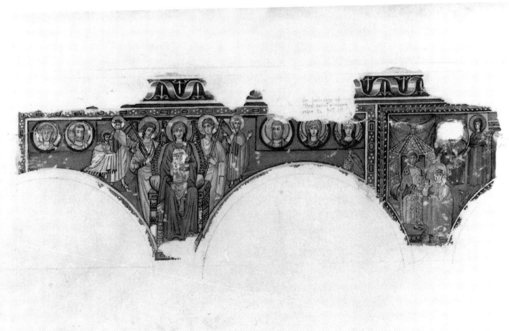

1 inch scale

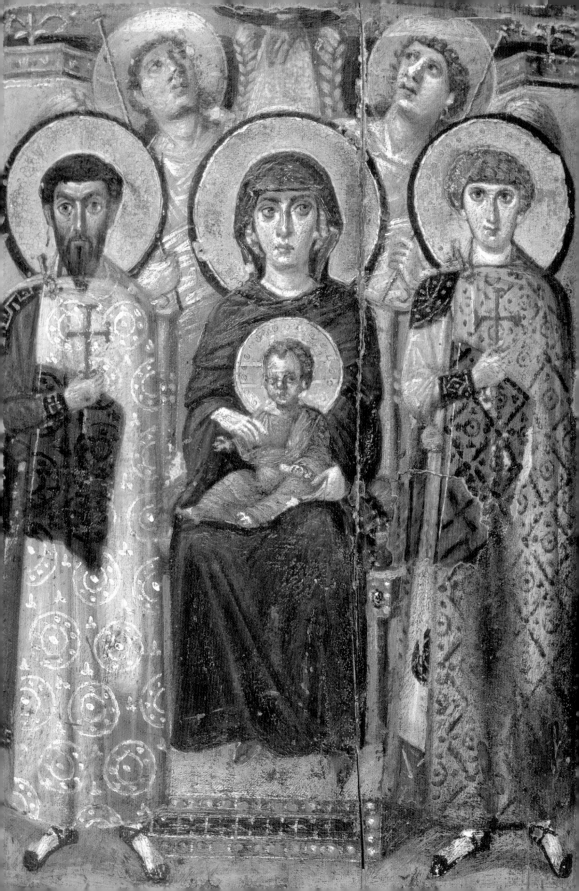

The Definition of an Orthodox Christian Empire

Byzantine Art 680–843

3

Justinianic art is deeply embedded in the personal ambitions of a great leader who changed Byzantine history. The study of its production and meanings cannot therefore limit itself to the evolution of style alone. If medieval art is ancient art transformed, the processes of transformation need to be surveyed across the whole spectrum. Pictorial images need linking with their social functions. We have to do more than describe a so-called abstract style in the mosaics of St Demetrios and a 'naturalistic' style in the contemporary David plates [43, 36].[1] It is too simple to say that one responded to a craving for devotional props and that the other met a demand for narrative clarity. The reality of production in the period of Justinian and its immediate aftermath does not fit into this strait-jacket, and it is too brutal a dichotomy. The seventh-century David plates cannot be treated as narrative alone if their subtext is to evoke the Byzantine emperor through Old Testament parallels; and they cannot be regarded as straightforwardly 'biblical' if they were intended to grace a dining-room in a domestic situation. The Sinai icon of the Virgin and Child with Saints equally has no neat stylistic definition [45]. There may be 'abstract' saints in the foreground, but they occupy a space that is naturalistically modelled through the device of an architectural niche. The angels appear 'real' enough in their roles as attendants to the enthroned Virgin and Child, and Mary at the centre of the panel is a solid, pivotal figure. The diversity of representation in this icon has been described as 'modes' that can communicate to the viewer the hierarchies of the sacred figures. The two saints as intercessors are the objects of human prayer and, hierarchically, are placed closest to the viewer. Their 'abstract mode' would be a pictorial device to declare them as available conduits for prayers to the Virgin, and through her to God, whose hand is shown at the top of the icon, but the term may not help greatly in this context; the viewer may be led by stylistic means to pray to these figures, but the odd feature then is why they are not actually identified. Identification seems an essential component of a special prayer. It is true that the male saint

in the mosaics at Thessaloniki [43] is, equally, not identified by an inscription, but the difference here is that St Demetrios was the patron saint of the church that contained the mosaic, and he is mentioned in the inscription below; and he appears repeatedly as a young man in senatorial dress in images all around the church. The texts of his *Miracles* tell us that he could be easily identified in dreams and visions because he looked just like his icons. His identity is therefore beyond question. Unless the Sinai icon was meant for a church or chapel dedicated to the two saints, or unless it had an original frame with an inscription, Byzantine viewers over the centuries, like the modern viewer, had a problem. Perhaps they, too, would identify the left saint with a dark pointed beard as St Theodore (because he is usually shown with this shape of beard); but for the saint on the right, there are no clear clues. We have the advantage of statistics to know that the young saints most frequently represented with Theodore are Sts George and Demetrios, but even with this information, we cannot know exactly to which saint or saints the prayer was to be directed. From the ninth century onwards, the Byzantines found the solution to this precise problem by writing the name beside each saint and so establishing identities without ambiguity. This shows that the problem we feel in the Sinai icon was a problem in the culture, too.[2]

The identification of saints in icons was a combination of visual and written clues. Potentially, writing poses the question of Byzantine literacy, for in any society before the invention of printing, the opportunities for reading were very limited, except for those with access to manuscripts. For art historians, the implications of a society with limited literacy are important at several levels, but perhaps the names on icons are at the least significant level. Even the 'illiterate' could learn to recognize common saints' names and the main narrative subjects. The visual solutions also required the memorizing of conventions. Already in the early icons of Sinai, certain saints, for example Sts Peter and John the Baptist, had already acquired distinctive and recognizable features and attributes: Peter has white hair and holds keys; the Baptist, long unkempt hair and a tunic of animal skins. Other saints appeared, not always consistently, as types: old, young, bearded, tonsured, and dressed to signal their occupations—a bishop's *omophorion*, a monk's mantle, or a hermit's loincloth. Such attributes must have been quickly learnt by the Byzantine viewer. Correct recognition of the saint must have been the first necessity in using an icon, and then the factor of style would begin to be of importance: this controlled and intensified the spiritual dimension of the experience. Did the artist match the choice of style to this function, or was it a factor of artistic training and tradition? So the question remains whether we can judge if the style of the saints on the Sinai icon fulfilled the devotional needs of the viewer, and how far the viewer as consciously noticed the style as

the identity of the saint. This is where the few texts we have need to be considered for possible elucidation. A short poem by the sixth-century writer Agathias in which he describes an icon of St Michael is one such aid:

The wax remarkably has represented the invisible, the form of the bodiless chief of the angels. This achievement means that the earthly viewer of icon can direct the mind to a higher contemplation. The viewer can directly venerate the archangel. With this perception of the features of the archangel in the mind, the viewer trembles as if in his actual presence. The eyes encourage deep thoughts; through art and its colours the innermost prayer of the viewer is passed to the imaged.[3]

This might be read with the ivory archangel (in the British Museum) in mind [23], or the saints' faces in the early icons. Agathias conveys both his viewing of an icon and its function as a spiritual support. He distinguishes between the model of the icon and the face before the viewer. Agathias gives one obvious clue to the reading of the Sinai icon, by making special mention of the gaze. The two saints' eyes meet those of the viewer, a priority that might also have a bearing on the manner of their depiction. The Virgin's gaze, in comparison, is more disturbing. Why does she look to the right? Is it implied that she is turned to another viewer, implicitly more worthy than the present one? May it even be a reference to avoiding the 'evil eye', the malevolent glance of an envious neighbour? If the gaze is a major element in the composition of the icon, it is equally a reminder of the attention given to protection from the evil eye, countered in everyday life in Byzantium by the 'much-suffering eye', which was depicted on the floors of private houses, in wall paintings and on amulets worn on the body.[4]

The quantity of art produced may well have diminished after Justinian's death. This did not, however, reduce its increasing importance in everyday life, both as didactic medium and an aid to worship and prayer. Christ's presence in the church was felt at the moment of transubstantiation in the eucharist. The presence of saints was proclaimed through their relics displayed in the church. Increasingly, the icon challenged both these functions, if the prototype was believed to be perpetually present in the icon. The concept was not new, but the background was pagan. Ancient writers had written of the gods dwelling inside their images, and giving inanimate statues the power of miracle-making and healing.[5] Increasingly from the sixth century, Byzantium had 'icons not made by human hands' (*acheiropoietos*), representations of Christ thought to be miraculously produced by divine means and containing the powers of healing and protection of Christ himself. These included the *Mandylion* of Edessa, represented in a tenth-century icon at Sinai [46], and the mosaic of Christ in the

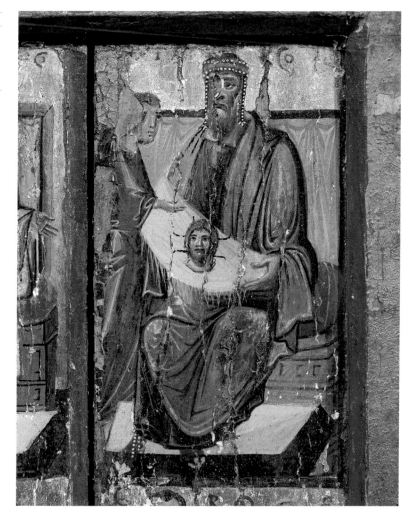

Icon of Abgar of Edessa showing the *Mandylion* of Christ. Constantinople [?]. Monastery of St Catherine, Sinai, Egypt. Tenth century.

This was a three-part icon (triptych), of which only the two leaves survive. The lost central panel must have shown the face of Christ, imprinted on a cloth. This detail shows King Abgar, the king of Syria in the time of Christ, receiving the cloth from a messenger who carried it from Christ as a gift.

church of Hosios David at Thessaloniki [**53**].[6] One of these miralulous images, the *Kamouliana* icon of Christ, appeared in Cappadocia in Asia Minor in the 550s. Accounts of its discovery differ in detail, but the fullest sixth-century text gives the circumstances in a way that reveals real attitudes of the period.[7] According to this version, the image was found by a pagan woman who had asked, 'How can I worship Christ if he is not visible, if I do not know him?' One day, she found an image imprinted on a piece of linen in a garden well, and recognized it as Christ. Its powers are demonstrated: it had come out of the water miraculously dry, and it left an imprint where it touched her dress. The imprint was an *acheiropoietos* too, and was soon found to contain the miraculous powers of the original. The copy was carried in procession in the years from 554 to 560 through cities in Asia Minor, and was used to help to raise funds for a church and village destroyed in a raid. People were ready to pay to see the image. Sixth-century writers com-

47

Gold *solidus* of Justinian II with the face of Christ on the obverse (inscribed: *Jesus Christos Rex Regnantium*) and portrait of the emperor on the reverse. Mint of Constantinople. First reign of Justinian II, 685–95.

This was the first Byzantine coin to show a portrait of Christ and it dates soon after the Quinisext Council of 692 which might be interpreted as encouraging the portrayal of Christ in human form rather than as a symbol. The model may have been one of the miraculous icons of Christ in Constantinople, and the type is similar to that of the Sinai icon.

ment on the significance of a procession with an image of Christ. It is compared to the practice of carrying effigies of the emperor in the provinces, and also seen as symbolic of the Second Coming. The *Kamouliana* icon was transferred to Constantinople in 574 and housed in a special shrine. In 586 it was taken into battle to inspire the Byzantine troops. The icon of Christ at Sinai, and the coins of Justinian II, may reproduce this famous image [**37, 47**], although it was only one of several such icons of Christ. Throughout the seventh century, this and other icons were carried to war; icons of the Virgin were also carried around the walls of Constantinople, just as at Thessaloniki St Demetrios is seen against the walls of the city in the mosaic panel [**43**]. Other icons of saints feature in stories of miracles and healings. Lives of holy men, stories of relics, and accounts of miracles with icons are staple reading for Byzantines in this period.

It is one thing to emphasize the prominence of art in everyday life, but another to link the character of art to historical events and situations. The *Kamouliana* icon and its reception is a case in point, and prompts several questions. How far is it a story about the need to convert pagans in Asia Minor in the sixth century—was Christianity still only skin-deep?[8] Was art able to effect conversions? Was the sudden appearance of the *Kamouliana* icon a symptom of communal fear and a desire for divine help, or was it a sign of the cynicism of the established church in playing on the 'credulity' of the countryside to raise its funds, a sign of imperial and metropolitan attitudes that the icon was transferred to Constantinople, and then invoked at times of crisis? Or was it a symptom of the desire of Byzantines to know for certain what Christ looked like? Was it all of these and possibly more?

Islam

Apart from the perpetual wars and other trials of the period, two situations must have impacted on the arts, the rise of Islam and the responses of the church to changing social and political conditions, which were in part, but not entirely, caused by the appearance of a rival Arab empire.

The rise and expansion of Islam meant far more to Byzantium than the loss of territories. It was at first mistakenly seen as the arrival of another tedious heresy (about the nature of Christ) in the Arab regions of the Mediterranean rather than as the threat of another popular religion acting to unite a new state. Relations between the two rival societies were an initial mixture of military confrontation and culture co-operation.[9] Byzantine mosaicists worked on the non-figurative decoration in the Dome of the Rock in Jerusalem (688–92), where the vine-scroll ornamentation has its closest parallels with the late sixth-century mosaics of the Patriarchal Palace attached to St Sophia [**52**], and in the mosaics of the Great Mosque at Damascus (finished about 706) where

the architectural vistas recall the façades of the Rotunda mosaics in Thessaloniki. In coinage, the new Islamic rulers in their capital at Damascus (from 635) first struck coins which imitated Byzantine models, but carefully adapted the obvious Christian elements, like the cross, and substituted Islamic signs, such as the ceremonial lance of Mohammed. They changed the Byzantine inscriptions and put instead Islamic statements: 'In the name of God. There is no God but God. Mohammed is the Prophet of God.' This numismatic interaction between the cultures was brought to an impasse with an unmatchable challenge on the Byzantine side. The decisive step came around 692 when, under the emperor Justinian II (685–95 and 705–11), the Byzantine gold *nomisma* was completely redesigned [**47**]. The coins now displayed the face of Christ on the obverse, and the emperor, holding the cross, was relegated to the secondary position on the reverse. The Umayyad caliph 'Abd al-Malik (685–705) had to respond, and the final outcome was the exclusion of all imagery from the Islamic dinar from 696/7. Arab coinage became purely epigraphic in design and contained only professions of faith and koranic verses on the mission of the Prophet. The autonomous world of Islam became thereby instantly visible; its coinage and its mosques and minarets declared that Islam could successfully adopt and subvert Byzantine visual arts to demonstrate its difference and 'otherness'. The assumption made by both rival societies is that the power lay within art to establish their cultural identity.

The change in Byzantine coinage was equally revolutionary.[10] The face of Christ had never before been represented on coins, and this meant that his image suddenly entered the secular environment of money. The innovator, Justinian II, had come to the throne in 685 at the age of 16, and a favourable treaty with the Arabs allowed him to turn his attention to the recapture of the Balkans. In 688 he led an army to Thessaloniki and from there deported thousands of Slavs to Asia Minor. He was able to complete the administrative transformation of the empire from the smaller Justinianic provinces of the sixth century into larger units, designated themes, which were managed by a *strategos*, or general, with military and civil powers. After a rebellion in Constantinople in 695, Justinian was banished to the Crimea and his nose cut off, a mutilation that was intended to disqualify him from state office forever. But Justinian, now nicknamed *Rhinotmetos*, or 'slit-nose', confounded the system and, with the help of a Bulgarian army, returned to take over Constantinople in 705 and regained the throne. The coinage of each of these two reigns had the figure of Christ stamped on them, but in two different types. In the first reign Christ is shown broad-faced with long hair falling behind his shoulders [**47**]. His right hand is held up in a gesture of blessing and the other holds a Gospel book. A cross appears behind his head, but no nimbus. In the

48

Gold *solidus* of Justinian II
with the face of Christ on the
obverse and portrait of the
emperor on the reverse. Mint
of Constantinople. Second
reign of Justinian II, 705–11.

The coins of the second reign
after his return from exile
have, for some reason, a
different portrait image of
Christ, with a thin beard and
curled hair, closer to the image
in the Rabbula Gospels.

second reign, his form is different: his head is longer, face thin and tri-angular, hair and beard scant and very curly [**48**].

Every little detail of the coins must have led to discussion throughout the Byzantine empire as well as outside it. The lack of a nimbus would have been noted, as also the different appearances of Christ. The second type strikes us as the more unconventional, since we know that the fully bearded Christ was eventually the norm in Byzantine art. This has led to the suggestion that the type derives from a special and topical *acheiropoietos* image. Theoretically, this would rule out the same sort of source for the first type, but it is hard to believe that the bearded Christ who appears in the Sinai icon and these coins is not the kind of portrait found on the Edessa *Mandylion* and *Kamouliana* image. Post-iconoclastic images of the *Mandylion* have the full-bearded face. It is preferable therefore to reckon that what lies behind the choice of two different images is the intention to make different intellectual points, and we might expect some kind of christological distinction to be involved. However, the references in the first round of production seem in part political, since in the legends around the coins Christ is named *Rex regnantium* ('King of Kings'), and the emperor *Servus Christi* ('Slave of Christ'), the latter a term that uses the (Latin) rhetoric of humility to demonstrate the mutual relationship of the heavenly and earthly sovereigns, and to profile the ordering of the Christian world in which the emperor is paradoxically at the top of the earthly hierarchy but at the same time obedient to the kingdom of heaven. Yet the references are not 'political' in any simple sense, since for an emperor to describe himself in such lowly terms can be taken (or was meant to be taken) as a sign of his Christian piety and humility.

The new imagery and legends of the coins worked on many levels. One was to display a distinctive Byzantine Orthodox identity in the face of Islam and other rivals. Another was to reinforce one of the clear messages of the reign of Justinian II—that Byzantium stood for good order (the Greek word is *taxis*) in every aspect of life. This is the second of the features of this period and it complements the first, the rise of Islam. Together they generated not simply Byzantium's concern to define itself, but also its need to feel pre-eminent over all its rivals. The resulting interest in the codification of Christian life and practices may seem authoritarian to us, although we may recognize in it a familiar process of identification and articulation of good practice.

The Meeting of Church and State

The Quinisext Council which took place in the imperial palace in 692 is the direct witness to the mood of the period.[11] The assembled bishops produced 102 canons, many concerned with discipline and control. A few are concerned directly with art. Canon 73 prohibited in future the representation of the cross on floors, and commanded that images

already there should be removed lest the trophy of the victory won by Christ be desecrated under foot. This prohibition was not actually a new one and previous councils had equally discouraged such positions for images of the life-giving cross, but had palpably been ineffectual. This time round, the canon was more thorough, and justified its recommended iconoclasm: crosses should be placed to receive the veneration (*proskynesis*) which was to be given in mind, in word, and in feeling, by the faithful. Canon 82 is the best-known art-historical statement of the council: it referred to the existence of icons in which John the Baptist pointed to an image of the Lamb, and decreed that in future 'that which is perfect' should be represented not as a symbol but in Christ's form. In this case, we have examples of the 'before and after' situation. The ivory cathedra of Maximian in Ravenna has the Baptist pointing to a lamb [**31**]; an icon from Sinai (now in Kiev) has the Baptist with the traditional medallion with the Lamb replaced with Christ's portrait.[12] This encouragement and legitimation of icons of Christ dates significantly to exactly the time of the minting of the new coinage of Justinian II. The various dynamics in these decisions are intriguing, but undocumented. Canon 100 is a key statement about the censorship of art, its logic being that all that is visible influences the beholder. Impurity was therefore to be avoided, and images were not to be made that attracted the eye, corrupted the mind, and incited base pleasures. The penalty for producing the wrong sort of art was excommunication.

These three canons give us some insight into Byzantine thinking about the nature of religious art at the end of the seventh century. They also convey a positive attitude towards the value of icons, moderated by a topical belief in the need for control of their forms and content. Among the dozens of other disciplinary rules and recommended social codes, several can be seen as likely to have had implicit consequences for the production of icons and the environment in which they would be viewed. Canon 68 forbade the destruction or mutilation of holy manuscripts, unless they were in such a bad state from dampness, bookworm attacks, or some such problem, as to be useless. Canon 70 forbade women to speak in church at the time of the holy liturgy; if they wanted to ask questions about the church, they had to ask their husbands at home. This prohibition (if imposed) would not only affect the character of worship in the church, but gave an official and misogynist expression of the inferiority of women, reflected throughout the Byzantine period in their less frequent achievement of sainthood and in the greater rarity of female icons, with the exception of the Virgin Mary. Canon 69 repeats the established rule in the Byzantine church that no layman may enter the sanctuary. But it specifically makes an exception for the emperor and allows him to go up to the altar. Both these canons add to our appreciation of the exceptional nature of the imper-

ial panels in S. Vitale [**33, 34**]. Others establish all manner of social codes: for church attendance every day over Easter (66); for monastic life; and for the celebration of the eucharist and baptism in chapels in private houses (31).

The scenario documented by this council and other developments of the late seventh century is not unfamiliar in world history—the attempt at the reassurance and enhancement of a society by the state projection of order and certainty. The Orthodox church was inextricably bound up with any imperial ambitions in this direction, and there were countless ways in which art might both reflect and promote them. The coins show the good order of a Christian empire, while the imagery of Christ on them conforms to the demand for clear and explicit representation. Successive popes in Rome understood these Byzantine claims to represent a well-ordered state and church, but took delaying actions before accepting or following the new conventions. The initial reaction there had been hostile, and Pope Sergius (687–701), who had been born in Syria, had refused to sign the acts of the Quinisext Council because a number of canons were seen as denials of the practices of the Roman church. Sergius held out, despite Justinian's threats and an abortive attempt to arrest him and take him to Constantinople. When Justinian came back to power in 705, he resubmitted the decrees to Rome for the attention and signature of the new pope, John VII (705–7). An outline of John's papacy is given in the medieval *Liber Pontificalis* from which we learn that he was born in Greece, meaning Constantinople, since his father had been an imperial official (*curator sacri palatii*).[13] The author of this text implies John found a solution to the political problem of the demand for an official discussion and ratification of the council's canons: the solution was to return them to the emperor with no suggested emendations at all. The *Liber Pontificalis* regards Justinian's action as intimidating and John's reaction as cowardly, and implies that John's premature death was a consequence. It has been assumed, perhaps too easily, that he did not sign the acts. His artistic patronage in Rome, however, suggests a more subtle scenario: John, a man of great learning, according to this biography, showed every indication that he comprehended and put into practice the initiatives from Constantinople. He built as his mausoleum an oratory in Old St Peter's which he dedicated to Mary.[14] This was decorated with mosaics made by Byzantine artists, which were in part taken down when St Peter's was rebuilt in the Renaissance, but what remains suggests the technical intervention of artists from the east. The scheme included major scenes of the Infancy of Christ, Miracles, and the Passion; the effect of such a pictorial cycle of Christian history must have been to evoke the order of the church calendar and the annual celebration of the events [**49**]. At the centre of the oratory was an image of the Virgin as Queen of Heaven and the pope with a square halo vener-

**Mosaic oratory chapel of
Pope John VII. Old St Peter's,
Rome. 705–7.**

The chapel of John VII was
taken down in the
Renaissance rebuilding of St
Peter's, but some fragments of
its wall mosaic were kept, and
this is a record in the
manuscript in the Vatican
library.

ating her. A text written in mosaic reads: 'John, unworthy bishop, slave of the Blessed Mother of God' (*'Beati Dei genetricis servus Ioannes indignus episcopus'*). The whole decoration works within the principles in operation at Constantinople, and in the term 'servant of Mary' the pope can only be directly echoing the coin legends. Yet modern interpretations have seen intended ambiguity here. The simple response is to see the pope expressing his piety in the same terms as the Byzantine emperor. The humble priest approaches God through the intercession of Mary. But a more subversive message has also been read: that the pope in Rome is independent of the earthly emperor and has direct access through Mary to the kingdom of God. A solution may be arrived at by bringing in the wall paintings of the church of S. Maria Antiqua in Rome which was given a major redecoration by John VII.[15] The artists employed appear again to be from the east. The north and south walls of the presbytery are decorated with Gospel scenes. The most striking image (now severely faded), a unique subject on the main east wall over the apse, was an Adoration of the crucified Christ, an adaptation of the iconography of the Worship of the Lamb. It clearly matched the prescription of canon 82 of the Quinisext Council for the representation of Christ in human form. Christ's face is of the second type, with the short hair and beard of the coins of the second reign of Justinian II. At first sight, this all looks like subservience to Byzantium, as the author of the *Liber Pontificalis* implies, but it has been suggested that through his choice of imagery, John was more subtle. Below the Adoration scene on the left side are the portraits of four popes, including John VII himself. One of them could have had a special significance. This is Pope Martin I (649–53), who would instantly have recalled to the Roman viewer the fate of a celebrated opponent of the

Byzantine emperor Constans II. Martin, on his appointment, summoned the Lateran Council of 649 which rejected the christological views of the Byzantine emperor. For this rebellion, he was arrested, brought to Constantinople, and condemned to death. He died in exile at Cherson, and the Byzantine church proclaimed him as a martyr. The choice of this imagery has been taken as a hint of double standards on the part of John VII in both accepting Byzantine ideas and representing their critic. John's ambivalence should not obscure the significance of the choice of the Crucifixion in this position over the altar. The imagery is precisely in line with the words of canon 82 which call for the representation of Christ in images, 'so that all may understand by means of it the depths of humiliation of the Word of the Lord', and 'the redemption which has come out of it'. The Crucifixion over the altar represents the historical event with new clarity; on the altar below, the eucharist re-enacts the event symbolically and re-creates the true body and blood of Christ.[16] The image of the Crucifixion is integrated with the sacrament, as the contemporary text of Germanos on the symbolism of the church implicitly explains. The iconography appears explicitly in the wall painting of the tympanum wall above the apse in a small rock-cut chapel in Cappadocia known as the chapel of Niketas the Stylite, in the region of Çavuçin. John the Baptist holds a scroll with the text that reads 'Behold the Lamb of God who takes away the sins of the world' (John 1: 29), which is quoted in canon 82, and points to a representation of the Crucifixion. This decoration has been dated to around 700.[17]

This art in Rome indicates that east and west around 700 were united in their desire to use art to teach the faith, and to add meaning and extra dimensions to the environment for the veneration of Christ and the saints; in the later Middle Ages, in both east and west, a Crucifixion over an altar screen was the norm. It is also clear that the patronage of art involved a great deal of careful and calculated planning and choice. Whether some of the ambiguities were equally anticipated and manipulated is difficult to ascertain. The bald text of the *Liber Pontificalis* aims to give factual accounts of the achievements of every pope, and is not a full guide to the public perception of their careers. By 710 the Syrian pope Constantine (708–15) had been summoned to Constantinople and had made peace with Justinian II who, 'crown on head, prostrated himself and kissed the feet of the pontiff'.[18] While it seems evident that it had been bold of a pope to display himself as the slave of Mary, we cannot measure precisely how bold it appeared or to how many audiences the meanings were addressed.

The clear reliance on the communicative powers of art at this period are even more aggressively demonstrated in Constantinople when Justinian II was overthrown and his family executed in 711. The new emperor was an Armenian general, Philippikos-Bardanes (711–13), an

advocate of monotheletism who refused to enter the palace until an image of the Sixth Oecumenical Council (680–1), which had a few years earlier been set up in the vestibule, had been obliterated from his sight. This idea of setting up records of the councils seems to have been more widespread, as a similar cycle was also represented in mosaic on the walls of the church of the Nativity in Bethlehem around 700. Philippikos, in compensation for his action, ordered that images of only the first five Oecumenical Councils be made in the *Milion*.[19] The *Milion* (milestone) was one of the most public places to choose for this challenge to orthodoxy. It was a vast *tetrapylon*, a domed structure between the central street of the city and the square in front of St Sophia, and it contained imperial statues, including those of Constantine and Helena holding a cross, and was guarded by the *Tyche*, or Fate, of the city. This caused an outcry in Rome where, in retaliation, the Six Councils were depicted in St Peter's and icons of the emperor Philippikos were banned from public display. The situation was returned to normal by the dethronement of Philippikos by the army in 713, and two further actions: his blinding and the addition of the Sixth Council in the *Milion*.

Iconoclasm

If increased control was at the centre of much of the policy of the state and church in this period, the outcome is perhaps predictable—a reactive period with new tensions. Repercussions could be expected. Was the growing power of the established and institutionalized church to be neutralized by these measures or, on the contrary, given more potential power? Similarly, was the alternative society of independent monasteries and charismatic hermits confined or enhanced in its status by these rulings? Would decisions about the uses of art channel it into certain functions, or would they confirm art's value and increase its importance as a means of public statement? Was the desire for authoritarian control on the part of emperors a sign of perceived threat from within the empire or was its purpose to promote solidarity in the face of the enemy?[20]

The Quinisext Council, in addressing some questions about art, succeeded in putting art firmly on the theological agenda. The next church council (the local council that took place in the palace of Hieria at Chalcedon near Constantinople in 754) focused on the allowable functions of religious art. So did its successor, the Seventh Council of Nicaea in 787, coming to diametrically opposed conclusions. Nicaea was repudiated by the local council of 815 in St Sophia, which turned the tables again and reaffirmed the decisions of Hieria. Finally, the period comes to an end in 843 with the Constantinopolitan Synod of 843 which upheld Nicaea as the Seventh Oecumenical Council and celebrated the Triumph of Orthodoxy as recorded in the British Museum icon [13].

Much of the eighth century and first half of the ninth century were intellectually dominated by iconoclasm, or icon destruction. While this was not the only crisis of the period—the Arab threat to Constantinople and the Byzantine empire was acute in the first half of the eighth century—yet the politicization of religious art impinged upon every area of thought and action. The art historian can point to empirical evidence of the destruction of images in the period, both in the centre of Constantinople, in the Patriarchal Palace of St Sophia [**52**], and elsewhere; and there is negative evidence of other destruction, such as the lack of any further mention of the *Kamouliana* icon of Christ. The church councils gave the legal evidence of a state-led policy on art, alternately by the iconoclasts, who denied the holiness of icons and rejected icon veneration, and by the iconophiles, or iconodoules, the 'slaves of icons', who defended icon production and icon veneration. The theological debate centred on the holiness of icons, the relation between icon and model, and the theoretical implications of representing Christ in human form. The polarity between icon destroyers and icon lovers was pursued as a battle to the death between heresy and orthodoxy. The key stage was the formulation of the Council of Hieria, summoned in 754 by the iconoclast emperor Constantine V (741–75). Although later iconophiles ensured that all its decrees were excised from the record, its required refutation at Nicaea in 787 ensures that we can deduce the main line of reasoning. The argument was christological: an icon of Christ either depicted his humanity alone, or both his humanity and divinity, and so either separated his human nature from his divine one or confused the two—both already anathematized heretical positions. The neat solution was to be that the eucharist was the only true representation of Christ. This meant that all manufactured icons of Christ were to be proscribed, in keeping with the second commandment of God given to Moses: 'You shall not make for yourself a graven image, or any likeness of anything that is in heaven above, or that is in the earth beneath, or that is in the water under the earth' (Exodus 20: 4). The justification of iconoclasm at this council was that it succeeded in solving the problem of idolatry by eliminating the objects that provoked it. The response to this was given at the Council of Nicaea in 787, summoned by Empress Eirene, who was regent for Constantine VI from 780 to 797, and empress from 797 to 802, and Patriarch Tarasios. It decreed that Christ's historic incarnation not only legitimated his visible representation in paint, but also demanded it. The veneration (*proskynesis*) given to icons was allowable, and it was not idolatry; absolute worship (*latreia*) was given to God alone. Although an icon contained a figural image, it was only the model of this image to which veneration was directed. These two councils polarized the arguments, and the later iconoclast council of 815 and iconophile synod of 843 had little to do except to confirm one or the other.

The timetable given by the councils covers a period of fanatical dispute and strife, which was not to be resolved on either side by argument alone. Since the whole history of the church, from the earliest apologetics, indicates different and extreme convictions about the use of images, it suggests that allegiance to one side or the other depends less on logic and more on emotional and spiritual factors. At certain periods, places of worship do not contain figural images, notably in the first 200 years of Christianity (or so it appears), in Byzantium during iconoclasm, and in parts of Europe during the Reformation. At other periods, certain individuals or groups may be committed opponents of images, imagining them as idols. This long-term situation makes it difficult to explain the precise reasons for the open outbreak of Byzantine iconoclasm in the eighth century, even if the events and stated positions were fully and clearly recorded. In the event, the failure of the iconoclasts was met with the systematic destruction of their books, the character-assassination of their careers, and the conscious (or unconscious) rewriting of history. Modern assessments of the period may, therefore, suffer from even greater bias than the medieval sources, since they may accept or reject what can be read or reconstructed on the basis of their own personal attitudes to the issues. If concepts of 'rationalism' or 'superstition' are seen as a factor in medieval attitudes, then the potential for modern prejudice abounds. But what is communicated by all our sources in common is the high emotion of the protagonists, whose genuine belief in their (incompatible) positions cannot be doubted.

The art-historical study of iconoclasm has special problems, not the least being fewer objects and more primary texts than in other periods. The difficulty of assessing texts containing anti-iconoclastic narratives and rhetoric cannot be overstated, as they are not simply repositories of information. A text widely quoted in studies of the period, as it appears to offer a clear account of the treatment of the decoration of the *Milion* during iconoclasm, may serve as an example of the problems inherent in its analysis. This is the life of the iconophile martyr, St Stephen the Younger of Constantinople (*c.*713–65) [**50**], who was said to have been tortured and finally executed for refusing to accept the decisions of the Council of Hieria.[21] Whether or not St Stephen was in fact the most outstanding monk who fought for the icons in the eighth century, as his biography claimed, its success meant that from the ninth century no one in Byzantium doubted this. The passage documents an event of iconoclasm as follows:

The tyrant [Emperor Constantine V] left the palace and proceeded to that part of the great street called the *Milion*. In that monument, since ancient times and since emperors have reigned with Christian piety, the six holy Oecumenical Councils have been represented and openly displayed, proclaiming the Orthodox faith to peasants, foreigners and the public. It is here

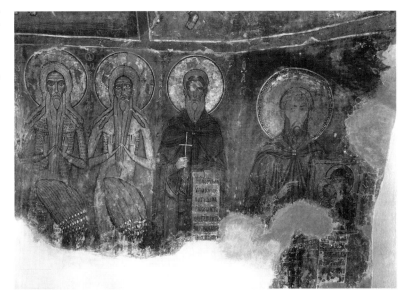

50

Wall painting of St Stephen the Younger with an icon. *Enkleistra* **of Neophytos, Paphos, Crete. 1197 or later.**

St Stephen the Younger (*c*.713–65) was the monk and iconophile during iconoclasm whose life, opposition to the Emperor Constantine V, and martyrdom are recorded in his *Life*. The account may well be exaggerated, but it gained him a place among Orthodox saints. Here, he is shown young, with a dark beard, no doubt to emphasize his premature death. He holds a portable icon (complete with ring for hanging it on a wall) which represents the Virgin and Child, and is the sign of his orthodoxy.

that in these sad days the tyrant, the new Babylonian, has smeared and obliterated the images in order to paint the satanic horse-race and demoniac charioteer, whom the tyrant, unworthy of heaven and earth, called *Ouraniakos* [Heavenly] because he was his lover and friend, and so honouring him more than the holy fathers of the church.[22]

This was the sole basis for the often repeated statement that Constantine removed representations of the councils from public display and used the *Milion* instead to show an image of his favourite charioteer—a substitution of secular art for religious art. It is in a way a return to the past, since a whole series of statues of famous charioteers had been set up on the *spina* of the Hippodrome (close to the *Milion*) around 500.[23] But can it be read literally? The text was written in 809 by Stephen, a deacon of St Sophia, some 40 years after the saint's death. He had been a member of the clergy of the patriarchal church at a time when the decrees of Nicaea were in operation, and the iconophile party in the church was in control and could hope to remain so. In the event, iconoclasm was declared again in 815 and Patriarch Nikephoros (806–15) was dismissed and replaced by an iconoclasm sympathizer. The text throughout exudes both the confidence and tensions of this interim period, and every statement at every circumstance in the life of the saint is heavily weighted. Undoubtedly, the tome communicates extraordinary anger on the iconophile side: the emperor was a tyrant, he had led the people into captivity like Nebuchadnezzar, he was homosexual, he was obsessed by horse racing, he was in league with the devil, he was not pious, and he had destroyed all the statements of Orthodox doctrine. The rhetoric is unambiguous, the anger clearly genuine. Nevertheless, the facts do not make sense! Why should the

emperor obliterate the six Oecumenical Councils when he had previously convened the Council of Hieria which had confirmed and clarified their doctrines? He was more likely to have added his own council to the sequence. Can we be sure that, if he had put an image here, it was of a charioteer? The text may have consciously or unconsciously reinterpreted a Christian scene of a charioteer, such as the Ascension of Elijah, as a secular portrait.

The reporting of this and other episodes should make us cautious about the historical details of the period, but not about the fact of iconoclasm. It was a major argument about the nature of the holy and about the nature and purpose of religious art. It was not a puritanical attack on art itself. The debate took place at the top, between emperor and patriarch, and it was particularly inflammable in the monasteries. But it was not confined to the 'chattering classes', because everybody, all the people, were accustomed to icons, and indeed to relying on their support. Yet they would also recognize the military success of the iconoclast emperors in removing the Arab threat from Constantinople; that could be attributed to their own piety and to iconoclasm. The iconophile historian Theophanes, whose *Chronographia* covers the period 285 to 813 chronologically, is perhaps inadvertently revealing about the extent of iconoclast support when he reports the year 813. He admits that the emperor Michael I (811–13) had been unfit to rule and Constantinople had been under severe threat from the Bulgarians in Thrace. While Patriarch Nikephoros was leading prayers in the church of Holy Apostles, a group of iconoclasts forcibly entered the adjacent imperial mausoleum built by Constantine the Great. They rushed to the sarcophagus of Constantine V, who had been so successful against the Bulgarians: 'Arise,' they begged him, 'and help the ruined state.' The iconoclasts then spread the rumour that Constantine would come back to earth, ride on horseback and fight the Bulgarians. Theophanes is at pains to point out that they prayed to Constantine, not God; and that Constantine was among the demons in hell.[24] Within weeks, Michael abdicated and went to a monastery. His successor Leo V (813–20) had re-established iconoclasm by 815, no doubt with some public support.

The nature of the written sources makes it impossible to plot the exact stages and motivations leading to the initial outbreak of iconoclasm. A strong emperor came to the throne in 717, Leo the Isaurian (717–41), who was to be succeeded by his son Constantine V (741–75). The first event of Leo's reign was the siege of Constantinople by the Arabs, and Leo's triumph over them. The Arabs withdrew on 15 August 718, the festival of the *Koimisis* of the Virgin Mary. A number of significant episodes are recorded around this time which have been brought into play in the attempt to find the spark which ignited iconoclasm. One of the first is the decree issued in 721 by the Arab caliph

Yazid II (720–24) ordering the destruction of Christian art in churches and homes in Islamic lands. Some damaged floor mosaics in the region give evidence of iconoclasm, and support the conclusion that Yazid's decree was carried out. It was in line with the earlier Arab attempts to stamp their identity on the art of the region. Also documented is a Christian movement in Asia Minor in the 720s against the veneration of icons, led by Bishop Constantine of Nakoleia; he was reprimanded by the patriarch Germanos (author of the *Ecclesiastical History and Mystical Contemplation*), who argued the erroneousness of equating the graven images of the second commandment with icons, and that veneration of icons was not prohibited in the Bible. The patriarch apparently failed to stem a growing movement in Asia Minor and actual episodes of iconoclasm. By January 730 Germanos had been forced out of office by the emperor and replaced by an iconoclast sympathizer, Patriarch Anastasios. This date has been taken to mark the imposition of iconoclasm by the emperor but, according to Theophanes, the crucial but irrational moment had came earlier.[25] After a massive eruption of the volcano Thera (present-day Santorini) in the Aegean Sea in 726/7, Leo III believed that God was angry with him, and decided to intensify his campaign against the icons. Theophanes records the next event as the destruction by the emperor's men of an icon of Christ on the Chalke Gate of the Great Palace in Constantinople, which prompted a public riot. The event became the focus of several colourful accounts, none, as it happens, earlier than 800, and iconoclasm is often therefore dated from 726. In one version, St Theodosia of Constantinople was martyred in the riot, and she is shown in the icon of the Triumph of Orthodoxy holding the icon of Christ taken down from the Chalke Gate [13]. But the nature of the evidence means we have no certainty that this episode actually happened, that there was an icon of Christ on the Gate in 726, or that Theodosia ever existed. No doubt, however, the eruption was interpreted as the wrath of God for the sins of mankind—that was the recurrent *topos* of the Byzantine mentality as recorded by Theophanes. Beyond that, the course of events is obscure. The broad picture is of Arab military advance, and of both Islamic and Christian desires to declare and define their faiths through art and other means. The period around 730 marks a significant time in the history of art, when all three religions that held in common the Old Testament declared that obedience to the second commandment meant that henceforth there could be no figurative images in synagogue, mosque or church.

How far iconoclasm was the systematic policy of Leo III has been seen to be open to doubt. How much more was it than an intention to regain the prestige of Constantine the Great and, like him, to fight under the sign of the cross?[26] It was not until a new emperor arrived and the Council of Hieria had taken place in 754 that iconoclasm be-

came official Orthodox doctrine. Until then, it had been an attitude rather than a reasoned belief, and the iconophile term of abuse against Leo III was that he was 'Arab-minded' and so an enemy to Christians. From the 720s, the cases for and against iconoclasm were rationalized by church and monks—the significant intellect on the iconophile side being St John of Damascus (*c.*675–*c.*753/4) who was declared a heretic at the Council of Hieria. He lived outside the empire, working at the monastery of St Sabbas, overlooking the Dead Sea, and had an extraordinary knowledge of Christian literature, as well as a familiarity with ancient art criticism. This enabled him to incorporate into his aesthetic thinking from Platonic and Neo-Platonic writings as well as from the mystical *Celestial Hierarchy* and *Ecclesiastical Hierarchy of Pseudo-Dionysios the Areopagite*.[27] His three *Apologies against Those who Attack the Divine Images* were the fundamental texts used at the Council of Nicaea for the definition of veneration, and as a documentation of collected iconophile statements.[28] His work formed the basis for the further treatises of St Theodore the Studite (759–826), who wrote three *Refutations of the Iconoclasts*, and for Patriarch Nikephoros (806–15), who wrote the *Apologeticus minor* (*c.*814) and three *Antirrhetics*, in which he systematically deconstructed iconoclastic interpretation of texts.[29] All these books taken together form a substantial corpus giving a systematic exposition of the range of functions of Christian art. It is not surprising that they were thoroughly studied again at the Reformation.

If the importance of the period of iconoclasm for the history of art was its massive concentration on articulating and rationalizing the Christian use of art, this did not inhibit the continued production of art, except that the scale and range of patronage was inevitably diminished, and the siege mentality of the times might have directed work to practical operations rather than to more grandiose schemes. A priority in Constantinople was the maintenance of the city walls and the improvement of the water supply; the aqueduct of Valens, which had been out of operation for over a century, was repaired in 766 after a drought. The fullest-documented activity is, nevertheless, as usual in the Middle Ages, the attention given to churches. In Constantinople, the church of St Eirene, adjacent to St Sophia and built as part of the whole patriarchal complex of the Justinianic Great Church, was severely damaged by an earthquake in 740. It was restored by Constantine V (741–75) in or soon after 753, according to evidence of the tree-ring dating of its wooden beams, and it remained in its iconoclast form for the rest of the Byzantine period [**51**].[30] Constantine's monogram is carved on the sanctuary screen (now broken up and used in the flooring), and the single gold mosaic iconoclast cross in the apse still dominates the nave, framed with two texts from the Old Testament. The main text from the Book of Psalms (64: 5) is found also

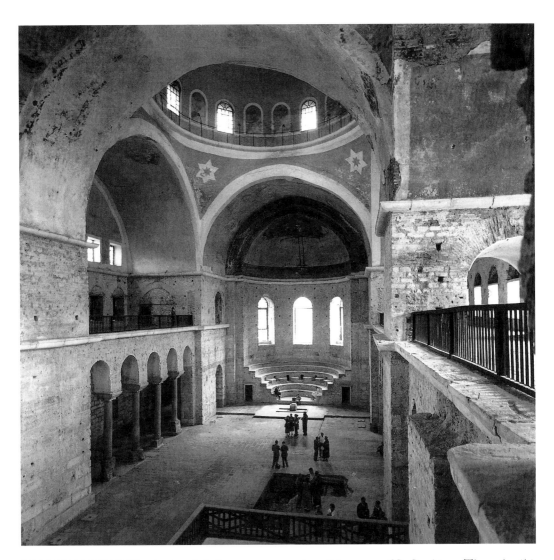

51

Mosaic apse of the church of St Eirene, Constantinople. After 740.

St Eirene (Holy Peace) was the first major church of Constantine, but went through several rebuildings, notably by Justinian. It acted jointly with St Sophia as the cathedral. After the earthquake of 740, it was substantially repaired by Constantine V between 741 and 775. The mosaic cross in the apse belongs to this work. Though a work of the iconoclasts, it survived unchanged throughout the rest of the Byzantine period.

in the eighth-century mosaics of the apse of St Sophia at Thessaloniki, and echoes the prayers used at the consecration of a church which asked for favour on the house. A non-figural decoration centred on the cross fits exactly with the cult of the cross which the iconoclasts seem to have encouraged. However, it is not distinctively 'iconoclast'. It repeats the scheme of St Sophia under Justinian, and is found again in the mosaic apse of St Sophia at Thessaloniki which is dated by the monograms of the joint reign of Emperor Constantine VI and his mother Eirene to the period 780 to 797, and so could have been set up before or after the iconophile council of 787. Indeed, many decorations consisting entirely of ornament and crosses are found in all parts of the empire, such as on the Greek island of Naxos and in the rock-cut churches of Cappadocia, in the chapel in the walls of the monastery of St Catherine on Mount Sinai, and in the early sixth-century mosaics of

the sanctuary of the Mesopotamian monastery church of Qartmin in the Tur Abdin. Some of the non-figurative schemes may be from the iconoclast period, but some are clearly not, and they are of both earlier and later dates. Whether they represent the deliberate avoidance of imagery, or a desire speedily to sanctify the church with the symbol of Christ, has to be decided through their context and on grounds of date. Although it has been suggested that Qartmin presents evidence of incipient iconoclasm already in the sixth century in Mesopotamia, its mosaics depicting crosses, vine-scrolls, a represented altar, and ciborium are too chance a survival to allow such a hypothesis, given the lack of corroboration in the theological literature of the area in either Greek or Syriac.[31]

St Sophia at Constantinople has one of the most conspicuous examples of iconoclast destruction and redecoration. This occurred not in the nave of the church but in a part of the gallery buildings belonging to the Patriarchal Palace which had been added to the south-west of St Sophia in the late sixth century (probably between 565 and 577).[32] The church was damaged in the earthquake of 740, but not as disastrously as St Eirene had been, and repair work was delayed until 768/9 under Patriarch Niketas (766–80). The later iconophiles recorded his activities with horror: in the two *Sekreta*, or reception rooms, of the patriarchate, Niketas scraped off the gold mosaic representations of Christ and the saints in the small *Sekreton*, and took down the icons made of painted wood in the large *Sekreton*, smearing the faces of the rest of the figures in the room. According to iconophile accounts, this was the period of severe iconoclastic persecution with martyrdoms, murders, and attempts at what would in another period be called the dissolution of the monasteries. The emperor and the patriarch were portrayed as the prime villains. While none of the 'facts' as presented by later iconophile versions can be taken at face value, the action of icon destruction in the small *Sekreton* is one of the few that can be tested, since its mosaic decoration has, at least in part, survived in its eighth-century condition [**52**]. It has never been altered again or its figural decoration restored, perhaps because the iconoclastic decoration of repeated crosses remained appropriate for its later use, the place where the relic of the True Cross was stored.

Mosaics from two periods appear on the vault and some of the lunettes around the windows of the small *Sekreton*. To the first phase belong the luxuriant green vine-scrolls which are part of the late sixth-century decoration executed when the room was built over the top of the ramp that led up from the ground floor to the south gallery of St Sophia. This was one of the four ways up to the gallery at each corner of the church, which were intended originally for catechumens—those receiving instruction for baptism—but with the universal spread of infant baptism, the galleries of St Sophia became the places for women

Mosaics of the small *Sekreton* of the Patriarchate. Room over the south-west ramp (south wall and window). 565–77 and 768/9.

The Patriarchal Palace of St Sophia was developed after Justinian's death, and a number of rooms were added to the south-west section of the church. The room over the ramp (which ran from the south-west vestibule to the gallery) was constructed and decorated, according to texts, with figures of Christ and other saints. The iconoclast patriarch Niketas is recorded in 768/9 as removing these images. The saints' portraits in the medallions were replaced with crosses, and the tesserae with their names below were picked out individually. The sixth-century ornamental mosaics were left intact.

and for imperial and patriarchal use. The scrolls are examples of Byzantine work which were later to influence the Islamic mosaics of Damascus and Jerusalem. The crosses in the medallions on the walls and at the apex of the vault belong to the second phase. The evidence for dating these later is that the plain gold crosses with large teardrop serifs set against spheres of various tones of blue have sutures around them, showing that they are inserted into an earlier ground, and that below the medallions is a disturbed area of inserted individual white tesserae which clumsily replace inscriptions, clearly the names of the portrait icons originally inside the medallions. These were the figures of Christ (at the apex) and of the saints that Niketas had removed. His new crosses echo the cross decoration of the church itself, and the painted decoration of crosses in the passageways of the ramp below; but it has been suggested that multiple agendas should be recognized in the representation of the cross, and that they may invoke the vision of a cross which Constantine the Great had received before his victory over Maxentius at the battle of Milvian Bridge at Rome in 312, which was to be interpreted as a vision of God.

Outside Constantinople, there is further evidence of iconoclasm in action. From Thessaloniki, the indications are circumstantial. An

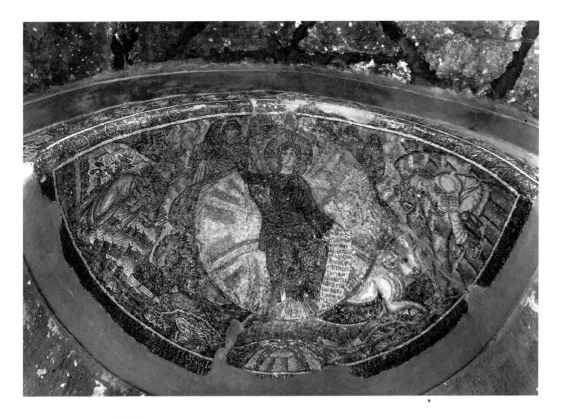

eleven-century text, *The Edifying Account of the Image of Christ in the Monastery of the Latomos*, celebrated the miracle of the uncovering of the apse mosaic of Hosios David in the reign of Leo V (813–20). The mosaic still exists and is in the small church now dedicated to that saint [53]. The text is a spiritual and highly embroidered account of the history of the mosaic.[33] The narrative relates how the image of Christ was hidden during the first period of iconoclasm, and remained visible in the city for most of the second period from 815 to 843, a possibility since it now appears that the mosaics of the Rotunda and St Demetrios escaped concealment during iconoclasm and remained visible. The church of the *Koimisis* of the Virgin Mary in the city of Nicaea was the katholikon (main church) of the clearly prosperous monastery of Hyakinthos, which was founded and first decorated in the late sixth or seventh century, making it near-contemporary with the three churches on Cyprus (at Kanakaria, Kiti [28], and Livadhia), which were decorated in the apse with mosaics of the Virgin. The church of the *Koimisis* was from the beginning decorated with mosaics in the sanctuary, which were torn out during iconoclasm. It was redecorated after iconoclasm, and was again thoroughly repaired and redecorated after an earthquake in 1065. The church was finally totally destroyed in 1922, and its architecture and decoration can now only be studied through a series of early twentieth-century photographs. The tell-tale clues in

Mosaic apse with Virgin and Child. Church of the *Koimisis*, Nicaea (now Iznik). Ninth century.

The monastery and church were destroyed in 1922, and the mosaics can now only be studied from photographs. These are clear enough to show three phases of work in this apse: the first decoration was a standing Virgin on a footstool and included the inscription and hand of God above. It must date before iconoclasm (seventh or early eighth century). The mosaic of the Virgin was removed by iconoclasts and replaced with a cross. Soon after 843, the present decoration restored the original scheme.

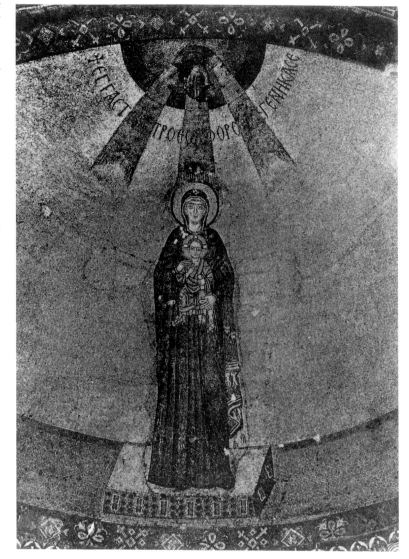

these photographs allow the dating of all the alterations to the mosaics [**54**].[34] The iconoclasts at Nicaea worked in the same way as those who had worked in the small *Sekreton* at St Sophia. They tore out the figures, and filled in the resultant hole with a cross. The iconophiles worked in the same way after 843, when they tore out the vertical arm of the cross, and filled in the gap with a figure, and the horizontal arms of the crosses with tesserae, one by one, so that a 'ghost' of the crosses remained detectable. The consequence of this economical, but practical, way of working, retaining much of the original mosaic, is that we can deduce the extent of each phase. The original mosaics showed a figure of Mary standing on a footstool in the conch, and on the barrel-vault of the sanctuary were archangels between the throne of God

(*etimasia*). Above the Virgin's head is an inscription written in an arc around the hand of God and the divine rays of light: it is a quotation from verse 3 of Psalm 109: 'I gave birth to you from the womb before the rise of the morning star' (Septuagint). Clearly, the original image would have been a Virgin and Child. The iconoclasts retained the inscription, but changed the image to a large cross, like that in the case of the apse of St Eirene. They also removed the archangels. The inscription must have been quite incongruous during iconoclasm, but its retention allowed the post-iconoclastic redecorators to replace the original scheme. They, like we, could deduce (or had records of) what had happened to the mosaics under the iconoclasts. But they, like the iconoclasts, could be economical with materials, making this a true restoration of the original mosaics and without innovation.

An important fortified Byzantine city in Bithynia in a fertile part of north-west Asia Minor, Nicaea has a high profile in Byzantine history, since it was where two major church councils took place, and was the capital of the Byzantine empire after the Crusaders took over Constantinople in 1204. The mountains of Bithynia (Mount Auxentios and Mount Olympos) attracted increasing numbers of monks and hermits during iconoclasm, partly as places of refuge or exile. St Stephen the Younger founded a monastery on Mount Auxentios, and in the ninth century the iconophile St Theodore the Studite was for a time in exile in Bithynia. Saints' lives and architectural survivals indicate that a significant number of monasteries was built from around 780 and continued to be developed through the first half of the ninth century.[35] These churches, often reusing the columns and capitals made for earlier buildings in the region, are significant for their architectural experimentation, itself partly provoked perhaps by the challenge of using ready-made materials, since the Marmara quarries appear to have fallen into disuse in the sixth century. There are the earliest examples here of cross-in-square churches, with the central dome supported by four (reused) columns. One, now the Fatih Camii at Tirilye, reuses beautiful sixth-century capitals in the style of those of St Sophia, and was probably the iconophile monastery of Trigleia documented in the early ninth century; dendrochronological examination of its wooden beams dates them to around 799.[36] The earliest standing example of the cross-in-square type in Constantinople is the Theotokos church of Constantine Lips of 907. This church, and the Theotokos church at the monastery of Hosios Loukas of around 1000 are impressive examples of the architecture; they too may use recycled columns.

Historically, the period of iconoclasm started with crisis and the feared collapse of Byzantium; by the time it ended, the Islamic 'Abbasid caliphate had moved from Damascus to Baghdad, and to Samarra from 836 to 892, and diplomatic and cultural relations were in place. By 843, the Balkans were more stable, and soon the two brothers, Constantine

(whose monastic name was Cyril) and Methodios, devised the Glagolitic alphabet and translated Greek works into literary church Slavonic and thereby accelerated the christianization of the region, and reduced its hostility to Byzantium. The art of the iconoclast emperors emphasized the life-giving cross, and avoided the representation of Christ and other saints. The embattled iconophiles found hiding places for their icons, and by definition must have commissioned more. By the second period of iconoclasm, there was greater tolerance, and it was even agreed that icons out of reach in churches hardly constituted a problem of idolatry. By the middle of the ninth century, fear of invasion was less acute, and iconoclasm was past history.

The Khludov Psalter (now in Moscow, previously in a monastery in the Princes Islands in the Sea of Marmara) is the work of art that brings us closest to Constantinople and to the ways of thinking and seeing during iconoclasm. It dates to the years immediately after the triumph of Orthodoxy in 843, and was probably produced either between 843 and 847, or soon afterwards [**55**]. The best preserved of a group of three small manuscripts, it has a text of the psalms and an extensive cycle of pictures (225 extant) in the wide margins that illustrates the contents of the songs (the Athos Pantokrator has 97 miniatures and the Paris marginal Psalter has 37).[37]

The idea of a whole book devoted to the Psalms, and containing in addition the nine Old Testament canticles, or odes, and selected hymns, was totally obvious to a Byzantine, especially to a monk whose life of worship involved communally reciting the whole of the Psalms every week, but also to priests, since Justinian had ordered in 528 that all clergy in every church must say the main daily offices. The cathedral church of St Sophia had the special distinction of a chanted (*asmatikos*) office and a trained choir. What was needed from a book was not so much the (familiar) words, but guidance on how to divide up the psalms to fit the services. The Khludov Psalter supplied just this information, indicating the 20 sections (*kathismata*) and 60 subsections (*doxai*) that made up the weekly round. The apparatus provided is suitable for either the cathedral or monastic divine office, which does not make the intended destination of the book easily apparent. However, the chanted refrains (antiphons) written into the manuscript make it likely, but not certain, that it was produced for use in St Sophia itself. The great test of the novice monk was learning the Psalms off by heart—St Theodore of Sykeon in the sixth century had apparently only managed to do this with the miraculous help of an icon of Christ after praying for a better memory. The value of psalters was therefore in part that they helped to ensure conformity of practices, but when a special illustrated volume was produced, as in these manuscripts, its personal value would have been different, and private devotion and contemplation would seem its most likely use.

55

Manuscript illustration of David composing the Psalms. Khludov Psalter. Constantinople. Soon after 843.

The manuscript is relatively small, and the text is surrounded by a substantial margin which holds 225 miniatures on 169 folios. Both miniatures and text were retouched in the Byzantine period. The pictures act as a commentary on the Psalms, either literally illustrating the words, or introducing more complex typological or even political references.

The ninth-century Khludov Psalter is the earliest surviving Byzantine illustrated psalter. Its user, we can be sure, knew the texts of the Psalms by heart. Contemplation of its pages must have offered a striking contrast between the familiar sacred words and the originality of the subjects set beside them. Some of the illustrations may have been copied from earlier, now lost, psalters, which would have been the highly treasured, but hidden, possessions of iconophile owners. The illustrations were studiously theological in their references, some from a long tradition of biblical exegesis and typological interpretation, others totally modern; but some carried all the pent-up emotions of the iconophile struggle, quite probably repeating polemical images attached to partisan documents, such as the books of Patriarch Nikephoros. The text of the Septuagint Psalm 51, verse 9 (folio 51 verso; [**56**]) is marked out with an arrow to indicate that it is the passage for illustration: 'see the man who would have none of God's help but relied on his store of riches and found his strength in his folly' (52: 7 in the Revised Standard Version). The imagery works by the parallelism of two references: above, St Peter is trampling underfoot Simon the Magician, who dropped the vase which has money falling out of it. A Greek text points out that Simon lost to Peter because of his greed. The topical parallel was to show the iconophile patriarch Nikephoros holding an icon triumphantly in his hands, trampling under his feet the last iconoclast patriarch, John the Grammarian (837–43), wallowing in gold coins. The caption reads: 'Patriarch Nikephoros marking

56

Manuscript illustration of Simon Magus and Patriarch Nikephoros. Khludov Psalter. Constantinople. Soon after 843.

The later rewriting of the Psalm text in minuscules is clear on this folio; but the heading of Psalm 52 is left untouched in the ninth-century uncial script of the original manuscript. Nikephoros (below) holds a circular icon of Christ, and wears his clerical garments. John VII Grammatikos, nicknamed Jannis (patriarch 837[?]–43) is sprawled below and has wild hair and nondescript dress. St Peter tramples Simon the Magician in the upper scene.

57

Manuscript illustration of the Crucifixion and iconoclasts whitewashing an icon of Christ. Khludov Psalter. Constantinople. Soon after 843.

The leading iconoclast is John VII Grammatikos. The description of an icon of Christ is compared literally with the suffering of Christ on the cross, but has a more theological level as well: that the suffering of Christ on earth can be used as an iconophile argument to support the representation of his body in icons.

out Jannis the second Simon and iconoclast.' The imagery is full of evocations: just as the emperor on the Barberini ivory [22] is shown trampling his enemies underfoot, so the symbolic ecclesiastical equivalent of trampling heretics at a church council vilifies Patriarch John as a magician, a simoniac or taker of bribes, and as a heretic.

Several of the pictures in the Khludov Psalter reveal premeditated vitriol of this kind. Folio 67 recto [57] shows the distinctive wild hair of Patriarch John the Grammarian again, and must have brought him to mind even if the figure is in lay clothes, unlike the bishop beside him. The caption beside their heads reads 'Iconoclasts'. The text is from Psalm 67: 22 (or RSV 68: 21): 'But God will shatter the heads of his enemies, the hairy locks of him who walks in his guilty ways.' The New Testament reference is to the Crucifixion and shows the Roman soldiers offering Christ a drink. The text begins 'They', and was probably meant to read 'offered him wine, mixed with gall' (Matthew 27: 34). The iconoclasts' words continue the idea: 'and they mixed water and lime over his face'. The pictorial aim is to convey the conviction that iconoclasm was a crime as evil as the Crucifixion itself, although to accept this suggestion literally one would have to be an iconophile, and to have a view about the icon as 'containing' its prototype in a sense beyond that proposed by the apologetics which took care to make the distinction between the representation and the model. To the converted, these images in the Khludov Psalter would be as visually powerful as the florid rhetoric of the *Life of St Stephen the Younger* was effective verbally in rewriting history. In one sense, the victory of the iconophile side was assured by the weapons at their disposal. The iconoclast's task was to prove that icons were counter to God's logic; this proved impossible. The outcome of the struggle, that figurative art was the proper and required form of religious art, shows less the victory of argument than the power of tradition—in this case, the established environment of both classical and early Christian art in the city of Constantinople endorsed the universal Byzantine acceptance of images from its foundation.

The battle for the icons was so bitter that after 843 their manufacture and display had to be a key element in the identity of Orthodox Christianity, and still today in Greece the first action in respect of a baptized baby, reborn as Orthodox Christian, is to take it to kiss the icons. The post-iconoclastic church was to become the ideal frame for the icons as much as the dwelling-place for Christ on earth.

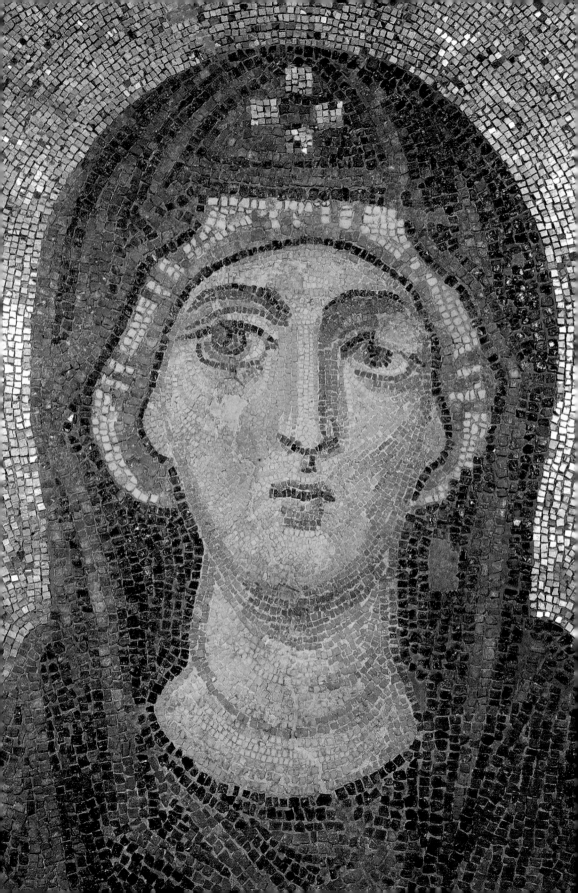

Developments and Diversions in the Consolidated Empire

Middle Byzantine Art 843–1071

4

For the Byzantine church, the ending of iconoclasm in 843 was seen as the ultimate victory. Faith and doctrine were finally agreed 'now and for always and for ever and ever'; the Seventh Oecumenical Council at Nicaea in 787 was the final statement on christology.[1] Several of the patriarchs after 843 were outstanding individuals; indeed the consequence of their leadership was that rivalries between Constantinople and Rome generated new rivalries, exacerbated by Photios (858–67 and 877–86) who insisted on the official use of the title Oecumenical Patriarch, and Michael I Keroularios (1043–58) who introduced it on his seals. The decisive schism between pope and patriarch finally came in 1054. Iconophile emperors, too, were enthusiastically supported by the church, and one emperor, Constantine VII Porphyrogenitos (913–59), compiled a handbook, *The Book of Ceremonies*, in which the whole year in Constantinople is portrayed as a well-ordered display of the harmony of church and palace before the people and in the sight of God. It was another witness to Byzantine political strategy to end a period of turmoil by the declaration of order and certainty, to reconnect with times of past security and to reinforce the dignity of the ruling dynasty.[2] Logically, the mood of the period had to be the revival of religious art and the holy icon, and concomitantly the renewed expansion of the monasteries also, since monks could claim that it was from them rather than from the politically more compliant 'secular' church in Constantinople that the real and effective opposition to iconoclasm had come. Although the Khludov Psalter (or a similar manuscript) was used as one model for a new illuminated psalter written, painted, and signed by Theodore, *protopresbyter*, in the monastery of St John Studios in the year 1066, and commissioned by its abbot Michael, there is one immediately conspicuous change in the planning of the new

58
Detail of 67

59

Manuscript illustration of
iconophiles Nikephoros and
St Theodore the Studite
holding an icon and arguing
with iconoclasts. Theodore
Psalter. Constantinople, in
the monastery of St John
Studios. 1066.

The manuscript contains the
Psalms and Odes, and has
435 marginal illustrations.
Much of the miniatures'
interest lies in the portrayal of
monastic virtues, and the
enhancement of Abbot
Michael. The psalter is named
after its scribe, the priest
Theodore, who was born in
Caesarea (Cappadocia), and
moved to Constantinople as a
monk at the Studios
monastery. The miniatures
also refer to iconoclasm and
the importance of the ninth-
century iconophile St
Theodore of Studios. The style
is colourful and decorative,
closer to enamels or the
mosaics of Nea Moni on Chios
than to the robust figures of the
Khludov Psalter.

book [**59**].[3] The prominent role of Patriarch Nikephoros as triumphant
iconophile is replaced with portraits of the monk St Theodore the
Studite. Natural though it was to celebrate a past member of the com-
munity in which the manuscript was made, it slants the opposition to
iconoclasm away from patriarch to monk.

This Middle Byzantine period was one of military achievement and
expansion up to the battle of Manzikert in August 1071 and defeat by
the Seljuk Turks. However much it is argued that this was more a polit-
ical debâcle than a significant military collapse, it marks the gradual,
and ultimately fatal, advance of the Turks. One work has been under-
stood as a record of Byzantine military achievements by linking the
campaign of John I Tzimiskes (969–76) to the Holy Land, which took
his army within sight of Jerusalem, with a set of biblical pictures. This is
the Joshua Roll (now 15 sheets of parchment painted with tempera and
gold in the Vatican Library [**60**]). It represented as a frieze the first 12
chapters of the book of Joshua, and his capture of the Holy Land.[4] This
is a highly narrative set of pictures and the text is very much in second
place. The question is whether a topical interpretation for its produc-
tion is reasonable. Does this explain the choice of a unique format?

The roll format of antiquity began to fall out of use with the rise of
the codex, the format of the modern book, in the second century.[5] The
codex was more convenient for reference and for handling, and also
for ease of painting. So a book of the Bible in roll format in the tenth
century was eccentric and must have been for a special purpose; this
may have been as a painted frieze for display in the palace, analogous

60

Manuscript roll of the Book of Joshua. Joshua Roll. Constantinople. c.950. Tempera and gold. Fifteen vellum sheets.

Up to 1902 the sheets were glued together to form a frieze over 10.5 m in length, but sheets of the beginning and end are lost. The current section illustrates events from chapters 2–10, and it probably never consisted of the whole Book of Joshua, but only a part. The text is abbreviated. This is sheet VI; Joshua sends spies to the city of Ai. The personification of Jericho sits to the left.

to the original purpose of the Bayeux tapestry in the west. Such an interpretation must influence the meanings we give to many other Byzantine works, including the David plates [**36**]. It does however have many difficulties. It involves dating the roll around 970 to coincide with the imperial campaign, despite its style fitting better with works of around 950. A further complication is the widely believed theory that this roll is nothing other than the copy of an earlier roll, now lost. The attraction of this theory is that it serves to explain why several of the pictures have missing details: they might indicate an artist's misunderstandings of an old and faded model. But it has several awkward implications. The lost model must be conjectured as a roll made at the same time as the David plates, and both works accepted as containing topical allusions through their biblical narratives of the capture of Jerusalem by Heraclios in 630. The style and pictorial meaning of the tenth-century roll becomes no more than a reproduction of an earlier original, opportunistically copied to celebrate another (less successful) campaign in the Holy Land. This kind of speculative argument occurs elsewhere in art history. A notorious case is the Roman floor mosaic showing Alexander the Great in battle in the House of the Faun at Pompeii, frequently described as a copy of a lost Hellenistic work, because of its so-called 'mistakes'.[6] The assumption that a model existed and was more 'accurate' must inevitably downgrade the work that we do have and can see. The embarrassment is that when we do have a model and its copy, as in the case of the Khludov Psalter and the Theodore Psalter [**56, 59**], we can find many differences and new ideas in the later work—it is not a slavish copy. In summary, whether or not this theory is accepted about the Joshua Roll and a possible model, it is surely more positive to treat it, not as an antiquarian reproduction, but as an object designed to make a strong im-

pact on the tenth-century viewer. Like the Alexander mosaic, the Joshua Roll illustrates the interests, taste, and achievements of the time of manufacture. The mid-tenth century in Byzantium was a time when the forms of classical art could be most effectively recreated.

The traditional art-historical response to the artistic richness of this period has been to speak of a second 'Golden Age' (the first being under Justinian), or to define a 'Macedonian Renaissance', the word 'Macedonian' referring to the imperial dynasty from the accession of Basil I in 866 to the death of Basil II in 1025. The intellectual emperor Constantine VII Porphyrogenitos has been regarded as the most congenial imperial character in Byzantine history by modern scholars, and the originator of a literary and artistic renaissance. His name has been connected with a small number of extant works of art, including the 14 full-page classicizing miniatures of the largest Byzantine illustrated psalter ever produced. This was the mid-tenth-century Paris Psalter in which, unlike the Khludov Psalter, the pictorial emphasis seems far more on style than substance [**61**].[7] The value of the book lies as much in the quantity of text: in addition to the psalms and the pictures which show the life of David and the authors of the Odes, it has a long, learned scholarly and theological commentary on the written word. Constantine has been taken to be an active painter himself on the basis of a couple of eulogistic texts, although they may be as fictitious as the earlier descriptions of Justinian as the builder of St Sophia. The terms 'Golden Age' and 'Renaissance', though ill defined, have been much repeated and in relation to quality of production they do flag the new range of expression and an increasing technical virtuosity in religious art and, as far as we can know it, secular art in the tenth century.

The paradox of this period is that innovation and change had necessarily to be presented as a return to the past. Since heresy must always be innovation, the defeat of heresy implies the survival of tradition. One opportunist idea to surface during iconoclasm was that St Luke was himself a painter, and had produced a portrait icon of Mary and Jesus from life. This icon even came to light in Constantinople after iconoclasm when at some undetermined date it was identified with one venerated in the Hodegon Monastery [**116**]. This complex was to the east of St Sophia, down towards the sea, and its reputation first depended on a miraculous spring that healed blindness. The nature of this icon, itself very large and heavy, is well known from numerous accounts of travellers and pilgrims, particularly in the fourteenth and fifteenth centuries, who witnessed all the charismatic rites of its weekly street display on Tuesdays among a large public expectant of miracles of healing. Of all the famous icons kept in Constantinople, this was the most frequent source of copies. According to the theory that the powers of the original passed to its copies, then every Byzantine community would welcome its own

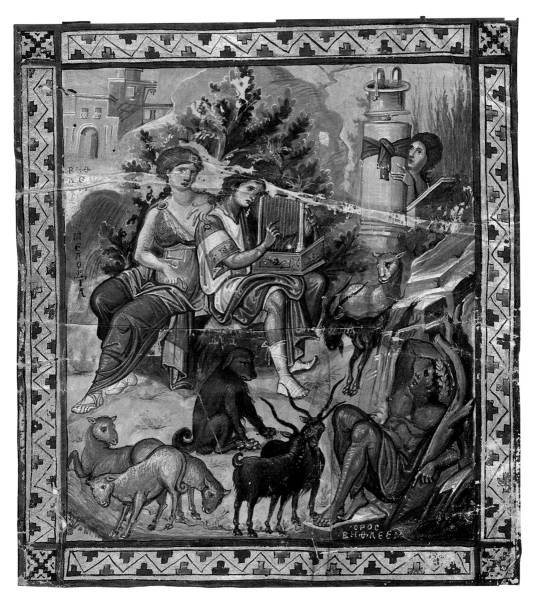

Hodigitria ('the one who shows the way'). The distinctive feature of the *Hodigitria* icon was the gesture of the Virgin, pointing towards her son. The Triumph of Orthodoxy icon [**13**] shows this image as the most important icon venerated by the Orthodox community. In 1453 the Hodegon icon was taken to the monastery of the Chora near the land walls of Constantinople during the last siege as the focus for prayers for salvation. On the fall of the city, the Janissaries, the sultan's personal troops, took the icon, stripped it of its precious ornaments and hacked it into four pieces.[8] Its true date cannot therefore be determined; it may have been an early icon to which the legend was attached, or a later icon made to justify the legend.

The choice of 843 to 1071 as the span for a subdivision of Byzantine art must prompt the question whether this is a justifiable unit. By making 843 the turning-point, the period becomes a sequel to iconoclasm.[9] Iconoclasm has itself been handled as the sequel to a period of religious as much as political realignment. In other words, in this interpretation of Byzantine art, the post-iconoclastic period forms one part of a succession in which the dynamic is seen in terms of the role played by religious art in the definition of the culture. Byzantium has never been considered a religious state in the integral sense that Islamic societies have been, with codes of law coming from the Koran. Yet Byzantium was a Christian empire, and early on the emperor was envisaged as the representative of Christ on earth, a theory that was frequently openly and formally declared, as on the coins of Justinian II. The codification of Roman law undertaken for the circumstances of the sixth century under Justinian (the *corpus juris civilis*) was updated during iconoclasm by Leo III and Constantine V with the issue of the revised code of the *Ecloga* in 741; predictably, perhaps, an attempt to supersede this and to re-appropriate Justinianic law was made in the ninth century with the production of the *Epanagoge* (soon revised and replaced by the *Prochiron*) in 886. The series of revised legal books demonstrates the maintenance of Roman legislative principles throughout the Byzantine empire as an important characteristic of the state. It also justifies the distinction between religious and secular art, although in Byzantium this may be less appropriate than that between public and private art.

Revival

Iconoclasm, from our perspective, was a time of exciting creativity and inventiveness, particularly in the literature and art of polemics. Innovation was from the point of view of the participants exactly what was wrong with the period: it came from the devil. To combat inventiveness, new procedures were followed at the session of the Council of Nicaea in 787. Whenever a quotation was adduced to make a point, the authentic book, or codex, from which it came had to be held up and then a reader recited it in public. This was a direct rebuttal of the suspect practices of the Hieria Council of 754 where the iconoclasts were alleged to have circulated only loose sheets of text, enabling them to invent evidence or take statements out of context.[10] At Nicaea around 70 books were shown as evidence of good faith in this way, nearly all coming from the library of the patriarchate of Constantinople. But despite all this apparent honesty, the iconophile chronicles, saints' lives and other literature of this period show that neither side was blameless when it came to creative fiction. Equally imaginative are the miniatures of the Khludov Psalter group [55–7], not only in the allusions and the innuendoes of their iconography, but also in their rough and lively style which, lacking parallels, has caused the difficulty of their precise

dating, and remains unexplained. For some art historians it represents 'popular' taste or 'monastic' art; but if, as seems most likely, its production belongs to the intellectual circles of the patriarch, this line of reasoning can hardly be pressed. The style might reflect, in this case, earlier models found in psalters made before iconoclasm, perhaps from the collection of the Patriarchal Library in St Sophia. The importance of the psalter in Byzantium suggests its likely production in the early period, but these books may only have had an author portrait of David, the writer of the Psalms, and a few marginal pictures in a sketchy style.[11] A regular feature of illuminated Christian books throughout the Byzantine period was the inclusion of the author's portrait—in books of the four Gospels, images of the four Evangelists were often the only pictures. These portraits must have acted in the nature of a guarantee of the authenticity of the authorial contents. The ninth-century *Sacra Parallela*, an anthology of theological quotations collected by St John of Damascus, contains dozens of author portraits, painted in the margins next to the writings [62].[12]

The downside of iconoclasm must have been disruption of artists' working conditions and their access to materials. Art in Byzantium was an apprenticeship system, the routine organization being a family business, with father training son and passing on his tools and materials as well as his expertise. A dislocation of this rhythm might be detected, for example, in the series of early icons from Sinai where from the eighth century the use of the hot wax medium (encaustic) is found

How to paint an icon

The preparation of wooden panels (cypress was the favoured wood) and the application of pigments with an egg tempera medium was a specialized skill and, at first sight, the development of the icon might be viewed as the story of increasing technical virtuosity and decreasing originality. But the long history of the icon is more elusive: generations of artists represented the unchanging truth of the Christian faith in subtly progressing ways—experimenting with colour, style, subjects, complex frames, and intricate triptychs.

The basic skills remained constant. The wood support was prepared and strengthened to prevent splitting or warping; strips of woven linen were glued to the wood surface to prevent cracks or splits from spreading up into the painted level; the linen was overlaid with layers of smoothly polished gesso (finely ground chalk whiting, mixed with size).

The design was drawn in charcoal, sometimes in late Byzantine art in Crete using pricked cartoons, copied from other icons. Gold leaf was laid and burnished. The most common medium was egg tempera, but wax encaustic was found in the early icons of Sinai (though not unknown in Middle Byzantine art, particularly if an artist had to paint onto a material like stone or marble). The pigments were earth colours, supplemented by azurite, cinnabar, malachite, verdigris, white lead, and bone black. The finished painting was protected with a glaze which acted as a varnish.

62

Manuscript illustration of St John of Damascus. *Sacra Parallela*. Constantinople. Second half of the ninth century.

The text is an anthology of quotations from the Bible and patristic texts intended for moral and ascetic edification, collected in the eighth century. This manuscript has over 1,000 portraits of the authors of the texts, 1,658 pictures altogether. This folio shows the 'editor', St John of Damascus; below him Cyril of Alexandria; and Philo and Josephus. Word and image are equally enhanced by a lavish use of gold leaf.

no more; all subsequent icons are in tempera. But it is most of all in the unconformity of ninth-century art that one may want to detect a situation where artists veered between a rediscovery of the past and an openness to new ideas and influences.

The renovation of the sanctuary mosaics of the monastery of the *Koimisis* at Nicaea [**54**] is a case of constructive renewal. The clock is turned back and the pre-iconoclastic phase painstakingly reconstructed, marred only by the clumsy insertion of the name of Naucratios who wanted to take credit for the operation (possibly the abbot of St John Studios at Constantinople, who died in 848). The mosaic technique corresponds with pre-iconoclastic works, such as the mosaics of Pope John V in St Peter's in Rome, and the panels of St Demetrios at Thessaloniki, with the use of differently coloured natural stone tesserae and transparent glass in the faces, and the distinction between the sizes of the cubes in the faces and garments. The difference lies in that the modelling of flesh uses contrasting coloured patches rather than modelling lines of tesserae as at Rome.

Coinage is another case of reverting to the situation before iconoclasm. The designs of the iconoclast period had fallen into a consistent pattern once Leo III had made the obvious decision to distance himself from the Christ imagery of the coins of Justinian II. The obverses showed the emperor, and the reverses showed his son as joint emperor or a deceased predecessor. The idea is simple, although a peculiarity of this period. It was to assist the succession of the dynasty, with the son

63

Gold *solidus* of Michael III
with the face of Christ on the
obverse (inscribed *Jesus
Christos*). Mint of
Constantinople. 843–56.

The coin systematically
reproduces the first coinage of
Justinian II [**47**].

associated on the throne with the ruling emperor as soon as possible,
usually only a few months after his accession. The portraits were
stereotyped and schematic, and made few concessions to reality.
Constantine V is shown with beard and moustache, although in life
he was clean-shaven, contrary to convention.[13] The coins of the last
iconoclast emperor Theophilos (829–42) were complicated by the
death of his eldest son Constantine, who appeared on them in 830 or
831, probably on the occasion of his coronation, but who died soon
after. The next coins showed Theophilos's wife Theodora and their
daughters, but soon after the birth of Michael III in January 840, the
type appeared with Theophilos on the obverse and Michael as a child
on the reverse. Michael's date of birth is celebrated in a monogram on
the huge double ornamented bronze doors of the south-west vestibule
of St Sophia which were donated by Theophilos and are a major
achievement of the iconoclast period.

Michael III succeeded to the throne when Theophilos died in
January 842, with his mother Theodora as regent, as shown in the
Triumph of Orthodoxy [**13**]. The first coins of the reign showed
Theodora on the obverse, and Michael and his sister Thecla on the re-
verse. Then came the significant change, and pre-iconoclast revival.
Coinage between 843 and 856 showed Christ on the obverse and
Theodora and Michael on the reverse [**63**]. From 856, when Michael

64

Cloisonné enamelled
reliquary cross with
Crucifixion and Virgin with
saints. Beresford Hope Cross.
Constantinople[?]. Ninth
century, after 843[?].

This may have contained a
relic of the True Cross, or at
least its precious appearance
gave this impression.

III became sole emperor, his mother disappeared from the reverse. This design was not just an echo of the coins of Justinian II; it was a conscious copying line by line, and also retained the motif of a cross behind Christ's head without a nimbus. The inscription was now short and simple: 'Jesus Christos'. It was a brilliant way of declaring the allegiance of the rulers to the icon, and of declaring a return to the past.

Artists found ways of returning to objects surviving from before iconoclasm, and recreating them. An alternative was to turn to expertise from outside Byzantium. A striking case is enamel-work. Before iconoclasm, Byzantine glass enamelling was done in the filigree technique in which the melted coloured glass was contained within loops of wire or metal strips set on edge. From the ninth century onwards Byzantine enamelling was by the *cloisonné* technique: cells divided by thin strips of gold (*cloisons*) were filled with coloured glass and fired. When cool and fused, the surface was ground and polished. An early example of this new technique is the Beresford Hope Cross (Victoria and Albert Museum, London), which was a hollow reliquary cross with Christ crucified between Mary and John depicted on the front, and an orant (praying) Mary with 4 saints on the back [**64**].[14] The relic it contained was most likely a fragment of the True Cross and it would have been worn on a chain around the neck. There is evidence that popular objects for iconophiles after 787 were pectoral reliquary crosses or phylacteries, some with images on them, which had the double power of confessing Orthodoxy and providing protection against misfortune. Most likely the Beresford Hope Cross, a grander version, dates from soon after 843. Another enamel, the Fieschi-Morgan reliquary box in New York, also belongs to the first half of the ninth century, probably after iconoclasm, although a date just before 815 has been proposed [**65**].[15] In both cases, for all their botched Greek inscriptions and crude handling of *cloisonné*, their iconography follows Byzantine traditions and they were probably made in Constantinople. But their artists' knowledge of the new technique must have come from outside, and the obvious source is Rome, where enamels of this type and these colours were in production, such as the cross of Pope Paschal I (817–24). Rome, with its established Greek monasteries, had been one place of refuge for iconophiles during iconoclasm; the future Patriarch Methodios was there from 815 to 821. It was just one place in the west where artists and others could share information and expertise—the painter Lazaros, persecuted by Theophilos as an iconophile and ordered to have his hands burned, who after 843 set up a new icon of Christ on the Chalke Gate of the Great Palace, went in the 850s and 860s on ecclesiastical missions to Rome. A travelling Byzantine artist is most likely responsible for the classicizing wall paintings of Christ and scenes from his early life in the small church of S. Maria foris portas at Castelseprio, north-west of Milan, which belong to the ninth or tenth century.[16]

Substantial redirection of Byzantine art through contact with the west must be envisaged in this period of revival and consolidation. Recognition of the closeness of east and west at this time does not exclude subsequent rapid and independent development of new media within Byzantium. This was certainly the case in the production of enamel, which by the tenth century was perfected as a distinctive Byzantine product [**66**]. In book production too there is varying evidence of contact with western manuscripts—in the types of design used for initials, for example, and in the question of the origin of changes in handwriting around 800. Books began to appear written in miniscule in the Carolingian west, in the Holy Land in the east, and in Constantinople. Majuscule (in uncials) was not instantly abandoned and continued in use for a number of major books of the ninth century [**62**]; but by the tenth century the transliteration of old texts into the new script was under way in earnest—miniscule was no doubt more economical of materials and quicker to write, and ultimately felt to be easier to read, especially when accents and breathings were added to words, which were not however regularly separated. This was the next great revolution in book production since the invention of the codex around 100 and the abandonment of the roll; it was the second filter through which early texts had to pass, both Christian books and the pagan literature of antiquity. But the question may be asked whether this universal adoption of miniscule in Mediterranean culture was coincidental, or whether priority lies in east or west.

Byzantium in this period also looked receptively to the east. Theophilos introduced into the *Magnaura*, the main throne-room of the Great Palace, an extraordinary object which impressed ambassadors and the other special visitors who, with the court, higher clergy, and imperial family were the only ones to see the hidden glories of the palace. This was the so-called throne of Solomon which was surrounded by golden lions and golden birds on a golden tree. At the entrance of visitors and their prostration on the floor, the emperor was glimpsed in his robes and regalia, the throne was elevated, the lions seemed to roar and the birds to sing. For extra effect, this display of imperial power was repeated several times.[17] Visitors to the palace of Constantine VII Porphyrogenitos were still being treated to the same magnificent spectacle (and all is recorded in the *Book of Ceremonies*), although it seems it was a new version as it has been suggested that Michael III melted down the gold. What was the source of these famous automata? Byzantium had the technology to make organs which were used in secular ceremonial only, but considered unsuitable for church use. One had been sent as an extravagant gift to the Frankish king Pepin in 757. Byzantium also had the technology to make some kind of flame-thrower (Greek fire) used in sea battles. But the idea, if not the technical expertise, for the throne most probably came from

65

Cloisonné enamelled reliquary box with Crucifixion and 27 saints. Fieschi-Morgan *Staurotheke*. Constantinople[?]. Ninth century, after 843[?].

The reliquary had silver compartments for a piece of the True Cross, making it a *Staurotheke*. The back of the enamelled cover has four scenes in *niello* (Annunciation, Nativity, Crucifixion and *Anastasis*). Christ on the cover wears the long *colobion* and has open eyes.

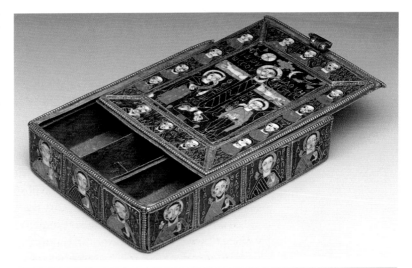

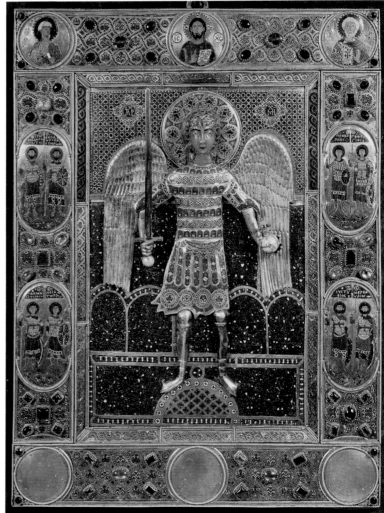

66

Cloisonné enamel icon with full-length figure of Archangel Michael. Constantinople. Around 1100.

It is presumed that this object came to Venice with the loot from Constantinople in 1204. Its virtuoso technical expertise and use of gold, silver, and stones must have dazzled the medieval viewer. Most likely, it was an imperial commission and kept in one of the churches in the Great Palace.

the Islamic court in Persia, at Baghdad or Samarra, with whom Theophilos had regular contact, and whose luxury at this time we know through the stories of the *Arabian Nights*.

The Great Palace also on these occasions put on display its many treasures, including great Persian silks. Silk was widely used in court dress and church vestments, hangings, and altar frontals. Since the seventh century the silk was highly prized and its manufacture and export strictly controlled. A few silks from Byzantium reached the west where they were often used as wrappings for holy relics. Silks produced in Syria and Persia in the eighth and ninth centuries have the same fine and compact quality, and their designs and styles can be indistinguishable from Byzantine products.[18] This makes for art-historical difficulties of attribution, and, in terms of interpretation, suggests, at the least, mutual sharing of ideas between Constantinople and the east.

Islamic influence has been recognized in this period not only in secular situations, but also in the imitation of Arabic writing, or Kufic, in religious paintings and as exterior decoration on churches, as, for example, the Theotokos church at Hosios Loukas [**92**]. The term 'pseudo-Kufic' in these circumstances conveys that the writing is decorative, and usually unreadable as genuine text.[19] Paper was introduced into the Byzantine world by the Arabs around 800, but did not catch on for common use until the eleventh century, when its prime purpose was for archival documents and imperial charters. When paper was used for religious books in the fourteenth century and onwards, the main source was Italy.

The revival of art after iconoclasm reveals a society looking outwards and artists and patrons who were open to new ideas. Constantinople was celebrated as a highly cosmopolitan city, no longer the fortress capital of the iconoclast period. Byzantium was rapidly realigning itself as a world power, a Christian culture realigned with the west in their mutual acceptance of figurative images in the church.

The mosaic decoration of St Sophia

If St Sophia was the Byzantine 'ideal' church, then every iconophile must have known that this had to be the showpiece monument of the new age after 843. It had to maintain an image as both the exception and the norm among Orthodox churches. Since St Sophia was the goal of every visitor to the city, and also accommodated the grand state occasions as well as housing some of the great relics of Christianity, the impression it gave offers us an understanding of Byzantium as it wished to be understood. Germanos wrote his description of the Christian church with St Sophia in mind; after iconoclasm this image would need bringing up to date. The problem was that the interior of St Sophia was so vast and high that it was inaccessible without massive wooden scaffolding. It required expertise, workers, time, and re-

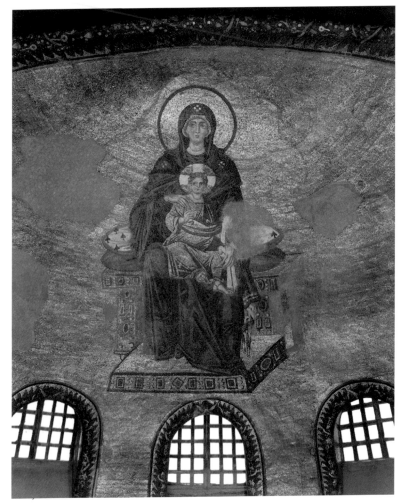

sources. It also required imagination and planning, because the architects of the sixth century did not build surfaces with a figurative overlay in mind. Beyond icons and no doubt other special furnishings, nothing had been done to replace the carpet decoration of crosses over the vaults by the time that Photios became patriarch on Christmas Day 858, the anniversary day of the dedication of the church. His personal dedication to this project resulted in the first new mosaic of the church [**67**]. It was in the apse and it had the obviously appropriate subject, considering the festival of the church and the symbolism of the conch of the apse outlined by Germanos ('The apse corresponds to the cave in Bethlehem where Christ was born, as well as the cave in which he was buried'): the Mother of God and her Son, the theme of the Incarnation of Christ.[20] Photios recorded the achievement with a hyperbolic dedication sermon:

If one called this day the beginning and day of Orthodoxy (lest I say something excessive), one would not be far wrong. For though the time is short

since the pride of the iconoclastic heresy has been reduced to ashes, and true religion has spread its lights to the ends of the world, fired like a beacon by imperial and divine command, this too is our ornament; for it is the achievement of the same God-loving reign.[21]

The day in question was Holy Saturday, 29 March 867, quite an interval since 843, but underlining the effort needed to organize the redecoration of the church. Work on the imperial palace had been proceeding somewhat faster: the new icon of Christ over the Chalke Gate was finished before 847, the Pharos Church by 864, and the Chrysotriklinos and other imperial areas between 856 and 867, either because caution suggested that the public display of icons should be carefully staged or because these works were easier to organize and more easily financed.

Photios's celebratory oration (Homily XVII) on the inauguration of the first mosaic after iconoclasm in St Sophia is one of the key documents of Byzantine art history. It is a public statement on a work of art in St Sophia given in the presence of the joint emperors by a celebrated intellectual. Photios's career is exceptional: he had been promoted in a week from a high position in the civil service in order to become priest and leader of the Orthodox church. His elevation was unconventional, and it involved the expulsion from office of Patriarch Ignatios, causing open hostility among the various groups in the church. Photios was banished in September 867, but returned as patriarch on the death of Ignatios in 877. The text of his oration of 867 is preserved in a collection of eighteen homilies in chronological order from his first period in office. He may have given the texts to a scribe for transcription or they may have been taken down in shorthand in the church while he was speaking from the ambo in the nave; both these systems were used by patriarchs in this period. The style of writing is florid and difficult in the extreme, but with ample evidence of the speaker's vast learning: he was the author of the *Bibliotheca*, a compilation of book reviews of the 279 volumes he had read over his lifetime, a number that has been described as a substantial proportion of all the books available in Constantinople in the ninth century.[22] Like all writings about art in Byzantium, the text is phrased in the critical vocabulary of *mimesis*, or imitation, derived from antiquity, not well suited to the differing aesthetic aims of Byzantine art. Photios does however subtly modify the notion of imitation with the addition of current iconophile expressions of the presence of the model within the representation (Mary is described as both 'lifelike imitation' and the 'real archetype'). Nor is it intended as an art-historical description of a mosaic high above the congregation; it is, as Byzantine *ekphrasis* tended to be, a literary meditation inspired by a visual image. This seems sufficient to account for the differences between the mosaic decoration in the apse uncovered during restoration work between 1935 and 1939, and with further examination in 1964, and the description of the Virgin and Child in the

homily.[23] The archaeological probe found the crucial information that the whole mosaic surface of the apse and sanctuary arch decoration was both homogeneous and coeval with the dedication inscription: 'The images which the heretics had cast down from here, pious emperors have set up again.' The co-emperors on Holy Saturday 867 were Michael III and Basil I; by September of that year Michael had been murdered by Basil and Photios was out of office. The scaffolding needed to undertake the work in the apse would have been immense. Despite the suggestion in the inscription and in Photios's oration that the iconoclasts had removed images from the apse, there is no evidence that its Justinianic decoration, most likely centred on a cross, was changed. This sounds more like rhetoric than ignorance on Photios's part. The year 867 may also have been the only time between Justinian and the Ottoman concealment of the image that a scaffolding had been erected in the sanctuary.[24]

Though we may visualize the actual occasion of the unveiling of the mosaic and read an iconophile statement of the devotional and didactic functions of this particular mosaic, this was an image that from 867 became a part of the permanent experience of the viewer who entered St Sophia. Against the clear gold background symbolizing heavenly light, Mary sits on a backless throne with the Christ child on her lap; with her right hand, she seems both to hold and to point to him—or as Photios describes her depiction, as 'an interceder for our salvation and teacher of reverence to God'. Photios does not mention the figures of the Archangels Michael and Gabriel represented on either side of the conch, although they add to the regal impression of the whole composition. He does however make clear his intentions to decorate the rest of the church in the final prayers at the end of the homily, which is addressed to 'the Word, Bridegroom, and Wisdom of the Father in which name the church is dedicated': 'Grant those also who have received it through you to reign on earth to consecrate the remainder of the church also with holy images.' No doubt Photios had more ideas for this decoration, and the decision to place the Virgin and Child in the apse probably indicates that the dome was to receive an image of Christ to replace the sixth-century cross.

The occasion for the further decoration of the vaults of St Sophia was soon forthcoming. In 869 an earthquake damaged the great western arch and other parts, and Basil I ordered a restoration. The arch, we are told, was redecorated with mosaics of the Virgin and Child between Sts Peter and Paul. An inscription recording the imperial restoration was inscribed in mosaic on the great north and south tympanum under the dome, a few letters of which survive, and parts of this decoration are still visible in the church in the lower parts of each tympanum.[25] The scheme was of standing figures under an image of Christ in the dome; this mosaic was damaged by collapses in 989 and 1346, and

Mosaic panel of St Ignatios the Younger, patriarch of Constantinople (847–58 and 867–77). Last quarter of the ninth century. North tympanum, St Sophia, Constantinople.

The Church Fathers were uncovered 1939–48. They belong to the new decoration of the church after iconoclasm when figures were set in the area below the dome in which Christ was represented. Prophets were in the area above the Church Fathers, most of whom seem chosen for their special connections with St Sophia. Ignatios is rarely found in Byzantine art. This image, which accurately shows him beardless (he had been a eunuch from the age of 14), is presumably a genuine portrait made soon after his death.

was remade after 1355, as probably the last Byzantine mosaic to be manufactured in Constantinople. In the pendentives were 4 seraphim; in the tympana there were (from top down) 4 archangels (2 on each tympanum), 4 major prophets (2 on each side), and 12 minor prophets (6 on each side between the windows). The lowest level consisted of church fathers in the niches, making 14 figures in all, only 4 of which are preserved. The choice of these saints seems to have been made on the grounds of their connections with St Sophia (8 had an annual commemoration) or with topical considerations of the time—the inclusion of St Gregory the Illuminator, the Armenian national saint, would link with a myth said to have been invented by Photios that Basil I had an Armenian royal pedigree. One of the figures is the sainted Patriarch Ignatios (847–58 and 867–77) [**68**]. The mosaics were probably finished soon after the death of Ignatios in 877 during the second patriarchate of Photios.

This ninth-century redecoration of the vaults included a few scenes where the architecture of the church allowed it: a Majesty of Christ and Pentecost in the two vaults of the central bay of the south gallery, and a Baptism in the same position in the north gallery (the second subject is unknown). Hidden from public view, the large *Sekreton* of the patriarchate on the gallery level of the church was decorated. This was a case of genuine restoration after the recorded iconoclast destruction

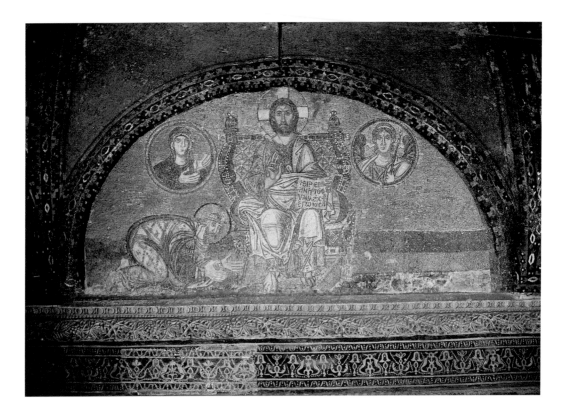

Lunette panel of Christ.
Around 900. Above central
door, inner narthex of St
Sophia, Constantinople.

An emperor venerates the
enthroned Christ. Mary (in a
medallion) holds her hands in
intercession and an archangel
(in a medallion) is to the right
of the lyre-backed throne.
There was no figure to the right
of Christ. The emperor is
unnamed, and has been
identified most often as Leo VI.
The mosaic is above the great
ceremonial entrance to St
Sophia, where patriarch and
emperor entered together.

of the room by Niketas in 768/9. The mosaics here are very fragmentary, but enough remains to suggest a dating of around 870 (the tree-ring dating of the wood used gives a date of after 854). This, too, was a single-figure scheme: Christ enthroned between Mary and St John the Baptist above the door into the church, and witnesses of Christ or his cross on icons around the walls, including apostles, prophets, Stephen and Constantine, and significant iconophile patriarchs, including Nikephoros and Methodios. Again this is a cycle that indicates an originally topical choice, but subsequent timeless icons.

The core of the mosaic decoration of St Sophia belongs to the ninth century, but further panels were added after this ensemble was completed. The effect is piecemeal in our terms, but successive generations of Byzantine viewers no doubt treated the decoration as a unity. Hidden away in the central bay of the north gallery is a single image of the emperor Alexander, who was sole emperor between 912 and 913, which to our viewing fits into no clear scheme. More obviously central to the viewing experience are the two lunette mosaics, one over the entrance door from the south-west vestibule and one over the central door into the nave from the inner narthex, called 'the Royal Doors' by Constantine VII Porphyrogenitos, used by emperor and patriarch on their ceremonial entrances [5, 69]. Their sequential positions and parallel references to emperors in the presence of God suggest a close connection, but the dates of

both are highly controversial, the vestibule being dated to the late ninth or tenth century, and the narthex to the second half of the ninth or first half of the tenth century. The vestibule panel describes the past great emperors, Constantine and Justinian, in the presence of the Virgin and Child [**5**]; and the narthex lunette shows an unnamed but also haloed emperor kneeling in *proskynesis* before Christ, seated on a lyre-backed throne, with medallion portraits of Mary and an archangel above [**69**]. The book held by Christ has two linked texts from the Gospel of St John: 'Peace unto you; I am the light of the world.' The symbolic connection of the pair might be seen as the Christ of the First Coming in the vestibule and of the Second Coming in the narthex, and a theological connection along these lines could be made without reference to the date of each component. However, the narthex mosaic has become in itself the subject of debate for the understanding of pictorial meaning in Byzantine art.

A substantial literature since its discovery and publication in 1933 has examined its date and its symbolic meanings. The emperor has been identified either as Basil I (866–86), his son Leo VI (886–912), or even his grandson Constantine VII Porphyrogenitos (913–59). Russian visitors in later centuries who entered St Sophia referred to an image of Leo VI in this area, but their accounts are as likely to be evidence of the myths that were popularly repeated about the church as historical fact. Several possible meanings of the mosaic have been suggested, some based on theological texts, some on historical correlations, and some on pictorial considerations. An important reappraisal of the evidence in 1976 shifted the discussion by connecting all the elements very precisely with one historical event.[26] The subject was suggested as unique and precise: the humiliation of Leo VI by the church, recording his exclusion from St Sophia from Christmas 906 for a terrible sin and his ultimate reconciliation through his repentance just before his death in 912. It has been suggested that Patriarch Nicholas Mysticos set up the mosaic in 920 as a record of the subjection of the earthly ruler to Christ and the church.

The background issue needs clarification and concerns canon law on marriage. According to this law an Orthodox Christian could marry only once; a second marriage was tolerated reluctantly. As for a third marriage, St Basil and others made it clear that this was 'polygamy and fornication'. A further marriage was 'beastly polygamy' and 'a way of life befitting swine and contrary to human nature'; it was a sin 'worse than fornication'. This was a live issue around 900, and Leo VI had in his youth (unwisely as it turned out) issued a law condemning third marriages. He did not anticipate his own problems with his ambition to produce a male heir. His first wife Theophano died childless in 897, and was declared a saint. Leo promptly married his mistress Zoe, who had already produced a daughter. She died 20 months later without further issue. Leo managed with extreme difficulty to extract

from the patriarch a dispensation for a third marriage, and in 900 married Eudokia Baiane, described in the sources as 'outstandingly beautiful'. She died in childbirth in 901 and the son survived only a few days after the christening. An inlaid marble icon of St Eudokia found in the church of Constantine Lips at Constantinople, founded in 907, may be an indication that she, too, was unofficially canonized and her cult promoted by the court.[27] Leo at the age of 35 had gone through three marriages and still had no male heir. His reaction was now first to father a son, and secondly, to think about legitimacy. So he flouted public opinion by taking a mistress, also called Zoe, in 901, who soon produced a child, a girl; their second child was a son, born in September 905, the future emperor Constantine VII Porphyrogenitos.

Leo persuaded Patriarch Nicholas to christen his heir in St Sophia on 6 January 906, but failed to get the dispensation for a fourth marriage. He married in a private church ceremony in the palace. Hence his exclusion from St Sophia from January 906. He was refused entrance into St Sophia, perhaps at the Royal Door. After a year, Nicholas was expelled from office, and from February 907 Leo was allowed entrance into St Sophia as a penitent. When he died in 912, he had, according to ex-patriarch Nicholas, written a last will condemning his fourth marriage, asking forgiveness, and restoring the latter to power. The mosaic can be seen as a sign of reconciliation set up by Patriarch Nicholas in 920, symbolizing Christ's message of 'peace'.

An interpretation of a Byzantine mosaic along these lines puts all its weight on topicality and on a single meaning. It makes an insider knowledge of events essential for a meaning, and without that knowledge there can be no understanding. In this case, the necessary 'facts' are several. The patron must be the patriarch Nicholas, not an emperor. The date must be right. The emperor must be Leo VI, although he is unnamed and the patriarch not represented; archaeological examination has shown that a figure on the right side of the lunette never existed. There is also a compromise position possible here: that Leo VI himself put up the mosaic as a sign of his penitence after 907. Viewers of any period need to know this information if they are to perceive that the action of the emperor kneeling before Christ is a grovelling prayer for forgiveness rather than a conventional act of humility with all the attached connotations. What if they ask how this reading can be confirmed? What if they suggest that the omission of the emperor's name was to communicate a general and fluid set of meanings?

The theoretical questions raised are about multiplicities of meanings in religious art, and the resolution of alternative interpretations, and how in Byzantium to handle the contrast between the topical circumstances which led to every artistic commission and the often apparent universality of the resultant imagery when the immediate topical reference is hidden. An art that supported and confirmed social values was

likely to be conformist in its subjects and treatments. In this case, as well as a multiplicity of visual hints and clues, there is a written text on Christ's book. The combination of phrases from the Gospel is claimed to be unique to this mosaic. Obviously, this is where the factor of losses of material cannot be ignored, but so far at least no exact parallel has been found. Another church exists, however, with another combination of passages from the Gospel of St John. These are found in the lunette mosaics above the entrance door from the narthex into the nave of the katholikon which was dedicated to the Annunciation, of the monastery of Vatopedi on Mount Athos.[28] The mosaics are an Annunciation and *Deisis*, and a dedication poem around the lunette refers to the donor Abbot Ioannikios and his disciple monk Sophronios, thus giving a date for the *Deisis* of around 1100. The texts written on Christ's book come from the Gospel of St John, as do those in St Sophia: 'I am the Light of the World. The Truth. The Life. The Resurrection. The Way. The Shepherd. The Door. Whoever enters through me will be saved.' While it is true that the word 'Peace' is not included, these harmonized texts from St John point to a primarily theological function of imagery for the faithful at the door of the church, and to the need to ask whether this might be the solution for St Sophia, too.

The visual problem is that the prostrate position of the emperor does not necessarily imply humiliation. Humility and repentance constituted the everyday language of the Orthodox emperor. It was under this door that every emperor fell in *proskynesis* before entering the church—a sight that so overwhelmed ambassadors from Kiev in 988 that they said they knew not whether they were in heaven or on earth. The viewer would know that only the Byzantine emperor came so directly close to Christ. His special access deserved humility; but it was no humiliation to recognize the King of Kings, portrayed here in the same type as on the coins of Justinian II; the innovation of Basil I's coinage was to replace the bust of Christ with a bearded Christ on a lyre-backed throne, just as in this mosaic.

The stylistic considerations of this mosaic—its similarity with the Homilies of Gregory of Nazianzus of 879 to 882 [**70**], and with the enthroned Christ in the large *Sekreton*—mean that a dating of around 880 cannot be ruled out. This would set it into the orbit of Photios and Basil I, and suggests its planning might be along the same lines as the apse mosaic, as documented in Photios's seventeenth homily. The emphasis at the entrance door was perhaps more on the dedication of the church to Holy Wisdom, the Logos, or the Incarnate Christ and less on the private life of the emperor. If the medallions evoke the Annunciation, then Christ with an open book becomes the Incarnate Christ as Logos, granting the gift of Peace and Wisdom to any Byzantine emperor entering St Sophia and its sister church St Eirene. The debate about the interpretation of this mosaic concerns the read-

70

Manuscript miniature with Raising of Lazarus and Entry into Jerusalem. Homilies of St Gregory of Nazianzus. Constantinople. 879–82. Tempera.

The manuscript was made for Emperor Basil I and his family, and no doubt its complex theological cycle was planned by Photios. Technically, the paintings have flaked very badly, revealing the artist's underdrawing beneath.

ing of Byzantine art in general, and how far knowledge of the detailed circumstances of production change the meanings rather than add to a fuller knowedge of the period. How far can the conventions of the public viewing of Byzantine art be set out, and how far can the now distant intentions of the individual planners lead the interpretation? In other, better-documented periods, this may be an unnecessary dichotomy; but for the student of Byzantine art, the narthex mosaic and its interpretation exhibit all the problems of handling the frequent anonymity of Byantine art and its producers.

Further panels in St Sophia were added at different times in later pe-

71

Mosaic panel with Christ, Emperor Constantine IX Monomachos, and Zoe. The Zoe Panel. 1028–34 and 1042–55. East wall, south gallery of St Sophia, Constantinople.

The mosaic was uncovered between 1934 and 1938; the lower section was not preserved. Although the changes made in the second phase of the mosaic's history (alterations of the inscriptions to add Constantine's name and the insertion of a new head each for all 3 figures) are visible since the restoration, the sutures were probably originally fully masked with painted plaster seams.

riods, and they, too, show Byzantine perceptions of the emperor's relationship with God. Two record and declare an act of generosity, and while this was no doubt intended to be communicated without great ambiguity, problems arise for us. These are the panels on the east wall of the south gallery, next to the doorway that then opened to a high walkway between St Sophia and the Great Palace. The south gallery acted as a private imperial preserve which had its own staircase down to the ground floor. The first panel was set up during the power struggles as the Macedonian dynasty was coming to an end through lack of male heirs in the eleventh century. Dynastic prestige was such that Zoe, middle daughter of Constantine VIII (1025–8), who was born around 978 and died in 1050, was by common assent the conduit through which power passed. She legitimated four emperors by marriage or adoption.

Zoe and her first husband, Romanos III Argyros (1028–34), gave a special donation to St Sophia, and arranged for a supplementary annual income to the church to be paid out of the imperial treasury. At the same time, the capitals of the church were gilded. This substantial act of generosity and piety was conspicuously recorded in the new panel in the south gallery [71] which showed Christ enthroned, gra-

ciously accepting the gift, the emperor in pride of place at Christ's right hand holding a purse filled with coins, and the empress on the right, lower down than her husband, holding the written contract of the donation. This was a commemorative plaque, set up no doubt on the first occasion of the donation, but recording (and ensuring) the endowment for perpetuity. In the event, however, both the panel and the act of piety it now records have been carefully altered. In the inscriptions, some new tesserae have been added and others have been chipped out one by one to change the name of the emperor to that of Zoe's third husband, Constantine IX Monomachos (1042–55). Between 1042 and 1050, the imperial couple gave an additional annual income to St Sophia to ensure that the cathedral could in future celebrate the liturgy daily instead of, as previously, only on great festival days, Saturdays, and Sundays. The Zoe Panel continued to commemorate the piety of emperor and empress, except that it was a different emperor and a different donation.

A puzzling feature of this mosaic in its altered form is why the mosaicist was required to do more than simply adjust the image and inscription of the emperor—in fact the faces, but not the bodies, of all three figures, Constantine, Christ, and Zoe, were remade at the time of the new dedication. One proposed explanation is that the patriarch in office at the time, Michael Keroularios, organized the work and saved money by substituting the heads from some other mosaic. This seems improbable as well as near impractical. The control of the project is more likely to have come directly from the palace, and Constantine was never an economical master, but one of the greatest patrons of mosaic in the history of Byzantine art. His highly ambitious projects included a massive new monastery in Constantinople known as St George of the Mangana, Nea Moni on Chios, and the restoration of the Holy Sepulchre in Jerusalem. The treatment of the Zoe Panel is therefore more likely to have some positive significance, and not done for simple reasons of economy. One further complication in the career of Zoe has been seen as relevant.[29] After the death of her second husband Michael IV the Paphlagonian (1034–41), Zoe adopted as son and heir Michael V Kalaphates (1041–2). Once on the throne, he exiled Zoe to the Princes Islands in the Sea of Marmara in 1042, thereby precipitating a public riot and his own rapid fall. He was sent, blinded, to Chios by Constantine Monomachos. It has been speculated that during this time of violence Michael destroyed Zoe's face in the mosaic as an act of *damnatio memoriae* in order to terminate her political influence. While this might seem to explain the need later to remake Zoe's face, it too is an unlikely theory. It assumes that Byzantium, and the Roman empire before it, had recognized procedures of eliminating people from power. This is probably an exaggeration, and the removal of names of enemies from public monuments happened in Rome only rarely and unsystem-

atically; it was not an established system to be passed on to Byzantium. This makes it improbable that Michael V engaged in such an action, and indeed it would have been irrational to destroy Zoe's face, but leave untouched her inscribed title 'ZOE THE MOST PIOUS AUGUSTA'. Most likely, therefore, the mosaic panel was changed only once, and the attention given to the faces and eyes matches the Byzantine interest in the gaze of figures which is found in the sixth-century verses of Agathias on an icon of St Michael. Changing the face of Christ may therefore have been a pictorial strategy designed to show his specific favour to the new imperial couple. Whatever the reason, it was an esoteric action since few would ever know of the changes—the divisions between old and new mosaics would have been hardly visible to the eye in the eleventh century—since any gaps were masked by painted plaster which has crumbled over time.

The companion panel shows another act of donation to St Sophia by Emperor John II Komnenos (1118–43) and Empress Eirene [72]. The only ambiguity here is whether the awkward fitting in of their son Alexios on the right was original or added when he was made co-emperor in 1122. The donation is not otherwise recorded and cannot be dated. Since the panels are pendants, no one could fail to see that the central image here is the Virgin Mary with Christ. In this panel, a new point is being made about imperial spirituality and ideology; it was also pictorially developed on coins in the twelfth century where a number of images of Mary appear.

The importance of the decoration of St Sophia is that it is quite exceptional in the Byzantine experience, yet it also had to define the social norms. Every Byzantine and every visitor to Constantinople must have wanted to attend a service in St Sophia and to visit the relics which were collected and displayed around the building. Each alteration to the church was specially considered and organized at the 'top' of Byzantine society, the patriarch and the higher clergy, the emperor and the court, and in this respect it does document the decisions of the élite, however much they may have been responding to the expectations of the public. St Sophia takes us to the centre of Byzantine art, culture, and politics in a way that no other monument can.

'Macedonian Renaissance'

Byzantine art history has sought an explanation for the flourishing of the arts in the period after iconoclasm that would account for its striking quality and characteristics as a cultural phenomenon and not merely as a symptom of material success. A frequent solution is the designation of the tenth century as the 'Macedonian Renaissance'.[30]

The term 'renaissance' recurs frequently in Byzantine art history writing, but the tenth century has always been at the centre of the debate, with the Paris Psalter and the Joshua Roll as the central witnesses

Mosaic panel with Virgin and Child, John II Komnenos, Eirene, and Alexios. 1118–34. East wall, south gallery, St Sophia, Constantinople.

This was a pendant to the right of the Zoe Panel, and was designed with differences and similarities. John's eldest son is set at right angles to the main panel, but may be homogeneous. In this case the donation must date after 1122 when Alexios was proclaimed co-ruler.

[60, 61]. The other key periods are a 'Komnenian renaissance' of the twelfth century, and a 'Palaiologan renaissance' after the recapture of Constantinople in 1261; but there are other periods, too, under consideration—even the mosaics of the Rotunda in Thessaloniki are a 'renaissance' candidate. The common factor in these works and periods is their stylistic fluency in the naturalistic style of classical antiquity, and the knowledge they show of the vocabulary of ancient art.[31] In the case of the Rotunda, there are echoes of the theatrical and architectural façades of Pompeian wall painting, and echoes in the case of the Paris Psalter of classical figures in landscapes and other settings, and the additional feature of classicizing personifications around the biblical figures. David is shown composing the Psalms with the help of Melodia; the rural setting evoked by a nymph of a spring and a river god is incongruously labelled 'hill of Bethlehem', but refers to David's place of birth [61].

The concept of renaissance in art only arises when periods after antiquity are felt to be directly linked with it in their stylistic intentions. Italian art of the fourteenth to the sixteenth centuries has been seen in this light, and the phenomenon was called the *rinascita* (rebirth) by Giorgio Vasari when he traced its history in the middle of the sixteenth century. His history of this art argued for an initial parting of the ways from Byzantine art in Italy in the late thirteenth century and he distinguished Italy's own discovery of antiquity from Byzantium's ignorance. It is therefore a contradiction of Vasari's narrative to reverse these values and claim episodes of renaissance in Byzantium, and so effectively to imply the prior discovery of antiquity in Byzantium. To avoid over-

playing the idea that the Middle Ages initiated *the* Renaissance, additional terms have been suggested for the identifiable periods of medieval use of antique styles in both the east and west, such as 'renaissance' with a small r, 'renascence', and *renovatio* and 'pre-renaissance'. Another way of refining the debate over the 'Byzantine Question' has been to propose criteria for denoting a renaissance: some basic ones proposed are that it must take place over a definable period of time, that it must encompass literature as well as the arts, and must create an intense intellectual climate, and that it must directly involve the study of antiquity and the pagan culture associated with it. The question is then whether any period in the Middle Ages can be justifiably termed one of renaissance before the Italian Renaissance.

The search to justify a 'Macedonian Renaissance' has led to both positive and negative assessments. Some scholars have argued that a period of successful re-creation of antiquity in art should be dated within the reign of Constantine VII Porphyrogenitos (913–59), with a corresponding knowledge of classical literature among the educated élite of Constantinople. A reference to rebirth (*palingenesia*) in a text of the time has also been used as a pointer to a self-awareness of a time of 'renaissance', although the word means little more than revival. The two works at the centre of the debate, the Paris Psalter and the Joshua Roll, do re-create classical narrative style. But did their classicism lie in their abilities to reproduce models from an earlier period? Or did they construct new compositions *all' antica*, working piecemeal from a creative knowledge of classical and Christian art? In either case, a decision is impossible so long as we do not have these models. Surprisingly, though, both methods of working are thought applicable to a period of renaissance.

The case against the 'Macedonian Renaissance', and equally against all the other periods of so-called renaissance, rests on questioning the extent of the movement and the relative degree of knowledge of and immersion in classical antiquity compared with the paradigm case of Italy. While there is evidence of the copying and reading of classical texts during this reign, this can be matched in earlier periods, like that of Photios and his circle in the ninth century and that of Arethas, archbishop of Caesarea, at the turn of the ninth century. The perennial, if fluctuating, Byzantine intellectual interest in antiquity undermines the notion of a decisive break in the Byzantine awareness of the classical past before the tenth century.[32] How to treat pagan knowledge had exercised theologians since late antiquity.

The scholarly stalemate over the feasibility of a concept of renaissance in Byzantium has prompted alternative interpretations of the same phenomena, the most frequent of which has been to view classicism as an endemic feature, a constant in Byzantine culture, emerging in different ways at different times. Rhetoric has been suggested as one

vehicle that maintained classicism; it remained part of the curriculum of advanced education, and teaching was based on the ancient hand-books and exercises, on selected ancient orators and church fathers, and collections of Byzantine speeches.[33] In this sense, Byzantium is it-self a true continuation of the Roman empire with its equally complex uses of classicism. But the conceptual trap that faces the art historian is to see only the continuities and to ignore the changes and discontinu-ities.[34] In the early Byzantine period, there is a clear continuity of tech-niques between Faiyum mummy painting and the early Sinai icons; but the character of the portraiture, especially noticeable in the treat-ment of the gaze, and the functions of the imagery, has radically changed. Similarly the Paris Psalter, for all its superficial similarities with Pompeian painting, is in a medium unknown at Pompeii—the fully painted codex page—and its juxtaposition of David and Melodia as sacred biblical king with his intellectual persona in a pastoral land-scape can be contrasted as much as it can be compared with antique art. The Small Metropolis at Athens, a church, perhaps of the twelfth cen-tury, with an exterior coated with classical and medieval carved reliefs, is a triumphant declaration of the victory of Christianity over pagan-ism, not a Renaissance product or evidence of superficial continuity. The stereotypical view of the Byzantine icon as anti-classicist is an ex-aggeration; and Vasari's notion of the nature of Byzantine art may apply better to Romanesque art in Italy than it does to the art of Constantinople. Byzantine art was always related to but different from classical art, and in ways that varied at different periods.

Questions of continuity and discontinuity, and knowledge and mis-understanding of classical culture, are probably easier to quantify in Byzantine literature than in the visual arts.[35] We can also see the cost and rarity of the books that put classical (and all other) literature be-yond the reach of ordinary Byzantines—manual workers were paid 6 to 10 *nomismata* a year. A stipend of 72 *nomismata* in the civil service seems to have been adequate, though the average has been put higher, at a few hundred. Annotations in some of the books of Archbishop Arethas around 900 recorded their cost: his Euclid cost 14 *nomismata* (perhaps not including the parchment), his Plato 21 *nomismata* (8 for the parchment), his Clement of Alexandria 26 *nomismata* (6 for the parchment). These books had no miniatures, which would have in-creased the cost substantially. A manuscript of 300 to 400 folia would, according to these statistics, have cost in the tenth century between 15 and 20 *nomismata* for the parchment and transcription.[36] Libraries in these circumstances were unsurprisingly few in number and small in size. The importance of the Patriarchal Library at the time of the Council of Nicaea in 787 is very obvious.

The seventeenth homily of Photios exhibits both his special knowl-edge of the past, and also the burden, as well as the advantages, of writ-

ing in a great tradition. Photios did in the event find his 'own voice', but at some expense of clarity. What has been seen as distinctive about the tenth century was that it was a period of encyclopaedic enterprises and compilations, side by side with the copying of earlier manuscripts from majuscule into miniscule script. The *Book of Ceremonies* was, as we have seen, just one of several attempts to collect and collate state protocol and policies in the imperial palace. However, even in these enterprises, there are earlier parallels, both in the codifications of the law by Justinian and other emperors, and in the anthologies of theological and spiritual learning compiled in the eighth century, resulting in such beautiful manuscript presentations as the late ninth-century *Sacra Parallela* of St John of Damascus [**62**]. In the careers of Photios in the ninth century and Michael Psellos in the eleventh, we can see how Byzantine intellectuals strove to combine classical learning with Christian truth, and to find a discourse in which to express this. Art confronted the same dilemma.

Yet the awareness of the past in tenth-century Byzantium hardly compares with the radical redirection of architecture and the visual arts during the Italian Renaissance and with the systematic humanist study of Greek and Latin books. Byzantine texts mention the names of famous artists of antiquity, but there is no evidence of their works being sought out among the collections of statuary in Constantinople. The culture of tenth-century Byzantium owed much to antiquity, but not with the intensity of Florence or Rome in the Renaissance. Any attempt to raise Constantine VII Porphyrogenitos to the level of a Medici patron is inappropriate, and probably misleading. The question of Constantine's patronage and support of the arts may be a broader question about 'imperial' art and the patronage of the court and the civil service. When all the known art of tenth-century Byzantium is taken into account, a different picture of the period begins to emerge.

The closest work of art to Constantine VII Porphyrogenitos is a commemorative ivory plaque recording his long-delayed accession as the sole emperor in 945 [**73**].[37] Under a canopy, the emperor is shown bowing to Christ and holding his hands in a gesture of prayer and adoration, close to Mary's gesture in the narthex mosaic of St Sophia. His title is written out on the plaque: 'CONSTANTINE IN CHRIST EMPEROR AND BASILEUS OF THE ROMANS'. Christ is standing on a footstool with a scroll in his left hand. He touches Constantine's crown with his right hand: this is the identical gesture used in the scene of St John the Baptist baptizing Christ, and the symbolic parallels must have been immediately communicated to the Byzantine society in which the ideology of kingship accepted that the emperor arose through divine selection. The iconography of the acclamation and legitimation of an emperor was explored in the miniatures of the Paris ninth-century manuscript of the Homilies of Gregory of Nazianzus which include a

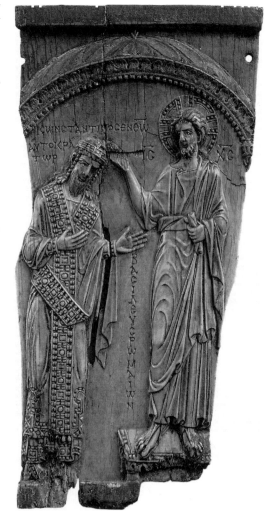

miniature of Gabriel touching the crown of Basil I, Constantine's grandfather.[38] Legitimation of the Macedonian dynasty was an urgent need in the reign of Basil I since he was of peasant origin, and probably illiterate, and had gained sole power by his murder of his patron Michael III. Constantine in the ivory wears the imperial crown and, as his ceremonial garment, the gem-encrusted *loros*, but no other imperial attributes or the halo that the living emperors in the mosaics of St Sophia and elsewhere were usually given is shown. His demeanour is one of humility, which is coupled with the viewer's knowledge, as in the narthex mosaic of St Sophia, that the emperor had access to Christ which was beyond the hopes of lesser mortals. Similar imagery of the declaration of divine choice of a humble emperor and empress is seen on a coronation ivory where Christ touches the crown of Emperor Romanos II and Empress Eudokia, who are both shown with similar

Ivory plaque with Christ crowning Romanos and Eudokia. Constantinople.

Christ crowns husband and wife as emperor and empress of the Romans. Current consensus is that they are Romanos II and his wife, and that the plaque was produced between 945 and 949; the alternative would be Romanos IV and Eudokia Makrembolites between 1068 and 1071.

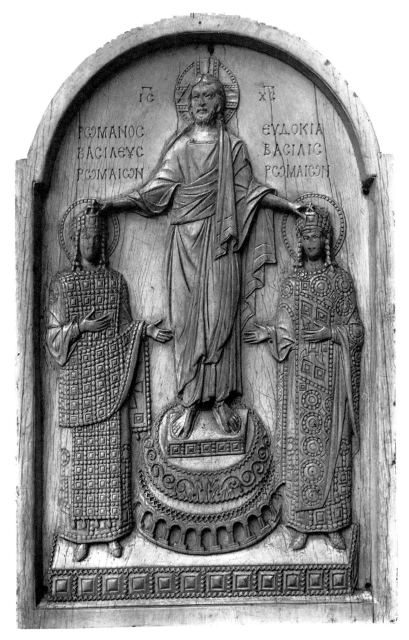

gestures to that of Constantine, but are haloed [**74**]. It has been suggested that the imperial couple are the son of Constantine VII Porphyrogenitos, who was crowned on Easter Day 945 as co-emperor, at the age of 6, and Eudokia, the western princess Bertha who was renamed Eudokia on her marriage at the age of 4. She died aged 8 in 949. This seems the correct dating of the ivory but an alternative dating identifies the couple as Romanos IV Diogenes (1068–71) and his wife, also named Eudokia. This eleventh-century dating not only has impli-

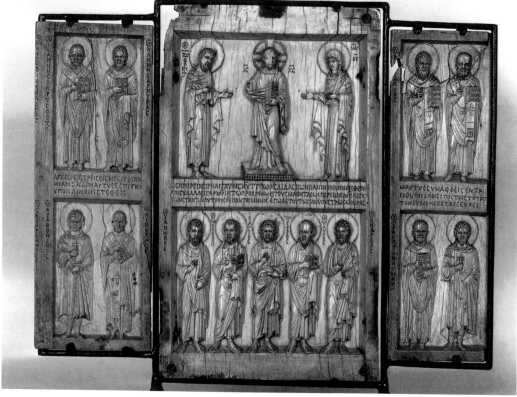

75

Ivory triptych with *Deisis* and Saints. Constantinople. Tenth century.

This is one of three similar triptychs from the tenth century, and perhaps the earliest. The inscription referring to Constantine has been associated with Emperor Constantine VII and used to support a dating between 945 and 959. Study of the saints represented on this triptych (thirteen on the front and eight on the reverse) has led to the suggestion that it was given by the emperor to a church dedicated to St Severianos (extreme right, lower register) and Agathonikos (extreme left, lower register).

cations for the imagery of imperial ideology, but also affects the general view that most Byzantine ivories belong to the tenth century, and that the medium virtually fell out of use in the course of the following century, partially replaced by other media, such as steatite and metalwork.[39]

The image of a pious and devout emperor is strongly promoted in other works of the reign. A mid-tenth-century ivory triptych (Palazzo Venezia, Rome) when opened out has a central scene of the *Deisis* with Christ and Mary and St John the Baptist, and the surrounding panels contain 21 images of saints [**75**]. The dedication inscription is a metrical prayer asking for the help of Christ, Mary, and the saints for one 'Constantine'. This is most likely to have been Constantine VII Porphyrogenitos, and the ivory to have been commissioned by him or by a loyal member of the court.[40] Piety is communicated in a different way in an icon with two wings at Sinai with the story of the *Mandylion* of Edessa, the *acheiropoietos* imprint of the face of Christ on a cloth, which was probably represented on the lost centre panel. According to Byzantine accounts, the *Mandylion* was taken to King Abgar at Edessa in the time of Christ and remained as the protection of the city until 944 when it was brought to Constantinople; its arrival at the palace where it was to be kept in the Pharos church is described in a text attributed to Constantine VII Porphyrogenitos. The *Mandylion* is first

Enamelled reliquary of the True Cross. The Limburg *Staurotheke*. Constantinople. Inner reliquary 959–63; enamels after 963.

This is the grandest Byzantine setting for a piece of the True Cross, and includes gilt metal as well as precious stones and enamels. An inscription records the donor of the enamels, Basil the *Nothos* ('bastard'), one of the best-documented artistic patrons of the tenth-century imperial court, who gained high office as a eunuch. He probably commissioned them soon after 963 (d.*c*.985). The treasury of S. Marco contains another commission by him (a chalice and paten). This reliquary was taken to Germany in 1207.

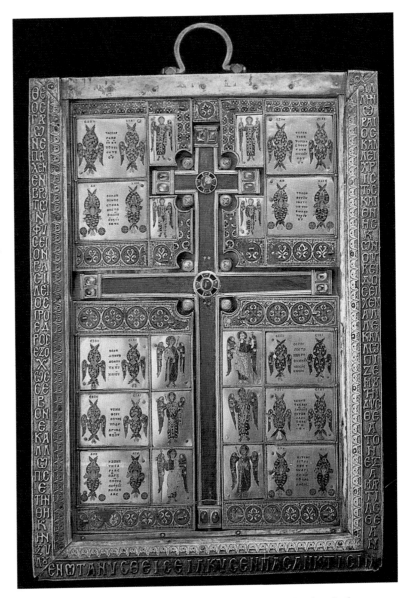

mentioned, like other miraculous icons of Christ, in the sixth century, and after the apparent disappearance of the *Kamouliana* icon during iconoclasm, it must have seemed a highly desirable replacement relic for the imperial city. The face of King Abgar on the icon resembles the portrait of Constantine on his coronation ivory and coins, which suggests that the icon was produced at Constantinople and sent to Sinai.[41]

The eunuch Basil the Nothos, or 'bastard', the son of Romanos I, who received one of the highest court titles (*proedros*) and exercised considerable power in the tenth century, as well as commissioning lavish works of art, was the patron of an extraordinarily rich object of piety when, soon after 963, he commissioned a *staurotheke* [**76**], a holder for a

Manuscript illustration of St Simeon Stylites. *Menologion* **of Basil II. Constantinople. Around 1000.**

The book is the first volume of a church calendar arranged chronologically and starting with the first day of the indiction, 1 September. The pages have a picture and a short notice about the saint or festival. The manuscript was produced by 8 artists under the supervision of the master Pantoleon. This page is painted by him; other artists followed his patterns and style.

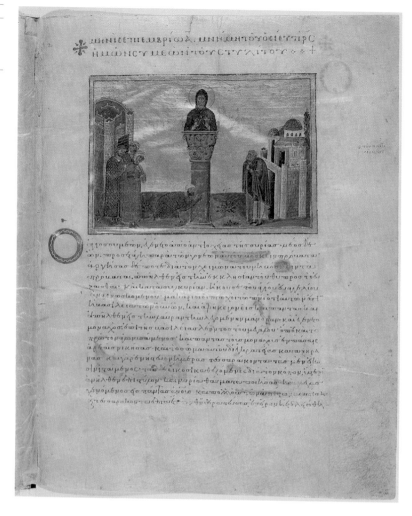

fragment of the True Cross and for other precious relics, including a piece of the towel with which Christ was said to have dried the apostles' feet. Decorated with a lavish amount of enamel and gems, it was in the form of a box made up of various sections and with a True Cross-shaped setting for the relic inside. Figures include seraphim, Sts Michael and Gabriel, a *Deisis*, and apostles and saints; inscriptions record not only the name of Basil but of the emperors Constantine and Romanos (probably Constantine VII Porphyrogenitos and Romanos II) who, we are told, crushed the barbarians just as Christ had broken down the gates of hell. The reliquary was kept in the palace until it became a major piece of crusader loot in 1207, was taken to a convent in Germany, and is now at the cathedral of Limburg. Another robust portrayal of imperial power and piety is also communicated in a pair of books produced for Basil II (976–1025), the grandson of Constantine VII Porphyrogenitos: a *menologion* (in the Vatican Library) [**77**] and a

Manuscript illustration of Basil II. Constantinople. Around 1000.

The illustrations consist of the picture of Basil II and a page with six scenes of the Life of David. The poem describing the portrait of Basil is on the facing page (fo. IIv.). All the features of the miniature are described, but the details left open, such as the identity of the emperor's enemies.

psalter (Venice, Marciana Library) [**78**]. The *menologion* is a church calendar (properly this is a *synaxarion*) with short notices for each saint; only the first volume, which starts on 1 September and goes to February, still exists. The page layout was to have 16 lines of text describing each saint or a commemoration, and a picture in the other half; 430 miniatures were finished, but the text is incomplete. Such a book implies the emperor's devotion to the saints, but it also includes a eulogistic poem praising the character of Basil II, and asking for help and intercession from the saints. The psalter has fewer miniatures, just a cycle of the life of David (which may have been meant to evoke typologically Basil's successful military and imperial career) and, more openly topical, an imperial miniature [**78**] with a supporting poem describing how the image is to be read. It is an *ekphrasis* which aims to elucidate pictorial content, and to emphasize that Basil's power came from God and that his success in overcoming enemies depended on his continuing piety and help from saints, six of whom are represented in icons:

Manuscript illustration of Leo and the Virgin. Bible. Constantinople. Second quarter of the tenth century.

Only the Old Testament section of the Bible commissioned by Leo for a monastery of St Nicholas (founded by his deceased brother Constantine) has survived. Each miniature is framed with a verse text. Leo, a beardless eunuch, kneels with his book before the Virgin, who intercedes with Christ on his behalf. His titles, *Patrikios*, *Praipositos*, and *Sakellarios* show that Leo was a major official in the imperial court.

A strange marvel is to be seen here: from Heaven, Christ, in his life-giving right, extends the crown, the symbol of power, to Basil, the pious and mighty Ruler. Below are the foremost two of the incorporeal Beings: one of them has taken the crown and brought it down, and is joyfully crowning the Emperor; the other, adding victories to the symbol of power, is placing the lance, a weapon that frightens the enemies away, in the ruler's hand. The martyrs are his allies, for he is their friend. They smite his enemies who are lying at his feet.[42]

The art of this period over most of which the Macedonian dynasty was in power exhibits a range of expressions that the term 'renaissance' cannot begin to convey. One Bible manuscript, earlier in date than the Paris Psalter, uses many of the same pictorial classical devices, but by adding explanatory verses in the frame around each picture, puts all the focus on the spiritual and theological content of the imagery. This is the Bible of the eunuch Leo Sakellarios ('treasurer'), made around 940 for his presentation to a monastery of St Nicholas [79].[43] The Old Testament, the only part to survive, was a very large volume. The texts and imagery are designed to emphasize Leo's devotion to the Virgin Mary. In comparison with this immersion in individual theology, the Joshua Roll and the Paris Psalter offer art rather than piety, more sophistication than fundamentalism. Yet this roll and psalter were probably kept in the palace, side by side with its many relics and shrines. Two more works help to show the sophistication of Byzantine art at élite levels, and an interest in classical art which was not confined to the middle of the tenth century alone. The so-called Veroli casket of the tenth or eleventh century has ivory panels containing mythological stories and classicizing figures. It presumably belonged to a rich, perhaps imperial, household, and a late antique book or set of models has been seen as its source.[44] Everything is extremely intricate, and the viewer would either need an encyclopaedic knowledge of the sources, or perhaps, taking the opposite approach, could ignore the detail and admire the impression of the antique. Even more indicative of this period is the tenth- or eleventh-century gilded and painted glass cup now in the Treasury of S. Marco at Venice, which was presumably taken after 1204 from Constantinople [80].[45] The glass is dark purple and is held in a silver-gilt frame. It has 7 figural medallions, figures light against dark, which have been compared visually with Greek vase painting and which evoke classical figure style, but are figures without clear identity. The smaller medallions are more reminiscent of ancient gems. The decoration around the images fits in with ornament to be found both in manuscripts and in monumental painting and mosaic and, like them, includes pseudo-Kufic letters. The technique of glass making shows equal sophistication to the enamelling of the Limburg *Staurotheke*. As a product of this period it indicates the range of Byzantine viewing interests, encompassing both antiquity and contemporary Islam.

In sum, the sources exploited by the artists of the period after

iconoclasm show a development from the disruption of the years after 843 to a confident handling of new techniques in the next generations. Classicism remained an important element of Byzantine art, but contemporary ideas from east and west gave the period a distinctive character, incorporating international ideas into an art that was more than ever the constructed picture of Byzantine order. In other words, we can begin to piece together an idea of how Byzantium was perceived in this period in its own time. This does not mean that the modern term 'renaissance' is automatically invalid, and indeed it may be impossible at this stage to detach it from tenth-century art history. It must be in part modern myth, in part useful—this was, after all, the period that rewrote and passed to posterity many of the texts from antiquity and the early Byzantine period that we now value. If this term is here to stay, then art history must have a clear vision of its strengths and weaknesses as a frame for understanding Byzantine art.

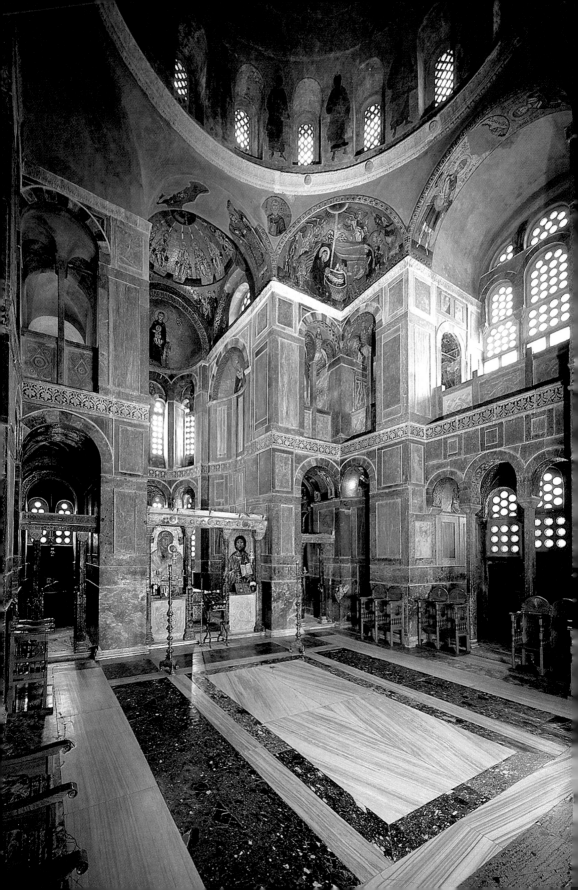

The New Spirituality of the Eleventh Century and the World of the Twelfth Century

5

Outside Constantinople

For any Byzantine, Constantinople was the centre because it was the place where decisions were made.[1] After iconoclasm, the revival of art depended on these decisions. The church wished to ensure no further attacks on its definitions of Orthodoxy, and art was both part of that Orthodoxy and one of the tools to promote it. The court found that the revival of church art intersected with the projection of the imperial image, too, and that there was a new range of materials and modes of expression that it could share with the church. St Sophia was redecorated, and was the showpiece monument where church and state met. This revival of art in Constantinople set a pattern of production that was known and imitated in the regions outside. This sets a problem for the art historian: how long after iconoclasm was Constantinople the artistic centre, and to what extent did the changes in the territorial extent of the empire, and the gradual decline in its fortunes and resources, mean that a distinction between centre and periphery is false?

The art historian, after iconoclasm, gives increasing attention to buildings and decorations that have survived outside Constantinople, and this prompts the question of to what extent there were local centres of production and whether Byzantine artists were perpetually on the move from commission to commission. Some builders and masons certainly worked their whole careers within distinct areas, and had the advantage that they were familiar with the acquisition and sensitive handling of local materials, just as Stephanos of Aila had been in the sixth century when building the katholikon of the Sinai monastery, even if the capitals there cannot exactly be regarded as sensitive translations of their models. This multifarious situation becomes clear when

one compares the building of various regions of Asia Minor with Greece, or in relation to Greece when the character of the churches of the area around Argos, for example, are compared with those in Epiros.[2] The activities and travels of sculptors can be traced by comparing *templon* screens and architectural mouldings in various parts of Greece but complications set in through the inevitable networking of patrons which may cause surprises and reveal builders and masons to be out of their usual terrain. It seems most likely that local patrons turned to their bishops for informed advice on practitioners as, for example, when Neophytos wanted to decorate his rock-cut monastery near Paphos, and the bishop helped him to bring a named artist from Constantinople [**103**].

Some materials of art may always have been the preserve of the artists of Constantinople. Most Byzantine ivories and enamels have been attributed to Constantinople, and another expert medium, mosaic, may have had a virtual monopoly here, too. Silk production was at first centred on the imperial factories in the palace and in private workshops, and those involved were members of professional guilds subject to the regulations policed by the eparch of the city, and collected in the *Book of the Eparch* (probably in 911/12). After the tenth century, silk-weaving is documented in Thessaloniki, Thebes, Athens, and Corinth, and may have been one source of wealth among the local aristocracy of Thebes. In 873/4 the initiative for the church dedicated to the Theotokos and Sts Peter and Paul at Skripou came from one Leo, both imperial official with contacts in Constantinople and local landowner. The case shows the overlap between the capital and the regions. The architecture and sculpture were probably all due to local organization, and the building materials are re-sawn marble classical blocks and columns taken from nearby ancient Orchomenos.[3]

The issue concerning Constantinople and the regions is often approached as a narrow art-historical question about attribution to artists and the relative quality of 'provincial' work. Constantinople as a large metropolis saw the production both of the highest-quality work of the period, as in St Sophia, but also no doubt of cheap souvenirs for pilgrims sold in markets around the famous sites and fora, and stereotyped icons for home use in the miserable backstreets of the city. The broader aspect is to consider how dependent on Constantinople the provinces were for major elaborate commissions, leaving local sponsorship always on a small scale. This scenario may fit buildings, but icons are a different matter. One can hardly get more remote from Constantinople than the monastery of St Catherine's in the Sinai desert. It had a permanent community of monks and an intermittent number of visitors and pilgrims. It owned properties in Cyprus, Crete, and Constantinople (and elsewhere). The sixth-century monastery was the outcome of imperial sponsorship, but the character of the work

indicates that even then the builders were regional and the mosaicists from Constantinople. There is no such easy dichotomy among the hundreds of icons now in the monastery, some of which originally belonged to hermits and chapels spread over the mountain of Moses. Many are works of the highest quality with direct stylistic similarities to works attributed to Constantinople [**85**]. Yet several of these icons, such as the twelfth-century *Heavenly Ladder* of St John Climakos, show subjects connected with the monastery and donors at the monastery [**27**] and their artists most probably worked on site. The *Heavenly Ladder* icon shows some monks, including the abbot of Sinai, achieving the ascent to heaven; others fall into the mouth of hell, tempted by demons. In this painting, the message of the icon is clear enough, and the identification of the unknown artist may seem unimportant.

The distance between the capital and the regions may sometimes be significant.[4] Thessaloniki, for example, is always treated as a special case, as a provincial capital which might support its own workshops, and which for some of the fourteenth century gained a measure of local independence. Yet in detail all the same problems arise as in Sinai. The architecture of the church of St Sophia, dated by some to the late eighth century as a sign of the recovery of the city from the long period of Slav hostility, and by others to the seventh, is in either case a heavy piece of local building, reusing capitals from the city. The decoration of the dome of the church with a striking Ascension composition was very likely carried out in the 880s and organized by Archbishop Paul, a correspondent of Photios [**82**]. The style of the figures has the same mixture of bold clear outlines and complicated surface drapery patterns as the Church Father mosaics in St Sophia and the manuscript paintings of the Homilies of Gregory of Nazianzus [**68, 70**]. This dome decoration was probably carried out by mosaicists who came from Constantinople and participated in further revival of the city after iconoclasm. The assumption that almost all Byzantine mosaics are the work of artists experienced in the medium, and based in Constantinople, is reasonable, but unprovable on the evidence. In other churches in Thessaloniki, the processes of interaction between art brought from the capital and local artists is a possibility. The ninth-century Ascension painting in the apse of the Rotunda is copied from the mosaic dome of St Sophia at Thessaloniki. Similarly the so-called Chalkeon church of the Theotokos in Thessaloniki, which was built as a family mortuary church in 1028, has wall paintings which might be the work of an artist from Constantinople. The decision rests on comparisons with the similar style of the wall paintings of St Theodore the Studite and St Theodora of Thessaloniki in the narthex of St Sophia at Thessaloniki, but of apparently lower quality. The quantity of work done in the regions suggests the availability of local artists, too. The arguments are unsatisfactory when they rest on subjective ideas of quality

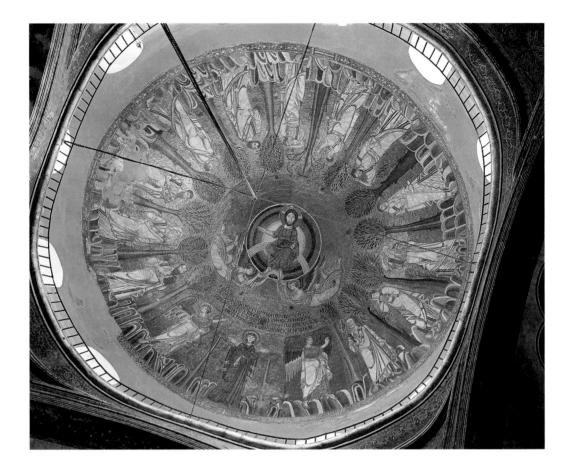

82

Dome mosaic of the Ascension. Around 885. St Sophia, Thessaloniki.

The mosaic shows Christ ascending, witnessed by archangels, 12 apostles and, as usual in the scene in Byzantine art, the Virgin. The dramatic composition in the central dome of the church was a new decoration after iconoclasm. The church was built either between 780 and 797 when the non-figurative mosaics of the sanctuary were made, or earlier. The Ascension is dated by an inscription, but not decisively, since only the indiction and part of the year remains, and it may not be part of the dome composition.

of execution. The new eleventh-century apse mosaic of the Virgin and Child in St Sophia in Thessaloniki might suggest that the narthex paintings of the same period are by artists from Constantinople. But the same problem comes back. The Virgin, replacing the previous cross, is very oddly proportioned, offering the interpretation that here, for once, local artists attempted the medium. Further afield, the cathedral of St Sophia at Ohrid was redecorated under Bishop Leo (after 1025), with wall paintings that have again been related to the Chalkeon church. Bishop Leo was previously a *chartophylax*, or archivist, in the church of St Sophia at Constantinople. Does that imply a Constantinopolitan axis of artistic contacts? The donor of the Chalkeon church in 1028 recorded that it was built for the remission of sins of the imperial military official, the *protospatharios* Christophoros, *katepano* of the *theme* of Longobardia (governor of the province of south Italy) and his family. This gives the nature of the commission, but no details. Christophoros was appointed from Constantinople to south Italy and, one presumes, had family connections with Thessaloniki. In the end the search for the origins of these artists seems fruitless. But there is plenty to see in their work. The Chalkeon church

of the Virgin was to hold the bodies of one family in a tomb in the nave for perpetuity until the day of the Last Judgement: the donor hopes for remission of the family's sins. The painting chosen for conspicuous representation over the door from narthex to nave was of the Last Judgement with the figure of Mary acting as intercessor. The symbolism is designed to match both the function of the church and, almost literally, the hopes of the donor.

Yet questions concerning the decentralization of Byzantine art and society do not go away. The movement of ideas from Constantinople around the empire has to be considered if the definition of Byzantine art is more than the art of Constantinople. Kastoria in northern Greece contains several painted churches which all seem to reflect the development of ideas elsewhere, whether in the tenth-century Last Judgement in St Stephanos, or in the other decorations of the eleventh and twelfth centuries and later. A comparative situation has often been accepted for the rural regions of central Asia Minor, as in the small rock-cut churches of Cappadocia of the second half of the ninth and early tenth centuries, such as Ayvalī kilise. The wall paintings of one of the largest churches, the New Church at Tokalī kilise [83], show a knowledge of the style of the Bible of Leo Sakellarios of the 940s [79].

83
Wall paintings of the nave of the 'New Church', Tokalī kilise, Cappadocia. Second quarter of the ninth century.

This was the grandest monastery church in Cappadocia—probably a katholikon of St Basil in a monastery of the Archangels. The architecture is unusual for its wide transverse nave—a liturgical arrangement that is found in the monasteries of the Tur Abdin in Mesopotamia—and large north and south chapels. The main apse has a Crucifixion over the altar, and the north apse has a Christ in Majesty. The church was made and developed in several stages, and the combined decoration has extended christological cycles and other scenes. The wall painting of the New Church is unique in Cappadocia for the expensiveness of its materials, using gold and silver leaf and ultramarine. The dating to the mid-tenth century and connections with the art of Constantinople at this time depend on arguments about its style and subjects chosen. It fits with a profile of patronage and decoration in Cappadocia which sees a very limited number of decorated rock-cut churches before iconoclasm, and an upsurge in development of secular and monastic foundations from the late ninth century up to the battle of Manzikert in 1071, with great activity in the region in the mid-eleventh century, and then a sharp falling away of monastic occupation and decoration in the twelfth century, but with some re-occupation and new wall painting in the following century.

The Transformation of the Sanctuary

The triumph of Orthodoxy intensified both the amount and the character of art. The most clearly visible long-term effect was in the organization of the nave and sanctuary of every Byzantine church. The innovation was an increasing emphasis on the screen that had in the early Byzantine church simply indicated the division between the spaces for the clergy and the laity. A low set of parapet slabs and posts had acted as a chancel barrier, sometimes jutting out into the nave. Even in the period before iconoclasm, there was some variation in the treatment of this barrier, which at its grandest was probably prominent, but low enough not to impede the view both to the altar and to the *synthronon*, the semicircular set of seats around the base of the apse, used by the clergy and from where the sermon would be delivered. The fact that Photios gave his seventeenth homily from the ambo of St Sophia represents a new development, possibly here because of the vastness of the church, and the challenge notoriously given to any patriarch to make himself heard by the congregation. The description of St Sophia by Paul the Silentiary at the time of its second dedication in 562 mentions six pairs of silver columns in the screen, which lasted until they were destroyed by the Crusaders in 1204, but however these were arranged, the whole barrier was low enough to allow a view of the sanctuary. The architectural arrangements in the interiors of the hundreds of Byzantine churches built before iconoclasm followed this pattern, but with variations—the church of St Demetrios had the odd

feature of a ciborion half-way down its central nave, and churches in Syria and Mesopotamia had very different systems, some with a large ambo filling the central nave. One text which describes the cult church of St Artemios at Constantinople in the seventh century can be read as describing a chancel barrier with icons on it of St Artemios, Christ, and St John the Baptist; the damaged sculptural portraits of Christ and saints from the church of Polyeuktos [**19**] have been interpreted as parts of a screen the faces of which had been mutilated by iconoclasts.[5]

After iconoclasm, the screen became increasingly dominant.[6] The church at Skripou of 873/4 had an intricately carved marble screen with columns and capitals arising from the parapet slabs in order to support a high architrave beam across the front of the sanctuary area. This screen closed off the central bay with the altar, and there were additional screens in front of the side chapels to north and south (the *prothesis* to the left, where the bread and wine were kept and prepared; and the *diakonikon* to the right, where the vestments and other church objects were kept). In the centre of the screen in front of the altar was the doorway which Byzantines called the 'Royal Doors', through which in the course of the eucharist the priest would bring the body and blood of Christ. This developed screen was called the *templon* in Byzantine texts, and this is the term used in art history until the final stage is reached in the fourteenth century of an iconostasis with a full set of icons in several registers which form a total decoration in their own right, and which completes the transformation of the sanctuary into a mysterious Holy of Holies, invisible to the laity.

The *templon* is well documented archaeologically in churches all around the empire from the ninth century onwards. The key question is the precise date at which it began to receive icons across the top of the architrave (such painted beams are found in Sinai from the twelfth century [**40**]), and when large icons or, alternatively, curtains were inserted into the spaces between columns, resting on the parapet and held above by the architrave. In some cases, this may have happened as early as the eleventh or twelfth century, but it may not have become the norm until the fourteenth century.

This development clearly caused the manufacture and veneration of a greater number of icons than before. But it also meant that symbolic interpretations of the church in the tradition of Germanos would need to be much refined. By the time that *templon* icons were censed in the course of the service, as recorded in St Sophia at Thessaloniki in the fifteenth century, and were taken out of the screen for parading in processions in the church or around the city or countryside, they would need to be incorporated into the whole interpretation of the church on earth.[7] One of the last Byzantine contributions to this mystagogical literature was by Symeon, archbishop of Thessaloniki (1426/7–9), and it shows how the presence of the high *templon* needed careful interpreta-

tion of its every detail, while remaining in the discourse of Germanos and his tradition.

The chancel signifies the distinction between the sensible and the intelligible; it is, as it were, a firm barrier between material and spiritual things. Being in sight of the altar, that is of Christ, its columns are those of the church itself, signifying those who strengthen us by their witness to Christ. Above the chancel the columns are joined by an unbroken decorated architrave signifying the bond of charity, which is the communion in Christ between earthly saints and heavenly beings. This is why a picture of the Saviour is placed here in the middle of the sacred images. His mother and the Baptist are on either side of him with angels and archangels, the apostles and the rest of the saints. This signifies Christ in heaven with his saints, Christ as he is with us now and Christ who will come again.[8]

The physical presence of the *templon* screen in every church obviously led to an exponential increase in the number of icons produced. As well as on the *templon*, icons would be needed for the walls on either side of the apse and for any special shrines (*proskynetaria*) for veneration of the patron saint, who was often celebrated with a biographical icon, showing the saint in the centre with panels recording the life around the cult image, and for other precious icons in the church's possession. More icons would be needed to illustrate the daily calendar of the church and the festival days. Only a few illustrated *menologia*, like that belonging to Basil II [**77**], and its several clones, were produced. The church needed either a single icon for each commemoration or a calendar icon which could be displayed in the church—the Sinai collection includes examples of icons for each month (or a block of 3 or 6 months on one icon). Icons seem at this time to have taken a greater part in the Easter rites; in particular the icon of the Christ as the Man of Sorrows, first found in the twelfth century in Byzantium on a double-sided icon from Kastoria, would have been most appropriate for veneration and procession during the vigil of Good Friday [**84**].[9]

The character and content of icons were also affected by the prominence that the *templon* gave them; as the number of icons on the *templon* increased over the period from the ninth to the fourteenth century, the altar and sanctuary behind became correspondingly more remote and mysterious, while the icons gave immediacy and access to the holy. They were incorporated into the ceremonial of the services and were kissed and censed. In their symbolic position, described by Archbishop Symeon as between two worlds, and in their virtual participation in the drama of the liturgy, icons gradually took on a different role from the wall paintings or mosaics on the walls, acting more as aids to devotion than pictorial narratives of the history of the church. It is in the eleventh and twelfth centuries that one can detect new subjects and new treatments and an interest in formulating responses to icons.[10] In

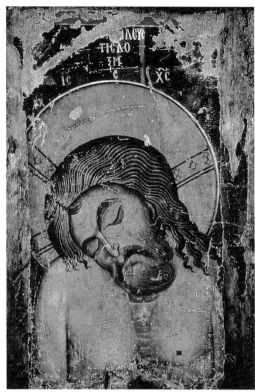

84

Double-sided icon with the Virgin *Hodigitria* (front) and the Man of Sorrows (back). Second half of the twelfth century.

The Good Friday devotional image of Christ, known in Byzantium as the *Akra Tapeinosis* (Utmost Humiliation), emerged around 1100 as part of the Easter ritual. The icon could be affixed to a pole for processional use or display. Christ is shown dead on the cross; written on it are the words 'King of Glory'. The image of the Virgin is in the *Hodigitria* type, but an attempt is made to convey the emotion of the young mother who fears the fate of her child. The earliest known example of this iconography, its place of making is unknown.

the monastery, new attention was given to the spiritual literature of the past, like the *Heavenly Ladder*. John Climakos wrote his text on the ascetic's spiritual development at Sinai in the seventh century; its popularity in the eleventh century led to the production of a number of manuscripts with images of the ladder. The Sinai icon of the twelfth century is the earliest icon to show the Heavenly Ladder and to communicate graphically the rewards and failures of the monastic life on Sinai [**27**].

Advice on the nature of prayer and spirituality was clearly in vogue too, and this period saw the massive expansion of organized asceticism on the Holy Mountain of Athos in north Greece which offered exclusion for hermits or communal worship for monks in a remote area from which women could be totally excluded.[11] It was here that monks could hope to come closest to most perfect spiritual life, imitating the 'angelic life' enjoyed by saints in heaven.[12]

A change in spiritual emphasis has been detected in the writings of Symeon the Theologian (Symeon the New, 949–1022) which encouraged individualist aspirations to the vision of divine light and salvation. Michael Psellos (1018–after 1081), who was philosopher at the court of the emperor Constantine IX Monomachos until he retired (tactically) into a monastery, and his teacher John Mauropous (*c.*1000–after 1075/81) are notable for a number of descriptions of works of art written

in the manner of a rhetorical *ekphrasis*. Mauropous wrote over 80 epigrams for icons, some to be written on their frames, in the same manner as the commentaries written around the pictures in Leo Sakellarios's Bible of the tenth century [**79**]. Their discourse coincides with an extension of the expressive devices in icons, such as the increase of narrative details and a wider range of emotional states over the eleventh and twelfth centuries. This apparent correlation has been explored as a way of documenting Byzantine viewing and of understanding the changes in art.[13] A case in point is when Psellos speaks of his own icon of the Crucifixion. The text documents the practice of private devotion, and is in itself a meditation on an icon. An expression Psellos uses in this text is 'living painting' (*empsychos graphe*). This has been proposed as the best term to describe the viewing of the icon in this period, since in the *Typikon* (Charter) for the monastery of Kosmosoteira at Pherrai in north Greece, founded by Isaac Komnenos in 1152, the same vocabulary is used: 'icons as appearing to our eyes as living beings which seem to speak graciously with their mouths'.[14] It remains a problem of how far this was only traditional rhetoric adapting to the undoubted changes in style, for Photios in 867 spoke in the same way in his seventeenth homily about the apse of the Virgin in St Sophia: 'You might think her not incapable of speaking, even if one were to ask her, "How did you give birth and remain a Virgin?"'[15] The stimulus for change in this period obviously depends on a number of factors, and relating icons to sermons and hymns may help us come nearer to the emotional and poetic states of their production and viewing. The late twelfth-century icon of the Annunciation at Sinai offers an extreme case of the dramatic icon of the period [**85**]. The swirling figure and drapery of the archangel Gabriel moving towards and surprising Mary offered the Byzantine viewer an experience far removed from the tranquillity of the moment found in other icons [**124**]. It was a device to convey the narrative of the New Testament in a new and arresting way. As a stylistic mode of expression, it is found in many other paintings of the late twelfth century, and could be adapted to several different scenes and figures. Other aspects of this icon, such as the evocation of spring by showing nesting birds and teeming nature, relied on the viewer's knowledge of hymns and sermons connected with the festival on 25 March. Such an icon brings into play all sorts of theological and emotional cross-currents. Illuminated manuscripts also strove to introduce new references and levels of meaning. The artist who produced in the second quarter of the twelfth century the Gospel manuscript now called the *Codex Ebnerianus* innovated by adding narrative scenes to the portraits of the evangelists [**86**]. The choice for each Gospel was carefully decided by reference to the liturgy. The scenes are the festivals at which the opening passage of each Gospel is read. The increase in the narrative content of the book is in fact an increase in its

85
Icon with the Annunciation.
Sinai or Constantinople. Late
twelfth century. Monastery of
St Catherine, Sinai, Egypt.

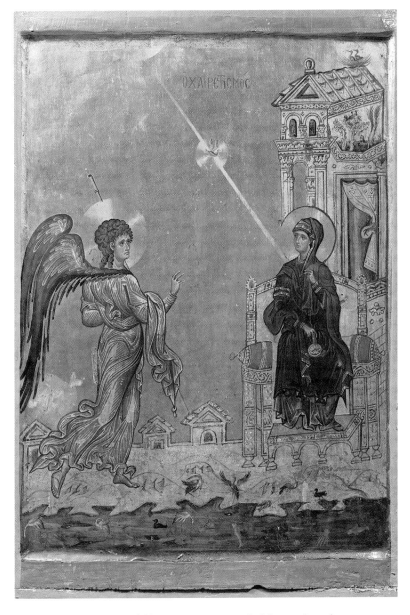

liturgical references.[16] The same artist probably produced two manuscripts at this date which give us a case of duplication, if not true 'mass-production' or 'publication'. These are the two versions of the six homilies of James the Monk from the monastery of the Virgin of the Kokkinobaphos [87], written in the twelfth century and forming a set of sermons about the life of the Virgin from her conception to her Visitation with Elizabeth. This is the longest and most detailed visual biography of the Virgin, and much of the detail derives from the apocryphal text of the *Protoevangelion of St James*, written around 200. The artist may have used an illustrated copy of this popular text which

Manuscript illustration of an evangelist. The *Codex Ebnerianus*, New Testament. Constantinople. First half of the twelfth century.

The four evangelists and authors of the Acts and Epistles are each shown within an ornamental architectural frame, writing their texts. The scenes chosen for illumination with each author represent the festival on which the opening of the Gospel or other book is read in the liturgy.

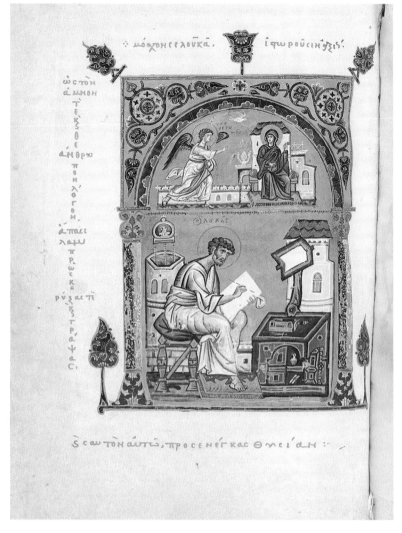

supplemented the meagre information about Mary contained in the Gospels.

The material increase in icon production and visual imagery therefore had a multiplier effect on viewers in Byzantium who, as more icons were produced, were ready for increased visual stimulation.

The Monastery

After iconoclasm, the developments in the cathedral of St Sophia and around the imperial court have been seen as a key to understanding the social and political functions of art in the period up to 1071. In Byzantine studies, the organization of the priesthood (*sacerdotium*), a hierarchy under the patriarch, is called 'secular' to distinguish it from the monasteries, which were outside the church. The emperor, the *autokrator*, was responsible for good order and government in all spheres

Manuscript page with the Ascension. Homilies of monk James Kokkinobaphos. Constantinople. First half of the twelfth century.

The second version is in the Vatican Library, Rome: Vat. gr. 1162. The same artist probably painted the *Codex Ebnerianus.*

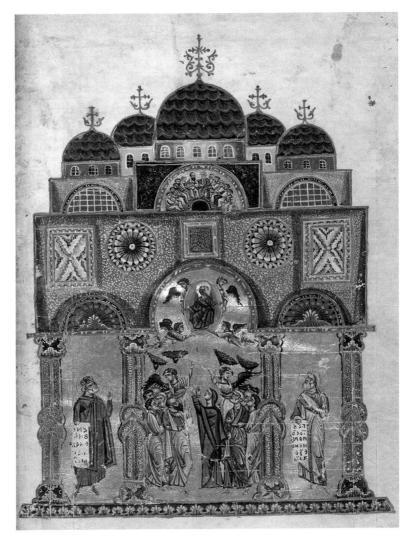

of Christian life, and this gave him absolute control over ecclesiastical and all other affairs. But side by side with these developments and overlapping with them was the greatest impact on the physical and mental landscape of Byzantium, the domination of emotional and social life by the monastery. Patriarch and emperor were necessarily implicated in the monastic sphere, and made attempts to control it, but it had a dynamic of its own. The head of the Orthodox church, the patriarch of Constantinople, might be appointed from a monastery, from the secular clergy or even, as in the case of Photios, from the civil service or from the imperial family. The very different styles of Ignatios the monk [**68**] and Photios led to bitter rivalries in the church. Another role of the monastic life was as a refuge for emperors or courtiers, who could retire to a monastery as a strategic retreat. The charisma of the monks was a challenge to the emperor and secular society: the emperor

might be the representative of Christ on earth, but monks lived like Christ on earth, and expected to climb to heaven up the spiritual ladder of John Climakos [27]. Society delegated the perpetual worship of God and celebration of the liturgy on behalf of mankind to the monks and in turn supported the monastery. The monastery, well endowed as a result, had the resources to enhance the sacred surroundings in which monks lived, prayed, and worshipped. In the pursuit of the ideal Christian way of life within the Orthodox faith, art was one tool to assist and enhance the spiritual experience. The art of the Middle Byzantine (843–1204) monastery must be the central force in the developments of the period.

Imperial patronage itself reveals the situation of cultural priorities. Constantine IX Monomachos (1042–55) gave the cathedral of St Sophia an income for an increased celebration of services, and his reign is recorded in the gallery of the church in the Zoe Panel [71]. But Michael Psellos tells us at length in the *Chronographia*, his history of his own times, what Constantine really cared about in the city: his new foundation of the monastery of St George of the Mangana, on the slopes to the east of St Sophia. The scale of building was enormous and the scale of his ambition equally unbounded. It was to rival and surpass all other buildings, especially St Sophia. The complex included a palace, hospital, and law school. Not only does this enterprise document where the artistic focus of the period was in Constantinople; the provision of a new monastery had another purpose. It was to be the mausoleum of the emperor and he was buried there in 1055, ensuring a place of security for his body and a place of regular prayer by the monks on behalf of his soul in the other world. This was the return that the emperor would expect from his provision of a monastic house. The previous site of imperial mausolea from the reign of Constantine the Great up to the eleventh century, and including the tomb of Constantine V around which the iconoclasts rallied in 813, was the church of Holy Apostles, maintained by the secular clergy, and by this time apparently devoid of further spaces for new tombs.[17] The Byzantine view of the fate of the soul after death, which was communicated in a number of texts of visions claiming to record near-death experiences, was that, unless people gained remission from sins by intercession, assisted, it was hoped, by the prayers of the monks for the dead, their souls in the netherworld would have to pass through a series of tortures and punishments to purify them before they had any chance of entering paradise.[18] This is, of course, tantamount to a notion of purgatory, between hell and paradise, but such a doctrine as in the Catholic church was never formulated by the Orthodox church.

The same priorities for monastic patronage emerge in the twelfth century. John II Komnenos, too, gave a donation to St Sophia and recorded this on his panel in the south gallery [72]. The focus of his

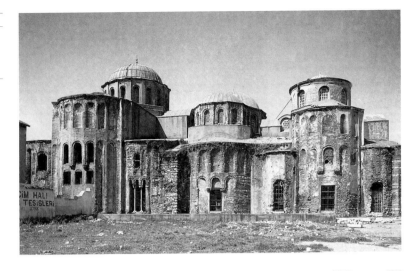

88
The Pantokrator Monastery
(Zeyrek Camii),
Constantinople. 1118–36.
Exterior from the east.

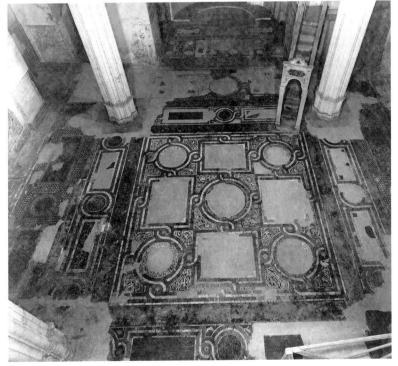

89
Marble floor and sanctuary of
the south church (katholikon)
of the Pantokrator Monastery,
Constantinople.

pious activities in Constantinople lay in the foundation of a large new monastery of Christ Pantokrator, dedicated in 1136, which is now Zeyrek Kilise Camii [**88**]. This extensive complex included three contiguous churches, a hospital, an old people's home, and a *leprosarium*. Each church was domed and decorated with cut marble, *opus sectile*, floors with coloured patterns and figural designs, marble revetments, mosaics, and stained glass [**89**]. In 1438, a fifteenth-century visitor to Venice, Sylvester Syropoulos, declared that the enamels of the *Pala*

Enamel plaque with the *Anastasis* in the altarpiece of S. Marco, Venice. The *Pala d'Oro*. Constantinople. Twelfth century.

This is one of the six feast scenes which were probably added to the altarpiece in 1209. It is probably loot from Constantinople, and Sylvester Syropoulos, who recorded seeing the enamels in 1438, has identified these pieces as coming from the Pantokrator Monastery. Whether or not this is true, such enamels are recorded on the *templon* screens of Constantinopolitan churches.

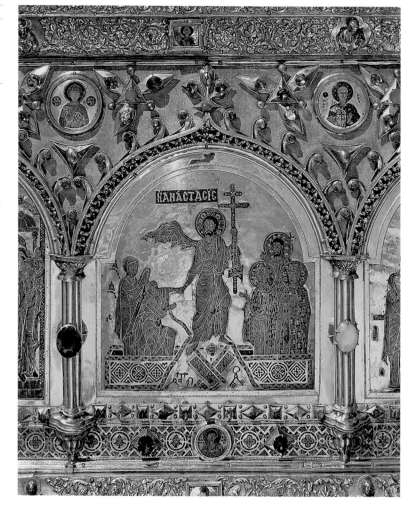

d'Oro, the altarpiece of S. Marco, came from the Pantokrator Monastery, and had formed its magnificent *templon* beam [**90**]. Women were only allowed to attend services in the north church, and the katholikon for the main services was the south church. The whole interior was designed to impress, especially at night through the lavish provision of candles. Compared with the rising Gothic architecture of the west, the Byzantine emperor seems to have put good architecture in the hands of bad builders. The exterior walls have 'recessed brick' masonry, a method found in the eleventh and twelfth centuries (and occasionally later), in which alternate courses are set back and mortared over. It may have been an economical way of using uneven bricks, or it may have been to create a decorative effect. From this period onwards, increasing attention is given to ornamental effects on the exterior of Byzantine churches, using brick patterns, relief sculpture, ceramic bowls, and wall painting. The contrast of later Byzantine ar-

chitecture and its surface decoration with the plain exterior of St Sophia is increasingly noticeable.

The central church of the Pantokrator complex reveals the ambitions of the founder: it is dedicated to St Michael and was called the *Heroon*, a calculated reuse of classical vocabulary to indicate that the church was to act as the family mausoleum of a great imperial hero, watched over by the angel of death, to whose special cult site Justinian had made the pilgrimage near the end of his life. As the century passed, the bodies of the emperors and their wives were interred in the monastery, and it was further enhanced with a precious relic. This was the red stone slab on which it was believed Christ's body had rested after the Crucifixion, brought from Ephesus in 1169/70 by Manuel I Komnenos (1143–80). The aim of the monastic foundation was identical to the purposes of Constantine IX Monomachos at the Mangana, and this is confirmed in its charter, the *typikon*. John II Komnenos not only ensured its secure future from an endowment of considerable estates from all over the empire which gave a steady income for a community of at least 80 monks, but set out all manner of detailed instructions. The *typikon* ended with the prayer that the beneficiaries of his endowment would gratefully pray for him and that he would be rewarded after death for his generosity. John included specific procedures for the annual commemoration of the imperial dead in the monastery for perpetuity. One arrangement was that on the day before the memorial liturgy, the prestigious icon of the Virgin *Hodigitria* was brought in procession across the city from its shrine in the Hodegon Monastery and set up in the *Heroon* beside the tomb of the emperor so that it was present during an all-night vigil and over the following day.[19] This miraculous icon alone would no doubt encourage public attendance at his memorial services. It clearly transpires from this document just how much attention an emperor was prepared to give to the preservation of his body after death, and to the maintenance of his memory and spiritual support. Two elements were considered essential for this purpose, in addition to the actual services and prayers. One was the presence of icons and a sacred space empowered by massive artistic investment; the other was the presence of the permanent community of monks, ensured by massive financial investment. The monks installed in this wealthy foundation could in their turn devote attention to further artistic enterprises which might assist in the remission of their own sins. This cyclical process can be envisaged all over the Byzantine world, but is documented in the case of the Pantokrator Monastery with a book produced for the abbot Joseph Hagioglykerites, who died in 1155. His patronage is connected with a manuscript that contained the sixteen homilies of St Gregory of Nazianzus which were in the twelfth century still read out regularly on prescribed days in the course of the liturgy (hence our term for this

Manuscript illustration of St Gregory of Nazianzus writing his homilies. Liturgical Homilies of St Gregory of Nazianzus. Constantinople, produced at the Pantokrator Monastery. 1136–55. Monastery of St Catherine, Sinai, Egypt.

The abbot of the monastery of the Pantokrator in Constantinople records his production of the manuscript and gift to the monastery of the Theotokos Pantanassa in two separate colophons. The bright colours and use of a complex architectural frame (with knotted columns, as in the Pantokrator *templon*) link this manuscript with the Kokkinobaphos group, both in date and style.

book as the 'liturgical edition').[20] This particular manuscript was one of the grandest books of its kind [**91**] and had not only highly coloured pictures, but also inventive initials in which the subjects included scenes of falconry as well as devotional images such as women venerating an icon of the Virgin. The production may have been due to the same artist as the illustrated Homilies of James of the Kokkinobaphos Monastery [**87**]. The name of Abbot James of the imperial monastery of the Pantokrator is recorded for posterity in pretentious inscriptions at the beginning and end of the book. These give the information that the book, enhanced with gold and silver, was made as a gift for the monastery of the Theotokos Pantanassa on the tiny island of St Glykeria on the Asiatic side of the Sea of Marmara, near Constantinople. The inscription reveals not only that he was earlier in his life a monk at this island monastery, but that his gift (which owes its

magnificence to the resources of his present community) was made with the hope for the remission and cleansing of his sins. The precious manuscript was later on (in 1550) taken by a Cretan monk to the monastery of St Catherine at Sinai, where it has remained a treasured possession of the library. This manuscript encapsulates how Byzantine spirituality was supported within the monastic system, and how religious emotions are translated into tangible works of art. The process that began with the lay foundation of a monastery to hold an imperial tomb and to increase the emperor's chances for the remission of his own sins and those of his family, past, present and future, expands into a wider resource for the production of art and to fulfil the hopes for salvation of an increasing constituency of dependants. Manuscripts were not the only form of art produced in (or for) monasteries, but they gave the opportunity for longer and discursive prayers for salvation, as in the case of this book, and the entry for 1550, recording its transfer to Sinai, includes a curse against book thieves.

Constantinople teemed with city and suburban monasteries, but for reasons of accidents of survival, our understanding of how the church decoration of the monastery functioned in the eleventh and twelfth centuries now comes from the regions, particularly from Greece and Cyprus. Three monasteries in Greece have the common factor of a full mosaic decoration—Hosios Loukas, Nea Moni on Chios, and Daphni, between Athens and Eleusis. As a set, they have been used as the basis for the definition of a 'system' of Middle Byzantine church decoration, which contrasts which the 'exceptional' pragmatic planning of St Sophia.[21] The merits of this way of describing church decorative schemes are much debated, the issue being whether any systematic rules for the layout of subjects was ever formulated, and whether the three churches in Greece show the evolution of a rigid system or a more pragmatic approach in each circumstance.[22] The chronological order of the three monasteries has been difficult to clarify in detail, but it is nevertheless crucial to the debate. A rapid assessment of these monuments will help to point to the special nature of each.

Hosios Loukas [81, 92] is the earliest foundation of the three, but its study involves working out the relationship and function of each of its three churches (Theotokos church, katholikon, and the crypt church). St Loukas the Younger [93], who was born at Kastorion (Delphi) around 900, founded the monastery near Stiris in Phokis. The region was known as the *Theme* of Hellas, and it was administered from Thebes. A *Life* of the saint was written (by an anonymous monk) after his death on 7 February 953.[23] As well as building up a dossier of ascetic acts of self-denial and good works during his life, and posthumous miracles to justify his sanctity, the *Life* records the prophecy, for which Loukas became famous, that the emperor Romanos would conquer

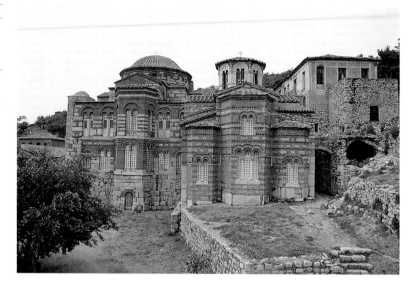

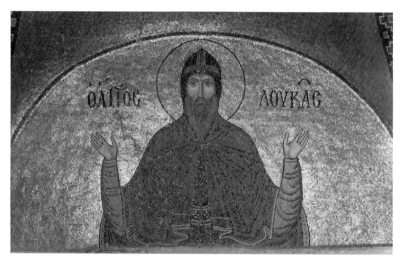

the island of Crete, then occupied by Arab pirates. The Delphic twist
was that he made the prediction around 942 when the emperor was
Romanos I Lekapenos; when questioned as to whether it was this em-
peror his prophecy referred to Loukas replied, 'Not this one, but an-
other one.' Crete was recovered in 961 under Romanos II, and the *Life*
was written soon after the event. It records the story of his life and fif-
teen posthumous miraculous healings. It also records that the military
governor then resident in Thebes, Krinites Arotras, donated the
money and work-force to build the church of St Barbara which was
constructed between 946 and 955, and that the monks developed the
site in 955 with communal buildings and guest-rooms and an oratory in
the shape of a cross built over the tomb of the saint. Other Byzantine
documents add more information. One is the *Akolouthia* which records

the deposition of the relics of the saint into a shrine in a new katho-likon. This liturgical text is very difficult to use as a historical record. It seems to document an abbot named Philotheos, but the dating of the event to 1011 or 1022 is very controversial. The marble revetments be-side the main door of the katholikon, both in the narthex side and on the west wall of the nave, have prayers from the donor of the work, the monk Gregory, for intercession for him. Some carved marble pieces from the church of Hosios Loukas at Aliveri on the island of Evvia, which was a *metochion*—a property owned by the monastery—have a date of 1014 and do look similar to the carved sculptures of the *templon* screens at Hosios Loukas. A *typikon* of the confraternity of Theotokos of Naupactos, founded at Thebes in 1048, mentions the name of a late abbot of Hosios Loukas, called Theodore Leobachos, perhaps singled out because he was a cardinal figure in the formation of the confrater-nity. The family is documented as rich landowners and government of-ficials in the *cadaster* of Thebes (the land registry for tax purposes). The document we have was redrafted between 1080 and 1120 when the con-fraternity consisted of 49 persons, including 26 laymen and 3 lay-women, and its aim was to promote the veneration of an icon of the Theotokos which was transported for a stay of a month at a time around the churches of the region. Signatories acknowledged them-selves as servants of the most holy Theotokos Naupaktitesa.[24] Finally, a further complication is the anecdotal information given by the monks in residence in 1436 'from an ancient book' to the Renaissance traveller, Cyriac of Ancona, that the founder was Constantine IX Monomachos (1042–55).

Despite this detailed and seemingly precise information, the well-preserved buildings of the monastery offer no clear chronology. The two churches are both cross-in-square in plan. The north church, now dedicated to the Theotokos, has its dome supported on 4 columns and is notable for the high quality of its capitals and *templon*, and even its lion-headed gargoyles on the exterior drum of the dome. It also has pseudo-Kufic decoration on the exterior, evidence that in the provinces as well as in Constantinople Arab letter forms were widely used as or-nament. The katholikon still has many of its mosaics and wall paint-ings, but the dome fell in 1593 and the reliquary shrine of Hosios Loukas in the north transept was damaged in the nineteenth century during the Greek War of Independence when the monastery was a centre of Greek resistance; it is now in a restored state. Its marble revet-ments and *templon* screen are well preserved. The crypt contains mar-ble sarcophagi of the abbots and is fully decorated with wall paintings, partly damaged by a *templon* fixed later.

The one clear archaeological clue is that the katholikon was built relatively later than the Theotokos church, since it overlapped and de-stroyed a painting of Joshua meeting the Angel on the west wall of the

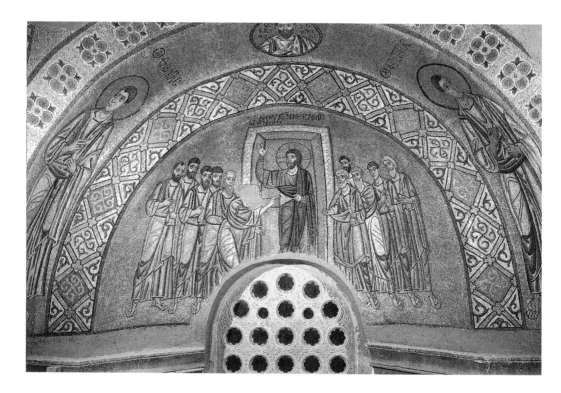

Mosaic panel of the Doubting
of Thomas. First half of the
eleventh century. South wall,
narthex, monastery of Hosios
Loukas.

Theotokos church. Before this discovery was published in 1970, the
consensus was that the katholikon was the first on the site. This new
information has tempted some scholars to identify the Theotokos
church with that of St Barbara (946–55), and others to date it to just
after 961 as a victory monument for the conquest of Crete. But the ar-
chitectural clues have also been interpreted to indicate that the
Theotokos church is not fully homogeneous from west to east and that
both of these dates are too early for what we have. The building of the
katholikon has been dated to 1011 on the basis of the *Akolouthia*, but
this has also been criticized as being too early for the style of the mo-
saics. One internal indication from the mosaics comes from the repre-
sentation of St Nikon, presumably later than *c.*1000, when he died in
Sparta. The mosaics and wall paintings have been most persuasively
'dated' to the 1030s, later than the Chalkeon church in Thessaloniki of
1028, and before the mosaics of St Sophia at Kiev, which date to be-
tween 1037 and 1046 [**94**]. It is clear that the wall paintings of the crypt
are later than the mosaics above, although probably not much later, as
are the wall paintings in the north-west and south-west chapels of the
katholikon. The best clue is in the Doubting of Thomas wall painting
in the crypt [**95**]. In the present condition of the panel, the first design
shows through the final painting surface, where Christ had held his
right hand high to show his wounds to Thomas. In the finished paint-
ing, the arm is lowered to make the more narrative point of Christ

thrusting Thomas's hand into the wound in his side. The mosaic in the narthex of the katholikon has the symbolic version with arm raised [94]. The crypt artist copied the mosaic for his first design in his underdrawing, but changed this in the final version. The consistent difference between the mosaics and the wall paintings is the increase in narrative effects in the crypt, contrasting with the clear and direct images in mosaic. Within one homogeneous and extensive decoration, the Byzantine artist or artists responded to medium, function, and setting, as they made choices about possible manners of expression [96]. The prominence of icons of St Theodore in both katholikon and crypt has been explained as the personal choice of the abbot Theodore Leobachos, mentioned in the *Typikon* of the Naupaktos icon, who was perhaps one of the benefactors of Hosios Loukas. His tenure, and the dating, have been deduced from the *Typikon* as being between 1035 and 1055; others have interpreted his dates as between 970 and 1000. This is the basis for a case that the mosaics depended on local sponsorship, either from a personal fortune at Thebes, or through fund-raising from grateful pilgrims to the tomb of the saint and local donations—such as the marble plaques of the monk Gregory. Unfortunately, the correlation of Theodore Leobachos with images of his namesake in the

95
Wall painting of the Doubting of Thomas. First half of the eleventh century. South-west bay, crypt of katholikon of Hosios Loukas.

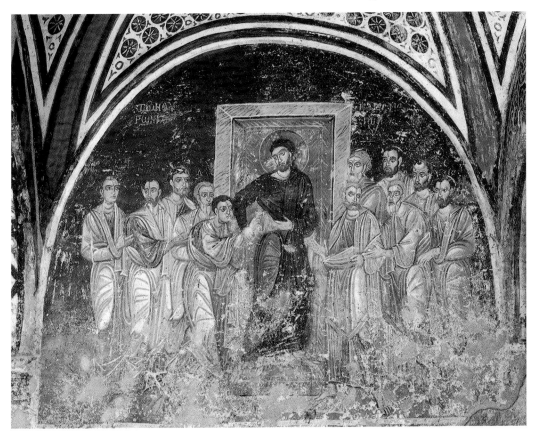

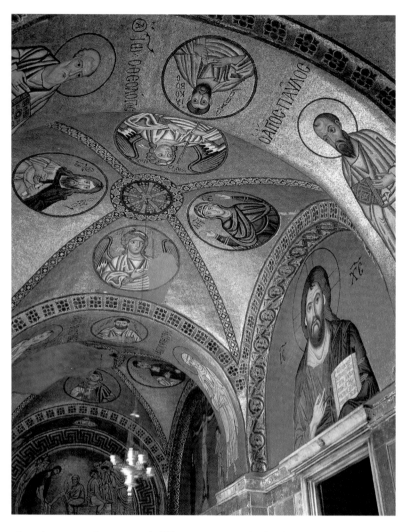

96
Mosaics of Christ and Saints. First half of the eleventh century. Narthex, katholikon of Hosios Loukas.

church cannot be pressed. The question of whether the splendour of the monastery derives from locally organized donations or, alternatively, from imperial sponsorship remains unanswered. Not only has Constantine IX Monomachos been connected with the monastery, but Basil II was in this region after his Bulgarian victory in 1018 and could have made a donation.

Nea Moni (the New Monastery) on Chios was documented as an imperial foundation of the eleventh century [**97**], but it has suffered much damage over the centuries. During the revolt against the Turks in 1822 the monastery was plundered and its archives and library burnt. In 1881 it suffered again, this time from earthquake damage, and went into decline. Sufficient documents have been gathered to infer that it was founded shortly before 1042, and that Michael IV, Zoe, and her sister Theodora were instrumental in this. But the main role in its development was played by Constantine IX Monomachos whose

97

Mosaic of the *Anastasis*.
1042–55. North bay,
katholikon, Nea Moni, Chios.

chrysobull of July 1049 gave permission to the monks to choose a bishop to officiate at the inauguration of the church. The period between July 1049 and January 1055—the year of Constantine's death—has been proposed for the mosaic decoration. Smaller than Hosios Loukas, its original refectory table seated 45 to 50 monks, making it a large monastery for the time, though not quite on the scale of the Pantokrator.

Unlike Hosios Loukas, which seems to have been continuously occupied and maintained despite troubles after 1204 and under the Turkish occupation, the history of the monastery of Daphni is more disjointed [**98**]. It was redeveloped as a Cistercian monastery between 1207 and 1211, and remained a Latin house until 1458. It contained a few Orthodox monks under the Turks, but was abandoned in the eighteenth century, and in the nineteenth century occasionally taken over for military or civil use. A restoration between 1889 and 1897 preserved the monument, but at the expense of considerable remaking of lost areas of mosaics and insensitive resetting of the cubes. Its short Byzantine period is scarcely documented. The very first signatory to the *Typikon* of the Naupaktos icon gave his name and title as: 'Dionysios, monk and priest of the monastery of Daphni'. The copy of the document we have is datable to somewhere between 1080 and 1120, and not earlier. Daphni is mentioned in a *Life* of Hosios Meletios (*c*.1035–*c*.1105), whose small monastery lies on the road from Daphni to Thebes and Hosios Loukas, and this has been taken as dating evidence

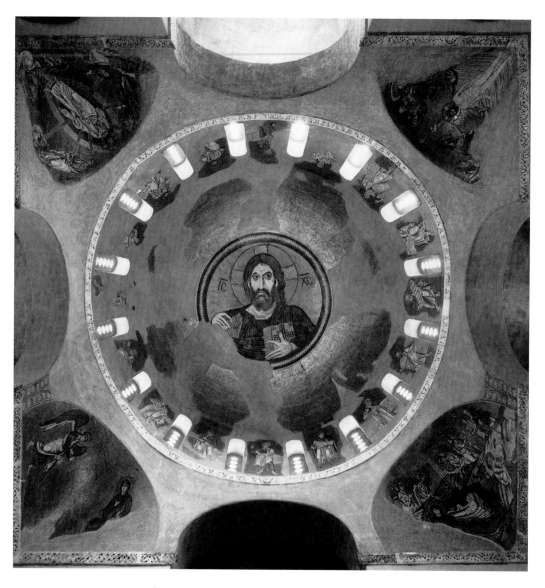

98

Cupola mosaic of Christ and Prophets. Twelfth century. Monastery of Daphni, Athens.

of its existence before 1105. More cautiously, it should be noted that there are two versions of the *Life* of Meletios written in the generation after his death which do not agree in their facts or dates, and so are evidence only of the existence of Daphni by around the middle of the twelfth century. A seal of Paul, abbot of Daphni, has been attributed to around 1100. Realistically this leaves only the features of the architecture and decoration to act as the indication for a date. The consensus has been that these point to a date between 1080 and 1100.

Much has been made of the differences between the decorative layout of the katholikon of each monastery, assuming that the relative chronology begins with Hosios Loukas and ends with Daphni. The decoration has been analysed and quantified into two categories, either

individual images of saints or narrative scenes, which consist either of the main events in the life of Christ (sometimes called 'festival' scenes, since they illustrate the principal commemorations of the church year) or of the Virgin Mary. The differences are certainly striking: Hosios Loukas had 9 scenes and around 150 saints; Nea Moni had 16 scenes and around 80 saints; Daphni had 19 scenes and 107 saints. These changing figures have been interpreted to mean that Hosios Loukas exemplifies a 'classical' system of Christian symbolism, that the balance between saints and scenes is changing at Nea Moni, and that Daphni represents nothing less than a case of equilibrium lost. By the end of the eleventh century, it is argued, the clarity of the layout of Hosios Loukas has been sacrificed in a scramble to include more and more narrative content, such as a cycle of the Life of Mary. The placing of the Birth of the Virgin in the north transept of the church, higher up than the Crucifixion, has been seen as a dissolution of the earlier logic, where domes, apses, and the highest vaults contained figures of Christ, angels and the Virgin, the next zone contained the festival scenes, and the lowest zone contained the choir of saints. In all, the Byzantine church is a frame for a logical system of symbolic decoration, and the process can be treated in the terms of an abstract evolutionary theory.

Such an interpretation is based on a tiny sample of Byzantine production and at the same time attributes a more rigid and inflexible attitude to church planning than we have found in evocative writers like Germanos. The reality of the planning of church decorations must surely, therefore, have been more pragmatic and flexible. While the repertory of subjects deemed suitable by theologians for inclusion in Byzantine churches was clearly always limited in range, each decoration must represent a mixture of choices based partly on tradition and convention, and partly on the specific circumstances of the dedication, local interests, and specific attitudes of the planners. But it is the case that both in churches and manuscripts of the twelfth century there was an increase in the repertory of subjects, and the greater number of narrative scenes in Daphni marks a change of expectations in the environment of worship. In comparison with the imagery of churches and monasteries in the west, the Byzantine repertory is always more limited, at least until the fourteenth century.

Hosios Loukas has a massive emphasis on mosaic portraits of saints. It was also the largest monastery of the three, and the cult site of a single holy man. Such a large repertory, including a number of specifically local saints, no doubt offered confidence and security to the monks who could see their models and the promise offered in return for the monastic life; pilgrims could see the power of the saints that supported the cult. Hosios Loukas himself [93] is represented around his tomb on the north side, a tomb that was strategically placed to give pilgrims maximum access from both churches to file past his relics. The *Life*

gives us the information that supplicants came to the tomb with diseases that included demonic possession, foot ailments, ruptures, cancers, and blindness. These were treated with oil from the lamp over the tomb, or with the drops of moisture on the surface of the tomb. In one case, the oil was not anointed, but drunk. Another hope of miraculous healing came from allowing the sick to sleep in the church, hoping for a dream in which the saint—recognizable from his icons, just as St Demetrios had been in Thessaloniki—would appear. Extra provision for pilgrims and a place for 'incubation'—although this term may too readily suggest a continuity with pagan practices of healing at the sanctuaries of the gods—probably accounts for the inclusion of a gallery in the architecture. This feature in turn influenced the available spaces for mosaic decoration. The organization of the mosaic decoration was influenced by the way the church was used. Its regular function was to provide the setting for the celebration of the liturgy by the community, with the climax at the eucharist on the altar. The mosaics emphasize this by drawing the eye of the spectator, who enters through the western door, across the dome and vaults and into the eastern apse where the Virgin and Child are represented, as in St Sophia at Constantinople. The planners had to make an unusual decision, however, since the architecture of the church included the rare feature of a small dome over the sanctuary. They decided to represent in it the scene of the Pentecost, the symbolic representation of the establishment of the church. The same choice of subject was made for one of the domical vaults in the south gallery of St Sophia in the ninth century.

The decoration of Hosios Loukas is not simply symmetrical from west to east, but has a second axis of decoration on the north side, where the spectator's eye is led to the image of the holy man [**93**] and so towards his tomb, the special possession of this monastery. In the side chapels of the katholikon, the images, whether in mosaic or fresco, are close to the viewer and more accessible to prayer. In contrast, the mosaics of the central part of the church and the narthex [**94, 96**] set out the imagery of church doctrine with scenes of Christ's Life and Passion. The images around the tomb of Hosios Loukas are portraits of the holy man himself and other saints; there is also a portrait of Abbot Philotheos offering an image of the church to Hosios Loukas. All this imagery shows that even at Hosios Loukas it is impossible to speak of a clear and 'classical' solution to the embellishment of the architecture. An equally complicating factor is that the style of the decoration is adapted to the various functions of the parts of the building. The mosaics of the main part of the church represent the saints and church doctrine in a cool, clear, direct style, devoid of detail or distraction. The mosaics of the narthex, closer to the spectator and very conspicuous, received special care and attention in their production, and

are very impressive products of Byzantine mosaic. The crypt wall paintings are even lower on the wall and therefore more accessible; their style is correspondingly softer and more intricate, with more narrative and background details. In an unusual scene just inside the south entrance, the community of monks is represented below a medallion of Christ, who blesses them in the very place where their bones will await the Second Coming.

The planning of Nea Moni on Chios was equally responsive to its special architecture and context. Dedicated to the Virgin, it was an imperial commission, with the architecture and decoration possibly planned in Constantinople. The whole of the nave is encompassed by a large dome, and the series of conches around it hold 8 scenes of the Life of Christ, chosen to reflect the main festivals of the liturgical year [**97**]. There were no spaces here for the festival scenes of the Ascension and Pentecost, which are in the narthex, together with a Passion cycle. The central dome decoration is lost but the presence of evangelists and angels indicates that the theme of the vaults was the Glory of the Pantokrator, and this was continued into the apses, with an orant Virgin chosen rather than an enthroned Virgin and Child as in both Hosios Loukas and Daphni where the Incarnation is evoked. The glorification of the Pantokrator may have seemed the most appropriate central theme for an imperial church—it was the dedication chosen by John II Komnenos for his monastery in Constantinople. The scheme in the nave left only a few spaces for saints and so most are concentrated in the narthex. Many thoughts must have led to the particular choice of the saints, and some are easier to deduce than others. For example, since the dedication of the church was to the Virgin Mary, her parents Joachim and Anna are included, as is Isaiah who most clearly foretold the Incarnation, holding a scroll with his prophecy 'Behold a Virgin shall conceive', which is read in the Byzantine liturgy at Christmas. Military saints, found already as part of the retinue of Mary in the sixth-century icon of Mary on Sinai [**45**], are also prominent at Chios. A more puzzling feature of the choice of saints is that, as at Daphni, most are commemorated in the first five months of the church calendar (September to January). All the mosaics of Nea Moni share the same stylistic features: brightly coloured figures, often with abrupt contrasts of hues, and gold is used as much in the drapery of the figures as in the backgrounds so that the entire decoration is suffused with light. More attention is given to colour and effect than to convincing modelling of bodies which, particularly in the narthex, appear somewhat misshapen. The effects of gold and vivid colours help to unify the decoration of the whole church.

Daphni is smaller than Hosios Loukas and it has no galleries, but its repetition of the festival scenes in the squinches below the dome is an indication that its mosaicists studied the scheme at Hosios Loukas and

99

Narthex mosaic with the Infancy of the Virgin. Twelfth century. Monastery of Daphni, Athens.

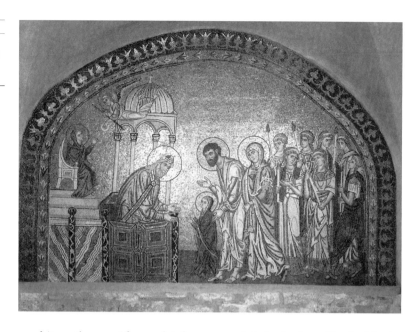

used it as the specific model for some of their choices. Daphni is the only church of the three to have its original dome decoration—an austere half-length figure of Christ Pantokrator encircled by 16 prophets with scrolls [**98**]. The argument that the decoration below has lost the clearer symbolism of the model fails to appreciate that the architecture of a church offered a more complicated surface. A series of panels was designed with marble frames. The church, like Nea Moni, must have been dedicated to the Virgin Mary, since the *Koimisis* of the Virgin is prominently set on the west wall, and the opportunity was taken to include both in the main part of the church and in the narthex several scenes of the Life of Mary. The style and schemes of the extended narrative of the Virgin in the narthex [**99**] has a manuscript parallel in the two twelfth-century editions of the Homilies of James of Kokkinobaphos [**87**]. The expansion of art in this period to accompany the Byzantine devotion to the Virgin Mary may better explain the difference between Hosios Loukas and Daphni than any concept of a classical system and its dissolution.

The mosaicists of Daphni may have been familiar with the various decorations at Hosios Loukas, but their handling of style is distinctively different. The figures are more naturalistically represented, and they blend more smoothly into their surroundings. Each scene is readily envisaged as a story from the Gospels; in contrast, the compositions and figures at Hosios Loukas are more generalized and balanced, and convey the dogma of the events rather than the narrative. Many of the single figures of the saints at Daphni similarly appear more natural and less stereotyped than at Hosios Loukas. Yet there are difficulties in generalizing about the style of Daphni. The faces of Christ

Pantokrator and of Sts John the Baptist and Nicholas in the apses of the eastern side chapels appear severe, almost threatening, to the viewer far below them. The mosaics lower down in the church are softer in expression, and altogether less intimidating. The scenes of the Life of Mary in the narthex are different again, more lively and detailed than those in the church. Since Byzantine churches were normally decorated from the vaults downwards, the artists lowering their scaffolding platforms in stages, one explanation for these changes in style would be to see them in chronological terms and attribute them to different producers over an extended period of time. Alternatively, the differences might be functional, different figures and scenes in the various parts of the architecture being designed to elicit different responses. Whatever explanations are accepted for the many differences between these three decorations, clearly the detailed circumstances of each commission need to be taken into account, and may be more significant in the organization of the scheme than general trends. These mosaics provide further examples of the delicate balance in Byzantine art between the precise historical moment of the commission and the conventions that demanded the production of an art to serve each congregation for eternity.

The growing prominence of monasteries in the course of the twelfth century had all sorts of consequences for the history of art. On the purely practical side, the demand for icons and other works of art increased, and on the spiritual side, icons continued to extend the emotional and intellectual experience of spectators. The popularity of the monastic life and the increasing wealth of the monasteries had its political effects, too, and criticism of monastic corruption and affluence grew also.[25]

Yet the catalogue of major patronage at all levels of society and in all regions is enormous. Imperial patronage produced the Kykko Monastery on Cyprus and Nerezi in the Balkans near Skopje. The monastery at Nerezi is dedicated to St Panteleimon and has an inscription dating its foundation by Alexios Komnenos to 1164. Its small church had a wide sweep of wall paintings with about 20 scenes, including the Passion cycle. This is a far more emotional and expressive development of the narrative styles at Daphni. The compositions totally integrate settings and figures, and in the *Threnos* (Lamentation) [100], the bent, mourning bodies of Mary and John are effectively balanced in the shapes of the rocks around them, and their tears echoed in those of the angels. In Byzantium, in the second half of the twelfth century, this dramatic style had intensified still more and led to contortion and exaggeration in icons and wall paintings, as in the Annunciation icon at Sinai [85], the church of the Panagia at Lagoudera on Cyprus (1192) [101], and St George at Kurbinovo in Macedonia (1191). It is these developments in pictorial narrative that

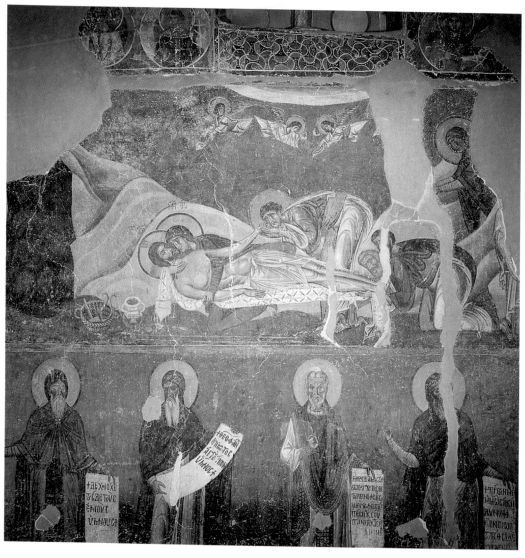

Wall painting of the
Lamentation with monastic
saints below. 1164. North
wall of the katholikon of the
monastery of St Panteleimon,
Nerezi, near Skopje.

are taken up in the thirteenth-century art of Italy, and notably by
Giotto at the Arena Chapel in Padua (1303–13).

The monastery of Chrysostomos, near Koutsovendi in Cyprus,
founded 'for the expiation of his sins' by Eumathios Philokales, gover-
nor of the island in 1092–1103 and 1110–18, exhibits patronage by the
upper classes. The wall paintings of the north church, which formed a
mortuary chapel, show the same kind of investment as in the church of
Tokalı kilise in Cappadocia [83], both using ultramarine for blue in
some places and gilding the haloes and parts of the garments. It seems
that the artist and architect probably came from outside Cyprus, but
stayed on to work for other clients at Trikomo, Asinou, and in other
churches. The small and poorly built monastery church of the Panagia
Phorbiotissa was first painted in 1105/6 for one Nikephoros, who styled

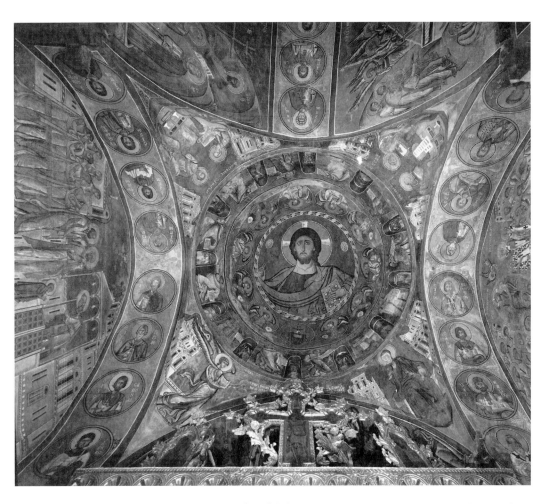

101

Dome of the church of Panagia tou Arakou, Lagoudera, Cyprus. The wall paintings are of Christ, angels with the *etimasia*, and prophets. 1192.

The decoration of the church is recorded over the north door. 'The most blessed church of the holy Mother of God of Arakos was painted by the donation and great desire of Leo, son of Authentis, in the month of December, indiction 11, of the year 6701.' This was 1192. Another inscription in verse, written beside the cult image of the Virgin, prays that the donor and his wife and children may live in happiness and in the end be favoured among the saved.

himself *magistros* [102]. The same title was claimed by the donor of the small church of St Nicholas Kasnitzes at Kastoria in the second half of the twelfth century: Nikephoros Kasnitzes *magistros*. Once a high-ranking title, it does not seem to have been awarded officially in the twelfth century. The assumption has been made that this patronage came from the local gentry, claiming rank. The paintings in both churches are limited in extent and in their range of pigments, but are of striking quality and effect. The church at Asinou was continually prone to collapses and settlement, but a narthex was added in the late twelfth century which was decorated with further paintings. It is an ex-cellent example of the high quality of 'standard' art in the regions in the Middle Byzantine period.

The cave monastery inland from Paphos, founded by Neophytos (1134–*c*.1214), which he called the *Enkleistra* (hermitage), has well-pre-served wall paintings and icons from the twelfth century and gives a very different picture of monastic art from the mosaics of Daphni. Neophytos was one of a large peasant family from Cyprus who built up

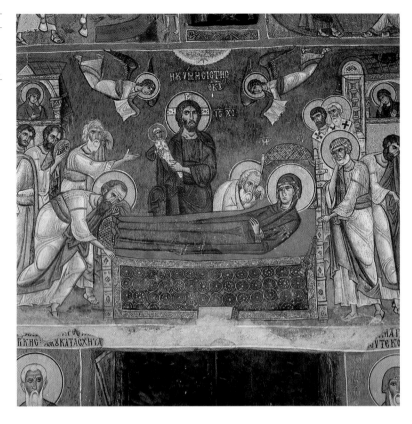

102
Wall painting of the *Koimisis*
of the Virgin. West wall.
1105/6. Church of Panagia
Phorbiotissa, Asinou, Cyprus.

a small community with extreme ascetic aspirations. His cell and
church were first decorated in 1182–3 and the artist, Theodore
Apseudes, signed and dated his work. His employment was very likely
due to the participation of the local bishop, Basil Kinnamos, who may
have arranged for him to come from Constantinople. But the individu-
ality of the subjects chosen to decorate the cell and church was clearly
dictated by Neophytos himslf, and partially explained in the rules of
the monastery which he later wrote out. He recorded visually his own
aspirations as a monk and his expectations to be rewarded with entry
into paradise [**103**]. A few years later, the decoration was extended by
other, less sophisticated artists, and the final scheme remains highly in-
dividual (with some help in viewing the narrative scenes by numbering
each one in sequence). The imagery on the walls at eye level shows the
saints designated by Neophytos as the best models for imitation in the
community. Their texts offer pithy advice to the aspiring ascetic and
express theological orthodoxy. Elsewhere in Cyprus, at Asinou, there
is revealing evidence of the devotional power of such images—candles
have sometimes been fixed into the painted plaster and the faces of the
icons have been scorched and blackened with soot. Several portraits of
Neophytos were included in the decoration at Paphos, as well as his
personal prayers: Mary, represented over the tomb where Neophytos

was to be buried, holds a text with the following words: 'Grant, my son, remission to him who lies here'; Christ answers: 'I grant it, moved as I am by your prayers.' These words were intended to be visible only to Neophytos within his sealed tomb, but other paintings in the monastery communicated his conviction that his life was an imitation of Christ and after death he, too, would be in paradise.

As a historical personage, despite his local fame and the survival of his monastery to the present day, St Neophytos must be one of the least-known saints of the Orthodox church. When he died, Cyprus had passed out of Byzantine control and since 1191 was in western hands. Neophytos, as an Orthodox monk in a Catholic island, wrote of his woes. But at this time the monk in Byzantium, too, was living through difficult times. The history of Byzantine art in this period consistently exhibits the success and achievement of a religious art that served spiritual needs, but at the same time also sheltered and concealed a society moving towards collapse and disaster.[26]

Byzantium from Outside

Over the eleventh and twelfth centuries the world around Byzantium changed out of all recognition. The schism of the Orthodox and Latin churches, declared in 1054, gradually polarized the Christian world. To the east and south, the Crusades from 1095 onwards altered the balance of power between Islam and Christendom. Jerusalem was captured in 1099 and initiated the establishment of various Latin kingdoms in the east. Arabs and Byzantines lost their political bases in Sicily and south Italy in the course of the eleventh century, and were replaced by the Normans. In the rest of Italy, the rise of the commercial cities of Pisa, Genoa, and Venice rapidly began to displace Byzantine trade. To the north, the grand princes of Kiev established themselves from the tenth

to the twelfth centuries when the centre of power in the Russian lands moved to Vladimir. Bulgarians, Hungarians, and Serbians became increasingly independent powers in this period, too.

Byzantium was therefore increasingly encircled by hostile and rival societies, whose single common belief was that Constantinople was the centre of political and artistic success. The secret of this achievement was believed to lie in the *taxis*, the 'good order' of the Byzantine state. Byzantine art had a major function in the construction and maintenance of this perception. The sophistication of the art of the Byzantine monastery promised order in this life and paradise in the next. Other societies were thus eager to appropriate this art as a surrogate for a successful state. The imitation of Byzantine art is correspondingly a major factor in the production of neighbouring culture. At the same time, the Byzantines absorbed ideas from outside, and the influences were not all in one direction: the Great Palace in the twelfth century was extended with an Islamic-inspired new building, the *Mouchroutas*, with a stalactite ceiling and other Arabic features.[27] While the period from 843 to 1204 supplies many individual cases to show the character of contact and influences, the overall question is: how did the outside world perceive Byzantine art?[28] This gives us a chance to see Byzantium through the eyes of contemporary viewers. The most revealing cases are those operations of the greatest commitment and investment, not those where outside artists copied and interpreted Byzantine art, but where an attempt was made at a transplant, where Byzantine artists were brought to another society and then incorporated into its culture.

Such an occasion was when, in the mid-tenth century, the emperor sent mosaic tesserae to 'Abd al-Rahman III in Spain. The work involved was in the most holy area around the *mihrab* in the Great Mosque at Cordoba. This part of the mosque is decorated with Islamic motifs using both Byzantine mosaics and glazed tiles of the technique found in the early tenth century in Constantinople, for example in the church of Constantine Lips of 907.[29] Byzantine expertise is used in the service of a strictly Islamic design. An even more substantial case of the import of Byzantine artists was in the cathedral of St Sophia at Kiev between 1037 and 1046, itself constructed according to Byzantine masonry techniques [104]. The building to be decorated was massive, with 13 domes and 5 aisles, and the solution was, as at Hosios Loukas, a combination of mosaic and wall painting. The style of the mosaics is close to the work at Hosios Loukas, but the scheme of decoration more similar to Nea Moni, including the Pantokrator theme and orant Virgin in the apse. These connections have been explained as reflections of the artistic procedures of Constantinople, but this is no solution for understanding the actual decisions made on site. The sheer area to be covered at Kiev meant the addition of local subjects, includ-

Apse mosaic with the Orant (Praying) Virgin and Communion of Apostles. Mosaicists from Constantinople[?]. 1037–46. St Sophia, Kiev.

Although the church of St Sophia was built and decorated by Byzantine workers, they were operating far from home and on a massive commission. This may explain the abandonment of mosaic for wall painting in parts of the church. They probably manufactured some of the tesserae on site. The mosaics of the sanctuary and main dome are close in style to the mosaics of Hosios Loukas.

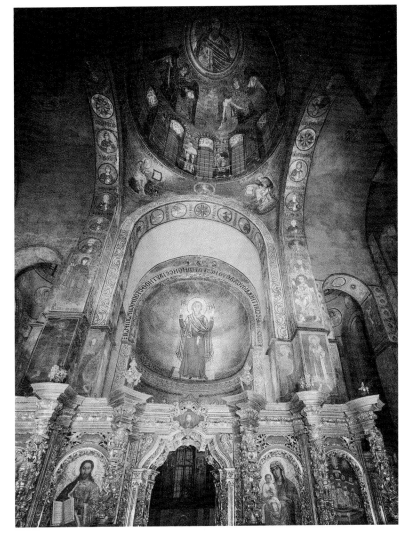

ing the representation in the nave of the portraits of the founder Jaroslav and his family, and scenes from the life of his patron, St George.

The consequence of the transplantation of Byzantine art to Kiev, including gifts of icons [**105**], was that for the next centuries the monumental art of the Russian lands was less a response to Byzantium than an extension of the working area of Byzantine artists, who regularly came for work to Rus' up to the fifteenth century. But patrons in Vladimir in the twelfth century show a discriminating response to outside art. In the cathedral of St Demetrios (1194–7), the architecture is distinctively Russian; the large amount of exterior figurative relief sculpture is the work of artists from the Romanesque west, but the interior wall painting, of which parts of the Last Judgement remain, is high-quality Byzantine work, comparable with the wall paintings of

**Icon of the Virgin and Child.
The Vladimir Icon.
Constantinople. *c.*1131.**

This icon was recorded as a
gift from Constantinople to
Kiev, and it eventually moved
to Vladimir and ultimately to
Moscow. Only the paint of the
faces of the Virgin and Child
seems to belong to the twelfth
century, and it was restored in
Russia after fire damage in
Vladimir in the thirteenth
century. This type of the Virgin
cherishing her Son, sometimes
called the *Eleousa*
(compassionate) type, is
found from the tenth century.
This particular icon was
believed to be miraculous, and
later legend attributed its
painting to St Luke.

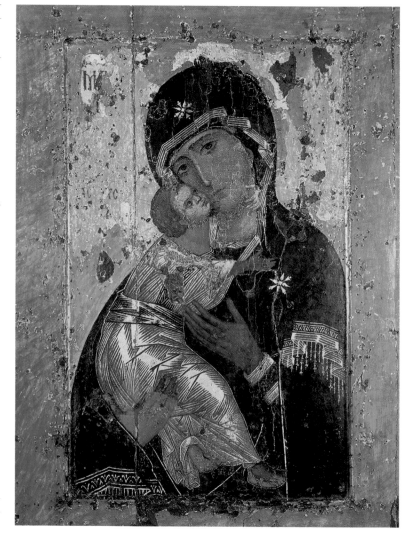

106

**Mosaics of the Cappella
Palatina, Palermo, Sicily.
1142/3. Artists from
Constantinople.**

The Norman king Roger II built
his palace and its chapel at
Palermo, employing both
Islamic and Byzantine artists to
ensure the regal nature of his
court. The various mosaics of
Sicily indicate the complicated
dynamic of Norman ambitions
and traditional craftsmanship.
These mosaics probably
closely reflect Byzantine style,
but the organization of the
subjects and their
arrangement on the walls and
vaults caused apparent
anomalies (such as Christ
represented in both the dome
and the apse).

this period in the church of Hosios David at Thessaloniki. Grand
Prince Vsevolod III (1176–1212), who founded the church, reflects very
accurately where the expertise of this period belonged.

In Italy, the response to Byzantium is much more differentiated. In
the Veneto, the first major import of Byzantine art was to the cathedral
of S. Maria Assunta on the island of Torcello, first with wall paintings
in the apse of the early eleventh century, but then, in the second half of
the century, there was a major decoration of mosaics in the apse and the
Last Judgement on the west wall. The church was reworked late in the
following century, and among other changes, the Last Judgement was
repaired and a Virgin Mary added in the apse. In the eleventh and fol-
lowing centuries, Byzantine mosaicists worked in S. Marco. There are
two complications in assessing the Byzantine component of these mo-
saics: one is that local artists were trained to work side by side with the

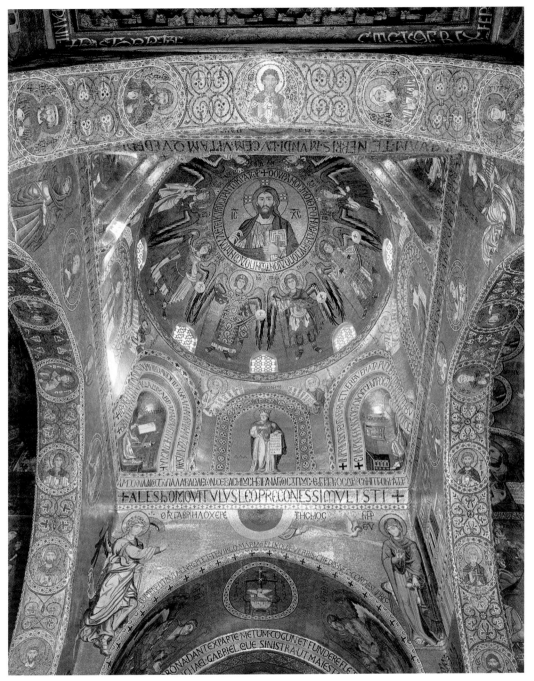

Byzantines and, secondly, the extent of later restoration, which has distorted much of the original appearance. Nevertheless, it is clear that the cultural strategy of Venice was to obtain Byzantine artists and artefacts, and to construct a visual setting that any visitor would compare favourably with Constantinople. The church of S. Marco itself was a declared copy of the Justinianic church of Holy Apostles in

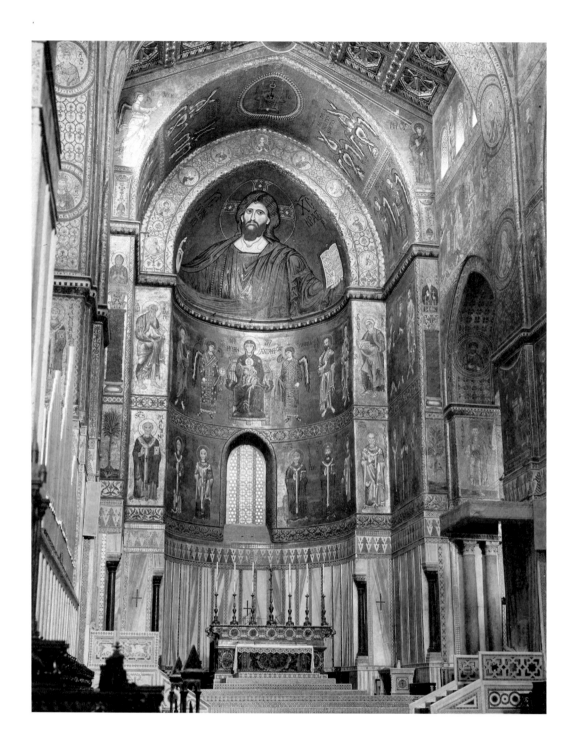

107

Mosaic apse with Christ.
Artists from Constantinople.
c.1180s Cathedral of
Monreale.

The basilica of Monreale was huge, and its walls have been estimated as a space of perhaps 8,000 square metres to cover. The Pantokrator in the apse, as elsewhere in the church, shows artists stretching out their compositions to fit the necessary area.

Constantinople, which housed the imperial mausolea. The reputation of the doges who built and gave donations to S. Marco could only be enhanced by the analogy.

The art of Norman Sicily is equally manipulative of outside cultures, and Byzantium was only one among several. The architecture of the Cappella Palatina of Roger II points to a south Italian architectural tradition, its stalactite ceiling to the Islamic world, and its mosaics (those of the cupola are dated 1143) to a Byzantine artist [106]. The church of the Martorana (1143–51) and the apse of Cefalu (1148) were also decorated by Byzantine mosaicists. Monreale, decorated probably after 1183, involved the largest surface that any mosaicist had yet attempted to cover, and its founder William II would have had no choice but to call in the specialists from Byzantium [107]. The Byzantine artists were confronted with a western situation and architecture, and western control. While they had learned techniques and style in Byzantium, and they brought to Monreale the current exaggerated manner of the Sinai Annunciation icon [85], yet they had to adapt their style to fit the circumstances of a vast basilica and subjects chosen by western patrons. The mystagogical principles of Germanos would have been difficult to apply here; the *Pantokrator* image in Cefalu and Monreale had to be worked into the broad span of their apses.

The great monuments of Norman Sicily indicate how mosaics could enhance a new royal regime; the kings and their subjects undoubtedly associated the medium with 'imperial' art and saw themselves in some way as the heirs to Byzantium. Their court art re-created many of the prestigious types of objects that would be seen in Byzantine and Islamic palaces. One tantalizing product of Sicily at this time is an illustrated manuscript that contains the chronicle of Byzantine history written in Constantinople by John Skylitzes in the second half of the eleventh century. The Sicilian version (now in Madrid) was written in the hand of a south Italian scribe, and is densely illustrated with pictures of Byzantine history (574 pictures survive out of an original cycle of around 650 to 700).[30] As an illustrated Byzantine chronicle, this is a unique type of manuscript: was this because a Byzantine artist came to Sicily with a model, or, more likely, did an artist in Sicily create a perceived world of Byzantine imperial history?

The Middle Byzantine period ends politically with the triumph of the western armies and the entry of the Fourth Crusade into Constantinople in 1204. But changes in the economy, society, administration, even the marriage patterns of the Komnenian emperors had already moved Byzantine life and culture closer to that of western Europe. In terms of the history of art, the idea of a completely self-contained and inward-looking Byzantine art had steadily been dissolved.

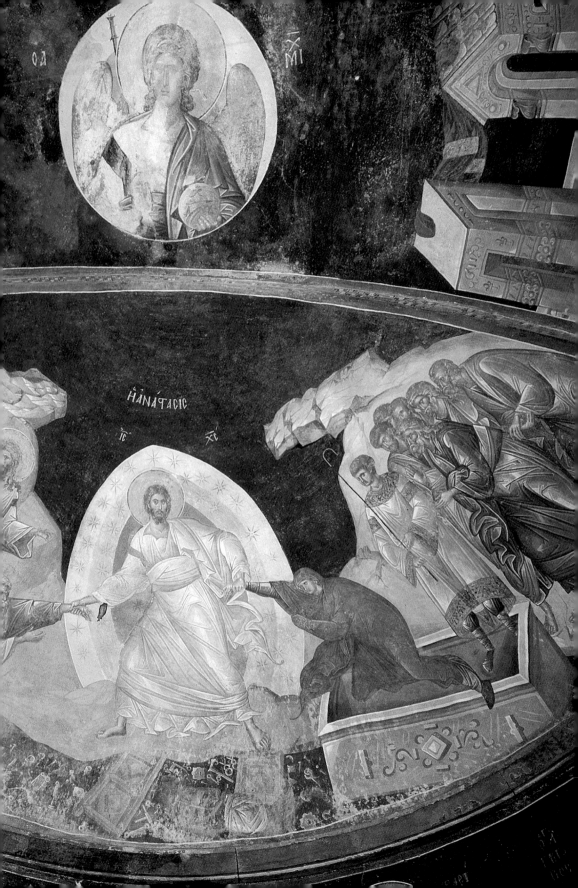

Art in the Service of a Failing Society

Late Byzantine Art 1204–1453

6

Westernization

Much of the Byzantine art we know today came to Italy and France as looted treasure after the Crusader Sack of Constantinople in April 1204. Christian relics from the palaces and churches were the prime target, and the church of S. Marco in Venice and its Treasury acquired chalices, crowns, icons, enamels, rock crystals, vessels, reliquaries, books, and bookcovers, the four bronze horses from the Hippodrome, imperial porphyry sculpture, reliefs and capitals from the collapsed church of St Polyeuktos, and ransacked marbles from St Sophia [**66, 80, 90**]. S. Marco, which began as the imitation of Byzantium, suddenly became the greatest living museum of Byzantine art itself.[1] Similarly Paris and the monasteries of France collected up the relics of Byzantium, and when the Sainte-Chapelle was built as a royal chapel around 1244, King Louis IX could supply the gold-mounted reliquary containing a piece from the Sepulchre of Christ looted from the Pharos chapel in the Great Palace [**108**], as well as the Crown of Thorns and the True Cross.[2] By the time of Louis XIV (1643–1715), the palace at Versailles could bring out for display 11 precious vessels of sardonyx and agate from Byzantium, cut either in the Middle Ages or antiquity, like the related pieces in S. Marco. Louis also owned one of the copies of the Homilies of the monk James of Kokkinobaphos [**87**]. Back in Constantinople, the late Byzantine imperial court tried to keep up appearances in vandalized palaces stripped of their most precious treasures.

The paradox of the Crusader contact with Byzantium is that when westerners, during the Latin Kingdom of Constantinople (1204–61), finally gained full access to the great charismatic monuments of the spacious city, which they had previously known through copies and versions, their perception of Byzantine art changed towards the appreciation of the small, exotic, and valuable. St Sophia was converted for Catholic use, and then allowed to deteriorate. The Pantokrator Monastery fell into Venetian hands, and the reused sculptures from St Polyeuktos in its *templon* may be restorations after 1261. The newly

108

Silver-gilt plaque and reliquary for a piece of stone from the Sepulchre of Christ with the Marys at the Empty Tomb. Constantinople. Second half of the twelfth century.

This precious reliquary was looted from Constantinople, probably from the Pharos chapel in the Great Palace; Nicolas Mesarites mentions the existence of such a relic there, regarding it as a material proof of the resurrection of Christ. The words of the Gospels are recorded on the plaque as well as the moment of the discovery of Christ's resurrection.

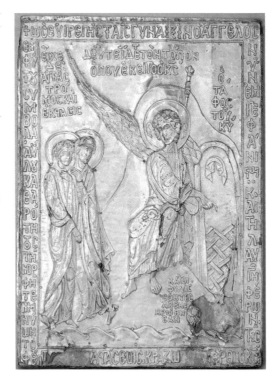

built late twelfth-century church of the Kyriotissa monastery (now Kalenderhane Camii) received wall paintings while in Latin hands, and therefore before 1261.[3] A small chapel to the south of the sanctuary was decorated with a standing figure of St Francis of Assisi and scenes from his life. New churches were built in Constantinople and in those parts of Greece occupied by Franks; in Cyprus, particularly large and impressive Gothic churches and abbeys were constructed.[4] Like the earlier massive remodelling of the church of the Holy Sepulchre, dedicated on 15 July 1149 to mark the fiftieth anniversary of the capture of Jerusalem, all these new churches were conspicuously built and decorated by western artists working in conspicuously western styles. Only in manuscripts, paintings, and the Crusader mosaics of the Holy Sepulchre was there an interactive meeting of east and west in the arts, and this production, Crusader art, or the art of the Crusaders, is crucial for the whole development of late Byzantine art [109].

The St Francis frescoes in Constantinople belong to a recognizable group of paintings found in both manuscripts and icons, of which one easy distinguishing hallmark is the large rolling eyes of some of the figures [110]. Among these works, the Arsenal Bible (now in Paris) was produced for King Louis IX while he was at Acre in the Holy Land between 1250 and 1254. This royal commission contained a new translation of the Bible into French and 20 accompanying miniatures. The artist had somehow seen such Byzantine manuscripts as the tenth-

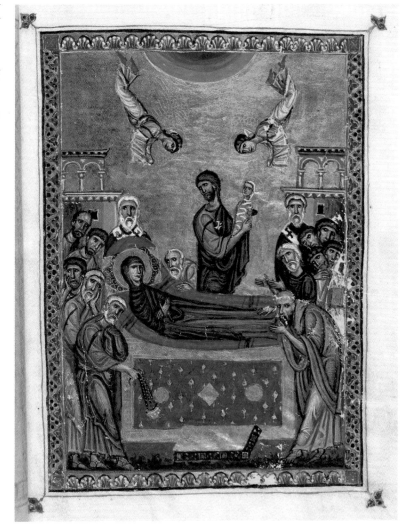

century imperial luxury manuscripts like the Paris Psalter in Constantinople and had developed his style in response. This is not the first case of such a composite style; among earlier books, the Psalter of Queen Melisende [**109**] was painted in Jerusalem between 1131 and 1143 by a western artist who flashily signed himself with a Greek name, Basilius, and who had to a greater or lesser extent in each miniature harmonized the Byzantine tradition of iconography and style into a composite art.[5] By the mid-thirteenth century, the Arsenal Bible had developed in a more integrated but clearly composite style. The same stylistic group is represented in a number of icons at Sinai. One of these, a triptych with the Virgin and Child at the centre and with, amongst other scenes on the wings, a Coronation of the Virgin, equally shows a mixture of Byzantine and western elements of style and contents—the Coronation is a western invention and theologically con-

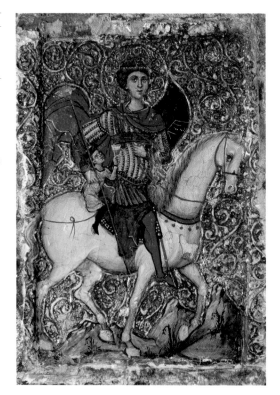

travenes Orthodox hierarchies by seating the Virgin beside Christ on the throne. The icon of St George rescuing the Youth of Mytilene (London, British Museum) also belongs to the group and, like the triptych, has a tooled silvered background [**110**]. Another clue to the context of the group comes from a Sinai icon of Sts Theodore and George with a kneeling donor who is accompanied by a prayer in Greek: '*Deisis* [prayer] of the slave of God, Georgios of Paris'. This, then, is a commission from a westerner born in Paris who, on living in the east, framed his prayer according to Byzantine conventions.

 Such portable works may have been produced in and around Acre for westerners temporarily in the east, relying on western artists. But as a scenario this may be too neat and simple, as the frescoes of St Francis for a community resident in Constantinople show. The society of the east is not so easily compartmentalized, and among westerners there were many whose families had settled for some generations and who mixed and intermarried, not simply with indigenous Greeks, but with Syrians, Armenians, Egyptians, and others. Thirteenth-century art served these 'multicultural groups' with their varied interests and backgrounds. Eastern and western features appear in the series of Armenian manuscripts made in the kingdom of Cilicia by the scribe and painter T'oros Roslin between 1256 and 1268, who worked for the leaders of the Armenian church and royal family [**111**].[6] In recognition

111 T'oros Roslin

Manuscript illustration of the Last Judgement. Hromkla, Cilicia (Lesser Armenia).

The Armenian artist T'oros Roslin was the leading artist and scribe employed by the American patriarchate and royal family, and he signed seven manuscripts between 1256 and 1268. The distinctive style of the minatures shows a combined knowledge of Armenian, Byzantine and western art (probably learned by direct contact with Franciscan missionaries to the region).

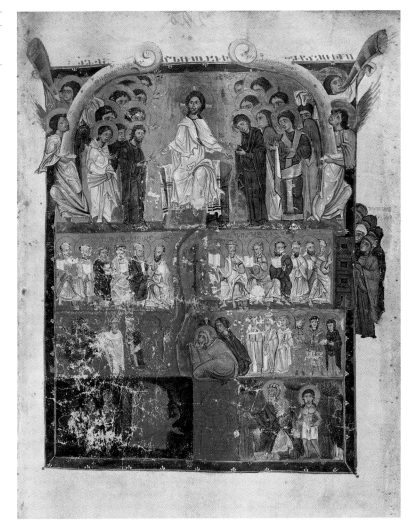

of this complex situation in the eastern Mediterranean, a group of over 100 icons at Sinai that had been seen as the work of western artists for Crusader patrons has been reconsidered; some, it is proposed, were the work of Byzantine and other eastern artists working for various patrons on Lusignan Cyprus in the thirteenth century. The island was certainly a major centre of production of icons for both Catholic and Orthodox communities, whose continuing patronage can be seen in the frescoes of such churches as the Panagia at Moutoullas of 1280.[7] Some of these revised attributions are stringent, as the suggestion that a diptych at Sinai with St Procopius and the Virgin Kykkotissa was produced on Cyprus by a Byzantine artist, perhaps working in Nicosia (the previous proposal was that the artist was a Venetian working in the east). The icon certainly reproduces the Kykko icon of the Virgin, a miraculous image kept in Cyprus in the monastery founded by Alexios I Komnenos (1081–1118) and believed to be one of the three archetypes in

the east painted by St Luke (today it is concealed under a silver-gilt cover dated 1576). Yet such debates show the difficulty of a decisive conclusion on the place of manufacture of these icons. This same icon includes images of St Catherine and Moses and their choice might be used as an argument that this icon and others were actually made by visiting or resident artists in the Sinai monastery itself. The difficulty in reaching any safe conclusions points to the versatility of eastern and western artists in this period. Western artists seem able to absorb Byzantine and other eastern pictorial ideas; Byzantine artists seem equally ready to absorb western ideas and techniques, and patrons and spectators learned to confront a range of experiences. If we cannot reliably distinguish the art of the east and the west, the reason lies in the circumstances of production. It is not that artists were simply pragmatic or eclectic as they responded to new materials: there was a deeper attempt to mould and share new ways of expression through their growing experience of diverse traditions. In the east, the westernization of Byzantine art reached a new and creative stage.

The consequences of the shifting political circumstances in the eastern Mediterranean was that from 1204 onwards Byzantine contact with the west was part of everyday experience. This sets the cultural background for the whole period up to 1453. For the artist and patron, it meant that their viewing could never be innocent, and choices were continually made between retaining the past traditions of Byzantine art and adaptation to new ideas and methods. For the emperors over this period, the political solution to the decline of their fortunes and the growing threat of the Turkish advance that presented itself was alignment with the west, if necessary by direct appeal.[8] John V Palaiologos was the first to travel west. In 1369 he went by sea to Naples, and in Rome in October he solemnly read aloud his personal confession of faith in accordance with Catholic dogma, and repeated this in a service in St Peter's in the presence of Pope Urban V. The return journey was inauspicious. He was arrested in Venice as a debtor, and released only when his son came in person to redeem him. Back in Constantinople, the patriarch declared his resistance. John V's son Manuel II Palaiologos (1391–1425) in 1399 travelled to Venice and to other Italian cities, on to France where he stayed four months in Paris, and then to London for two months. His return journey gave him a further two years' residence in Paris during which time he wrote an *ekphrasis*, a 'Picture of Spring', about a tapestry in the Louvre palace. Finally, news received, two and a half months after the event, that Timur (Tamerlane) had defeated the Turkish army in July 1402, and so relieved an ecstatic Constantinople from immediate danger, brought him home through Genoa and Venice after three and a half years of absence, and near fruitless appeals. In gratitude for his reception in Paris, Manuel on his return to Constantinople commissioned between 1403

Manuscript illustration of Emperor Manuel II, his wife Helen, and their three children under the protection of the Virgin and Child. Constantinople. 1403–5. The works of Pseudo-Dionysios the Areopagite.

The lavish use of gold in the imperial portrait and in the other miniature in the manuscript—a portrait of the author, Dionysios—was an attempt to claim the survival of the Byzantine empire, despite the circumstance of the times. The rest of the manuscript is, nevertheless, an important edition of the complete theological writings of Dionysios, donated to the abbey of St Denis at Paris, where his relics were preserved.

and 1405 a manuscript of the writings of St Dionysios the Areopagite and had it delivered to the abbey of Saint-Denis by his ambassador Manuel Chrysoloras in 1408. It contained two miniatures, one of St Dionysios, the other of Manuel and his family, the emperor and empress crowned by the Virgin Mary and Child. It is a magnificent full-page portrait gallery, with the imperial family in full regalia, matching the French reports of Manuel's appearance on his entrance into Paris as being worthy of an emperor [112].[9]

It was also imperial opportunist initiative that encouraged Michael VIII Palaiologos (1259–82) to send legates to the Second Council of Lyons in 1274 with letters declaring Byzantine obedience to the Catholic church and to the required articles of faith as demanded. The union of the churches declared at Lyons came to a rapid and bitter end in 1289. The next attempt at union of the churches was at Ferrara and then at Florence in 1438–9, and was attended by a Byzantine delegation

of 700, including the patriarch of Constantinople, Joseph II (who died there), and the emperor John VIII Palaiologos (1425–48). An agreement was signed despite distrust on the Byzantine side, and when they returned and celebrated a union service in St Sophia, opposition was expressed by Lukas Notaras: 'Better to see in the city the power of the Turkish turban than that of the Latin tiara.'[10] When the military crusade promised by Pope Eugenius IV was annihilated at the battle of Varna in 1444, it was only a matter of time before the union was repudiated by the Orthodox church.

For the church there was continual dialogue with the western church, and discussion over the controversial issues: papal primacy, *filioque* (the western view added to the creed that the Holy Spirit proceeded not only 'from the Father' but also 'from the Son'), purgatory, and azymes (the unleavened bread used in the Armenian and Latin church in the eucharist, unlike the Byzantine use of the leavened bread following their interpretation of the Gospel account of the Last Supper). Intellectually, western theological works were known in Byzantium, and in the case of scholasticism familiarity came partly through discussion with the many Dominicans resident in the east, and partly through translations by Demetrios Kydones in the mid-fourteenth century and Patriarch Gennadios II Scholarios in the fifteenth century. It was a period of intense and well-informed theological debate on both sides, but over the key issues there was little chance of compromise. In the fourteenth-century movement of Hesychasm and the extreme meditative practices it encouraged, the most bitter adversaries were Gregory Palamas who spoke of the uncreated light of God at the Transfiguration, and Barlaam of Calabria, who argued that it was created light. Barlaam was bilingual in Latin and Greek, came to Constantinople from south Italy and returned to the west after being condemned at the Constantinopolitan council in 1341, and was immediately converted to Catholicism. Two more councils were convened in Constantinople to reaffirm the theology of Palamas as orthodox in 1347 and 1351. The emperor who presided over the last, John VI Cantacuzenos (1347–54), himself became a monk and commissioned an illuminated manuscript of his pro-Hesychast theological works from a scribe at the Hodegon Monastery between 1370 and 1375; the full-page Transfiguration [113] was used as the best image to communicate the thinking and practices of the Hesychasm movement.[11]

All these discussions involved at one level or another attitudes drawn from western or eastern theology. The clash emerged in another way in the last years of Byzantium when there was a lively centre of philosophical thinking around Gemistos Plethon (1360–1452) at Mistra in south Greece, where he was sent as an exile from Constantinople around 1407 for heresy and paganism. His thought and writing show that Byzantium witnessed something very similar to

113

Manuscript illustration of the Transfiguration. Theological Works of John VI Cantacuzenos. Constantinople. 1370–5.

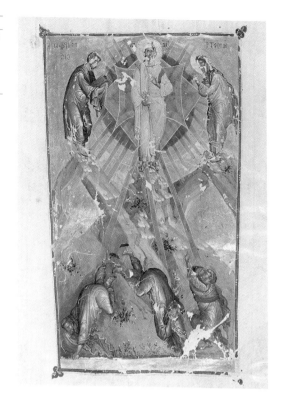

Renaissance humanism.[12] The pro-unionist Bessarion, who was born in Trebizond in 1399/1400, and died in Ravenna in 1472, went to Mistra to study with Plethon before becoming a monk in 1423 in Constantinople. In 1439 he converted to Catholicism in Italy, and became a cardinal, and even titular Latin patriarch of Constantinople after 1453. Bessarion wrote in Latin and Greek, and was involved in Rome in organizing the acquisition and translation of Greek texts.

This historical information highlights how everyone in Byzantium, from the fanatical 'anti-papists' to the disillusioned intellectuals who emigrated to Italy, was touched in different ways by contact with the west. Byzantine art, as much as everything else in the culture, reflects this in all manner of ways, sometimes very obviously, as in the overtly pro-unionist fifteenth-century icon from Crete which represents the monogram 'IHS' of the Franciscan St Bernardino of Siena, one of the Latin pro-unionists at the Council of Florence, in order to convey both Catholic and Orthodox pictorial versions of the Resurrection to the Byzantine viewer.[13] Otherwise, the westernization of Late Byzantine art or, alternatively, its resistance in some form to westernization is more covertly or more gradually communicated in the production of this period. It is always necessary to assess this factor and to judge how to take it into account. At no point after 1204 can we imagine that Byzantium did not know of the various developments in the Gothic and

114

Wall painting of Tomb G with the deceased woman in the presence of the Virgin and Child. Chora Monastery (Kariye Camii), Constantinople. Second quarter of the fifteenth century.

This was the last tomb monument to be made in the church in what was originally the archway of the second bay of the outer narthex wall. The painting was on a rectangular panel between the sarcophagus and the lunette window. This is the only tomb painting with clear evidence of Italian Renaissance style.

Renaissance west. If a Byzantine treatment of pictorial perspective is divergent from western developments, it can be considered as a matter of self-conscious choice, not ignorance. Yet the variety of production and forms of expression remain considerable, and there is no one straight line of evolution towards greater acceptance of western ways of expression or techniques; for example, egg tempera remained the standard medium for the icon. Within the decorations of the Chora Monastery in Constantinople, the most important monument of the Late Byzantine period, the mosaics and wall paintings, which date from 1316 to 1321, do show an interest in perspective and its role in narrative portrayal, but treat spatial elements very differently from the way scenes in the Arena Chapel at Padua are treated. But shortly before 1453, the last tomb to be added in the outer narthex of the Chora Monastery demonstrates how well, even if not in perfect perspective, a Byzantine artist could reproduce the art of quattrocento Italy [**114**]. In the preserved lower section, the deceased woman is shown in the same sacred space as the Virgin and Child enthroned. She is standing in front of the throne on the receding marbled floor; she wears a heavy damask silk dress and over it a long dark coat. The Virgin wears a violet-red mantle over a blue tunic, and the Child is dressed in golden clothes. The throne and footstool are foreshortened. The three-dimensional effect is very striking: the dead woman is seen quite literally in paradise.[14]

In these circumstances of Byzantine artistic versatility and intense religious emotions, the whole spectrum of art is extremely complicated to comprehend. Westernization involved all manner of different aspects and different reactions. However, there are a number of strategies that

At least one Byzantine artist wished his name to be recorded on the walls of the church he decorated in the town of Veria in north Greece, and a poem was inscribed prominently over the west wall:

> Xenos Psalidas builds a church of God
> Seeking redemption from his many sins
> Giving it the name of the *Anastasis* of Christ.
> His wife Euphrosyne completes this.
> The artist's name is Kalliergis
> —in respect to my noble and modest brothers—
> Of all Thessaly the best painter.
> A patriarchal hand dedicates the church
> In the reign of the great emperor Andronikos
> Komnenos the Palaiologos in the year 6823 [=
> 1314/15]

(Quoted by S. Pelekanides, *Kalliergis of All Thessaly the Best Painter* (in Greek) (Athens, 1973), 7–12.)

To the name of Kalliergis, we can add a fair number of others, some known from literature alone and others from signatures on their paintings. In the case of Angelos Akotantos of Crete, we have not only his will of 1436 but a number of signed icons. Artists are described as *zographos* (painter), *historiographos* (painter), *maistor* (master), *ktistes* (creator). Some, including manuscript illuminators, are priests or monks, but others are professional painters, working in a family business. In the case of the *Menologion* of Basil II of the early eleventh century, there were eight artists at work on the miniatures, under the supervision of Pantoleon. In the case of John Pagomenos of Crete, between 1313 and 1347, one artist is recorded at work in eight different churches. In the sense of classical and renaissance art where artists were in their lifetimes publicly known and discussed, there is no art history in Byzantium. It is of course possible to look for 'hands' in Byzantine art—asking how many artists were needed to produce one manuscript, or how many people were involved in a major mosaic decoration, where assistance was needed to put up the scaffolding, mix and apply the lime plaster to the walls, and to supply the glass and stone tesserae to be pressed into the painted surfaces. Monreale in Sicily must have needed many workers, but the mosaics of Hosios Loukas look far more like the work of one overall master. Daphni, with its different styles, might have been a place where several artists were needed. Artists could apparently work in several media—mosaics, wall paintings, icons, and book illumination—but ivory carvers and enamellists no doubt specialized, as did monumental masons and sculptors.

Some artists certainly gained local and international reputations in Byzantium, but Kalliergis's long inscription remains exceptional. Perhaps the anonymity of 'Byzantine' has been exaggerated, but the social status of the 'artist' in Byzantium is part of the nature of the Byzantine community, different from the ancient world.

The will of Angelos (1436) gives insights into the attitudes of the professional painter:

> I Angelos Akotantos, the painter, being a mortal man and subject to death, and being about to sail to Constantinople, do make my testament about my possessions as follows:
>
> My child who is about to be born, if a boy, I wish him first to learn to read and write and then the art of painting. And if he learns the latter, I bequeath to him my drawings [*teseniasmata*] and all the articles of the craft; but if he does not learn the craft, I bequeath my drawings [*skiasmata*] and all the articles of the craft to my brother John. And my books I bequeath to my child, if male, so that he may learn to read. I also wish that the head of St Catherine, the round icon, should be given after my death to the monks of Sinai, who will display it every year on the festival day of the saint in my memory. I wish also that the two icons that are in my room, the *Anastasis* of Christ and Nativity of Christ, be taken to the church of Christ Kephalas at Candia and set up in the middle of the church together with the veil which I have for this purpose, namely the *Anastasis* on Easter Day and the Nativity on Christmas Day ...

may be suggested as factors in the production of late Byzantine art. The political trauma of Latin occupation had long-term effects. As well as the draining away of its most precious objects, Byzantium permanently lost territories and could never regain even the pretence of a unified empire. There were rival Byzantine courts and rival empires. The empire of Trebizond under the Grand Komnenoi lasted from 1204 to 1461, and the city developed as a capital in miniature with numerous churches. The monastery of St Sophia outside the city was founded by Manuel I of Trebizond (1238–63) as the imperial mausoleum and decorated fully with wall paintings and exterior sculptures. The fortified city of Nicaea acted as the capital of the empire and seat of the patriarch for the first half of the thirteenth century, and there is evidence of accompanying artistic work in Nicaea and around. The despotate of Epiros was an independent kingdom from 1204 up to the Turkish conquest which held north-west Greece and much of Thessaly and Albania; it even took Thessaloniki from the Franks in 1224 until it lost it to Nicaea in 1246. The monuments of Epiros were numerous, ornate, and not a little pretentious. The metropolitan church of the Virgin Paregoretissa at Arta, built around 1290, is the most important. There is much reuse of ancient marbles from nearby Nicopolis, but the end product is a building with the appearance more of a palace than a church, an extensive mosaic decoration under its towering cupola, and sculptural carvings by western artists. The Peloponnesos became Frankish from 1205 until 1262 when the Nicaean Byzantines regained the south. This section was organized as the despotate of Morea from 1349 until its capital, Mistra, fell to the Turks in 1460 [**115**]. The extensive late Byzantine architecture at Geraki, Monemvasia, and Mistra therefore belongs in the Byzantine orbit, but is surrounded by westerners. The rival empire of Serbia and the second empire of Bulgaria were able from 1204 to control much of the Balkans until the advance of the Ottoman Turks. Artistically they both employed Byzantine artists for many commissions, such as Sopocani [**118**], or emulated Byzantine visual culture through imitation, as in the Gospels of Ivan Alexander (London, British Library). The one group that did not benefit from the events of 1204 were the Rus', who were themselves threatened from 1230 by the Mongolian invasion, and were not able to commission major Byzantine artists to work on their Orthodox churches until Theophanes the Greek (Theofan Grek) came from Constantinople to work at the church of the Transfiguration at Novgorod in 1378, and then to the Annunciation cathedral inside the Moscow Kremlin [**125**]. Theophanes worked with Russian artists, notably Andrei Rublev (*c*.1360/70–*c*.1427/30), and from this time the Russian icon and the high iconostasis were developed in the north, partly looking to the Byzantine tradition, partly to the west.

Constantinople after 1204 never regained its former prestige or territories. In 1261 Michael VIII Palaiologos (1259–82) recaptured the city

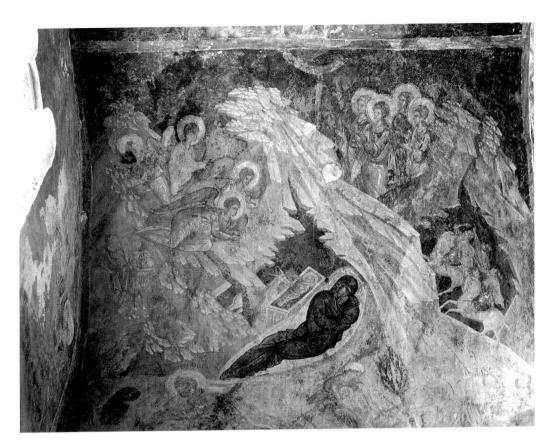

115
Wall painting of the Nativity in the church of the Virgin Peribleptos, Mistra. Third quarter of the fourteenth century.

and on the festival of the *Koimisis* of the Virgin on 15 August he made a triumphal entrance accompanied by his court and the patriarch through the Golden Gate with a prayer of thanksgiving, and then went on horseback along the streets to St Sophia. The restoration of the Byzantine empire was ceremonially proclaimed, and the procession was led by the ancient icon of the Virgin *Hodigitria*, the protectress of the city [**116**], which the Venetians had been keeping in the Pantokrator Monastery. Yet the Latin occupation caused a trauma as deeply psychological as it was political. One expression was the growing use of the Byzantine self-description as Hellenes rather than Romans. Up to the thirteenth century the word 'Hellene' had meant pagan, but now it began to imply membership of a Greek nation. This in turn may have encouraged intellectuals to turn back to a Greek past, but this did not always have a beneficial result: it encouraged the notion that the present generation had sinned and was inferior to its predecessors, and lacked their originality.[15] There was certainly nostalgia, expressed elegantly by Theodore Ducas Lascaris, emperor of Nicaea between 1254 and 1258, in a letter describing the greatness of the Hellenic past he could see on visiting the city of Pergamon, compared with the buildings of his day.[16] These many strands make up the profile

Manuscript illustration of the shrine of the *Hodigitria*. Hamilton Psalter. Constantinople. Fourteenth century.

The miniature shows a partly realistic image of the shrine in which the *Hodigitria* icon was kept in Constantinople. The large panel with the Virgin and Child between bust-length archangels is under a ciborion and inside a grille. The icon is held up on a stand. There is a small copy below the icon, presumably for kissing. The picture shows a group of figures praying and venerating the icon, perhaps a family.

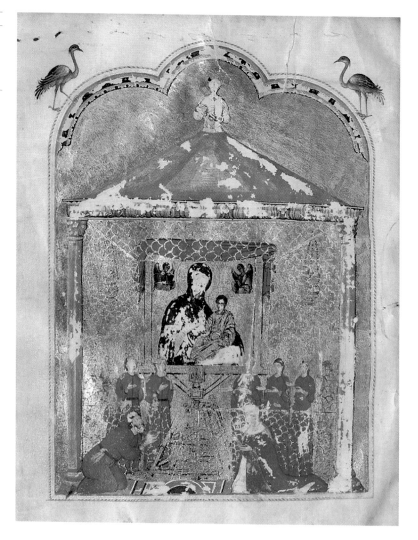

of patronage from 1261. Perhaps the majority of Byzantines for their own self-esteem would defend their traditions and superiority over their rivals. One would expect the art of the capital to continue to support the Orthodox faith and to communicate its superiority, even though the Byzantines' viewing experiences had changed. In the territories where Orthodox lived with Catholics as disadvantaged neighbours, as in Crete and Cyprus, for example, the different strands of artistic expression were more openly developed.

Constantinople after 1261 and the Chora Monastery

The return to Constantinople of the grand court and patriarch was celebrated with the greatest optimism by ceremonial and the eulogistic accounts of that ceremonial. The city was in reality dilapidated and the empire no more than the western coast of Asia Minor, northern

Greece and the south-eastern Peloponnesos. Re-establishment of the past prestige of the Byzantine empire required all manner of practical gestures, and there was clearly massive activity all around the city. Michael VIII Palaiologos commissioned a bronze statue of himself kneeling before the archangel Michael, offering a model of the city. Russian travellers who came after 1261 were able to visit and describe an unexpectedly large number of relics and treasures, somehow found and displayed:

Entering Constantinople is like entering a great forest; it is impossible to get around without a good guide, and if you attempt to get around on the cheap without offering sweeteners you will not be able to see or kiss a single saint unless it happens to be the festival of that saint when you can see and kiss the relics.

So wrote Stephen of Novgorod in 1349.[17] As for the relics of Christ's Passion previously in the Great Palace, and reputed to be dispersed to the west after 1204, remarkably a set of these was inside a chest covered in gold with a Crucifixion in silver on the top and displayed at the church of St George at the Mangana. 'The Lord's Passion relics are there, locked and sealed with the imperial seal. During Holy Week the emperor himself and the patriarch unseal and kiss them, and afterwards it is impossible for anyone to see them. We sinful men kissed the body of St Anne which reposes there.'[18]

Refurbishing St Sophia was the absolute priority for the prestige of Byzantium. For over fifty years, it had been a cathedral for the Latin rite and had lost parts of its decoration, including marble revetments in the imperial area of the south gallery. In September 1261 the patriarch was enthroned in St Sophia, followed soon after by the imperial coronation. For these events, the church was refitted for the Orthodox liturgy, and a new mosaic was made on the west side of the central bay of the south gallery. This enormous mosaic, the *Deisis*, was 5.2 metres in height and 6 metres in width. We can still see the upper part of this panel, with the Virgin Mary to the left on the window side, Christ enthroned in the centre and St John the Baptist to the right [117]. The image shows Christ at the Second Coming, and so the prayer it represents can be read as an intercession for all mankind. We can re-create the topical circumstances of its production in 1261, and see the universality of the image.

The striking feature of the *Deisis* mosaic is its monumental size, in contrast with the intimate and devotional character of the imagery. The panel towers above the spectator, yet the figures are each individually designed to appear naturalistic and caring. Christ has a blessing gesture and is shown calm, contemplative, and approachable. His face is so softly modelled that it is more like a painted icon than a monumental mosaic, and it is strikingly close to the early icon of Christ from

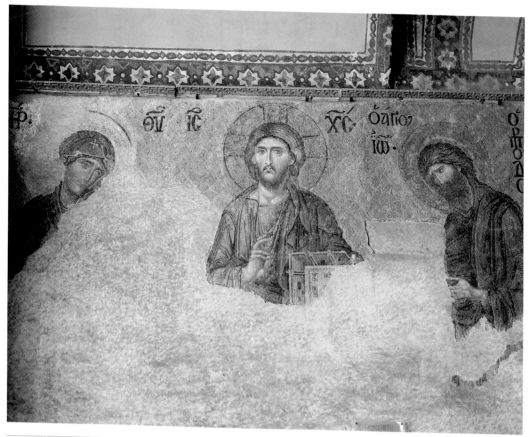

117

Mosaic panel of the *Deisis*. 1261[?]. South gallery, St Sophia, Constantinople.

There is little evidence of monumental mosaic work in the east in the thirteenth century, although artists continued to produce icons, wall paintings and manuscripts. Clearly, a major work in St Sophia after the ending of the Latin occupation was likely to be in the traditional medium used in the church. Perhaps more than any other Byzantine mosaic, the effect here is of the imitation of painting. Miniature mosaics tended to have a similar effect.

Sinai (perhaps repainted in the thirteenth century) [**37**]. Mary's face is seen turned towards Christ in intercession, and she is even more softly modelled, belying the technical hardness of the glass and stone of the tesserae. Again, the closest Byzantine parallel is with an icon, and the comparison that was instantly made when the mosaic was uncovered in the 1930s was with the twelfth-century icon of Vladimir, sent to Kiev around 1130 [**105**]. It, too, is distinctive for the delicacy of the model-ling of the Virgin's face, and it might have been the kind of Byzantine art that Psellos's term 'living painting' was trying to invoke. The *Deisis* panel was, however, produced at the time when naturalism in the por-trayal of figures and space was being further developed in church deco-rations, such as at Sopocani in Serbia around 1260 [**118**]. Not only did these wall paintings show highly modelled figures on a grand scale, but the detailed treatment of the face of Christ in the *Koimisis* is like that in the *Deisis* mosaic.

The *Deisis* mosaic is an 'icon' of extraordinary scale, and other late Byzantine churches, such as the Christ Pantokrator church at Decani, built and decorated between 1327 and 1347, had similar images. But the late Byzantine period also developed the medium of the virtuoso micro-mosaic panels, which look at first sight like painted icons. These

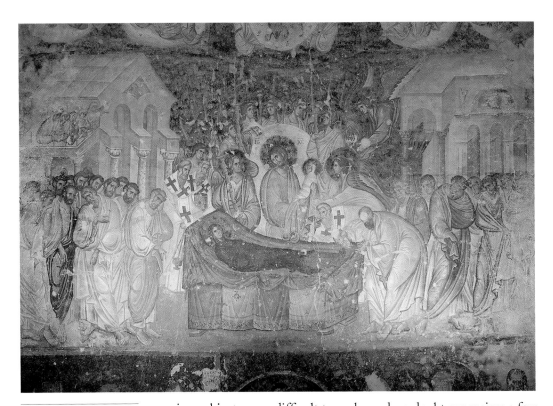

Wall painting of the *Koimisis* of the Virgin. 1260s. West wall, cathedral of the Trinity, Sopocani.

The Serbian royal family brought in Byzantine painters to decorate their family mausoleum church. The interest in the development of perspective in this composition and the naturalistic, if bulky, figure style marks parallel interests with western artists at this period.

precious objects were difficult to make and no doubt expensive; a few still remain in monasteries in the east. They appealed not simply to the Byzantines but also became collectors' items in the west; Pope Paul II (1464–71) had 25 of these miniature mosaics in the Vatican. The making of the *Deisis* mosaic certainly involved great technical expertise, but the most obvious art-historical issue that it raises is the 'Byzantine Question'. The delicately modelled face of the Virgin is nothing less than an example of the 'new' style of the early Renaissance, the 'human' treatment of sacred figures that in the account of Vasari severed the art of Giotto and Duccio from Byzantium. Instead, a date of 1261 makes it a predecessor of their art, and it is placed in the one building that most obviously makes statements about the Byzantine identity of Orthodox art. As in the case of the contemporary Crusader icons, eastern and western ideas are combined in one work. This meeting of east and west in art is paralleled by the move towards the unification of the churches and, at a practical level, one can assume that the exchange of artistic gifts during the negotiations for the Council of Lyons of 1274 did literally cause the movement of works of art between those involved in the proceedings. But seen more broadly, the Deisis mosaic is only one case of convergence between east and west, to be compared with the wall paintings of Nerezi, the Crucifixion at the Serbian church of the Virgin Mary at Studenica (1208/9), and Sopocani. Whatever caused the striking resonance between east and west in the *Deisis* mosaic, its

119

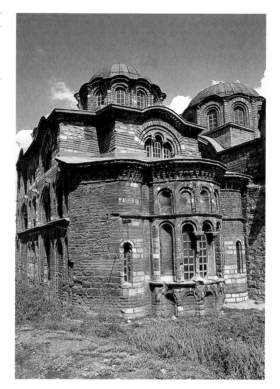

119

The church of St Mary Pammakaristos (Fethiye Camii), Constantinople. Soon after 1304.

The *parekklesion* was built in the south side of an earlier katholikon of a monastery by Maris, the widow of Michael Glabas Tarchaneiotes, and this is recorded in a verse inscription, written around the exterior of the small cross-in-square church, by the popular poet Manuel Philes.

power lies in the charismatic evocation of Christian mercy at the time of the Second Coming.

By the end of the thirteenth century a distinctive form of aristocratic patronage in Constantinople was the addition of new structures to pre-existing monasteries. The two most ambitious are the side-church, the *parekklesion*, added to St Mary Pammakaristos (now Fethiye Camii) [**119**] and the rebuilding of the Chora Monastery (now Kariye Camii) [**121**]. In 1305–10, the widow of Michael Glabas Tarchaneiotes, a former general, built beside the Pammakaristos a mausoleum in the form of a miniature cross-in-square church dedicated to Christ.[19] The mosaics were carefully planned to function as icons of intercession for the deceased. The execution of the mosaics discloses a pattern of working that is typical after 1261 [**120**]. Christ in the dome is a conventional Pantokrator image; the artist had no doubt seen many, and had probably represented Christ in this form many times. Christ in the apse, part of a *Deisis* group, and the focal point of the intercessory cycle, was in contrast given special treatment, and owes much to the new mode of the Christ in the *Deisis* panel of St Sophia. The interplay of these two objectives, the traditional and the experimental, is the dynamic of artistic production more obviously after 1261 than before.

The assessment of late Byzantine art properly depends on the Chora Monastery, since it was intended by its patron Theodore Metochites to be the greatest monastery project of the age, and he was

120

Mosaics of the church of St Mary Pammakaristos (Fethiye Camii), Constantinople. Soon after 1304.

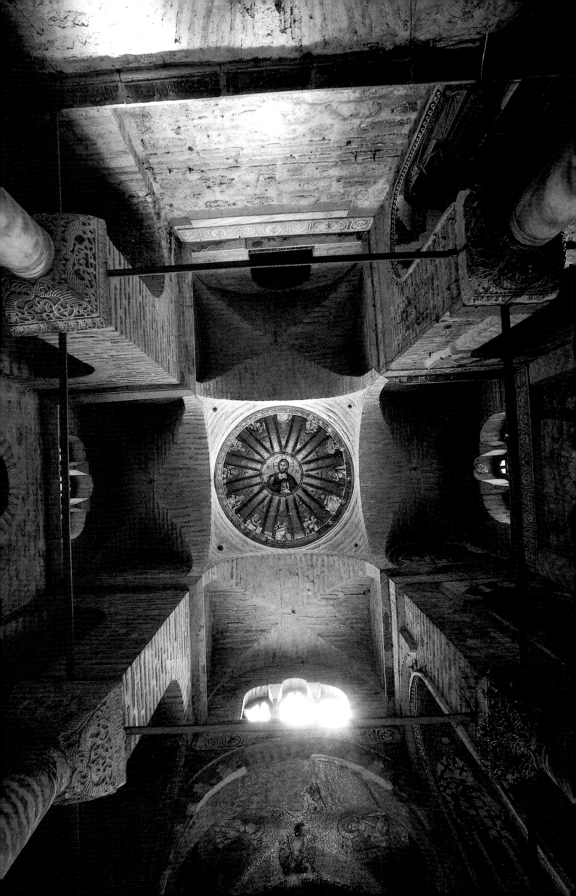

Mosaic panel of the founder
of the Chora Monastery,
Theodore Metochites.
1316–21. Kariye Camii,
Contantinople.

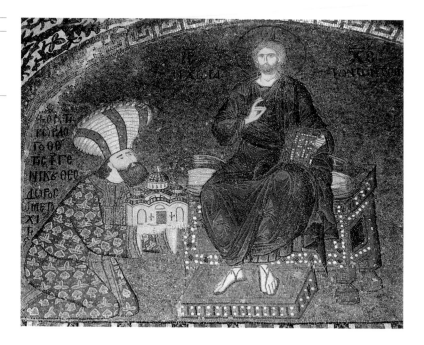

represented over the door from the inner narthex into the nave in full
state regalia kneeling directly before Christ [**121**]. In our terms, it is a
multi-media operation: architecture, sculpture, mosaics, wall paint-
ings, and fully stocked library. Theodore was *mesazon* and *Grand
Logothete*, special titles which he held as the most powerful man after
the emperor, Andronikos II Palaiologos (1282–1328). When the latter
was deposed in civil war in 1328, Theodore, too, went into exile. For
most of his life he described himself as statesman by day and scholar at
night.

The Chora project, which started around 1316, and was finished by
Easter 1321, was a radical restoration of a monastery near the land walls
and the nearby Vlachernai Palace. It was to provide perfect surround-
ings for the scholar and a mortuary chapel for Theodore, who ulti-
mately died there in 1332 under his monastic name of Theoleptos,
following the custom that a monk should choose a new name with the
same initial as his original name. The artist appears to have been
brought in from the (unfinished) mosaic operation at the patriarchal
commission of Holy Apostles at Thessaloniki and brought back to
Constantinople. Artist, architect, and church planner worked together
in the operation, which involved rebuilding the vaults of the earlier
katholikon, building an inner and outer narthex, adding the *parekkle-
sion*, and any other necessary structure. Their co-operation is shown by
all sorts of careful decisions, such as ensuring the number of flutes in
the two domes of the inner narthex matched the number of ancestors
of Christ (16 in the north and 24 in the south). The architecture al-
lowed for extensive cycles of the Life of the Virgin and the Infancy and

Ministry of Christ. The main church has now only the mosaic icons beside the *templon* and the *Koimisis*, but the *parekklesion* paintings mostly survive. The images focus on salvation of the soul and on the importance of the Virgin. Like the sanctuary design of S. Vitale, the parts of the decoration are bound together by a series of medallions along the vault, culminating in the mandorla of Christ in the apse. He is shown raising the souls of Adam and Eve from hell in a developed *Anastasis* [122].

The cycles have been described as 'conservative', and it is true that the *Koimisis* is traditional in its style. Yet this is a superficial assessment. It is clear enough that the artist must have searched for models and had sometimes to fill in redundant spaces with conventional motifs.

The cycle of the Life of the Virgin [123] includes rare scenes, and some, like Mary receiving the Skein of Purple Wool, are found in no other churches. A feature of the design of these scenes is the use of perspective to create pictorial space in which the narrative takes place, but the Byzantine devices, in foreshortening buildings, differ from later Renaissance constructions towards one vanishing point (the basis of the later tomb painting in this church [114]). Instead, the lines of the build-

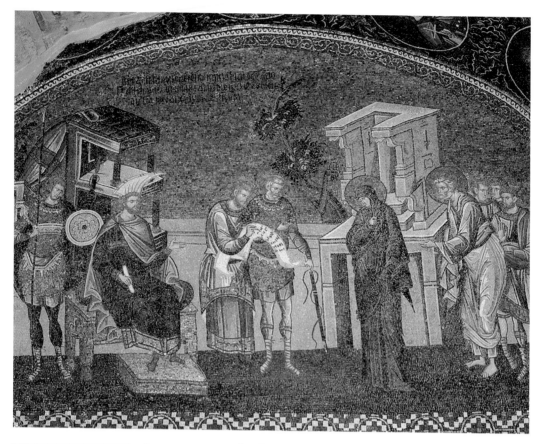

123
Mosaic of the Enrolment for Taxation at Bethlehem. 1316–21. Outer narthex, Chora Monastery, Kariye Camii, Constantinople.
The Life of the Virgin and Infancy of Christ cover the vaults of the inner and outer narthexes of the church. This lunette in the outer narthex shows the enthroned governor Cyrenius on the left, the scribe recording names, and the pregnant Mary in front of Joseph. The composition and perspective help to dramatize the narrative.

124
Double-sided icon of the Annunciation and Virgin. Constantinople. Early fourteenth century.

ing converge on the figures in the foreground and highlight the action and story. Attention is also given in the decoration to rich and varied ornament and borders. Both the mosaics and the wall paintings of the church introduce new ideas and designs into Byzantine monumental art, some derived from manuscripts, some derived from a knowledge of the international ideas of the period. It must therefore be a distortion to describe the art of this church as conservative. Yet this is a reasonable reaction to the rhetoric of Theodore Metochites in his own writings which reflects his great political acumen. What he had learned from his father's unhappy life was the danger of being too much of an adherent of any church movement; George Metochites, as an enthusiastic pro-unionist, was dismissed in 1283 from his position as an archdeacon in the church at Constantinople when the precarious union declared at Lyons broke down. He remained in prison in Asia Minor till his death in 1328. Theodore, born in 1270, learned from his father's mistake and managed to start a government career in 1290 and to rise to the top. His writings make it clear that he considered it wise to avoid obvious originality or involvement in theology. The Chora church puts this into practice pictorially: it is a monument of understated originality. In comparison with the mosaics of Holy Apostles at Thessaloniki, the subjects chosen and

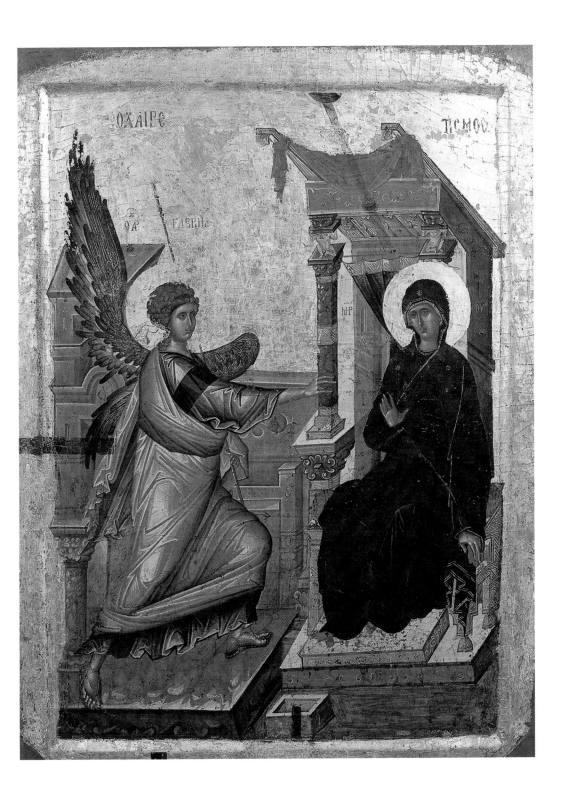

their intricate details show the ways in which an artist in Byzantium responded to the ideas and theological learning of the patron. Although some of the pictorial devices and decorative manipulation of perspective are found in other works from Constantinople (and in the west as well) at this period, like the two large double-sided icons sent from the monastery of the Virgin Psychosostria at Constantinople to Ohrid [124], Theodore Metochites' commission does achieve his obvious aim of producing the most sophisticated monument of the period.[20]

Theodore Metochites, both as political leader and as an intellectual, has been treated with relative disdain by modern scholarship.[21] He has been dismissed as a potential humanist because he did not collect antiquities and his exploration of classical literature was unsystematic. He does not match up, on this approach, with his younger contemporary Petrarch. Another of Theodore's contemporaries in the west was Enrico Scrovegni, the wealthy patron of the Arena Chapel in Padua who paraded his patronage with the commission of an openly 'modern' artist, Giotto. The situation of Theodore in Constantinople and the artistic expression of the Chora only show that the conditions for production of Byzantine art in this period were divergent from those in the west, but there were related interests. Byzantine art responded to the needs and practice of Orthodox worship, and Byzantine artists reacted to antiquity in different ways from those in the west. The comparison of the art of the Chora with contemporary art in Italy should help to show its originality and difference from earlier Byzantine art rather than its rejection of early Renaissance features.

The Icon

The character of the sacred space of the Orthodox church changed still more in the course of the fourteenth century. The *templon* screen between the nave and the sanctuary had begun earlier to hold some icons, often a painted beam with the 12 main festival scenes [40]. The next stage was to transform the *templon* structure into an opaque high iconostasis which held several layers of icons. Church architecture became increasingly ornate on the exterior and there was an expansion in the number and complexity of cycles in the interior—texts such as the sixth-century *Akathistos*, a hymn in honour of the Virgin, were used as the basis for new iconography. The proliferation of extended cycles in the monasteries matched the concentration of the monk on the glorification of the works of God through long services of prayer. The Chora was the last major mosaic decoration in Byzantium, except for the piecemeal renovation of the mosaics of the dome and eastern arch of St Sophia after earthquake damage. Late Byzantine church decoration consisted of wall painting and icons, the latter increasingly the focus of attention and patronage. Phenomenal numbers of icons were produced, and it was in this medium that the move towards westernization

At the east end of the early Byzantine church, generally a basilica, the altar was visible to the laity within a sanctuary surrounded by low chancel barriers. After the building of St Sophia at Constantinople by the emperor Justinian I between 532 and 537, the favoured Byantine church form was a centrally planned cross-shaped building with a dome; after iconoclasm (736–843), a new development was the marble or wooden screen between the nave and the altar, which the Byzantines called the *templon*. By the twelfth century, icons, usually of Christ and the Mother of God, were placed on either side of this screen; some icons began to be placed on the *templon*. This screen with its wall of icons concealed the Holy of Holies from the laity, and enhanced the ritual of the liturgy with opportunities for concealment and revelation. The eucharist became the preserve of the clergy in their sanctuary.

By the fifteenth century the *templon* may have developed into the full-scale opaque iconostasis of the modern Orthodox church, with a set system of icons arranged in each register, though allowing for some flexibility of choice. The high iconostasis, surmounted by a crucifix, was generally constructed with carved wood, and often gilded. On each side of the Royal Doors were the *proskynetaria* icons which could be kissed: icons of Christ, the Mother of God and the patronal saint of each particular church. The Annunciation and Four Evangelists commonly appear on the doors. In the register above there was the Great *Deisis* with Saints and the Great Festivals of the Church. The iconostasis could develop to include a programme covering the whole divine dispensation, with registers of Prophets and Patriarchs.

was most pronounced. Since icons within any church often accumulated as the outcome of donations by instalments and each one could reflect the personal tastes of the donor, the range of spiritual experience could be quite diversified.

Another growing practice of this period was for the artist to include a signature on the wall painting or icon. What in the twelfth century at the monastery of Neophytos, when Theodore Apseudes signed and dated his painting, was an exception, became something of a convention in the late Byzantine period. Art-historically this encourages the classification of art according to artistic personality, but it may not have been the intention of the Byzantine artist to make this kind of statement. In the west, artistic signatures may indicate the growing social status of the profession and indicate that consumers discriminated between different artists. Perhaps there is an element of social change and patronal taste indicated by the practice in Byzantium, too, but the Orthodox church's discouragement of novelty and emphasis on the need for traditional observances makes the interpretation complicated. But it is the case that we can confidently begin to comment on individual artists' styles and concerns.[22] The figure style of Theophanes the Greek, working in Novgorod and Moscow in the late fourteenth century, is distinctive and experimental

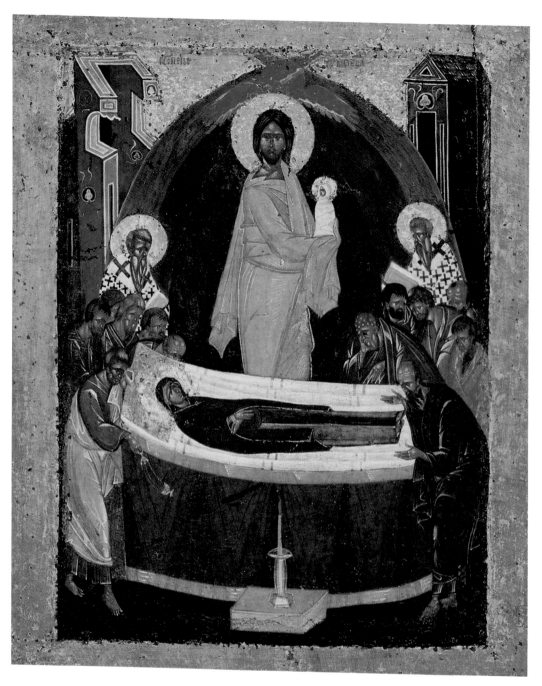

Theophanes the Greek.
Double-sided icon of the
Virgin of the Don and the
Koimisis of the Virgin. Late
fourteenth century.

in its facial distortions and elongation [**125**]. Another artist, Angelos Akotantos, working in Crete in the first half of the fifteenth century, signed a number of icons [**126**]. He is independently documented through the survival in the notarial archives of Crete of his will, written in 1436. A prolific painter, his icons show an ability to satisfy a demand for either traditional images or for paintings that include

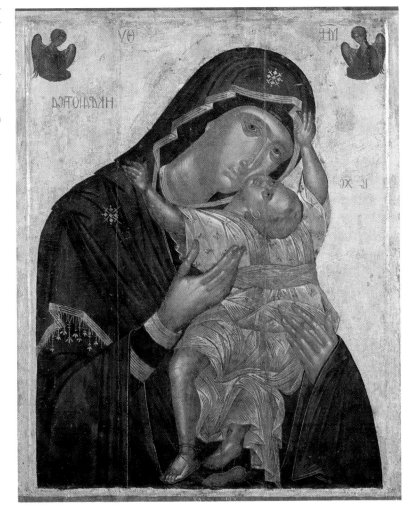

distinctively western details or conventions. His production of such different works may depend on the individual patronage or on their function, whether intended for use in an Orthodox monastery like that of St John on the island of Patmos or in a church in Crete with a Catholic congregation. These two artists were highly influential: the work of Rublev and his followers depends directly on the work of Theophanes, and the character of Cretan production, which ultimately led to such artists as El Greco, owes much to Angelos. Is it just a coincidence that we happen to know their names as well as their work or did the signature help to promote each artist?

At every period of Byzantine art, except for the disruption under iconoclasm, the everyday medium of the culture was the painted panel. Over time, icons changed in style, subjects, and functions, and the reasons for these changes are at the centre of Byzantine art history. The Byzantine church and its congregation could accommodate diverse objects into their everyday experience, and find icons of disparate dates

and appearance equally satisfying aids to worship and prayer. The modern visitor to any established Orthodox monastery which still shows its Byzantine heritage, like those on Athos, Meteora, or Sinai, can have the same experience of the co-existence of all kinds of objects from different Byzantine periods. The quantity of icons that have survived indicates their central role in the Byzantine involvement with art. To glimpse or to kiss other products, like a rare and precious reliquary of the True Cross or Sepulchre of Christ [**76, 108**], must have been a high point of emotional experience, and not an ordinary, everyday occurrence. Similarly the architecture and decoration of St Sophia are central to Byzantine culture, yet highly exceptional. The study of every object and decoration in Byzantium exhibits the need to distinguish between convention and specific choices. Beneath the apparent stereotypes of the icons and the timelessness of church decoration, context has been necessary for our viewing. One icon was discussed at the beginning of this book; it deserves further examination in the context of the fourteenth century when it was painted [**13**].

The icon of the Triumph of Orthodoxy is the earliest known example of this subject in Byzantine art. Another icon of the same subject, painted around 1500, has been discovered recently.[23] Since this second example is a direct copy of the earlier, it seems to corroborate its uniqueness within the Byzantine period. Most likely this is a new subject of the fourteenth century, probably pictorially derived from pictures recording the display of famous icons of the Virgin [**116**]. The icon was made for display on the so-called Sunday of Orthodoxy at the beginning of Lent. The festival was instituted on the ending of iconoclasm in the ninth century, but the text declaring Orthodox doctrine that was read out every year was continually updated by the church. In a council at Constantinople in 1166, this Sunday was described as the commemoration of the Triumph of True Faith over all heresies. The central image of the fourteenth-century icon gave greater prominence to the *Hodigitria* than to the icon of Christ set up on the Chalke Gate in or soon after 843, although this did appear, (dis)placed to the lower register and held up by St Theodosia. The composition of the icon of Orthodoxy put greater emphasis on the veneration of the *Hodigitria*, a feature of fourteenth-century devotion and pilgrimage, than on the historical icon of Christ. In this sense, a timeless commemoration of the failure of iconoclasm and heresy carries a topical reference to current issues and spirituality. The fourteenth century was also a time of acute interest in the condemnation of heresy—the establishment of Hesychasm as Orthodox belief and the exposure of its critics as heretics involved a series of councils up to 1351. The production of a new imagery of the Triumph of Orthodoxy therefore has a distinct topical resonance: it commemorated the antiquity of Orthodox tradition, and the contrast between Byzantine continuity and the innovations of the

western church. The choice of a highly refined and traditional style may be another channel of this message of the maintenance of past tradition in Byzantium. Emphasis on the miraculous icon of the *Hodigitria* was a powerful reminder to the viewer of its supposed production by St Luke in Gospel times—it gave a direct material contact with Mary and Christ. The *Hodigitria's* optimistic message, and its weekly public display, was that the healing miracles from the time of Christ still happened in the modern Orthodox world. Beneath its declaration of timeless and unchanging faith and art, the icon is very much an object of its own time.

All icons contain several layers of reference of this kind, and they impart Byzantine ways of thinking. For example, another inherent element in the imagery of the Triumph of Orthodoxy is a statement about the gender of power. Only men could be priests: Byzantine parish priests could marry, but only the celibate reached the higher posts and patriarchate. Hence the prominence of men in establishing the beliefs and values of this Christian society. But not all the figures are male. The Virgin Mary is seen as a mother, and two of the champions of Orthodoxy are women, the empress Theodora and the martyr St Theodosia. This may even raise the suspicion that art history's treatment of Byzantine art as a social construct might have underestimated the role of women in its production.

Byzantine women are well enough documented as patrons, often in later life as widows. Asceticism gave an alternative way of life to marriage, and the convent was a well-established feature of the Byzantine scene. The image of the nun Theodosia on the icon can be paralleled in many other works, but the illustrations of the fourteenth-century Typikon of the convent of *Bebaias Elpidos* (Good Hope) in Constantinople show the whole community of nuns together with their founder, offering a model of the convent to the Virgin *Hodigitria* [**127**].[24] The perpetual contact of Byzantines with the imagery and language of the cult of the Mother of God must have directed and shaped society's concept of the role of women. But the purity of Mary was contradicted by the biblical depiction of Eve and sin, and this incited male prejudice, for example, against Justinian's wife Theodora [**34**] and no doubt accounts for the fate of Theodora, represented on the Triumph of Orthodoxy icon as the regent for her son, but disgraced and deposed in 856 when he came to maturity. Female patronage of the arts is certainly an empirical fact, and women may also have been prime producers of textiles and silks. In the church, men and women stood segregated in different parts of the building, but both genders equally engaged in devotions to icons, both in public and in the home. There is nothing, therefore, to connect art with gender-specific interests.[25]

The question to which we can now finally return is that of the definition of Byzantine art. Byzantine art is often regarded as the anony-

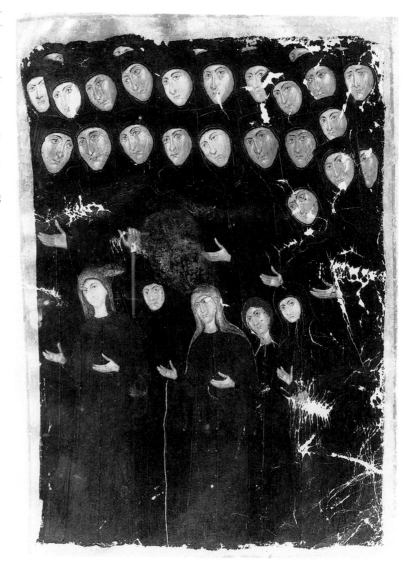

mous product of an anonymous culture. This is contradicted by the extraordinary amount of detail and information that research has uncovered. The production of many works can be related to specific circumstances and people. Individual study of works of art shows how much did actually change over the centuries, and that these changes reflected many different conditions and events. The notion of Byzantine art as a homogeneous style that can be defined as an entity is too incomplete to be helpful. The art served a culture that valued tradition and a church that promoted eternal values and doctrines. In this sense, Byzantine art is a highly functional art in which continuity and conformity were key qualities, and where artists managed to maintain a lively interest in endlessly repeated subjects and themes, which must, like

images of Christ on the cross, have met with different interpretations at different times as theological debate progressed. It was, therefore, a radical change when Byzantine artists produced icons that were signed and dated: such an icon became more a personalized work of human art and less a vehicle of communal values. A definition of Byzantine art must explain the nature of 'holy icons' which themselves stand for Byzantine identity. Byzantine art was a highly artificial art designed to convey and heighten the desire for an ideal world and existence, and it did this with decorum, balance, and tranquillity. If Byzantine art was in this sense a social construct, there is another implication. When the city of Constantinople and its Byzantine institutions, including rulership by a Christian emperor, seen as the representative of Christ on earth, came to an end in 1453, so had Byzantine art to end, too. After 1453, Byzantine traditions in Orthodox art have continued, but that is something different. What generated Byzantine art was the combination of a Roman state and Christianity, implying that the period of 330 to 1453 was a cultural unit. But the perception of a continuing and stable Roman empire was more of a vision than a reality, and neither the state nor the religion was unchanging or timeless. Byzantine art contributed to that vision.

Notes

Chapter 1. Rome with a Christian Face?

1. E.A.R. Sewter, *The Chronographia of Michael Psellus* (London, 1953), ch. 185, 188.

2. J. Haldon, 'Everyday life in Byzantium: some problems of approach', *Byzantine and Modern Greek Studies*, 10 (1986), 51–72.

3. T.D. Barnes, *Constantine and Eusebius* (Cambridge, Mass., 1981).

4. G. Dagron, *Constantinople imaginaire* (Paris, 1984).

5. C. Mango, *Studies on Constantinople* (Aldershot, 1993), and C. Mango, 'The water supply of Constantinople', in C. Mango and G. Dagron, *Constantinople and its Hinterland* (Aldershot, 1995), 9–18.

6. Mango, *Studies* 1993, esp. studies II, III, and IV.

7. C. Mango, 'Antique statuary and the Byzantine beholder', *Dumbarton Oaks Papers*, 17 (1963), 53–75.

8. S.G. Bassett, 'The antiquities in the Hippodrome of Constantinople', *Dumbarton Oaks Papers*, 45 (1991), 87–96; T.F. Madden, 'The Serpent Column of Delphi in Constantinople: placement, purposes and mutilations', *Byzantine and Modern Greek Studies*, 16 (1992), 111–42. See O. Panvino, *De Ludis circensibus* (Venice, 1600), p. 61, pl. R for an engraving of the Hippodrome (dated late fifteenth century by C. Mango). M. Jacoff, *The Horses of San Marco and the Quadriga of the Lord* (Princeton, 1993), 1–11; L. James, '"Pray not to fall into temptation and be on your guard": pagan statues in Christian Constantinople', *Gesta*, 35/1 (1996), 12–20.

9. N. Spivey, *Understanding Greek Sculpture. Ancient Meanings, Modern Readings* (London, 1996), 7–12.

10. A. Frolow, 'La dédicace de Constantinople dans la tradition byzantine', *Révue de l'histoire des réligions*, 127 (1944), 61ff.

11. M. Whitby and M. Whitby, *Chronicon Paschale 284–628 AD* (Liverpool, 1989), 16.

12. J. Wilkinson, *Jerusalem Pilgrims before the Crusades* (Warminster, 1977), *passim*.

13. A. Grabar, *Martyrium: Recherches sur le culte des reliques et l'art chrétien antique*, 2 vols (Paris, 1943–6), *passim*.

14. J.B. Ward Perkins, 'Notes on the structure and building methods of early Byzantine architecture', in D. Talbot Rice (ed.), *The Great Palace of the Byzantine Emperors*, Second Report (Edinburgh, 1958), 52–104.

15. G. Dagron, *Naissance d'une capitale: Constantinople et ses institutions de 330 à 451* (Paris, 1974), 233ff and 535ff.

16. P.C. Finney, *The Invisible God. The Earliest Christians on Art* (Oxford, 1994).

17. M. Barasch, *Icon. Studies in the History of an Idea* (New York, 1992), 95ff.

18. A. Grabar, *Christian Iconography. A Study of its Origins* (London, 1969), 7ff.

19. C.H. Kraeling (ed. D. Bradford Welles), *The Excavations at Dura-Europos. Final Report VIII, Part II: The Christian Building* (New Haven, 1967); and A.J. Wharton, *Refiguring the Post-Classical City. Dura Europos, Jerash, Jerusalem and Ravenna* (Cambridge, 1995), 15–63.

20. Sister C. Murray, *Rebirth and Afterlife: A Study of the Transmutation of Some Pagan Imagery in Early Christian Funerary Art* (Oxford, 1981).

21. W. Wixom, 'Early Christian sculptures at Cleveland', *Bulletin of the Cleveland Museum of Art*, 54 (1964), 65–88.

22. E.S. Malbon, *The Iconography of the Sarcophagus of Junius Bassus* (Princeton, 1990), 42ff.

23. A. Cameron, *Porphyrios the Charioteer* (Oxford, 1973), 180–7.

24. D. Bullough, '"Imagines regum" and their significance in the early medieval west', in G. Robertson and G. Henderson, *Studies in Memory of David Talbot Rice* (Edinburgh, 1975), 223–76.

25. H.B. Dewing (ed.), *Procopius*, vol. VII (Loeb Classical Library, 1940).

26. M. Chatzdakis (ed.), *Byzantine Art. An*

European Art. Lectures (Athens, 1966).
27. Lecky's History of European Morals of 1869, quoted by R.J.H. Jenkins, Byzantium. The Imperial Centuries AD 610–1071 (London, 1966), 1–2.
28. I. Kalavrezou-Maxeiner, Byzantine Icons in Steatite (Vienna, 1985), and A. Cutler, The Hand of the Master. Craftsmanship, Ivory, and Society in Byzantium (9th–11th Centuries) (Princeton, 1994).
29. K. Wessel, Byzantine Enamels (Shannon, 1969).
30. See C.R. Dodwell (ed.), Theophilus. De Diversis Artibus (The Various Arts) (London, 1961); and P. Hetherington (ed.), The 'Painter's Manual' of Dionysius of Fourna (London, 1974).
31. Procopius (ed. H.B. Dewing), De Aedificiis, I, i, 48ff.
32. W.E. Kleinbauer, 'The iconography and the date of the mosaics of the rotunda of Hagios Georgios, Thessaloniki', Viator, 3 (1972), 27–108; J.-M. Spieser, Thessalonique et ses monuments du IVe au VIe siècle (Paris, 1984).
33. P. Lemerie, Les plus anciens recueils des Miracles de Saint Démétrius, 2 vols (Paris, 1979–81); C. Bakirtzis (ed.), The Miracles of St Demetrios (in Greek) (Thessaloniki, 1997); A. Papadopoulos-Kerameus, Varia graeca sacra (St Petersburg, 1909) for the Narratio de imagine Christi in monasterio Latomi (Diegesis of Ignatius).
34. J.-P. Sodini, 'L'ambo de la Rotonde Saint-Georges', Bulletin de Correspondance Hellénique, 100 (1976), 493–510.
35. See C. Mango, The Art of the Byzantine Empire 312–1453 (Englewood Cliffs, 1972), 190–1 (from Theophanes Continuatus, 163–4).
36. H. Torp, 'Quelques remarques sur les mosaiques de l'église Saint-Georges à Thessalonique', in Proceedings of the 9th International Byzantine Congress (in Greek), Thessaloniki, 1953, vol. I (Athens, 1955), 489–98: still maintained in B. Kilerich and H. Torp, Bilder og billedbruk i Bysants (Oslo, 1998), 23ff.
37. D. Buckton (ed.), Treasures of Byzantine Art and Culture (London, 1994), cat. 140, 129–30.
38. N. Chatzidakis, Icons. The Velimezis Collection (Athens, 1998), cat. 5, 86–91; M. Chatzidakis and D. Sofianos, The Great Meteoron. History and Art (Athens, 1990), 52–5.
39. J. Gouillard, 'Le Synodikon de l'Orthodoxie; édition et commentaire', Travaux et Mémoires, 2 (1967), 1–316.
40. A. Grabar, L'empereur dans l'art byzantin (Paris, 1936; reprinted London 1971); B. Brenk, Die frühchristliche Mosaiken in Santa Maria Maggiore zu Rom (Wiesbaden, 1975).
41. M. Mundell Mango, The Sevso Treasure, part 1 (Ann Arbor, 1994).

Chapter 2. In the Shadow of St Sophia

1. P. Meyendorff, St Germanus of Constantinople on the Holy Liturgy (New York, 1984), 56–7.
2. B. Laourdas, Homilies of Photios (in Greek) (Thessaloniki, 1959), 167–8; translated in C. Mango (ed.), The Homilies of Photius (Cambridge, Mass., 1958), 290–1.
3. Chronicon (Bonn Corpus, vol. 36), 289; M. Philippides, The Fall of the Byzantine Empire: A Chronicle by George Sphrantzes, 1401–1477 (Amherst, Mass., 1980).
4. M. Harrison, A Temple for Byzantium (London, 1989).
5. O. Mazal, Byzanz und das Abendland (Vienna, 1981), cat. 376, 475–6.
6. S. Hill, The Early Byzantine Churches of Cilicia and Isauria (Aldershot, 1996), 78–82.
7. J. Durand et al. (eds), Byzance. L'art byzantin dans les collections publiques françaises (Paris, 1992), Louvre catalogue, cat. 20, 63–6.
8. D. Buckton (ed.), Byzantium (London, 1994), cat. 64, 73–4.
9. J. Sumption, Pilgrimage (London, 1975); R. Ousterhout (ed.), The Blessings of Pilgrimage (Urbana, Ill., 1990); S. Coleman and J. Elsner, Pilgrimage (London, 1995).
10. See G. Majeska, 'St Sophia in the fourteenth and fifteenth centuries: the Russian travelers on the relics', Dumbarton Oaks Papers, 27 (1973), 69–87.
11. G.H. Forsyth and K. Weitzmann, The Monastery of Saint Catherine at Mount Sinai. The Church and Fortress of Justinian (Ann Arbor, n.d.).
12. J. Wilkinson, Egeria's Travels (London, 1971), 91–6.
13. H.B. Dewing (ed.), Procopius, vol. VII (Loeb, 1940), De Aedificiis, V.viii.
14. See J. Elsner, 'The viewer and the vision: the case of the Sinai apse', Art History, 17 (1994), 81–102.
15. C. Luibheid and N. Russell (eds), John Climacus. The Ladder of Divine Ascent (London, 1982).
16. G. Brett et al., The Great Palace of the Byzantine Emperors (Oxford, 1947); D. Talbot Rice, The Great Palace of the Byzantine Emperors, Second Report (Edinburgh, 1958).
17. F.W. Deichmann, Ravenna. Hauptstadt des spätantiken Abendlandes. I Geschichte und Monumenten (Wiesbaden, 1969). II.I Kommentar (1974), III Frühchristliche Bauten und Mosaiken von Ravenna (Baden-Baden, 1958 and 1976), Plananhang (Wiesbaden, 1976); Kommentar II, 3 (Stuttgart, 1989).
18. I. Andreescu-Treadgold and W. Treadgold, 'Procopius and the imperial panels of S. Vitale', Art Bulletin, 79 (1997), 708–23.
19. Averil Cameron, Flavius Cresconius Corippus. In Laudem Iustini Augusti minoris (London, 1976), 44, lines 276ff.
20. Dewing (ed.), Procopius, vol. VII (1940),

De Aedificiis, IV.1.19–27; R.F. Hoddinott, *Early Byzantine Churches in Macedonia and Southern Serbia* (London, 1963).
21. E. Cruikshank Dodd, *Byzantine Silver Stamps* (Washington, 1961); M.M. Mango, 'Imperial art in the seventh century', in P. Magdalino (ed.), *New Constantines* (Aldershot, 1994), 109–38.
22. M. Mundell Mango, *Silver from Early Byzantium* (Baltimore, 1986).
23. W.E. Kleinbauer, *The Art of Byzantium and the Medieval West: Selected Studies by K. Kitzinger* (Bloomington, 1976), esp. part II.
24. A. Kartsonis, *Anastasis. The Making of an Image* (Princeton, 1986).
25. Averil Cameron, 'The language of images: the rise of icons and Christian representation', in D. Wood (ed.), *The Church and the Arts*, Studies in Church History, vol. 28 (Oxford, 1992), 1–42.
26. K. Weitzmann, *The Monastery of Saint Catherine at Mount Sinai. The Icons. From the Sixth to the Tenth Century* (Princeton, 1976); K.A. Manafis (ed.), *Sinai. The Treasures of the Monastery of Saint Catherine* (Athens, 1990).
27. P. Romanelli and P.J. Nordhagen, *S. Maria Antiqua* (Rome, 1964).
28. R. Cormack, *Writing in Gold* (London, 1985), 58ff.

Chapter 3. The Definition of an Orthodox Christian Empire

1. E. Kitzinger, *Byzantine Art in the Making* (London, 1977).
2. H. Maguire, *The Icons of their Bodies. Saints and their Images in Byzantium* (Princeton, 1996), 37ff.
3. C. Mango, *The Art of the Byzantine Empire* (Englewood Cliffs, 1972), 115; the epigram is from W.R. Paton, *The Greek Anthology* (Loeb, 1916), Book I, 34, 20–3.
4. Maguire, *Icons* (1996), 106ff.
5. M. Barasch, *Icon* (New York, 1992), 23ff.
6. E. von Dobschütz, *Christusbilder. Untersuchungen zur christlichen Legende. Texte und Untersuchungen zur Geschichte der altchristlichen Literatur* (Leipzig, 1989); H. Belting, *Likeness and Presence. A History of the Image before the Era of Art* (Chicago, 1994).
7. Von Dobschütz, *Christusbilder* (1994), 189ff, 40ff, and Belting, *Likeness* (1994), 53.
8. S. Ashbrook Harvey, *Asceticism and Society in Crisis* (Berkeley, 1990).
9. A. Grabar, *L'iconoclasme byzantin. Dossier archéologique* (Paris, 1957, 2nd edn 1984).
10. J.D. Breckenridge, *The Numismatic Iconography of Justinian II (685–695, 705–711 AD)* (New York, 1959); and R. Grierson, *Byzantine Coins* (London, 1982).
11. F.-X. Murphy and P. Sherwood, *Constantinople II et Constantinople III* (Paris, 1973).

12. K. Corrigan, 'The witness of John the Baptist in an early Byzantine icon in Kiev', *Dumbarton Oaks Papers*, 42 (1988). 1–11; A. Kartsonis, 'The emancipation of the crucifixion', in A. Guillou and J. Durand, *Byzance et les images* (Paris, 1994), 151–87.
13. R. Davis, *The Book of Pontiffs (Liber Pontificalis)* (Liverpool, 1989), 88–9.
14. P.J. Nordhagen, 'The mosaics of John VII (705–707 AD)', *Acta ad Archaeologiam et Artium Historiam Pertinentia*, 2 (1965), 121–66.
15. P.J. Nordhagen, 'The frescoes of John VII (705–707 AD) in S. Maria Antiqua in Rome', *Acta ad Archaeologiam et Artium Historiam Pertinentia*, 3 (1968).
16. Kartsonis, 'The emancipation of the crucifixion' (1994), 151–87.
17. C. Jolivet-Lévy, *Les Églises byzantines de Cappadoce* (Paris, 1991), 53–6.
18. Davis, *Book of Pontiffs* (1989), 91.
19. C. Mango, *The Brazen House. A Study of the Vestibule of the Imperial Palace of Constantinople* (Copenhagen, 1959), 48.
20. A. Bryer and J. Herrin, *Iconoclasm* (Birmingham, 1977).
21. Marie-France Auzépy, *La Vie d'Étienne le Jeune par Étienne le Diacre* (Aldershot, 1997).
22. C. Mango, *Art* (1972), 153; Auzépy, *La Vie* (1997), ch. 65, 166–7 and 264–5.
23. A. Cameron, *Porphyrios the Charioteer* (Oxford, 1973).
24. P.J. Alexander, *The Patriarch Nicephorus of Constantinople* (Oxford, 1958), 111ff. C. Mango and R. Scott (eds), *The Chronicle of Theophanes Confessor* (Oxford, 1997), year 812/13.
25. J. Herrin, *The Formation of Christendom* (Oxford, 1987), 334.
26. P. Speck, 'Byzantium: cultural suicide?', in L. Brubaker (ed.), *Byzantium in the Ninth Century: Dead or Alive?* (Alderhot, 1998), 73–84.
27. Barasch, *Icon* (1992).
28. St John of Damascus, *On the Divine Images*, trans. David Anderson (St Vladimir's Seminary Press, Crestwood, New York, 1980).
29. St Theodore the Studite, *On the Holy Icons*, trans. Catharine P. Roth (St Vladimir's Seminary Press, Crestwood, New York, 1981); P.J. Alexander, *The Patriarch Nicephorus of Constantinople* (Oxford, 1958); J. Travis, *In Defense of the Faith. The Theology of Patriarch Nikephoros of Constantinople* (Brookline, Mass., 1984).
30. R. Ousterhout, 'Reconstructing ninth-century Constantinople', in L. Brubaker, *Byzantium in the Ninth Century: Dead or Alive?* (Aldershot, 1998), 115–30.
31. E. Hawkins and M.C. Mundell, 'The mosaics of the Monastery of Mar Samuel, Mar Simeon and Mar Gabriel, near Kartmin', *Dumbarton Oaks Papers*, 27 (1973), 279–96; A. Palmer, *Monk and Mason on the Tigris Frontier* (Cambridge, 1990).

32. R. Cormack and E.J.W. Hawkins, 'The mosaics of St Sophia at Istanbul: the rooms above the south-west vestibule and ramp', *Dumbarton Oaks Papers*, 31 (1977), 175–251.

33. Partly translated in Mango, *Art* (1972), 155–6.

34. P. Underwood, 'The evidence of restorations in the sanctuary mosaics of the Church of the Dormition at Nicaea', *Dumbarton Oaks Papers*, 13 (1959), 235–42.

35. C. Mango and I. Ševčenko, 'Some churches and monasteries on the southern shore of the Sea of Marmara', *Dumbarton Oaks Papers*, 27 (1973), 235–77.

36. Ousterhout, 'Reconstructing ninth-century Constantinople' (1988), 115–30.

37. K. Corrigan, *Visual Polemics in the Ninth-Century Byzantine Psalters* (Cambridge, 1992).

Chapter 4. Developments and Diversions in the Consolidated Empire

1. T. Mathews, 'The sequel to Nicaea II in Byzantine church decoration', *Perkins Journal*, 41 (1988), 11–21.

2. A. Cameron, 'The construction of court ritual: the Byzantine *Book of Ceremonies*', in D. Cannadine and S. Price, *Rituals of Royalty* (Cambridge, 1987), 106–36.

3. D. Buckton (ed.), *Byzantium* (London, 1994), cat. 168, 154.

4. H.C. Evans and W.D. Wixom, *The Glory of Byzantium* (New York, 1997), cat. 162, 238–40; J. Lowden, The *Octateuchs* (University Park, Penn., 1992).

5. K. Weitzmann, *Roll and Codex* (Princeton, 1947).

6. A. Cohen, *The Alexander Mosaic* (Cambridge, 1997).

7. H.C. Evans and W.D. Wixom, *The Glory of Byzantium* (New York, 1997), cat. 163, 240–2.

8. R. Janin, *La Géographie ecclésiastique de l'empire byzantin. Constantinople* (Paris, 1969), 199–207.

9. C. Barber, 'From transformation to desire: art and worship after Byzantine iconoclasm', *Art Bulletin*, 75 (1993), 7–16.

10. See C. Mango, 'The availability of books in the Byzantine empire AD 750–850', in *Byzantine Books and Bookmen* (Washington, 1975), 29–45.

11. A. Cutler, 'The Byzantine psalter: before and after iconoclasm', in A. Bryer and J. Herria (eds), *Iconoclasm* (Birmingham, 1977), 93–102.

12. K. Weitzmann, *The Miniatures of the Sacra Parallela. Parisinus Graecus 923* (Princeton, 1979).

13. R. Grierson, *Byzantine Coins* (Berkeley, 1982), 152ff.

14. Buckton (ed.), *Byzantium* (1994), cat. 141, 132.

15. A. Kartsonis, *Anastasis* (Princeton, 1986), 123.

16. K. Weitzmann, *The Fresco Cycle of S. Maria di Castelseprio* (Princeton, 1951).

17. R. Cormack, 'But is it art?' in J. Shepard and S. Franklin (eds), *Byzantine Diplomacy* (Aldershot, 1992), 218–36.

18. H. Granger-Taylor, 'Byzantine textiles' in Buckton (ed.), *Byzantium* (1994), 16–17.

19. G.C. Miles, 'Byzantium and the Arabs: relations in Crete and the Aegean area', *Dumbarton Oaks Papers*, 18 (1964), 1–32.

20. P. Meyendorff, *St Germanus of Constantinople on the Holy Liturgy* (New York, 1984), ch. 3.

21. B. Laourdas, *Homilies of Photios* (in Greek) (Thessaloniki, 1959); trans. in C. Mango (ed.), The *Homilies of Photius* (Cambridge, Mass., 1958).

22. See Mango, 'The availability of books' (1975), 29–45.

23. H. Maguire, 'Originality in Byzantine art criticism', in A.R. Littlewood, *Originality in Byzantine Literature, Art, and Music* (Oxford, 1995), 101–14.

24. N. Oikonomides, 'Some remarks on the Apse Mosaic of St Sophia', *Dumbarton Oaks Papers*, 39 (1985), 111–15.

25. C. Mango, *Materials for the Study of the Mosaics of St. Sophia at Istanbul* (Washington, D.C., 1962); R. Cormack, 'Interpreting the mosaics of S. Sophia at Istanbul', study VIII, in R. Cormack, *The Byzantine Eye* (London, 1989).

26. N. Oikonomides, 'Leo VI and the Narthex Mosaic of Saint Sophia', *Dumbarton Oaks Papers*, 30 (1976), 151–72.

27. S.E.J. Gerstel, 'Saint Eudokia and the imperial household of Leo VI', *Art Bulletin*, 79 (1997), 699–707.

28. T. Steppan, 'Die Mosaiken des Athosklosters Vatopaidi', *Cahiers archéologiques*, 42 (1994), 87–122.

29. B. Hill, L. James, and D. Smythe, 'Zoe: the rhythm method of imperial renewal', in P. Magdalino, *New Constantines* (Aldershot, 1994), 215–29.

30. K. Weitzmann, 'The character and intellectual origins of the Macedonian renaissance', in K. Weitzmann, *Studies in Classical and Byzantine Manuscript Illumination* (Chicago, 1971), 176–223.

31. C. Walter, 'Expressionism and Hellenism: a note on stylistic tendencies in Byzantine figurative art from Spätantike to the Macedonian "renaissance"', *Revue des études byzantines*, 42 (1984), 265–87.

32. N.G. Wilson, *Scholars of Byzantium* (London, 1983).

33. H. Maguire, *Art and Eloquence in Byzantium* (Princeton, 1981).

34. A. Kazhdan and A. Cutler, 'Continuity and discontinuity in Byzantine history', *Byzantion*, 52 (1982), 429–78.

35. P. Lemerle, *Le premier humanisme byzantine* (Paris, 1971), 5.

36. N.G. Wilson, 'Books and readers in Byzantium', in Dumbarton Oaks Colloquium, *Byzantine Books and Bookmen* (Washington, D.C., 1975), 1–15, esp. 3 and Mango, 'The availability of books', in the same colloquium, 29–45.

37. H.C. Evans and W.D. Wixom, *The Glory of Byzantium. Art and Culture of the Middle Byzantine Era AD 843–1261* (Metropolitan Museum of Art, New York, 1997), 140, 203–4.

38. L. Brubaker, 'To legitimize an emperor: Constantine and visual authority in the eighth and ninth centuries', in P. Magdalino (ed.), *New Constantines. The Rhythm of Imperial Renewal in Byzantium, 4th–13th centuries* (Aldershot, 1994), 139–58.

39. A. Cutler, *The Hand of the Master. Craftsmanship, Ivory, and Society in Byzantium (9th–11th centuries)* (Princeton, 1994), and A. Cutler, 'The date and significance of the Romanos Ivory', in C. Moss and K. Kiefer (eds), *Byzantine East, Latin West. Art-Historical Studies in Honor of Kurt Weitzmann* (Princeton, 1995), 605–10.

40. A. Cutler, *The Hand* (1994), fig. 176 and 157.

41. H.L. Kessler, 'Medieval art as argument', in B. Cassidy (ed.), *Iconography at the Crossroads* (Princeton, 1993), 59–70.

42. I. Ševčenko, 'The illuminators of the Menologium of Basil II', *Dumbarton Oaks Papers*, 16 (1962), esp. 272ff.

43. D. Olster, 'Byzantine hermeneutics after iconoclasm: word and image in the Leo Bible', *Byzantion* 64 (1994), 419–58.

44. Evans and Wixom, *Glory of Byzantium* (1997), cat. 153, and 230–1.

45. I. Kalevrezou-Maxeiner, 'The Cup of San Marco and the "classical" in Byzantium', in K. Bierbrauer, P.K. Klein, and W. Sauerländer (eds), *Studien zur mittelalterlichen Kunst, 800–1250: Festschrift für Florentine Mütherich zum 70. Geburtstag* (Munich, 1985). 167–74.

Chapter 5. The New Spirituality of the Eleventh Century and the World of the Twelfth Century

1. M. Mullett, *Theophylact of Ochrid. Reading the Letters of a Byzantine Archbishop* (Birmingham, 1997), esp. 43ff.

2. P.L. Vokotopoulos, *The Ecclesiastical Architecture of Western Central Greece and Epiros* (in Greek) (Thessaloniki, 1975); G. Millet, *L'École grecque dans l'architecture byzantine* (Paris, 1916); R. Krautheimer, *Early Christian and Byzantine Architecture* (Penguin Books, 1965, and later eds); C. Mango, *Byzantine Architecture* (New York, 1974).

3. Mango, *Byzantine Architecture* (1974), 208, and R. Cormack, 'Away from the centre: "provincial" art in the ninth century', in L.

Brubaker, *Byzantium in the Ninth Century: Dead or Alive?* (Aldershot, 1998), 151–63.

4. A.J. Wharton, *Art of Empire. Painting and Architecture of the Byzantine Periphery* (University Park, Penn. and London, 1988), esp. 91ff. for Thessaloniki and Macedonia, and 13ff. for Cappadocia; also A.W. Epstein, *Tokalı Kilise. Tenth-Century Metropolitan Art in Byzantine Cappadocia* (Washington, D.C., 1986); D. Mouriki, 'Stylistic trends in monumental painting of Greece during the eleventh and twelfth centuries', *Dumbarton Oaks Papers*, 34–5 (1980–1), 77–124.

5. A. Papadopoulos-Kerameus, *Varia graeca sacra* (St Petersburg, 1909), 51–2; C. Mango, 'On the history of the *Templon* and the Martyrion of St Artemios at Constantinople', *Zograf*, 10 (1979), 40–3.

6. C. Walter, 'The origin of the iconostasis', *Eastern Churches Review*, 3 (1971), 251–65 (reprinted in his *Studies in Byzantine Iconography* (London, 1977)); C. Walter, 'A new look at the Byzantine sanctuary barrier', *Revue des études byzantines*, 51 (1993), 203–28.

7. R. Janin, *Les églises et les monastères des grands centres byzantins* (Paris, 1975), 406–11.

8. *On the Sacred Temple*, Migne, *PG* 155, col. 345.

9. H. Belting, 'An image and its function in the liturgy: the Man of Sorrows in Byzantium', *Dumbarton Oaks Papers*, 34–5 (1980–1), 1–16.

10. H. Belting, *Likeness and Presence* (Chicago, 1994), esp. ch. 13.

11. J. Hussey, *The Orthodox Church in the Byzantine Empire* (Oxford, 1986), 122ff.

12. E. James, 'Monks, monastic art, the sanctoral cycle and the middle Byzantine church', in M. Mullett and A. Kirby (eds), *The Theotokos Evergetis and Eleventh-Century Monasticism* (Belfast, 1994), 162–75, and (in the same volume) C. Barber, 'The monastic Typikon for art historians', 198–214.

13. Belting, *Likeness and Presence* (1994).

14. Belting, *Likeness and Presence* (1994), text 22, 517–19.

15. C. Mango, *The Homilies of Photius* (Cambridge, Mass., 1958), 290.

16. D. Buckton (ed.), *Byzantium. Treasures of Byzantine Art and Culture* (London, 1994), cat. 178, 162–3; H.C. Evans and W.D. Wixom, *The Glory of Byzantium. Art and Culture of the Middle Byzantine Era AD 843–1261* (Metropolitan Museum of Art, New York, 1997), cat. 62, 107–9.

17. P. Grierson, 'The tombs and obits of the Byzantine emperors (337–1042)', *Dumbarton Oaks Papers*, 16 (1962), 3–63.

18. C. Mango, *Byzantium: The Empire of New Rome* (London, 1980).

19. P. Gautier, 'Le typicon du Christ sauveur Pantocrator', *Revue des études byzantines*, 32 (1974), 1–145.

20. K. Weitzmann and G. Galvaris, *The*

Monastery of Saint Catherine at Mount Sinai. The Greek Illuminated Manuscripts from the Ninth to the Twelfth Centuries (Princeton, 1990), cat. 56, 140ff.

21. O. Demus, Byzantine Mosaic Decoration (London, 1948); E. Diez and O. Demus, Byzantine Mosaics in Greece: Daphni and Hosios Lucas (Cambridge, Mass., 1931).

22. James, 'Monks, monastic art, the sanctoral cycle and the middle Byzantine church' (1994).

23. C. and R. Connors, The Life and Miracles of St Luke of Steiris (Brookline, Mass., 1994).

24. J. Nesbitt and J. Wiita, 'A confraternity of the Comnenian era', Byzantinische Zeitschrift, 68 (1975), 360–84.

25. R. Morris, Monks and Laymen in Byzantium 843–1118 (Cambridge, 1995).

26. C. Mango and E.J.W. Hawkins, 'The Hermitage of St Neophytos and its wall paintings', Dumbarton Oaks Papers, 20 (1966), 119–206, esp. 184.

27. P. Magdalino, Tradition and Transformation in Medieval Byzantium (Aldershot, 1991); study V, 'Manuel Komnenos and the Great Palace'.

28. R. Cormack, 'Lessons from "The Glory of Byzantium"', Dialogos, 5 (1998), 27–39; A. Lidov, 'Byzantine church decoration and the Great Schism of 1054', Byzantion, 68 (1998), 381–405.

29. C. Mango (ed.), 'The Monastery of Lips (Fener Isa Camii) at Istanbul', Dumbarton Oaks Papers, 18 (1964), 251–315.

30. A. Grabar and I. Manoussacas, L'illustration du manuscrit de Skylitzès de la Bibliothèque Nationale de Madrid (Venice, 1979).

Chapter 6. Art in the Service of a Failing Society

1. H.R. Hahnloser (ed.), Il Tesoro di San Marco: vol. I: La Pala d'Oro (Florence, 1965); vol. II: Il Tesoro e il Museo (Florence, 1971).

2. J. Durand et al. (eds), Byzance. L'art byzantin dans les collections publiques françaises (Paris, 1992), cat. 248, 333–5.

3. C.L. Striker and Y.D. Kuban (eds), Kalenderhane in Istanbul. The Buildings, their History, Architecture and Decoration (Mainz, 1997).

4. C. Enlart (edn of 1899 trans. and ed. D. Hunt), Gothic Art and the Renaissance in Cyprus (London, 1987).

5. H. Buchthal, Miniature Painting in the Latin Kingdom of Jerusalem (Oxford, 1957); J. Folda, The Art of the Crusaders in the Holy Land 1098–1187 (Cambridge, 1995).

6. S. Der Nersessian, Miniature Painting in the Armenian Kingdom of Cilicia from the Twelfth to the Fourteenth Century (Washington, D.C., 1993).

7. D. Mouriki, 'The wall paintings of the Church of the Panagia at Moutoullas, Cyprus', in I. Hutter (ed.), Byzanz und der Westen (Vienna, 1984), 171–221; D. Mouriki, 'Thirteenth-century icon painting in Cyprus', The Griffon, N.S. 1–2 (1985–6), 9–158; K.A. Manafis (ed.), Sinai Treasures of the Monastery of Saint Catherine (Athens, 1990).

8. D.M. Nicol, The Last Centuries of Byzantium 1261–1453 (London, 1972).

9. Durand et al. (eds), Byzance (1992), cat. 356, 463–4.

10. M. Dukas, Historia byzantina, XXXVII; Bonn edn, 264.

11. Durand et al. (eds), Byzance (1992), cat. 355, 461–2.

12. R. Webb, 'A slavish art? Language and grammar in late Byzantine education and society', Dialogos, 1 (1994), 81–103.

13. R. Cormack, Painting the Soul. Icons, Death Masks, Shrouds (London, 1997).

14. P.A. Underwood, The Kariye Djami, 3 vols (London, 1966); P.A. Underwood (ed.), The Kariye Djami. Studies in the Art of the Kariye Djami and its Intellectual Background (London, 1975); R.G. Ousterhout, The Architecture of the Kariye Camii in Istanbul (Washington, D.C., 1987); R.S. Nelson, 'Taxation with representation. Visual narrative and the political field of the Kariye Camii', Art History, 22 (1999), 56–82.

15. I. Ševčenko, 'The decline of Byzantium seen through the eyes of its intellectuals', Dumbarton Oaks Papers, 15 (1961), 167–86.

16. C. Mango, The Art of Byzantine Empire 312–1453 (Englewood Cliffs, 1972), 245.

17. G.P. Majeska, Russian Travelers to Constantinople in the Fourteenth and Fifteenth Centuries (Washington, D.C., 1984), 45–6.

18. Ibid., 34–7.

19. H. Belting, C. Mango, and D. Mouriki, The Mosaics and Frescoes of St Mary Pammakaristos (Fetiye Camii) at Istanbul (Washington, D.C., 1978).

20. K. Weitzmann, The Icon. Holy Images Sixth to Fourteenth Century (London, 1978), 126.

21. I. Ševčenko, 'Theodore Metochites, the Chora, and the intellectual trends of his time', in Underwood (ed.), The Kariye Djami (1975), 18–91.

22. E. Smirnova, Moscow Icons 14th–17th Centuries (Oxford, 1989); C. Baltoyianni, Icons. The Mother of God in the Incarnation and the Passion (Athens, 1994), esp. cat. 26, 114ff.

23. N. Chatzidakis, Icons of the Velimezis Collection (Athens, 1998), cat. 5, 86–91.

24. A. Cutler and P. Magdalino, 'Some precisions on the Lincoln College Typikon', Cahiers archéologiques, 27 (1978), 179–98.

25. L. James (ed.), Women, Men and Eunuchs. Gender in Byzantium (London, 1907).

Visual arts		Historical events		Byzantine emperors	
				NB *Overlapping dates show periods of joint reigns.*	
Before 256					
	Conversion of a house at Dura Europos on the Euphrates into a Christian church with a painted baptistery				
313–15	Arch of Constantine at Rome				
324	Foundation of Constantinople on the site of Byzantium	324	Constantine I becomes sole emperor of the Roman empire, defeating Licinius at the battle of Chrysopolis	324–37	Constantine I the Great
		325	First Oecumenical Church Council at Nicaea proclaims the divinity of Christ		
c.329	St Peter's at Rome completed				
330	The city of Constantinople dedicated on 11 May				
325/6	Construction begins at Holy Sepulchre in Jerusalem			337–61	Constantios II
359	Sarcophagus of Junius Bassus in Rome	361–3	Emperor Julian reinstates paganism		
c.360	Dedication of the first church of St Sophia	392	Theodosios I bans pagan cults	361–3	Julian
				363–4	Jovian
393	Forum of Theodosios I, including a cochleate column			364–78	Valens
				379–95	Theodosios I
402	Ravenna developed as a capital			395–408	Arcadios
404	First church of St Sophia partially burnt				
404	Cochleate column of Arcadios	410	Rome sacked by Alaric the Visigoth	408–50	Theodosios II
413	Theodosios II extends the city of Constantinople with new land walls				
415	Dedication of rebuilt St Sophia	429–31	Vandal conquest of Africa		
432–40	S. Maria Maggiore in Rome	431	Third Oecumenical Council at Ephesus proclaims Mary as Mother of God	450–7	Marcian
c.450	Building of St John of Studios	455	Rome sacked by Vandals	457–74	Leo I
From c.450		459	Death of Symeon the Stylite		
	Development of Thessaloniki as a provincial capital, including construction of major churches	476	Last western emperor, Romulus Augustulus, deposed by Odovar the Ostrogoth	474	Leo II
				474–5	Zeno
493–526	S. Apollinare Nuovo built and decorated			475–6	Basiliscos
				476–91	Zeno (again)
c.512	Dioskorides manuscript completed			491	Anastasios I
				518–27	Justin I
524–7	St Polyeuktos built by Anicia Juliana	525	Antioch destroyed by earthquake	527–65	Justinian I the Great
532–7	St Sophia burnt in Nika riots, and rebuilt by Justinian	529	Codification of Roman law		
537	St Sophia dedicated on Christmas Day	533–54	Reconquest of Africa, Sicily, and Italy		
547	Dedication of S. Vitale at Ravenna				

330

527

Visual arts	Historical events	Byzantine emperors
548–65 Justinian sponsors monastery of St Catherine on Mount Sinai		
558 First dome of St Sophia collapses	568 Italy invaded by Lombards	565–78 Justin II
586 Rabbula Gospels	c.570–632 Muhammad, prophet of Islam	578–82 Tiberios I Constantine
		582–602 Maurice
	586 Slavs and Avars invade Balkans	
	590 Gregory the Great, pope in Rome	
	602–28 War with Persia; Greece and Balkans invaded by Avars and Slavs	602–10 Phocas
		610–41 Heraclios
	614 Jerusalem captured by the Persians	
c.620 Mosaic redecoration of St Demetrios at Thessaloniki	622 Emigration (hegira) of Muhammad from Mecca to Medina on 16 July marks beginning of Moslem era	
	626 Constantinople attacked by the Avars	
c.629 David plates	632 Death of Muhammad	
	634–42 Arab conquest of Syria, Palestina, and Egypt	
	638 Jerusalem falls to Arabs under Caliph Omar I	641 Constantine III and Heraclonas
	674–8 First Arab attack on Constantinople	641 Heraclonas
		641–68 Constans II
	c.675–750	668–85 Constantine IV
685–95 Face of Christ on Byzantine gold coins	John of Damascus, iconophile theologian	685–95 Justinian II (first reign)
	692 Quinisext Council at Constantinople	
	697/8 Carthage, last Byzantine stronghold in Africa, falls to Arabs	695–8 Leontios
		698–705 Tiberios II
	705–7 Pope John VII at Rome	705–11 Justinian II (second reign)
	717–18 Arab siege of Constantinople	
		711–13 Philippicos
	726/30–787	713–15 Anastasios II
	First period of Byzantine iconoclasm	715–17 Theodosios III
	732 Charles Martel victorious over Arabs at Poitiers	717–41 Leo III
c.740 St Eirene rebuilt after earthquake of 740		741–75 Constantine V
768/9 Patriarchal Palace of St Sophia redecorated with non-figural mosaics	751 Ravenna falls to Lombards; end of Byzantine exarchate	
	754 Council of Hieria declares iconoclasm as Orthodox doctrine	
	762 Baghdad founded by Caliph el Mansur	775–80 Leo IV
	787 Seventh Oecumenical Council of the Orthodox church at Nicaea condemns opposition to icons as heresy	780–97 Constantine VI
		797–802 Irene

730

787

Visual arts		Historical events		Byzantine emperors	
		800	Imperial coronation at Rome by Pope Leo III: Charlemagne crowned emperor of the Romans	802–11	Nikephoros I
		811	Byzantine army crushed by Bulgarians	811	Stauracios
		815–42	Iconoclasm reaffirmed as Orthodox belief	811–13	Michael I Rangabe
				813–20	Leo V
After 843	Khludov Psalter	c.820–93	Photios, scholar and patriarch 858–67 and 877–86	820–9	Michael II
		826	Crete falls to Arabs		
		827–78	Sicily falls to Arabs	829–42	Theophilos
		843	Final condemnation of iconoclasm as heresy	842–67	Michael III
		860	First Russian attack on Constantinople		
		863	Victory over Arabs; Byzantine offensive in the east	866–86	Basil I
867	Inauguration of Apse Mosaic of St Sophia by Patriarch Photios	875–902	Byzantine reconquests in Italy and Sicily		
867–86	Basil I builds new churches in the Great Palace			886–912	Leo VI
879–82	Illustrated Homilies of Gregory of Nazianzus made for Basil I			912–13	Alexander
				913–59	Constantine VII Porphyrogenitos
c.950	Paris Psalter and Joshua Roll	957	Russian Princess Olga received at imperial court	920–44	Romanos I Lecapenos
968–85	Limburg Reliquary of the True Cross			959–63	Romanos II
		961	Reconquest of Crete	963–9	Nikephoros II Phocas
962	St Athanasios founded the Great Laura Monastery on Mount Athos	976–1025	Empire extended under Basil II	969–76	John I Tzimiskes
				976–1025	Basil II
c.1000	Menologion of Basil II	988	Russian conversion to Orthodox Christianity		
After 1000	Katholikon of Hosios Loukas	1017	Basil II annexes Bulgarian kingdom	1025–8	Constantine VIII
1028	Chalkeon church at Thessaloniki	1018–96/7		1028–34	Romanos III Argyros
			Michael Psellos, philosopher, historian, courtier, and monk	1034–41	Michael IV
1037–46	St Sophia in Kiev			1041–2	Michael V
1042–55	Nea Moni, Chios, and St George of the Mangana	1054	Schism declared between Orthodox church and Roman church	1042	Zoe and Theodora
				1042–55	Constantine IX Monomachos
				1055–6	Theodora (again)
				1056–7	Michael VI
		1061–91	Norman conquest of Sicily	1057–9	Isaac I Komnenos
1064	S. Marco in Venice rebuilt and decorated with Byzantine mosaics			1059–67	Constantine X Ducas
				1068–71	Romanos IV Diogenes
1066	Theodore Psalter	1067	Turks take Caesarea in Asia Minor		
c.1100	Daphni Monastery	1071	Seljuk Turks defeat Byzantines at battle of Manzikert; Bari taken by Normans and Byzantium loses southern Italy	1071–8	Michael VII Ducas
1105/6	Church of Panagia Phorbiotissa at Asinou			1078–81	Nikephoros III Botaneiates
				1081–1118	
		1096–9	First Crusade		Alexios I Komnenos
		1099	Jerusalem becomes a Latin kingdom		
1108	Church of St Michael at Kiev			1118–43	John II Komnenos
		1147–9	Second Crusade	1143–80	Manuel I Komnenos

Visual arts	Historical events	Byzantine emperors
*c.*1130 Vladimir icon of the Virgin and Child sent from Constantinople to Kiev		
1136 Dedication of Pantokrator Monastery		
1140s Employment of Byzantine mosaicists in Norman Sicily, for Capella Palatina, Cefalu, and Martorana	1149 Corfu retaken by Byzantium from Normans	
1164 Dedication of church of St Panteleimon at Nerezi by Alexios Komnenos	1171 Venetians in empire arrested and properties confiscated	
	1180 Serbian empire established by Stephen Nemanja	1181–3 Alexios II Komnenos
	1182 Latins massacred in Constantinople	1183–5 Andronikos I Komnenos
	1185 Normans sack Thessaloniki	1185–95 Isaac II Angelos
	1186 Second Bulgarian empire	
	1187 Jerusalem captured from Crusaders by Saladin	
1191 St George at Kurbinovo	1189–92 Third Crusade	
1192 Church of the *Panagia*, Lagoudera, Cyprus		1195–1203 Alexios III Angelos
1204	1202–4 Fourth Crusade	1203–4 Isaac II (again) and Alexios IV Angelos
1209 Wall paintings in church of *Panagia* at Studenica	1204:12 April Capture of Constantinople by armies of the Fourth Crusade	1204 Alexios V Murtzuphlos
		1204–22 Theodore I Lascaris
	1204–61 Latin empire of Constantinople	
1260s Cathedral of Sopocani in Serbia	1204–1340 Despotate of Epirus	
1260s St Sophia at Trebizond	1204–1461 Empire of Trebizond	
	1204 Boniface of Montferrat sells Crete to Venetians for 1,000 marks	
	1211–1669 Venetian period in Crete	1222–54 John III Ducas Vatatzes
	1240 Mongols take Kiev	1254–8 Theodore II Laskaris
1261	1261 Recapture of Constantinople by Michael VIII Palaiologos	1258–61 John IV Laskaris
		1259–82 Michael VIII Palaiologos
	1274 Council of Lyon reunites the churches	
	1282–1328 Andronikos II Palaiologos emperor	1282–1328 Andronikos II Palaiologos
	1282 Church Union of Council of Lyons repealed	
	1288–1326 Osman, founder of Ottoman dynasty	
1300s Mosaics of St Mary Pammakaristos	1304 Ephesus falls to the Ottomans	
1312–14 Holy Apostles, Thessaloniki		

V____ arts		Historical events		Byzantine emperors	
1315	Church of the *Anastasis* of Christ at Verria painted by George Kalliergis				
1316–21	Theodore Metochites decorated monastery of Chora			1328–41	Andronikos III Palaiologos
1346	Collapse of eastern arch and semi-dome of St Sophia	1329	Turks capture Nicaea and take control of Asia Minor	1341–91	John V Palaiologos
		1348	Mistra seat of a despot	1347–54	John VI Cantacuzenos
c.1350–75	Church of Peribleptos at Mistra	1354	Turks cross into Europe		
By 1355	Mosaics of St Sophia restored	1359	Turks at walls of Constantinople		
1373	Theophanes the Greek painted church of the Transfiguration at Novgorod	1376	Ottoman capital established at Adrianople	1376–9	Andronicos IV Palaiologos
		1389	Serbian empire falls to Turks at battle of Kosovo	1390	John VII Palaiologos
		1393	Turks occupy Bulgarian empire	1391–1425	
		1397	Constantinople attacked by Turks		Manuel II Palaiologos
		1399–1402			
			Manuel II in the west		
		1402	Turks defeated by Timur (Tamerlane) at battle of Ankara		
		1422	Constantinople attacked by Turks		
c.1428	*Pantanassa* decorated at Mistra	1430	Ottoman Turks take Thessaloniki on 29 March	1425–48	John VIII Palaiologos
		1438	Church Council at Ferrara		
		1439	Union of Greek and Latin churches agreed at Council of Florence on 6 July	1448–53	Constantinople XI Palaiologos
1453		1453	Siege and Fall of Constantinople on 29 May to Ottoman Turks under Sultan Mehmet II		
		1460	Fall of Mistra		
		1461	Fall of Trebizond		

Glossary

Acheiropoietos: not made by human hands, and so miraculously produced.

Ambo: a prominent raised platform, often made of marble, in the nave of the church from which the Gospel was read in the liturgy. It was also used in other parts of the services, both for recitations of the Psalms and prayers, and also for special ceremonial, such as the Exaltation of the Cross on 14 September. It evolved into the pulpit for the delivery of sermons.

Anastasis: 'Resurrection'. The Easter image of the Orthodox church, showing Christ breaking down the Gates of Hell and releasing Old Testament figures into Paradise.

Basileus: principal title of the Byzantine emperor.

Bema: the sanctuary of the church.

Ciborion: a domed or pyramidal structure, supported by columns, and covering a tomb, the altar or other sacred spaces. In the church of St Demetrios at Thessaloniki, the silver ciborion was thought to mark the saint's tomb.

Deisis: literally, a prayer or petition, it is often used to refer to the iconographical composition of Christ with the Virgin Mary and St John the Baptist.

Diakonikon: the space, often a chapel, to the right of the sanctuary which acted as the sacristy.

Ekphrasis: a literary description of a work of art.

Etimasia: the empty Throne prepared for the Last Judgement.

Hodigitria: one of the iconic types in which the Virgin and Child are regularly represented: Mary points to the Child, seated on her lap or held on her left arm. From the period of iconoclasm, it was believed that the first image of this type was painted from the life by the evangelist St Luke.

Iconoclasm: the period from *c.*730 to 787 and from 815 to 842 when figurative images were banned from churches, and existing works of art were destroyed or concealed.

Iconoclast: a supporter of iconoclasm who denied the holiness of religious images.

Iconophile (or iconodoule): an opponent of iconoclasm who venerated images.

Indiction: the tax year (1 September to 31 August), and numbered in cycles of 15 starting from 312.

Katholikon: the main church of a monastery, usually dedicated to the patron saint of the foundation.

Koimisis: the 'Falling Asleep' of the Virgin Mary, when her soul was taken up to heaven (festival day 15 August).

Liturgy: in Byzantium, the eucharistic rite, often called the Divine Liturgy.

Loros: the long scarf worn on special occasions by emperors and empresses, and decorated with jewels. Also worn by archangels in the presence of Christ.

Mandylion: the miraculous image of the face of Christ on a cloth which, according to legend, was sent to cure King Abgar of Edessa, and which was taken to Constantinople in 944.

Martyrium: a special building made to commemorate an event from the life of Christ or the death of a martyr.

Menologion: a collection of saints' lives arranged according to their commemoration in the church year, which started on 1 September.

Missorium: a large plate as part of a table service, or for display.

Monotheletism: a seventh-century theological

movement, whose adherents believed that Christ had one will.

Naos (literally, 'temple' in Greek): a church or, strictly speaking, the nave of a church where the congregation stood.

Narthex: transverse vestibule of a church, sometimes used for baptismal or funerary services, and the place for penitents.

Omophorion: long white scarf worn by a bishop.

Palladium: in Greek mythology, a sacred image of Pallas Athene sent by Zeus to protect the city of Troy. Christian icons, particularly images of the Virgin and Child, seen as the defenders of Byzantine cities, have been interpreted as being in the same category of images.

Panagia: 'all-holy'—the epithet of the Virgin Mary.

Parousia: the Second Coming of Christ.

Phoros: forum.

Proskynesis: literally, 'prostration'. Act of supplication or reverence, particularly before Christ, icons, and the emperor.

Prothesis: the space to the left of the sanctuary, often a chapel, where the bread and wine were prepared for the liturgy.

Sekreton: office or reception room.

Spina (in Greek, *euripos*): the central barrier of the hippodrome around which the chariots raced; in Constantinople, it was decorated with the Obelisk of Thutmosis III on a marble base set up by Theodosios in 390, with the masonry Obelisk of Constantine VII, with the Serpent Column from Delphi (the central shaft of a tripod set up in 479 BC), and with statues of famous charioteers.

Staurotheke: a reliquary preserving a portion of the True Cross.

Synthronon: semi-circular steps of seats around the base of the apse.

Templon: screen separating the sanctuary from the nave.

Theotokos: Mother of God—the usual description written on representations of the Virgin Mary.

Typikon: a monastic *typikon* contains the charter and rules and regulations of the community; the *typikon* of St Sophia contained the liturgical rites of the church.

Further Reading

The chronology and geographical range of Byzantine art are formidable enough, but the art-historical consensus is that the entire period from 330 to 1453 can (and should) be studied as an entity and that a fuller picture can be pieced together out of material that is nowadays scattered around the world and often fragmented. The bibliography is a mixture of the broad with the highly specialist and technical monograph, and although it is multinational, much is written in English (or translated into it). The period and the ways in which it has been approached are treated as an issue by R. Nelson, 'Living on the Byzantine borders of western art', *Gesta*, 35 (1996), 3–10; and R. Nelson, 'The map of art history', *Art Bulletin*, 79 (1997), 28–40.

The accessibility of terms, facts, and references about Byzantium has been significantly changed by recent handbooks, notably the massive publication of A.P. Kazhdan (editor-in-chief), *The Oxford Dictionary of Byzantium*, 3 vols (New York and Oxford, 1991). Its entries offer a consistent transliteration of Greek and the other languages of the subject (along American conventions), and this terminology has influenced subsequent publications, including the present book. The *ODB* has changed the character of writing on Byzantine art, since it gives easy access to a bibliography of all aspects of the period and sets out all the technical terms. Its entries have something to say about almost everything, but with the unevenness to be expected from a compilation of many authors. Two other handbooks are useful, too: F.L. Cross and E.A. Livingstone (eds), *The Oxford Dictionary of the Christian Church*, 3rd edn (Oxford, 1997); and S. Hornblower and A. Spawforth (eds), *The Oxford Classical Dictionary* (Oxford, 1996). Longer entries are in K. Wessel and M. Restle (eds), *Reallexikon*

zur byzantinischen Kunst (Stuttgart, 1963–). For the historical geography, see F. Van Der Meer and C. Mohrmann, *Atlas of the Early Christian World* (London, 1966); J. Riley-Smith, *The Atlas of the Crusades* (London, 1991); and J. Steer and A. White, *Atlas of Western Art History* (New York, 1994). For timecharts and dynasties (including an explanation of the Byzantine system of dating from the creation of the world in 5508 BCE), see V. Grumel, *Traité d'études byzantines. I. La chronologie* (Paris, 1958). The periodical *Byzantinische Zeitschrift*, founded in 1892, contains the most complete cumulative bibliography of Byzantine studies; the entries on Byzantine art between 1892 and 1967 were published as *Dumbarton Oaks Bibliographies*, vol. 1 (2 parts), *By Location* (London, 1973), and vol. 2, *By Categories* (London, 1976).

History

The art history of Byzantium is not well integrated into the history writing, which is primarily political and administrative. There is the additional factor in English history writing of Edward Gibbon (1737–94). His hostile approach to Byzantium in his monumental history, published in parts from 1776 to 1788, and printed in many subsequent editions, most recently D. Womersley, *The History of the Decline and Fall of the Roman Empire* (London, 1995), has bedevilled the field ever since. It offered a perception of Byzantium as 'decline', and creatively supplied the best repertory of aphorisms with which to damn the whole period. Few can still resist the temptation to quote 'the triumph of barbarism and religion'. In one way or another, modern Byzantine history has searched for the antidote to this narrative political history. The standard political exposition was first published in 1940: G. Ostrogorsky, *History of the Byzantine State*

(trans. J. Hussey, Oxford, 1980). Gibbon's interpretations are challenged in the medium of narrative history by R.J.H. Jenkins, *Byzantium. The Imperial Centuries AD 610–1071* (London, 1966), and as cultural history by C. Mango, *Byzantium: The Empire of New Rome* (London, 1980), and A. Kazhdan and G. Constable, *People and Power in Byzantium. An Introduction to Modern Byzantine Studies* (Dumbarton Oaks, Washington, D.C., 1982). A review of the historiography is found in A. Kazhdan in collaboration with S. Franklin, *Studies on Byzantine Literature of the Eleventh and Twelfth Centuries* (Cambridge, 1984), 1–22. An attempt to 'show the centrality of Byzantium's role in world history' is offered by A.E. Laiou and H. Maguire (eds), *Byzantium. A World Civilization* (Washington, D.C. , 1992).

Other historical coverage is by period. A. Cameron, *The Mediterranean World in Late Antiquity* (London, 1993); J. Herrin, *The Formation of Christendom* (Oxford, 1987); P. Brown, *The Rise of Western Christendom* (Oxford, 1996); J.F. Haldon, *Byzantium in the Seventh Century* (Cambridge, 1990); M. Whittow, *The Making of Orthodox Byzantium 600–1025* (London, 1996); M. Angold, *The Byzantine Empire 1025–1204* (London, 1984); M. Angold, *Church and Society in Byzantium under the Comneni 1081–1261* (Cambridge, 1995); A.P. Kazhdan and A.W. Epstein, *Change in Byzantine Culture in the Eleventh and Twelfth Centuries* (Berkeley, 1985); P. Magdalino, *The Empire of Manuel I Komnenos 1143–1180* (Cambridge, 1993); S. Runciman, *A History of the Crusades* (Cambridge, 1951–4, 3 vols); C.M. Brand, *Byzantium Confronts the West 1180–1204* (Cambridge, Mass., 1968); A.E. Laiou, *Constantinople and the Latins. The Foreign Policy of Andronicus II 1282–1328* (Harvard, 1972); D. Nicol, *The Last Centuries of Byzantium 1261–1453* (London, 1972).

Byzantine history writing is closely allied to the study of text, and is prone to use art as merely illustrative matter without interpretative value; Whittow's study of the period 600–1025 brings in the evidence of material archaeology and includes an excellent discursive bibliographical guide; Haldon's conceptual analysis of the seventh century is essential reading for the interpretation of Byzantine society, and interesting for his use of Kitzinger's art-historical studies (see E. Kitzinger, *The Art of Byzantium and the Medieval West*, ed. W.E. Kleinbauer (Bloomington, 1976)).

Primary texts

It was once said (in exaggeration, of course) by an outsider that you find that all Byzantinists read primary texts, but never the same ones. The total amount of literature is enormous, and the theological writings alone take up many volumes of the collection put together by J.P. Migne, *Patrologiae cursus completus. Series Graeca*, 162 vols (Paris, 1857–66). The best reference books to this literature are H.G. Beck, *Kirche und theologische Literatur im byzantinischen Reich* (Munich, 1959) and Fr Halkin, *Bibliotheca Hagiographica Graeca*, 3 vols (Brussels, 1957). Editions of historical texts were published in the nineteenth century in the series *Corpus scriptorum historiae Byzantinae* (Bonn, 1928–97), and are gradually being replaced with modern editions. For a positive overview of the character of Byzantine literature and its study, see M. Mullett, *Theophylact of Ochrid. Reading the Letters of a Byzantine Archbishop* (Aldershot, 1997), esp. 1–10.

Art historians' uses of text have been much influenced by the invaluable collection of translated passages relating directly to art compiled by C. Mango, *The Art of the Byzantine Empire* 312–1453 (Englewood Cliffs, 1971; reprinted Toronto, 1986), which replaces but does not entirely supersede F.W. Unger, *Quellen der byzantinischen Kunstgeschichte* (Vienna, 1878), and J.P. Richter, *Quellen der byzantinischen Kunstgeschichte* (Vienna, 1897). For eye-witness descriptions of Jerusalem and the Holy Land, see J. Wilkinson, *Jerusalem Pilgrims before the Crusades* (Warminster, 1977) and J. Wilkinson with J. Hill and W.F. Ryan, *Jerusalem Pilgrimage 1099–1185* (London, 1988). Also useful for material in the west is C. Davis-Weyer, *Early Medieval Art, 300–1150* (Englewood Cliffs, 1971; reprinted University of Toronto, 1986). A broader historical collection of texts is given by D.J. Geanokoplos, *Byzantium. Church, Society, and Civilization seen through Contemporary Eyes* (Chicago, 1984). The Center of Byzantine Studies at Dumbarton Oaks, Washington, D.C. is to publish translations of Byzantine *typika*, and these are available on the internet at www.doaks.org/index.html

Mango's anthology helps the entry into any period of Byzantine art, but there are many more writings from Byzantium that directly or indirectly illuminate the history of art. Recently increasing attention has been devoted to questions of text and image. The pioneering paper in the field was that of S. Der Nersessian, 'The illustrations of the Homilies

of Gregory of Nazianzus, Paris gr. 510', *Dumbarton Oaks Papers*, 16 (1962), 197–228, who transformed the study of one manuscript away from previous philological concerns of the transmission of models into the question of how the imagery of a manuscript was related to the text, and how far it was a visual interpretation or commentary. L. Brubaker, *Vision and Meaning in Ninth-Century Byzantium. Image as Exegesis in the Homilies of Gregory of Nazianzus* (Cambridge, 1999) revisits the same manuscript.

Another discussion has been to ask how far the discourse of texts can help to unravel the discourse of pictures: H. Maguire, *Art and Eloquence in Byzantium* (Princeton, 1981); H. Maguire, *The Icons of their Bodies. Saints and Images in Byzantium* (Princeton, 1996); papers by various authors in A.R. Littlewood, *Originality in Byzantine Literature, Art and Music* (Oxford, 1995). The most radical statement of theory is L. James and R. Webb, '"To understand ultimate things and enter secret places": ekphrasis and art in Byzantium', *Art History*, 14 (1991), 1–17.

Surveys of Byzantine art and architecture
The period is covered in the Pelican History of Art by J. Beckwith, *Early Christian and Byzantine Art* (1970), and R. Krautheimer, *Early Christian and Byzantine Architecture* (first edn 1965, but revised in several subsequent edns, most recently in 1985). C. Mango, *Byzantine Architecture* (New York, 1976) emphasizes the practical aspects of Byzantine architecture and building, while A. Grabar, *Martyrium. Recherches sur le culte, les reliques et l'art chrétien antique*, 3 vols (Paris, 1943–6) had explored the relations between function and forms which are at the centre of Krautheimer's interests.

The surveys cover the pictorial arts and mark the state of research at the time of writing: N. Kondakoff, *Histoire de l'art byzantin*, 2 vols (Paris, 1886 and 1891); C. Bayet, *L'art byzantine* (Paris, 1892); O.M. Dalton, *Byzantine Art and Archaeology* (Oxford, 1911); O. Wulff, *Altchristliche und byzantinische Kunst* (Potsdam, 1918); C. Diehl, *Manuel d'art byzantin* (Paris, 2nd edn, 1925–6); D. Talbot Rice, *Byzantine Art* (London, 1935); D. Talbot Rice, *The Art of Byzantium* (London, 1959); W.F. Volbach, *Early Christian Art* (London, 1961); V.N. Lazarev, *Storia della pittura bizantina* (Turin, 1967; an extended revision of his survey in Russian, published in Moscow, 1947); W.F. Volbach and J. Lafontaine-Dosogne, *Byzanz und der christliche Osten* (Berlin, 1968); A. Grabar, *Christian Iconography. A Study of its Origins* (London, 1969); E. Kitzinger, *Byzantine Art in the Making. Main Lines of Stylistic Development in Mediterranean Art 3rd–7th Century* (London, 1977); B. Brenk, *Spätantike und frühes Christentum* (Oldenburg, 1977); T.F. Mathews, *The Clash of Gods: A Reinterpretation of Early Christian Art* (Princeton, 1993), L. Rodley, *Byzantine Art and Architecture* (Cambridge, 1994); J. Lafontaine-Dosogne, *Histoire de l'art byzantin et chrétien d'orient*, 2nd edn (Louvain-la-Neuve, 1995); A. Cutler and J.-M. Spieser, *Byzance médiévale 700–1204* (Paris, 1996); J. Lowden, *Early Christian and Byzantine Art* (London, 1997); T.F. Mathews, *The Art of Byzantium* (London, 1998); B. Killerich and H. Torp, *Bilder og billedbruk i Byzants* (Oslo, 1998).

Exhibitions
An increasingly important literature for Byzantine art is the exhibition (and museum) catalogue, recording special exhibitions and permanent collections and making the full range of materials available. Among the most important are: Walters Art Gallery, *Early Christian and Byzantine Art* (Baltimore, 1947); Ninth Exhibition of the Council of Europe, *Byzantine Art. An European Art* (Athens, 1964); I. Furlan *et al.* (eds), *Venezia e Bisanzio* (Venice, 1974); State Pushkin Museum of Fine Arts, *Byzantine Art in Collections of the Soviet Union* (in Russian), 3 vols (Moscow, 1977); K. Weitzmann (ed.), *Age of Spirituality. Late Antique and Early Christian Art, Third to Seventh Century* (New York, 1979); J. Lafontaine-Dosogne (ed.), *Splendeur de Byzance* (Brussels, 1982); D. Buckton (ed.), *The Treasury of San Marco, Venice* (Milan, 1984); M.M. Mango, *Silver from Early Byzantium. The Kaper Koraon and Related Treasures* (Baltimore, 1986); M. Acheimastou-Potamianou (ed.), *From Byzantium to El Greco* (London, 1987); Musée du Louvre, *Byzance. L'art byzantine dans les collections publiques françaises* (Paris, 1992); Biblioteca Apostolica Vaticana, *Liturgie und Andacht im Mittelalter* (Cologne, 1992); N. Chatzidakis, *Venetiae quasi alterum Byzantium. From Candia to Venice. Greek Icons in Italy 15th–16th Centuries* (Athens, 1993); *Ikonen. Bilder in Gold. Sakrale Kunst aus Griechland* (Akademische Druck-u.- Verlagsanstalt, Graz, 1993); M. Borboudakis (ed.), *Icons of Cretan Art*, exhibition catalogue (in Greek), (Iraklion, 1993); D. Buckton (ed.), *Byzantium. Treasures of Byzantine Art and Culture* (London, 1994);

H.C. Evans and W.D. Wixom (eds), *The Glory of Byzantium. Art and Culture of the Middle Byzantine Era, AD 845–1261* (New York, 1997); A.A. Karakatsanis (ed.), *Treasures of Mount Athos* (Thessaloniki, 1997); N. Chatzidakis, *Icons. The Velimezis Collection* (Benaki Museum, Athens, 1998); A. Effenberger and Michael Wolfson (eds), *Byzanz. Die Macht der Bilder* (Berlin, 1998); L. Wamser and G. Zahlhaas (eds), *Rom und Byzanz, Archäologische Kostbarkeiten aus Bayern* (Munich, 1998); R. Baumstark (ed.), *Rom und Byzanz. Schatzkammerstücke aus bayerischen Sammlungen* (Munich, 1998); M. Acheimastou-Potamianou, *Icons of the Byzantine Museum of Athens* (Athens, 1998).

Chapter 1. Rome with a Christian Face?

On the growth of Constantinople as a capital, see H.-G. Beck, 'Constantinople. The rise of a new capital in the east', in K. Weitzmann (ed.), *Age of Spirituality. A Symposion* (New York, 1980), 29ff for a historical view, and G. Dragon, *Naissance d'une capitale. Constantinople et ses institutions de 330 à 451* (Paris, 1974), and G. Dagron, *Constantinople imaginaire. Études sur le receuil des 'Patria'*, (Paris, 1984) for the mythical setting. R. Krautheimer, *Three Christian Capitals. Topography and Politics* (Berkeley, Los Angeles, and London, 1983) sets the architecture in context. The precise character of the city and its environment is carefully pieced together in C. Mango, *Le développement urbain de Constantinople (IVe–VIIe siècles)*, 2nd edn (Paris, 1990), and C. Mango and G. Dagron (eds), *Constantinople and its Hinterland* (Aldershot, 1995).

On the topography and buildings of Constantinople: A.G. Paspates, *The Great Palace of Constantinople* (London, 1893), a translation by W. Metcalfe of the Greek edition of 1885; J. Ebersolt, *Le grand palais de Constantinople et le livre des Cérémonies* (Paris, 1910); A. Van Millingen, *Byzantine Churches in Constantinople. Their History and Architecture* (London, 1912); J. Ebersolt and A. Thiers, *Les églises de Constantinople*, 2 vols (Paris, 1913); C. Mango, *The Brazen House. A Study of the Vestibule of the Imperial Palace of Constantinople* (Copenhagen, 1959); R. Janin, *Constantinople byzantine. Développement urbain et répertoire topographique* (Paris, 1964); R. Janin, *La géographie ecclésiastique de l'empire byzantin. Le siège de Constantinople et le patriarche oecuménique. Les églises et les monastères* (Paris, 1969); R. Guilland, *Études de topographie de Constantinople byzantine*, I–II (Berlin, 1969);

T.F. Mathews, *The Early Churches of Constantinople. Architecture and Liturgy* (University Park, Penn., 1971); T.F. Mathews, *The Byzantine Churches of Istanbul. A Photographic Survey* (University Park, Penn., 1976); W. Müller-Wiener, *Bildlexikon zur Topographie Istanbuls* (Tübingen, 1977); C. Mango, *Studies on Constantinople* (Aldershot, 1993); G.P. Majeska, *Russian Travelers to Constantinople in the Fourteenth and Fifteenth Centuries* (Dumbarton Oaks, Washington, D.C., 1984). Among these, Mathews (1971) has an illuminating account of how the early churches were designed to match the early Byzantine liturgy (itself needing to be reconstructed from the evidence of the architecture).

These studies give photographs and accounts of the past and present state of the churches of the city, all of which, except the church of Theotokos *Panagiotissa* (or St Mary of the Mongols), were converted into mosques after 1453. Certain churches have been archaeologically investigated, and the results published, notably:

D. Talbot-Rice (ed.), *The Great Palace of the Byzantine Emperors*, Second Report (Edinburgh, 1958).

For the Pantokrator Monastery (Zeyrek Camii), see A.H.S. Megaw, 'Notes on recent work of the Byzantine Institute in Istanbul', *Dumbarton Oaks Papers*, 17 (1963), 335–64; Th. Macridy and others, 'The Monastery of Lips (Fener Isa Camii) at Istanbul', *Dumbarton Oaks Papers*, 18 (1964), 251–315; P.A. Underwood, *The Kariye Djami*, vols 1–3 (New York, 1966), and vol. 4 (Princeton, 1975); O. Hjort, 'The sculpture of the Kariye Camii', *Dumbarton Oaks Papers*, 33 (1979), 201–89; R.G. Ousterhout, *The Architecture of the Kariye Camii in Istanbul* (Washington, D.C., 1987); H. Belting, C. Mango, and D. Mouriki, *The Mosaics and Frescoes of St Mary Pammakaristos (Fethiye Camii) at Istanbul* (Washington, D.C., 1978); C.L. Striker, *The Myrelaion (Bodrum Camii) in Istanbul* (Princeton, 1981); R.M. Harrison, *A Temple for Byzantium. The Discovery and Excavation of Anicia Juliana's Palace-Church in Istanbul* (London, 1989); C.L. Striker and Y.D. Kuban (eds), *Kalenderhane in Istanbul. The Buildings, their History, Architecture, and Decoration* (Mainz, 1997).

The question of antiquities in Constantinople and their influence was outlined by C. Mango, 'Antique statuary and the Byzantine beholder', *Dumbarton Oaks Papers*, 17 (1963), 55–75, and C. Mango, 'L'attitude byzantine à l'égard des antiquités

gréco-romaines', in A. Guillou and J. Durand (eds), *Byzance et les images* (Paris, 1994), 95–120. Also H. Saridi-Mendelovici, 'Christian attitudes toward pagan monuments in late antiquity and their legacy in later Byzantine centuries', *Dumbarton Oaks Papers*, 44 (1990), 47–61; S.G. Bassett, 'The antiquities in the Hippodrome of Constantinople', *Dumbarton Oaks Papers*, 45 (1991), 87–96; L. James, '"Pray not to fall into temptation and be on your guard": pagan statues in Christian Constantinople', *Gesta*, 35 (1996), 12–20. For one of the enigmatic texts (probably written around 780) which struggles to describe antique statues in Constantinople and how they were regarded, see A. Cameron and J. Herrin, *Constantinople in the Early Eighth Century: The Parastaseis Syntomoi Chronikai* (Leiden, 1984).

For the first Christian art, see P.C. Finney, *The Invisible God. The Earliest Christians on Art* (Oxford, 1994); Sister C. Murray. 'Art and the early church', *Journal of Theological Studies*, N.S. 28 (1977), 303–45, and E.S. Malbon, *The Iconography of the Sarcophagus of Junius Bassus* (Princeton, 1990). An overview of late antiquity is given in F.M. Glover and R.S. Humphreys (eds), *Tradition and Innovation in Late Antiquity* (Madison, 1989), but the most influential studies on the religious climate of the period are P. Brown, *Society and the Holy in Late Antiquity* (London, 1982). For a review of the monuments of early Thessaloniki, see J.-M. Spieser, *Thessalonique et ses monuments* (Paris, 1984), who dates the Rotunda to the early sixth century, and discusses the alternative suggestions. The late fourth-century date was argued by H. Torp, *Mosaikkene i St. Georg-rotunden* (Oslo, 1963); H. Torp has promised a fuller account to appear in 1999, maintaining the late fourth-century date. The British Museum icon of Orthodoxy is described in D. Buckton (ed.), *Byzantium. Treasures of Byzantine Art and Culture* (London, 1994), cat. 140, 129–31.

Chapter 2. In the Shadow of St Sophia

The church of St Sophia has attracted massive attention, and it is the best-measured and surveyed medieval church: R.L. Van Nice, *St Sophia in Istanbul: An Architectural Survey*, two instalments (Washington, D.C., 1965 and 1986), and R. Mainstone, *Hagia Sophia* (London, 1988). The classic accounts are those of W.R. Lethaby and H. Swainson, *Sancta Sophia Constantinople* (London, 1894); E.M. Antoniadi, *Hagia Sophia* (in Greek), 3 vols (Athens, 1907–9), and E.H. Swift, *Hagia*

Sophia (New York, 1940). For an account of its mosaics, see C. Mango, *Materials of the Study of the Mosaics of St Sophia at Istanbul* (Washington, D.C., 1962); R. Cormack, 'Interpreting the mosaics of S. Sophia at Istanbul', *Art History*, 4 (1981), 131–49. Also R. Mark and A.S. Cakmak (eds), *Hagia Sophia. From the Age of Justinian to the Present* (Cambridge, 1992). For a striking photographic coverage, see C. Mango and A. Ertug, *Hagia Sophia* (Kocabiyik, 1997); and for a close reading of a sixth-century description of the church, see R. Macrides and P. Magdalino, 'The architecture of ekphrasis: construction and context of Paul the Silentiary's poem on Hagia Sophia', *Byzantine and Modern Greek Studies*, 12 (1988), 47–82.

For accounts of the Sinai monastery, see O. Baddeley and E. Brunner, *The Monastery of Saint Catherine* (London, 1996); K. Manafis (ed.), *Sinai: Treasures of the Monastery of Saint Catherine* (Athens, 1990); G.H. Forsyth and K. Weitzmann, *The Monastery of Saint Catherine at Mount Sinai. The Church and Fortress of Justinian. Plates* (Ann Arbor, n.d.), and K. Weitzmann, *The Monastery of Saint Catherine at Mount Sinai. The Icons. Volume One: From the Sixth to the Tenth Century* (Princeton, 1967). K. Weitzmann, *Studies in the Arts at Sinai* (Princeton, 1981) is a collection of important studies. The most evocative account of Ravenna remains that of O. von Simson, *Sacred Fortress: Byzantine Art and Statecraft in Ravenna* (Chicago, 1948), and a view of Ravenna through the medieval literature is given by J.M. Pizarro, *Writing Ravenna. The Liber Pontificalis of Andreas Agnellus* (Ann Arbor, 1995), with a bibliography on the city.

A.D. Kartsonis, *Anastasis. The Making of an Image* (Princeton, 1986) is a thorough account of the emergence of new imagery before iconoclasm, related to the spiritual climate of the period. A repertory of iconography was put together by G. Millet, *Recherches sur l'iconographie de l'évangile aux XIVe, XVe et XVIe siècles* (Paris, 1916; reprinted Paris, 1960), and supplemented by J. Lafontaine-Dosogne, *Iconographie de l'enfance de la Vierge dans l'empire byzantin et en occident*, 2 vols (Brussels, 1964 and 1965). For a review of iconography as a method of study, see C. Walter, *Studies in Byzantine Iconography* (London, 1977), and B. Cassidy (ed.), *Iconography at the Crossroads* (Princeton, 1993). For the liturgy and commentaries on it, see R.F. Taft, *Liturgy in Byzantium and Beyond* (Aldershot, 1995).

The basic investigation of Byzantine silver stamps is in E. Cruikshank Dodds, *Byzantine Silver Stamps* (Washington, D.C., 1961).

Chapter 3. The Definition of an Orthodox Christian Empire

E. Dobschütz, *Christusbilder. Untersuchen zur christlichen Legende* (Leipzig, 1899) systematically brought together the texts which document the early representations of Christ, and this collection was extensively used by E. Kitzinger, *The Art of Byzantium and the Medieval West*, ed. W.E. Kleinbauer (Bloomington, 1976), and by H. Belting, *Likeness and Presence. A History of the Image before the Era of Art* (Chicago, 1994): English translation of *Bild und Kult: Eine Geschichte des Bildes vor dem Zeitalter der Kunst* (Munich, 1990). The materials were set out by A. Grabar, *L'iconoclasme byzantin. Dossier archéologique* (Paris, 1957), and there is a full-length study of the imagery of the Khludov Psalter by K. Corrigan, *Visual Polemics in the Ninth-Century Byzantine Psalters* (Cambridge, 1992).

Other attempts to define change in Byzantium in this period are J. Elsner, 'Image and iconoclasm in Byzantium', *Art History*, 11 (1988), 471–91; A. Cameron, 'The language of images: the rise of icons and Christian representation', in D. Wood (ed.), *The Church and the Arts* (Oxford, 1992); R. Ousterhout and L. Brubaker (eds), *The Sacred Image East and West* (Urbana, 1993); C. Barber, 'The body within the frame: a use of word and image in iconoclasm', *Word and Image*, 9 (1993), 7–16.

Iconoclasm has elicited a prolific literature, and multiple interpretations and estimates of its cultural importance and connections with the rise of Islam. It takes a prominent role in J. Herrin, *The Formation of Christendom* (Oxford, 1987), and D. Freedberg, *The Power of Images* (Chicago, 1989). Other major contributions are E.J. Martin, *A History of the Iconoclastic Controversy* (London, 1930; reprinted 1978); E. Kitzinger, 'The cult of images in the age before iconoclasm' (from *Dumbarton Oaks Papers*, 8 (1954), 83–150), reprinted in W.E. Kleinbauer (ed.), *The Art of Byzantium and the Medieval West: Selected Studies by E. Kitzinger* (Indiana U.P., 1976), 91–156; C. Mango, *The Brazen House. A Study of the Vestibule of the Imperial Palace of Constantinople* (Copenhagen, 1959); H.-J. Geischer, *Der byzantinischer Bilderstreit* (Gütersloh, 1968); H. Hennephof, *Textus Byzantinos ad Iconomachiam Pertinentes* (Leiden, 1969); P. Brown, 'A Dark Age crisis:

aspects of the iconoclastic controversy', *English Historical Review*, 88 (1973), 1–34, reprinted and expanded in P. Brown, *Society and the Holy in Late Antiquity* (London, 1982); F.-X. Murphy and P. Sherwood, *Constantinople II et Constantinople III* (Paris, 1974); P. Henry, 'What was the iconoclastic controversy about?' *Church History*, 45 (1976), 16–31; A. Bryer and J. Herrin (eds), *Iconoclasm* (Birmingham, 1977); G.R.D. King, 'Islam, iconoclasm, and the declaration of doctrine', *Bulletin of School of Oriental and African Studies*, 48 (1985), 267–77; D.J. Sahas, *Icon and Logos. Sources in Eighth-Century Iconoclasm.* (Toronto, 1986); K. Parry, *Depicting the Word. Byzantine Iconophile Thought of the Eighth and Ninth Centuries* (Leiden, 1996).

Chapter 4. Developments and Diversions in the Consolidated Empire

The exhibition catalogue, H.C. Evans and W.D. Wixom (eds), *The Glory of Byzantium. Art and Culture of the Middle Byzantine Era, AD 843–1261* (New York, 1977), covers the materials from this period and their interpretation. A number of specialist books give insights into particular aspects: C. Jolivet-Lévy, *Les Églises byzantines de Cappadoce. Le programme iconographique de l'abside et de ses abords* (Paris, 1991) surveys the wall paintings of Cappadocia, and updates M. Restle, *Byzantine Wall Painting in Asia Minor* (Shannon, 1969); J. Lowden, *The Octateuchs. A Study of Illustrated Byzantine Manuscripts* (Pennsylvania, 1992), sets out the manuscript issues of the period, from the aspect of illustrated Bibles; A. Cutler, *The Hand of the Master. Craftsmanship, Ivory, and Society in Byzantium (9th–11th Centuries)* (Princeton, 1994) looks at the evidence of ivories; I. Kalavrezou-Maxeiner, *Byzantine Icons in Steatite* (Vienna, 1985) covers steatites; K. Wessel, *Byzantine Enamels* (Shannon, 1969); and A. Muthesius, *Studies in Byzantine and Islamic Silk Weaving* (London, 1995). Byzantine sculpture was surveyed by A. Grabar, *Sculptures byzantines de Constantinople (IVe–IXe siècle)* (Paris, 1963) and *Sculptures byzantines du moyen age. II. (XIe–XIVe siècle)* (Paris, 1976). Other regions are covered in A. and J. Stylianou, *The Painted Churches of Cyprus* (London, 1985); M. Chatzidakis, *Byzantine Art in Greece. Kastoria* (Athens, 1985); R. Hamann-MacLean and H. Hallensleben, *Die Monumentalmalerei in Serbien und Makedonien vom 11. bis zum frühen 14 Jahrhundert* (Giessen, 1963); and A.J. Wharton, *The Art of Empire. Painting and*

Architecture of the Byzantine Periphery (Berkeley, 1988). M. Chatzidakis and J. Bitha, *Kythera* (in Greek) (Athens, 1997) represents the first volume of a corpus of monumental painting in Greece.

For views on the notion of renaissance, see W. Treadgold (ed.), *Renaissances before the Renaissance. Cultural Revivals of Late Antiquity and the Middle Ages* (Stanford, 1984).

Chapter 5. The New Spirituality of the Eleventh Century and the World of the Twelfth Century

The changes in the church are considered by J.M. Hussey, *The Orthodox Church in the Byzantine Empire* (Oxford, 1986), and more broadly by A.P. Kazhdan and A. Wharton Epstein, *Change in Byzantine Culture in the Eleventh and Twelfth Centuries* (Berkeley, 1985). See also T.F. Mathews, *Art and Architecture in Byzantium and Armenia. Liturgical and Exegetical Approaches* (Aldershot, 1995). The nature of the monastery in this period is the subject of M. Mullett and A. Kirby (eds), *The Theotokos Evergetis and Eleventh-Century Monasticism* (Belfast, 1994).

The recent studies of Byzantine mosaics in part supersede the pioneering stylistic treatments: E. Diez and O. Demus, *Byzantine Mosaics in Greece: Hosios Lucas and Daphni* (Cambridge, Mass., 1931); O. Demus, *Byzantine Mosaic Decoration* (London, 1948); O. Demus, *The Mosaics of Norman Sicily* (London, 1950); and O. Demus, *The Mosaics of San Marco in Venice*, 2 vols (Chicago/London, 1984). For description and analysis of forms, the work of Demus has been very influential, particularly on the work in Greece of D. Mouriki (including 'Stylistic trends in monumental painting of Greece during the eleventh and twelfth centuries', *Dumbarton Oaks Papers*, 34/35 (1980–1), 77–124). On Sicily see E. Kitzinger, *The Mosaics of St. Mary's of the Admiral in Palermo* (Washington, D.C., 1990), and W. Tronzo, *The Cultures of his Kingdom. Roger II and the Capella Palatina in Palermo* (Princeton, 1997). For Russian materials, see V. Lazarev, *Old Russian Murals and Mosaics* (London, 1966).

Chapter 6. Art in the Service of a Failing Society

The broad classic statement of the 'Byzantine Question' in terms of influence on the west is by O. Demus (*Byzantine Art and the West* (London, 1970)). This is reworked with a detailed analysis of the thirteenth century by A. Derbes, *Picturing the Passion in Late Medieval Italy. Narrative Painting, Franciscan Ideologies, and the Levant* (Cambridge, 1996). Meanwhile, the way that the presence of the Crusaders and their artists had an impact on Byzantium is much discussed, particularly stimulated by H. Buchthal, *Miniature Painting in the Latin Kingdom of Jerusalem* (Oxford, 1957), and now set out by J. Folda, *The Art of the Crusaders in the Holy Land, 1098–1187* (Cambridge, 1995), which has a full coverage of the literature. Also I. Hutter, *Byzanz und der Westen. Studien zur Kunst des Europäischen Mittelalters* (Vienna, 1984), and V.P. Goss (ed.), *The Meeting of Two Worlds. Cultural Exchange between East and West during the Period of the Crusades* (Kalamazoo, 1986).

The centrepiece of Late Byzantine art, the Chora Monastery, is still best studied in the volumes of P. Underwood, but there are exemplary studies of monumental decoration by D. Mouriki in H. Belting, C. Mango, and D. Mouriki, *The Mosaics and Frescoes of St Mary Pammakaristos (Fethiye Camii) at Istanbul* (Washington, D.C., 1978), and in A. Weyl Carr and L.J. Morrocco, *A Byzantine Masterpiece Recovered: The Thirteenth-Century Murals of Lysi, Cyprus* (Austin, Texas, 1991). The materials are listed in T. Velmans, *La peinture murale byzantine à la fin du Moyen Age* (Paris, 1977). S. Ćurčič and D. Mouriki (eds) *The Twilight of Byzantium* (Princeton, 1991) is oddly thin on icons, which are the major medium of the late period: see B. Davezac (ed.), *Four Icons in the Menil Collection* (Austin, Texas, 1992); K. Weitzmann, *The Icon* (London, 1978); K. Weitzmann *et al.* (eds), *The Icon* (London, 1982); and the recent icon exhibition catalogues. For a treatment of many new images see C. Baltoyianni, *Icons. Mother of God in the Incarnation and the Passion* (Athens, 1994).

On technical aspects, see P. Hetherington, *The 'Painter's Manual' of Dionysius of Fourna* (London, 1974); D.C. Winfield, 'Middle and later Byzantine wall painting methods. A comparative study', *Dumbarton Oaks Papers*, 22 (1968), 61–139; G. Ramos-Poqui, *The Technique of Icon Painting* (Tunbridge Wells, 1990); and L. James, *Light and Colour in Byzantine Art* (Oxford, 1996).

To experience Byzantine art in its original settings is desirable but requires travel and perseverance. Major works can be seen in museums and galleries, and some monasteries now have websites – for example, see *www.bates.edu/~rallison/friends* for information about Mount Athos.

Museums

United Kingdom

British Museum
Houses the national icon collection.

www.british-museum.ac.uk

Victoria and Albert Museum

www. vam.ac.uk

British Library
Manuscripts collection.

www.bl.uk

Bodleian Library
University of Oxford
Manuscripts collection.

www.bodley.ox.ac.uk

Ashmolean Museum
Oxford
Byzantine collection section.

www.ashmol.ox.ac.uk

University Library, Cambridge
Manuscripts collection.

www.lib.cam.ac.uk

United States

Dumbarton Oaks
Washington, DC
The most important collection of Byzantine art in the US. The website offers access to many resources, including manuscripts.

www.doaks.org

Metropolitan Museum
New York
Significant collection of Byzantine art.

www.metmuseum.org

Cleveland Museum of Art
Cleveland, OH
Collection of Byzantine art.

www.cwru.edu/buildings/cultural/art_museum.htm

Walters Art Gallery
Baltimore, MD
Collection of Byzantine art.

www.thewalters.org

Princeton University Library
Princeton, NJ
Manuscripts collection.

www.princeton.edu/~rbsc/manuscripts.htm

University of Chicago Library
Chicago, IL
Manuscripts collection.

www.lib.uchicago.edu/e/spcl/mss.htm

France

Louvre
Paris
Major collection of Byzantine objects and manuscripts.

www.paris.org/musees/Louvre

Cluny Museum
Paris
Major collection of Byzantine objects and manuscripts.

www.paris.org/musees/Cluny

Italy	**Vatican Museums** Rome Major collections of objects and manuscripts.	www.christusrex.org/www1/vaticano/ o-musei.htm
	Treasury of the Church of San Marco Venice A striking single collection, including the Pala d'Oro at the high altar of San Marco.	
Greece	There are Byzantine museums in Athens and Thessaloniki, as well as many sites and objects on the mainland and islands (particularly Crete).	www.benaki.gr
	Benaki Museum at Athens Substantial collection.	
Turkey	The **Antalya Museum** is of interest, and the archaeological museums of **Izmir**, **Ephesus**, and **Aphrodisias** have materials excavated locally.	www.exploreturkey.com/ist_arch.htm
	Istanbul Archaeological Museum Major collection of materials from Constantinople and elsewhere.	
Syria	**National Museum of Syria** Damascus Dura Europos synagogue paintings.	www.syriatourism.org/national_museum.htm
Balkan countries	Major collections, particularly of icons, are collected in the main urban museums.	
	Belgrade	www.serbia-info.com/enc/monuments/ belgrade.html
	Sofia	www.sofia.com/museums
	Bucharest	www.itc.ro/itenet/muzste.htm
Russia	**Hermitage Museum** St Petersburg The website offers access to the collection of icons and precious objects and allows visual searches.	www.hermitagemuseum.org
	Tretiakov Gallery Moscow	www.alincom.com/tretiakov

Websites

The best web pages for information on
Byzantine art are:

www.fordham.edu/halsall/medweb
This site gives links to all the main Byzantine
sites.

www.georgetown.edu/labyrinth/
labyrinth-home.html
This site gives links to Byzantine and other
medieval sites.

www.courtauld.ac.uk/pages/indexframe.html
This site offers links to major art-historical
sites.

www.perseus.tufts.edu
Perseus focuses on the classical world but has
much material for the study of Byzantine art.

List of Illustrations

24. The monastery of St Catherine, Sinai, Egypt. 548–65. Photo Robin Cormack.

25. Apse mosaic of the monastery of St Catherine, Sinai, Egypt. 565/6 or possibly later. Photo Jane Taylor/Sonia Halliday Photographs, Weston Turville.

26. Detail of apse mosaic of the monastery of St Catherine, Sinai, Egypt. 565/6 or later. Photo E.J.W. Hawkins.

27. Icon with the *Heavenly Ladder* of John Climakos. Sinai or Constantinople. Late twelfth century. Tempera. 41.1 × 29.5 cm. Monastery of St Catherine, Sinai, Egypt. Studio Kontos/Photostock, Athens.

28. Mosaic apse of the church of the Panagia Angeloktistos, Kiti, Cyprus. Sixth or seventh century. Photo E.J.W. Hawkins.

29. Mosaics of the church of S. Apollinare Nuovo, Ravenna. South wall, looking east. Sixth century. Photo Alinari, Florence.

30. Manuscript page with Raising of Lazarus and Old Testament Prophets. Rossano Gospels. Constantinople (?). Sixth century. Rossano, Cathedral Treasury, Italy. Photo Scala, Florence.

31. Ivory-panelled chair of Archbishop Maximian. Constantinople (?). 540s. Museo Arcivescovile, Ravenna/photo Alinari, Florence.

32. Sanctuary of the church of S. Vitale, Ravenna. Photo Scala, Florence.

33. Mosaic panel of Justinian in the sanctuary of S. Vitale, Ravenna. 540s. Photo Scala, Florence.

34. Mosaic panel of Theodora in the sanctuary of S. Vitale, Ravenna. 540s. Photo Scala, Florence.

35. Silver-gilt *Missorium* or commemorative dish of Theodosios I. Constantinople (?). Silver. Diameter 74 cm. Real Accadémia de la Historia Hispanic, Madrid/photo Institut Amatller d'Art Hispànic, Barcelona.

36. The David plates: David and Goliath plate. Constantinople. Date-stamped 613–29/30. Silver. Diameter 49.4 cm. Metropolitan Museum of Art, New York, Gift of J. Pierpont Morgan, 1917 (17.190.396)/photo Schecter Lee.

37. Icon of Christ. Constantinople (?). Sixth century (with later Byzantine repaint). Encaustic. 84 × 45.5 cm. Monastery of St Catherine, Sinai, Egypt. Studio Kontos/Photostock, Athens.

38. Icon of Christ the Saviour and St Menas (Apa Mena). Egypt (?). Tempera. 57 × 57 cm. Musée du Louvre, Paris/photo © Réunion des Musées Nationaux.

39. Manuscript illustration of the Crucifixion. Rabbula Gospels. Produced at the monastery of Beth Mar John of Beth Zagba, north of Apamea, Syria. Dated 586. 33.6 × 26.6 cm. Biblioteca Medicea Laurenziana (Ms.Laur.Plut.1.56, f.13), Florence.

40. *Templon* beam with the *Anastasis* and other festival scenes. Sinai (?). Tempera. Twelfth or thirteenth century. Monastery of St Catherine, Sinai, Egypt. Photo G. Dagli Orti, Paris.

41. Icon of the Crucifixion. Sinai (?). Eighth century. Tempera. 46.4 × 25.5 cm. Monastery of St Catherine, Sinai, Egypt. Photo G. Dagli Orti, Paris.

42. Wall painting of the Crucifixion. 741–52. Theodotus chapel of the church of S. Maria Antiqua, Rome. Photo Alinari, Florence.

43. Mosaic panel of St Demetrios with the bishop and prefect. Church of St Demetrios, Thessaloniki (on pier to right of the sanctuary). *c.*620. Photo Josephine Powell, Rome.

44. Mosaic panel of the enthroned Virgin and Child with St Demetrios, saints, and donors. Church of St Demetrios, Thessaloniki. North inner aisle. Sixth century. Watercolour copy by W.S. George. Photo Conway Library, Courtauld Institute of Art, London.

45. Icon of Virgin and Child with Saints. Constantinople (?). Sixth century. Encaustic. 68.5 × 49.7 cm. Monastery of St Catherine, Sinai, Egypt. Photo Studio Kontos/Photostock, Athens.

46. Icon of Abgar of Edessa showing the *Mandylion* of Christ. Constantinople (?). Tempera. 34.5 × 25.2 cm. Monastery of St Catherine, Sinai, Egypt. Photo G. Dagli Orti, Paris.

47. Gold *solidus* of Justinian II with the face of Christ on the obverse and portrait of the emperor on the reverse. Mint of Constantinople. First reign of Justinian II, 685–95. Diameter 20 mm. Byzantine Collection, Dumbarton Oaks, Washington DC.

48. Gold *solidus* of Justinian II with the face of Christ on the obverse and portrait of the emperor on the reverse. Mint of Constantinople. Second reign of Justinian II, 705–11. Diameter 21 mm. Byzantine Collection, Dumbarton Oaks, Washington DC.

49. Mosaic oratory chapel of Pope John VII. Old St Peter's, Rome. 705–7. Biblioteca Apostolica Vaticana (Barberini lat.2733), Vatican City/photo Warburg Institute, University of London.

50. Wall painting of St Stephen the Younger with an icon. *Enkleistra* of Neophytos, Paphos, Crete. 1197 or later. Photo Dumbarton Oaks Center for Byzantine Studies, Washington DC.

51. Mosaic apse of the church of St Eirene, Constantinople. After 740. Photo Josephine Powell, Rome.

52. Mosaics of the small *Sekreton* of the Patriarchate. Room over the south-west ramp (south wall and window). 565–77 and 768/9. Dumbarton Oaks Center for Byzantine Studies, Washington DC.

53. Mosaic apse with Christ in a mandorla. Church of Hosios David, Thessaloniki. Sixth

century. Photo Hirmer Verlag, Munich.

54. Mosaic apse with Virgin and Child. Church of the *Koimisis*, Nicaea (now Iznik). Ninth century. From T. Schmidt, *Die Koimesis-Kirche von Nikaia* (Berlin, 1927).

55. Manuscript illustration of David composing the Psalms. Khludov Psalter. Constantinople. Soon after 843. 19.5 × 15 cm. State Historical Museum (GIM 86795 or Khlud.129-d, folios 1 verso and 2 recto), Moscow.

56. Manuscript illustration of Simon Magus and Patriarch Nikephoros. Khludov Psalter. Constantinople. Soon after 843. 19.5 × 15 cm. State Historical Museum (GIM 86795 or Khlud.129-d, folio 51 verso).

57. Manuscript illustration of the Crucifixion and iconoclasts whitewashing an icon of Christ. Khludov Psalter, Constantinople. Soon after 843. 19.5 × 15 cm. State Historical Museum (GIM 86795 or Khlud.129-d, folio 67), Moscow.

58. Detail of the face of the Virgin in the mosaic apse with Virgin and Child. St Sophia, Constantinople. 532–7 and 867 (?). Photo E.J.W. Hawkins.

59. Manuscript illustration of iconophiles Nikephoros and St Theodore the Studite holding an icon and arguing with iconoclasts. Theodore Psalter. Constantinople, in the monastery of St John Studios. 1066. 23.1 × 19.8 cm. The British Library (Add.19352, folio 27 verso), London.

60. Manuscript roll of the Book of Joshua. Joshua Roll. Constantinople. *c.*950. Tempera and gold. Fifteen vellum sheets, each between 30 and 31.5 cm in height and 42 and 89.5 cm in length. Biblioteca Apostolica Vaticana (Vat.Pal.gr.431, VI), Vatican City.

61. Manuscript illustration of David composing the Psalms. Paris Psalter. Constantinople. *c.*950. Tempera and gold leaf. 37 × 26.5 cm. Bibliothèque Nationale (MS gr.139, folio 1 verso), Paris.

62. Manuscript illustration of St John of Damascus. *Sacra Parallela*. Constantinople. Second half of the ninth century. 35.6 × 26.5 cm. Bibliothèque Nationale (MS gr.923, folio 208 recto), Paris.

63. Gold *solidus* of Michael III with the face of Christ on the obverse (inscribed *Jesus Christos*). Mint of Constantinople. 843–56. Diameter 19 mm. Byzantine Collection, Dumbarton Oaks, Washington DC.

64. *Cloisonné* enamelled reliquary cross with Crucifixion and Virgin with saints. Beresford Hope Cross. Constantinople(?). Ninth century, after 843(?). 9.1 × 5.7 cm. Trustees of the Victoria and Albert Museum, London.

65. *Cloisonné* enamelled reliquary box with Crucifixion and 27 saints. Fieschi-Morgan *Staurotheke*. Constantinople(?). Ninth century, after 843(?). 10.2 × 7.4 cm. Metropolitan Museum of Art, New York, Gift of J. Pierpont Morgan, 1917 (17.190.715).

66. *Cloisonné* enamel icon with full-length figure of Archangel Michael. Constantinople. Around 1100. 46 × 35 cm. Treasury of San Marco, Venice/photo Scala, Florence.

67. Mosaic apse with Virgin and Child. St Sophia, Constantinople. 532–7 and 867(?). Photo E.J.W. Hawkins.

68. Mosaic panel of St Ignatios the Younger, patriarch of Constantinople (847–58 and 867–77). Last quarter of the ninth century. North tympanum, St Sophia, Constantinople. Photo I. Keribar/Artephot, Paris.

69. Lunette panel of Christ. *c.* 900. Above central door, inner narthex of St Sophia, Constantinople. Photo Colorphoto Hans Hinz, Allschwil, Basel.

70. Manuscript miniature with Raising of Lazarus and Entry into Jerusalem. Homilies of St Gregory of Nazianzus. Constantinople. 879–82. Tempera. 41 × 30 cm. Bibliothèque Nationale (MS gr.510, folio 196 verso), Paris.

71. Mosaic panel with Christ, Emperor Constantine IX Monomachos, and Zoe. The Zoe Panel. 1028–34 and 1042–55. 2.44 × 2.40 m. East wall, south gallery of St Sophia, Constantinople. Photo G. Dagli Orti, Paris.

72. Mosaic panel with Virgin and Child, John II Komnenos, and Eirene. 1118–34. 2.47 × 2.76 m. East wall, south gallery, St Sophia, Constantinople. Photo G. Dagli Orti, Paris.

73. Ivory plaque with the Coronation of Constantine VII Porphyrogenitos. Constantinople. *c.* 945(?). Photo Hirmer Verlag, Munich.

74. Ivory plaque with Christ crowning Romanos and Eudokia. Constantinople. 24.6 × 15.5 cm. Bibliothèque Nationale (Cabinet des Medailles), Paris/photo Hirmer Verlag, Munich.

75. Ivory triptych with *Deisis* and Saints. Constantinople. Tenth century. 24 × 14.5 cm (closed). Palazzo Venezia, Rome/photo Hirmer Verlag, Munich.

76. Enamelled reliquary of the True Cross. The Limburg *Staurotheke*. Constantinople. Inner reliquary 959–63; enamels after 963. 48 × 35 × 6 cm. Diozesanmuseum, Bistum Limburg.

77. Manuscript illustration of St Simeon Stylites. *Menologion* of Basil II. Constantinople. *c.* 1000. 36.5 × 28.5 cm. Biblioteca Apostolica Vaticana (MS vat.gr.1613, folio 2 recto), Vatican City.

78. Manuscript illustration of Basil II. Constantinople. *c.* 1000. 39 × 30 cm. Biblioteca Marciana (cod.marc.Gr.Z.17 (=421), folio III recto), Venice/Foto Toso.

79. Manuscript illustration of Leo and the Virgin. Bible. Constantinople. Second quarter of the tenth century. 41 × 27 cm. Biblioteca Apostolica Vaticana (Vat.Reginensis gr.1, folio 2 verso), Vatican City.

80. Gilded and painted glass cup. Constantinople. Middle of the tenth century or perhaps later. 17 × 17 cm. Treasury of San

Marco/Procuratoia di San Marco,
Venice/Foto Carrieri.

81. Interior of the katholikon of Hosios
Loukas, central Greece. First half of the
eleventh century. Photo Bruce White, © 1997
the Metropolitan Museum of Art, New York.

82. Dome mosaic of the Ascension. *c.* 885. St
Sophia, Thessaloniki. Photo Studio
Kontos/Photostock, Athens.

83. Wall paintings of the nave of the 'New
Church', Tokalï kilise, Cappadocia. First half
of tenth century. Photo G. Dagli Orti, Paris.

84. Double-sided icon with the Virgin
Hodigitria (front) and the Man of Sorrows
(back). Second half of the twelfth century.
Tempera. 115 × 77.5 cm. Byzantine Museum,
Kastoria/photos Courtauld Institute of Art,
London.

85. Icon with the Annunciation. Sinai or
Constantinople. Late twelfth century.
Tempera. 61 × 42.2 cm. Monastery of St
Catherine, Sinai, Egypt. Photo G. Dagli Orti,
Paris.

86. Manuscript illustration of an evangelist.
The *Codex Ebnerianus*, New Testament.
Constantinople. First half of the twelfth
century. 20.4 × 15.5 cm. Bodleian Library (MS
Auct.T.inf.1.10, folio 118 verso), Oxford.

87. Manuscript page with the Ascension.
Homilies of monk James Kokkinobaphos.
Constantinople. First half of the twelfth
century. 23 × 16.5 cm. Bibliothèque Nationale
(MS gr.1208, folio 3 verso), Paris.

88. The Pantokrator Monastery (Zeyrek
Camii), Constantinople. 1118–36. Exterior
from the east. Photo Josephine Powell, Rome.

89. Marble floor and sanctuary of the south
church (katholikon) of the Pantocrator
Monastery, Constantinople. Photo Center for
Byzantine Studies, Dumbarton Oaks,
Washington DC.

90. Enamel plaque with the *Anastasis* in the
altarpiece of S. Marco, Venice. The *Pala d'Oro*.
Constantinople. Twelfth century. Photo
Cameraphoto Arte, Venice.

91. Manuscript illustration of St Gregory of
Nazianzus writing his homilies. Liturgical
Homilies of St Gregory of Nazianzus.
Constantinople, produced at the Pantokrator
Monastery. 1136–55. 32.3 × 25.4 cm. Monastery
of St Catherine (Ms.gr. 339), Sinai, Egypt.
Photo Studio Kontos/Photostock, Athens.

92. Exterior of the churches of the monastery
of Hosios Loukas. First half of the eleventh
century. Photo Henri Stierlin, Geneva.

93. Mosaic portrait of Hosios Loukas.
Monastery of Hosios Loukas. Photo
Josephine Powell, Rome.

94. Mosaic panel of the Doubting of Thomas.
First half of the eleventh century. South wall,
narthex, monastery of Hosios Loukas. Photo
Makis Skiadaressis, Athens. From N.
Chatzidakis, *Hosios Loukas: Mosaics and
Wallpaintings* (Athens: Melissa, 1996).

95. Wall painting of the Doubting of Thomas.

First half of the eleventh century. South-west
bay, crypt of katholikon of Hosios Loukas.
Photo Makis Skiadaressis, Athens. From N.
Chatzidakis, *Hosios Loukas: Mosaics and
Wallpaintings* (Athens: Melissa, 1996).

96. Mosaics of Christ and Saints. First half of
the eleventh century. Narthex, katholikon of
Hosios Loukas. Photo G. Dagli Orti, Paris.

97. Mosaic of the *Anastasis.* 1042–55. North
bay, katholikon, Nea Moni, Chios. Photo R.
Percheron/Artephot, Paris.

98. Cupola mosaic of Christ and Prophets.
c. 1100. Monastery of Daphni, Athens. Photo
Josephine Powell, Rome.

99. Narthex mosaic with the Infancy of the
Virgin. Twelfth century. Monastery of
Daphni, Athens. Photo Josephine Powell,
Rome.

100. Wall painting of the Lamentation with
monastic saints below. 1164. North wall of the
katholikon of the monastery of St
Panteleimon, Nerezi, near Skopje. Photo
Josephine Powell, Rome.

101. Dome of the church of Panagia tou
Arakou, Lagoudera, Cyprus. The wall
paintings are of Christ, angels with the
etimasia, and prophets. 1192. Dumbarton Oaks
Center for Byzantine Studies, Washington
DC.

102. Wall painting of the *Koimisis* of the
Virgin. West wall. 1105/6. Church of Panagia
Phorbiotissa, Asinou, Cyprus. Photo Sonia
Halliday, Weston Turville.

103. Theodore Apseudes, wall painting of
Neophytos ascending with archangels. 1182/3.
Sanctuary of the *Enkleistra*, near Paphos,
Cyprus. Photo Sonia Halliday, Weston
Turville.

104. Apse mosaic with the Orant (Praying)
Virgin and Communion of Apostles.
Mosaicists from Constantinople(?). 1037–46.
St Sophia, Kiev.

105. Icon of the Virgin and Child. The
Vladimir Icon. Constantinople. *c.*1131. 78 × 55
cm. Tretyakov Gallery, Moscow/photo
Artephot, Paris.

106. Mosaics of the Cappella Palatina,
Palermo, Sicily. 1142/3. Artists from
Constantinople. Photo G. Dagli Orti, Paris.

107. Mosaic apse with Christ. Artists from
Constantinople. *c.*1180s. Cathedral of
Monreale, Sicily. Photo Scala, Florence.

108. Silver-gilt plaque and reliquary for a piece
of stone from the Sepulchre of Christ with the
Marys at the Empty Tomb. Constantinople.
Second half of the twelfth century. 42.6 × 31
cm. Musée du Louvre (Département des
Objets d'Art), Paris/photo Chuzeville,
Réunion des Musées Nationaux.

109. Manuscript illustration of the *Koimisis* of
the Virgin. Queen Melisende's Psalter.
Jerusalem. 1131–43. 21.5 × 14 cm. The British
Library (MS Egerton 1139, folio 12 recto),
London.

110. Icon of St George and the Youth of

Mytilene. East Mediterranean. Middle of the thirteenth century. Tempera on linen. 26.8 × 18.8 cm. The British Museum (MLA 1984,0601.1), London.

111. T'oros Roslin, manuscript illustration of the Last Judgement. Hromkla, Cilicia (Lesser Armenia). *c.*1256-68. Walters Art Gallery (W.539, folio 109 verso), Baltimore MD.

112. Manuscript illustration of Emperor Manuel II, his wife Helen, and their three children under the protection of the Virgin and Child. Constantinople. 1403–5. The works of Pseudo-Dionysios the Areopagite, folio 2 recto. 27 × 20 cm. Musée du Louvre (Département des Objets d'Art), Paris/photo Arnaudet, Réunion des Musées Nationaux.

113. Manuscript illustration of the Transfiguration. Theological Works of John VI Cantacuzenos. Constantinople. 1370–5. 33.5 × 24 cm. Bibliothèque Nationale (MS gr.1242, folio 92 verso), Paris.

114. Wall painting of Tomb G with the deceased woman in the presence of the Virgin and Child. Chora Monastery (Kariye Camii), Constantinople. Second quarter of the fifteenth century. Dumbarton Oaks Center for Byzantine Studies, Washington DC. © 1999 by Dumbarton Oaks Trustees for Harvard University.

115. Wall painting of the Nativity in the church of the Virgin Peribleptos, Mistra. Third quarter of the fourteenth century. Colorphoto Hans Hinz, Allschwil, Basel.

116. Manuscript illustration of the shrine of the *Hodigitria*. Hamilton Psalter. Constantinople. Fourteenth century. Kupferstichkabinett (Codex 78.A.9, folio 39 verso), Berlin/photo Jörg P. Anders, © Staatliche Museen zu Berlin Preussischer Kulturbesitz.

117. Mosaic panel of the *Deisis*. 1261(?). South gallery, St Sophia, Constantinople. Photo Keribar/Artephot, Paris.

118. Wall painting of the *Koimisis* of the Virgin. 1260s. West wall, cathedral of the Trinity, Sopocani. Photo Held/Artephot, Paris.

119. The church of St Mary Pammakaristos (Fethiye Camii), Constantinople. Soon after 1304. Photo Anne Stierlin, Geneva.

120. Mosaics of the church of St Mary Pammakaristos (Fethiye Camii), Constantinople. Soon after 1304. Photo Henri Stierlin, Geneva.

121. Mosaic panel of the founder of the Chora Monastery, Theodore Metochites. 1316–21. Kariye Camii, Constantinople. Photo G. Dagli Orti, Paris.

122. Wall painting of the Anastasis in the *parekklesion* of the Chora Monastery. 1316–21. Kariye Camii, Constantinople. Photo G. Dagli Orti, Paris.

123. Mosaic of the Enrolment for Taxation at Bethlehem. 1316–21. Outer narthex, Chora Monastery. Kariye Camii, Constantinople. Photo G. Dagli Orti, Paris.

124. Double-sided icon of the Annunciation and Virgin. Constantinople. Early fourteenth century. Tempera. 94.5 × 80.3 cm. National Museum, Ohrid/photo G. Dagli Orti, Paris.

125. Theophanes the Greek. Double-sided icon of the Virgin of the Don and the *Koimisis* of the Virgin. Late fourteenth century. Tempera. 86 × 68 cm. Tretyakov Gallery, Moscow/photo Scala, Florence.

126. Icon of the Virgin Kardiotissa. Second quarter of the fifteenth century. Signed 'Hand of Angelos'. 121 × 96.5 cm. Byzantine Museum, Athens.

127. Manuscript illustration of a community of nuns. Constantinople. Between 1327 and 1342. Lincoln College Typikon. 25 × 18 cm. © Lincoln College (MS Gr.35, folio 12 recto), Oxford/photo Bodleian Library.

The publisher and author apologize for any errors or omissions in the above list. If contacted they will be pleased to rectify these at the earliest opportunity.

Index